Digital Nature
Photography

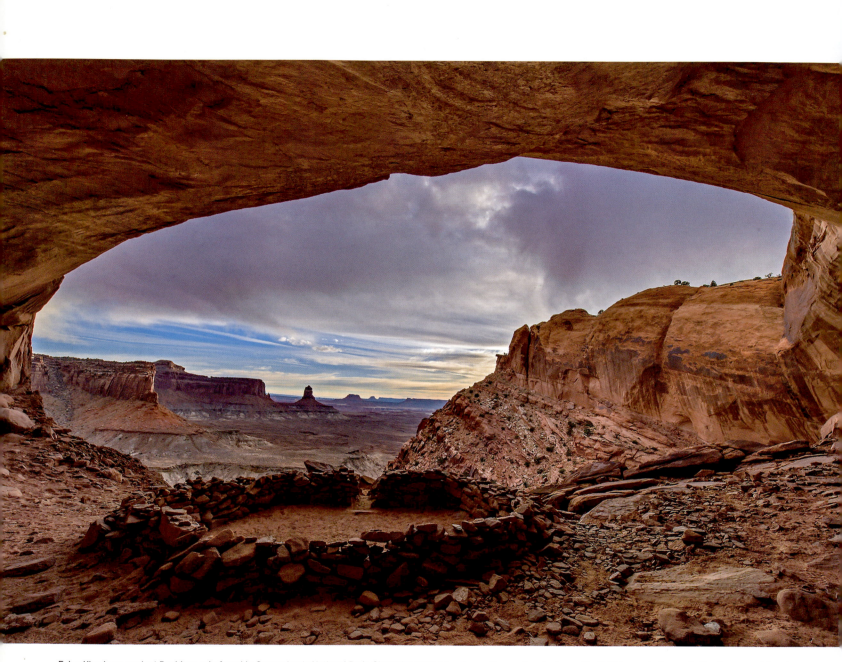

False Kiva is an ancient Puebloan ruin found in Canyonlands National Park. Since the ruins lie underneath a vast rock alcove, the light is much dimmer in the foreground than in the distant background. Instead of shooting an HDR series of exposures to cover the dynamic range, Barbara used the Shadow/Highlight tool in Photoshop CS6 to subdue the high contrast. Nikon D4S, Nikon 14–24mm f/2.8 lens at 14mm, ISO 100, f/18, 1/80 sec, Cloudy WB, manual exposure mode and AF-C on the back-button control.

Digital Nature Photography

The Art and the Science

Second Edition

John and Barbara Gerlach

Focal Press
Taylor & Francis Group

NEW YORK AND LONDON

First published 2007 by Focal Press
This edition published 2015 by Focal Press
70 Blanchard Road, Suite 402, Burlington, MA 01803

and by Focal Press
2 Park Square, Milton Park, Abingdon, Oxon OX14 4RN

Focal Press is an imprint of the Taylor & Francis Group, an informa business

Notices
Knowledge and best practice in this field are constantly changing. As new
research and experience broaden our understanding, changes in research
methods, professional practices, or medical treatment may become
necessary.

Practitioners and researchers must always rely on their own experience and
knowledge in evaluating and using any information, methods, compounds,
or experiments described herein. In using such information or methods they
should be mindful of their own safety and the safety of others, including
parties for whom they have a professional responsibility.

Product or corporate names may be trademarks or registered trademarks,
and are used only for identification and explanation without intent to
infringe.

Library of Congress Cataloging in Publication Data
A catalog record for this book has been requested

ISBN: 978-0-415-74242-9 (pbk)
ISBN: 978-1-315-81465-0 (ebk)

Typeset in Slimbach and Helvetica
By Keystroke, Station Road, Codsall, Wolverhampton

Printed and bound in India by Replika Press Pvt. Ltd.

Bound to Create

You are a creator.

Whatever your form of expression — photography, filmmaking, animation, games, audio, media communication, web design, or theatre — you simply want to create without limitation. Bound by nothing except your own creativity and determination.

Focal Press can help.

For over 75 years Focal has published books that support your creative goals. Our founder, Andor Kraszna-Krausz, established Focal in 1938 so you could have access to leading-edge expert knowledge, techniques, and tools that allow you to create without constraint. We strive to create exceptional, engaging, and practical content that helps you master your passion.

Focal Press and you.

Bound to create.

We'd love to hear how we've helped you create. Share your experience:
www.focalpress.com/boundtocreate

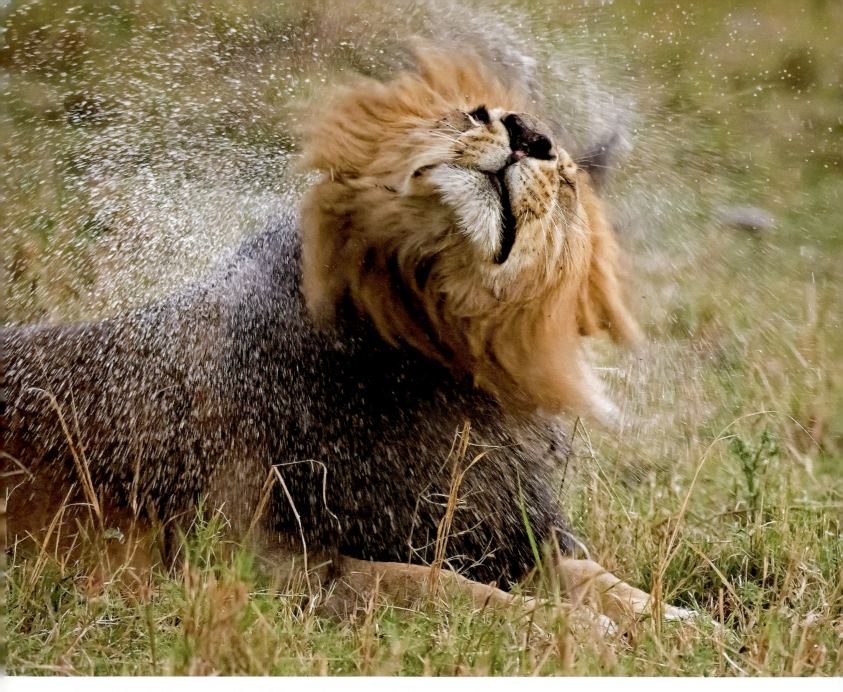

Barbara patiently waited for the expected "head shake shot" during a torrential rainstorm. When the rain subsided, the lion cooperated perfectly. Due to the dim light, she had to use a high ISO and managed the noise with Photoshop CS6. Many photographers are attracted to cameras with sensors that have a huge number of photosites (pixels). We are not. More photosites crammed into the sensor means they are smaller and noisier! We seek cameras that offer the best noise control when using high ISOs and long exposures. Currently, the cameras for us that meet this need include the Nikon D4S and the Canon 5D Mark III. Nikon D4S, Nikon 200–400mm f/4 lens at 420mm with a Nikon 1.4x teleconverter, ISO 14400, f/6.7, 1/500 second, Cloudy WB, manual exposure mode with AF-C on the back button.

Table of Contents

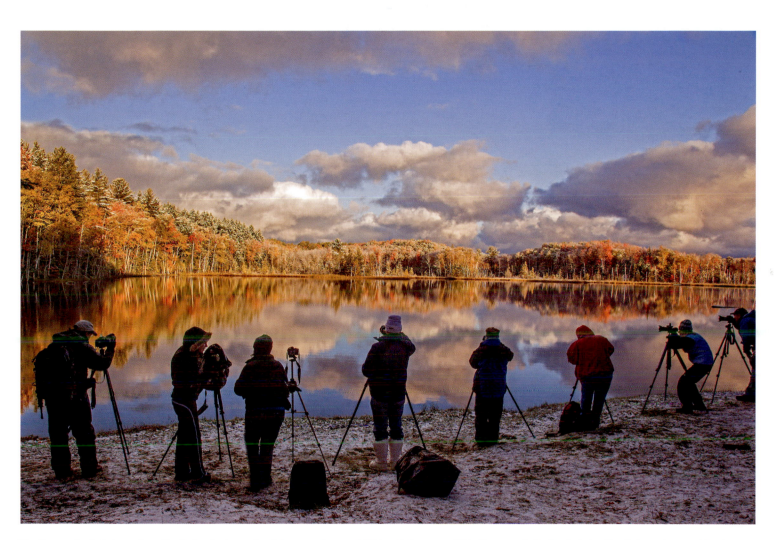

The thousands of photography enthusiasts who have attended our seminars and field workshops over thirty-five years helped us in being the photographers and teachers we are today. We appreciate you tremendously! Your probing questions and brilliant observations make all of us far more skillful and creative photographers. We have traveled the world together learning to photograph while enjoying the natural world around us. This group is appreciating a spectacular autumn dawn at Council Lake during a Michigan field workshop. Nikon D4, Nikon 24–85mm lens, ISO 400, f/16, 1/30 second, Sun WB, manual metering and AF-C focus on the back-button.

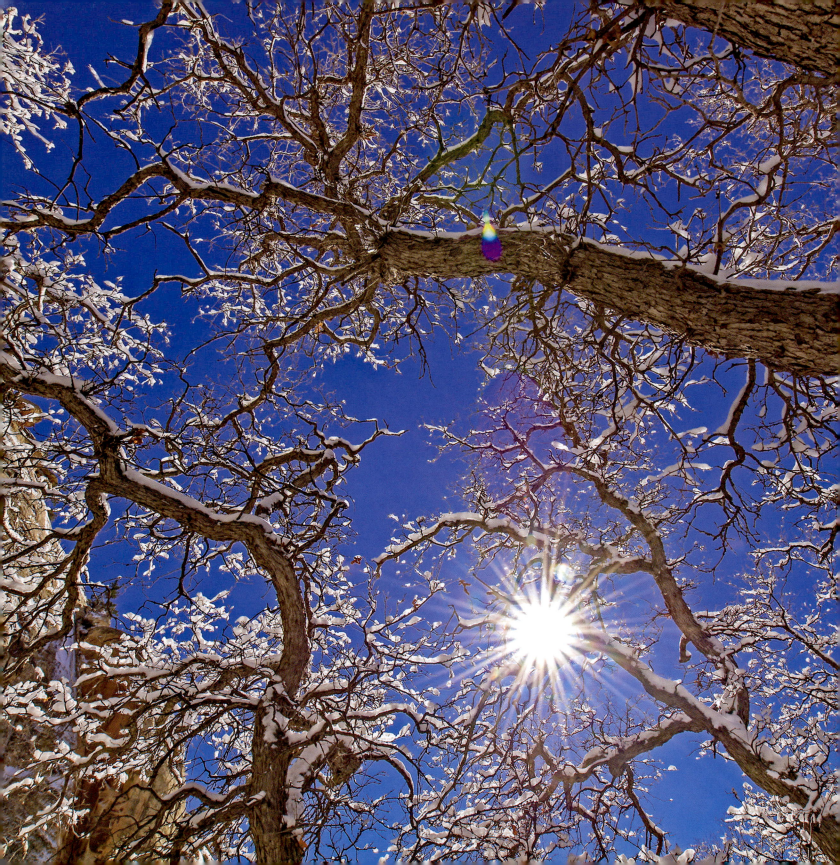

Acknowledgments

John and Barbara Gerlach dedicate this book to the thousands of photography enthusiasts who have attended our instructional photography workshops, seminars, and exotic photo tours for over thirty-five years. Your enthusiasm, thought-provoking questions, good humor, and friendship have helped us immensely in developing the shooting system we use and teach that lets everyone capture outstanding images without difficulty and consistently.

Writing is incredibly hard work. If I (John) had known I would spend so much of my life writing, I would have paid more attention in the few required writing classes I took in college. If I could do it all over again, I would have omitted my chemistry classes and taken more journalism classes. Several of my clients are excellent writers who volunteered to edit this manuscript—in other words, make sense out of it, which is no easy feat. My deepest gratitude goes to Woodice Fuller, Al Hart for his technical expertise and good humor, and Dave and Kim Stringer. With their help, I feel confident the text is easier to read and the concepts presented here are described in a more logical fashion. Many thanks to all of you! I know this book reads considerably better due to the tremendous effort you have put into helping this accidental author make sense of it all in this book and in previous books.

Special thanks go to Tom Walker, who lives near Alaska's Denali National Park. His advice about where to go to photograph brown bears, mountain goats, northern lights, prairie chickens, and wintering Japanese wildlife has always been right on. He is a tremendous nature photographer and prolific best-selling author, but he wouldn't want me to say that, so don't tell him you heard it here. We know him as "Cowboy" and "Tender Tundra Tom," but let's keep that a secret as well.

And most of all, everyone needs to thank Barbara Gerlach, who reads the text to find out where I have gone astray, keeps me on schedule

It is fun and easy to create sunstar images! The frosted tree branches drew Barbara's attention. She used a short focal length lens and stopped down to f/16 to produce the sunstar and underexposed the image to darken the sky and make the sunstar more prominent. Nikon D4S, Nikon 14–24mm f/2.8 lens at 14mm, ISO 100, f/16, 1/200 second, Sun WB, manual exposure mode and manual focus.

(usually), selects all of the images being used in this book, processes the RAW images with Photoshop, sends these huge files over the Internet to the publisher, and does innumerable office chores that must be done in a timely fashion to get the book to you.

Introduction

I was fortunate to discover my passion while I was a wildlife biology student at Central Michigan University in the early 1970s. I loved learning about game animals—ducks, geese, pheasants, grouse, deer—and thought I would spend my life working with them, but it was not to be. While at college, I developed a passion for all forms of life including fish, amphibians, reptiles, butterflies, wildflowers, trees, and everything in the ecosystem. My keen interest in nature photography compelled me to photograph everything. Upon graduation in 1977, I decided to become a self-employed professional nature photographer instead of working for someone else as a biologist. I put everything I owned in my pick-up truck and drove toward California to explore new ecosystems such as the alpine zone in the Rocky Mountains and creatures of the southwestern deserts. I had little money and relied on unreliable income from photo sales and articles. Therefore, I lived under the stars as a homeless person for several years while simultaneously perfecting my business and photography skills. This period of enduring a meager existence was fulfilling, though challenging, but still incredibly fun for me. To this day, when a person asks me how to succeed in life, I tell them, "Find your passion and pursue it relentlessly. There is no better way to earn a living than doing what you truly love to do. Why settle for anything less?"

Barbara also enjoyed an early life with nature and animals. She grew up on a small horse farm that took good care of other people's horses and her horse, too. Her life was full of domestic animals and the wildlife that were attracted to the farm near Avon Lake, Ohio. Barbara

Sometimes luck prevails. The safari driver spotted the leopard slinking through the bushes in Kenya's Masai Mara. The dawn light was gradually brightening, but the light levels in the bushes varied considerably as the leopard moved through them. I used my favorite exposure strategy to deal with rapidly changing light levels where a high shutter speed must be maintained to capture a sharp image. I used the shutter-priority exposure mode and set a shutter speed of 1/1000 second. Then I set Auto ISO to maintain the optimal exposure. Canon 5D Mark III, Canon 800mm f/5.6 lens, Auto ISO 1600, f/5.6, 1/1000 sec. with shutter-priority, +.7 exposure compensation, Cloudy WB, back-button focusing using continuous autofocus.

loved shooting images well before she met me. We met when I was the keynote speaker at a summer meeting of the Southwestern Michigan Camera Club Council. Over time, we joined our similar passions and have worked together ever since. She is a tremendously talented outdoor photographer with superb instincts and an exceptional eye for composition. She is a whiz with computers, unlike your author who constantly struggles with computer programs that refuse to do what he thinks they should do. I do all of the writing, but Barbara helps to determine the content, points out when I need to simplify things, and does all of the image processing.

Together, we select images for the book to illustrate the key points. My college background in physics and math makes it easy for me to understand the numbers and science of photography. Do not panic—you do not need to know that much of the science—but it does help me explain crucial photo concepts in fairly simple terms. I do not include a lot of technical formulas in the photography books we produce because you truly do not need to know most of it. Instead, it is best to stick to mastering the key shooting tactics that produce successful images shot after shot.

OUR FORMULA FOR SUCCESSFUL IMAGES

I am really not keen on a formula because I saw too many in my science studies, so let's refer to it as a guideline. Stunning images need three key factors that must be present at the same time. If any one of these factors is missing, the image suffers. Let us examine each of these factors.

1. PHOTOGENIC SUBJECT

It is difficult to make a gorgeous image when the subject is not attractive. A bighorn sheep shedding its winter fur coat in the spring always looks ragged and not visually attractive, especially when compared to the same animal in late autumn or winter when the fur is in prime condition. A wildflower beginning to decay or a butterfly missing wing scales or which has tears in the wings are similarly not good photo prospects.

2. SUPERB TECHNIQUE

A handsome Bald Eagle perched on a frost-covered branch with a trout in its talons makes a lousy image if it is badly underexposed, not properly focused, or poorly composed. Strive to acquire excellent camera and lens handling technique and your images will improve tremendously. Fortunately, the technique portion of this simple formula is completely under your control and is mastered by anyone without difficulty.

3. PLEASING SITUATION

A beautiful mountain goat standing in a parking lot with a crowd of humans behind it with full sun on it at noon is a terrible situation in any event. No matter how good the animal looks or how superb your technique is, the goat image will never be awesome. The circumstances are dreadful! Find this same goat on a mountain ledge in golden evening sunshine with an uncluttered distant background and you have a winning subject!

WRITING BOOKS

This is my fifth instructional book on nature and outdoor photography. This fact amazes even me as I never had any intention of writing a book until recently in my career. Books require a tremendous amount of work, but worse yet, I must be at the desk to write them, which is especially difficult for me because I am addicted to being outdoors. I find books to be an interesting project, and each one helps me learn more about photography because it forces me to put my thoughts into words. However, I write these books primarily to share with photographers all around the world the photo ideas and shooting strategies that we and our many clever clients have come up with over the years. Our books are being published in other languages because they contain many techniques that are relatively unknown and not published elsewhere. For example, we have been at the forefront of High Dynamic Range (HDR), focus stacking, back-button focusing, using the RGB histogram for exposure, advanced manual metering tactics, fill flash, main flash, balanced flash for outdoor subjects, and much more. It takes time to get the word out!

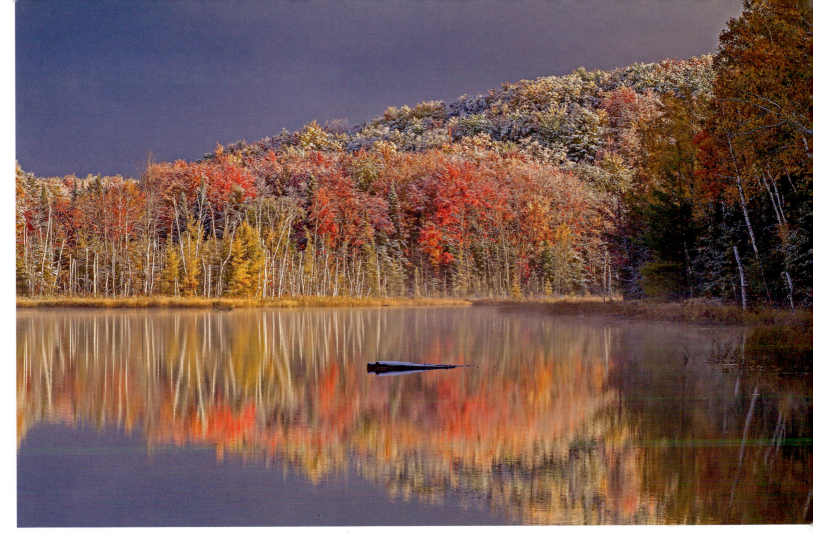

The group in the previous image photographed the Council Lake shoreline. Making attractive images that command attention is uncomplicated when you follow a simple guideline. You must use excellent shooting technique, have a fabulous subject, and find a favorable situation. When all three come together, shooting rewarding images is fun and predictable. Canon 5D Mark III, Canon 70–200mm f/4 lens at 131mm with polarizer, ISO 200, f/16, 1/20 second, Daylight WB, manual exposure and continuous AF with the back-button control.

Take back-button focusing, for example. We have been using this method for at least twenty years and started using it with film cameras. Only now are we beginning to see back-button focusing mentioned in magazines occasionally. It still amazes us that back-button focusing, one of the best ways to control autofocus, is still unknown to so many photographers despite our best efforts to explain it in all of our books and to post a detailed article about it on our website. Focus stacking is another tremendous game-changer that is just getting attention. Hopefully, it will not take two decades to become widely known and used.

My perpetual problem with writing a book is having to decide what to leave in and what to leave out. I would love to be able to tell you this is the complete book on outdoor photography, but *complete* in the title of any book is absurd. I could easily expand every chapter in this book into an entire book of its own. Since space is at a premium—even in a book—I will emphasize the key shooting strategies that work so well in order to shoot superb images effortlessly and efficiently. The emphasis is on producing quality images and doing it easily. I know many photographers would be happy if I told them handheld shooting is fine, you don't need a flash, and use

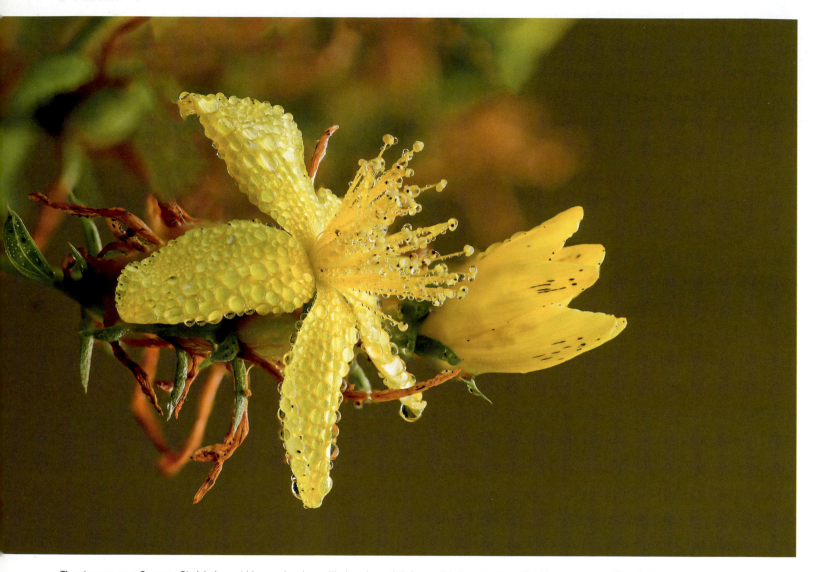

The stamens on a Common St. John's-wort blossom bead up with dew drops. It is impossible to make the entire blossom sharp with a single exposure at high magnification. Thanks to new focus stacking techniques, now everything can be in sharp focus. Barbara shot a stack of seventy-three images in which each image is focused at a different distance. She merged the stack of images into one final sharp image using Zerene Stacker software and used Photoshop for final image adjustments. Nikon D4S, Nikon 200mm f/4 macro lens, ISO 200, f/18, 1/200 second, Cloudy WB, manual exposure and focusing.

f/22 all of the time for maximum depth of field, but I won't. All of these widely accepted ideas are nonsense almost all of the time, and the quality of your images will suffer significantly if you believe them. I must assume and hope you want quality images, are not willing to cut quality corners, and are willing to adopt the superb shooting habits we will suggest and explain.

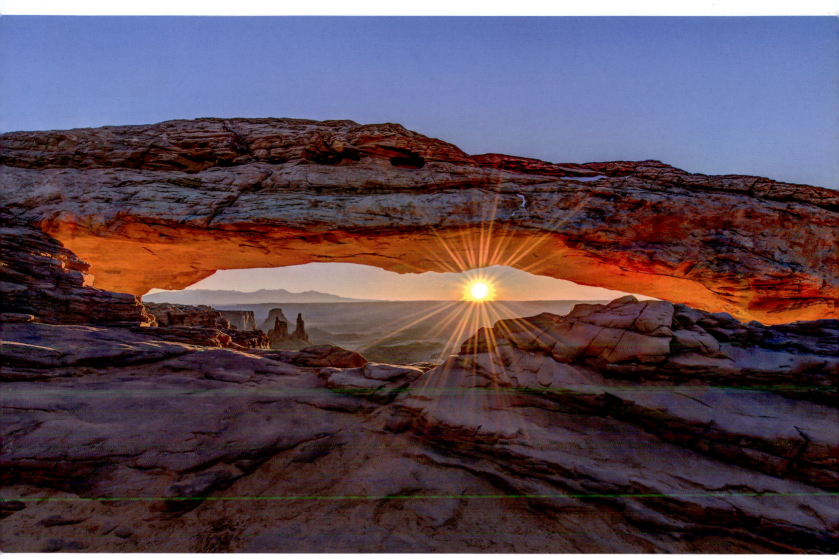

Mesa Arch is spectacular at dawn when the rosy rays of sunshine first light up the bottom of this well-known arch in Canyonlands National Park. Three exposures were shot by varying the shutter speed. These images were combined with Photomatix Pro software. Nikon D4S, Nikon 14–24mm f/2.8 lens at 14mm, ISO 100, f/18, shutter speeds of 1/15 – 1/4 – 1/60 second, Sun WB, manual exposure mode and AF-C autofocus on the back-button control.

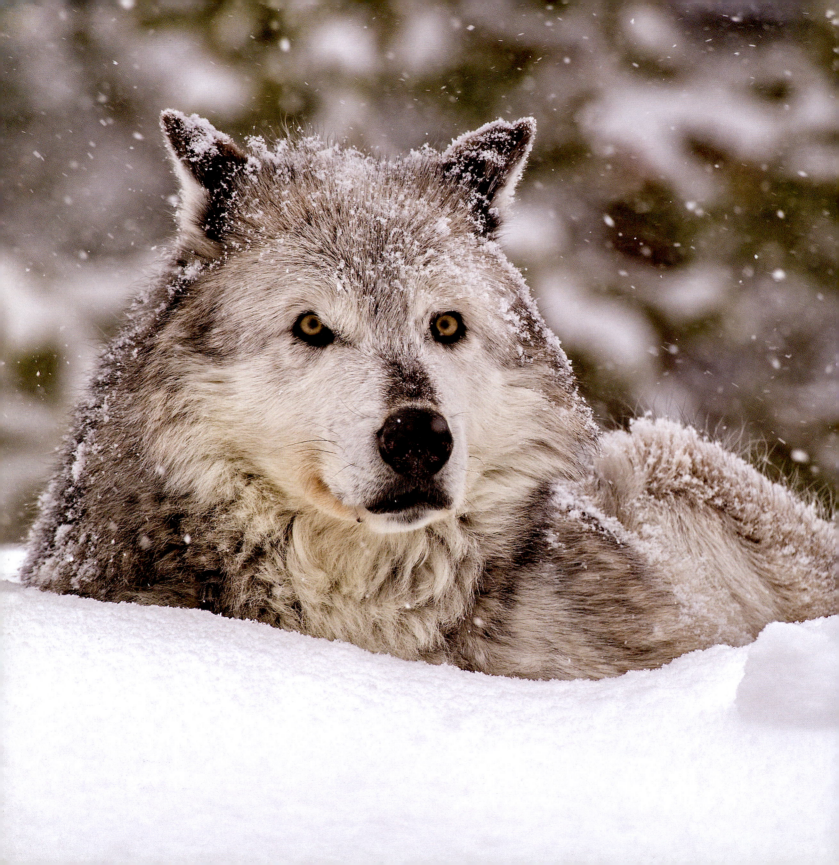

1

Cameras and Accessories

CAMERA SYSTEM CHOICES

All of the popular camera companies—Nikon, Canon, Sony, Olympus, Pentax, and Sigma—make excellent products. You can't go wrong with any of these brands. However, Nikon and Canon produce two of the largest product lines. They offer various camera models, lens choices, and other accessories. Though having just the right equipment is important to achieving your photo goals, all of those options can bewilder a beginner. Let me shed some light on the available choices.

Barbara shoots all Nikon cameras and lenses and has done so throughout her entire career. I began with Canon in 1971, switched to Nikon ten years later, and then switched back to Canon in the late 1980s to use their newly introduced tilt/shift lenses. Today, I mostly shoot Canon equipment, but I did sometimes borrow Barbara's fantastic Nikon 200–400mm lens when I photographed wildlife! In the spring of 2014, I bought Canon's 200–400mm lens, so I no longer need to borrow hers. Barbara sometimes borrows my Canon camera to use Canon's tilt/shift lenses or the fabulous Canon 65mm macro for high magnification focus stacking work. We shoot both Canon and Nikon because we genuinely like both. Knowing both systems thoroughly helps us tremendously in teaching field workshops because 90 percent of our workshop clients are shooting either Canon or Nikon.

Most likely you already have a camera and perhaps a few lenses. It makes sense to stay with your chosen system because it is expensive to switch. However, if you are deciding on a system, we suggest you look at the Canon and Nikon systems closely for four reasons:

We do not photograph many captive animals, but we enjoy photographing the gray wolves at the Grizzly and Wolf Discovery Center (www.grizzlydiscoveryctr.com) in West Yellowstone. We especially like photographing them during winter because their fur coats are immaculate and the snow "cleans up" their enclosure and makes the image appear wilder. Nikon D4, Nikon 200–400mm f/4 lens at 400mm, ISO 640, f/7.1, 1/500 second, Cloudy WB, manual exposure and AF-C autofocus on the back-button.

1. Nikon and Canon offer a wide variety of cameras, lenses, and flash options.

2. Plenty of instructional materials—e-books, third-party books on the system, books on individual cameras, and websites devoted to these systems—are available.

3. Most photo instructors shoot one of these two systems. If you are shooting the same camera system as your photo instructor, they should be able to help you more.

4. If you are on a photo trip—Antarctica, for example—and your lens or camera malfunctions, the chances are much greater you can borrow what you need from another passenger if you are shooting a system that many of the other passengers are shooting.

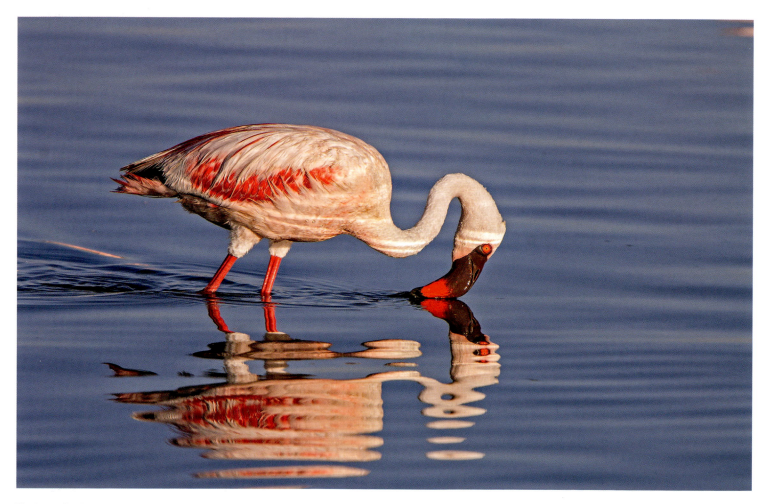

The lesser flamingo is filtering the water for blue and green algae at Kenya's Lake Nakuru. The flamingo is simple to photograph well if your technique is flawless. Compose the flamingo feeding on the left side to give it space to walk into the image. Be sure to include the reflection of the bird to add interest. Focus by selecting a single AF point that corresponds to the head of the bird. Set the autofocus to continuous focus to keep the bird in focus, select a fast shutter speed, and shoot many images. Having a large buffer in the camera allows you to keep shooting as the bird walks by in front of you. Nikon D200, Nikon 200–400mm f/4 lens, ISO 200, f/8, 1/500 second, Sun WB, shutter-priority at +.7 EC and AF-C autofocus on the back-button control.

KEY CAMERA FEATURES

HIGH MEGAPIXEL COUNT

The cameras sold today offer plenty of megapixels. If your camera can capture 12MP RAW files or larger, then you have enough. Having more megapixels means you can make large prints that are sharp or crop the image more while retaining satisfactory resolution.

FAST SHOOTING SPEED

Being able to shoot six or more images per second is crucial for action photography. If you tend to shoot still subjects—portraits, landscapes, still-life—then shooting speed is far less critical.

LARGE BUFFER

Most cameras can shoot images faster than they can be written to the storage media such as a Compact Flash (CF) card. Therefore, the camera has a built-in buffer where the image data are temporarily stored while waiting to be written to the card. When the buffer is full, the camera stops shooting until enough data are written to the storage media and removed from the buffer.

Photographers who tend to shoot many images quickly benefit from having a large buffer.

ADJUSTABLE SELF-TIMER

Most cameras offer an adjustable self-timer. Pressing the shutter button with the self-timer invoked gives you time to get in the picture before the camera shoots the image.

You can use the self-timer to fire the camera without touching it, which effectively produces sharper images. Gently press the shutter button with your finger. This causes the camera to shake a little, but it dissipates in a second or two. Then the camera shoots the image when the camera is perfectly still. The typical self-timer runs down in about 10 seconds. That time interval is fine if you want to be in the picture, but far too long for merely firing the camera.

Being able to set a 2-second self-timer interval is more convenient.

CABLE OR WIRELESS REMOTE RELEASE

To shoot sharper images when the camera is mounted on a tripod, fire the camera without touching it by using a cable release that attaches to the camera or a wireless release. Make sure your camera offers these options—most do.

RGB HISTOGRAM

The histogram display provides a way to more accurately determine the optimum exposure, especially when a single color in the subject dominates or the light is highly biased to a single colorcast, such as the red light at sunset or the blue light in the shade. Of course, the worst situation is a dominant color that is illuminated with light of that color. A red fox bathed in the red light of sunset is an example in which the reds are likely to be overexposed with the averaging histogram. The red channel of the RGB histogram immediately shows there is a problem with the red light that is easy to overcome by reducing the exposure.

BACK-BUTTON FOCUSING

Your camera has this feature if there is a designated AF-On button on the rear of your camera near the right side of the viewfinder. Even if you don't have this button, most cameras offer a way to take autofocus off the shutter button and move it to a button on the rear of the camera.

Having a camera that can do this is absolutely essential as back-button focusing is an enormously precise and efficient way to hit sharp focus with autofocus!

MIRROR LOCK-UP

This mechanism allows you to lock the mirror in the upright position before shooting the image.

This produces sharper images when shooting on a tripod, especially in the shutter speed range of 1/4 to 1/30 of a second. Without mirror lock-up the camera moves slightly when you shoot because the mirror has to move out of the way to allow the light to strike the sensor.

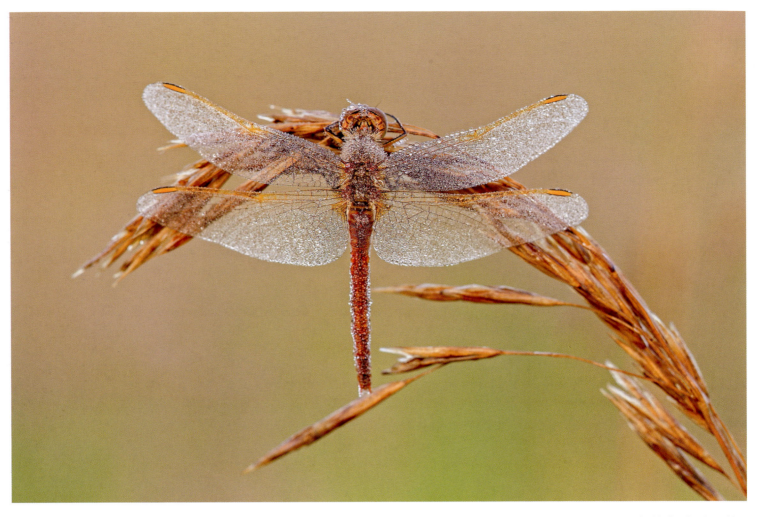

Dew-laden dragonflies are plentiful on cool mornings in northern Michigan meadows. They roost on top of flowers and grasses and become soaked with dew by dawn. Your shooting technique is crucial for making the finest possible image. Tripping the shutter with your finger jars the camera and creates camera-shake. Instead, trip the shutter with a cable release or a wireless remote release to eliminate the image-softening effects of vibration. Canon 1D Mark III, Canon 180mm f/3.5 macro lens, ISO 200, f/8, 1/6 second, Daylight WB, manual metering and focus.

LIVE VIEW

With live view activated, you can see the image that will be captured on the LCD display before firing the camera. On many cameras, a live histogram is offered. Using a magnified live view focus is the best way to achieve critical sharp focus on all close-up and macro images.

BUILT-IN WIRELESS FLASH CONTROL

Most Nikons, some Canons, and many other camera brands that have a built-in pop-up flash on top of the camera allow the pop-up flash to be the Commander or Master controller. This means the pop-up flash can control another dedicated flash that is not attached to the camera.

This feature provides enormously useful wireless flash control.

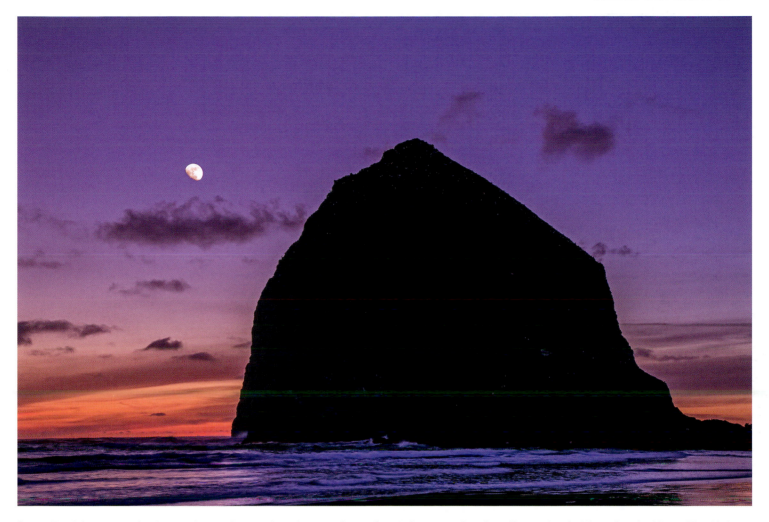

Cannon Beach is a spectacular place to photograph sunset in northwestern Oregon. Sea stacks are amazing when silhouetted against the amber sky. After making this image of 235-foot Haystack Rock, I noticed the moon hovering in the sky. The moon was too high to compose into the scene in a single shot, but no worries. I set my camera to multiple exposure and used a 105mm focal length and the Mooney 11 rule to add the moon to the scene. I kept the moon small for a more natural size. Canon 5D Mark III, Canon 24–105mm f/4 lens at 105mm, ISO 400, f/10, 1/50 second, 10,000K WB, manual exposure and continuous autofocus on the back-button control, the second exposure for the moon is 1/800 at f/8.

MULTIPLE EXPOSURE CAPABILITY

This feature allows the photographer to shoot two or more images that are assembled into a single image directly in the camera. Until recently, few cameras offered it (Canon has been a laggard in this regard), but it is now becoming more widely available. Multiple exposures are generally used for creative effects by adding an element such as a flower or the moon to an image. It is incredibly useful for lighting up more than one object with flash or extending the reach of a flash by allowing it to be fired at full power multiple times.

SENSOR SIZE

Your camera has an imaging sensor that is made up of filtered photosites that measure photons of light. The size of the sensor is either full frame or some predetermined smaller ratio

size. A full-frame sensor is 36 x 24mm in size. If the sensor is smaller than full-size, then it is said to have a crop factor or magnification factor. For example, a Canon 7D has a sensor size of 22.3 x 14.9mm. Relative to a full-frame sensor, it has a crop factor of 1.6x. I prefer not to call it a magnification factor because nothing is really being magnified. The small-sensor camera is merely cropping the image one gets with the full-frame sensor.

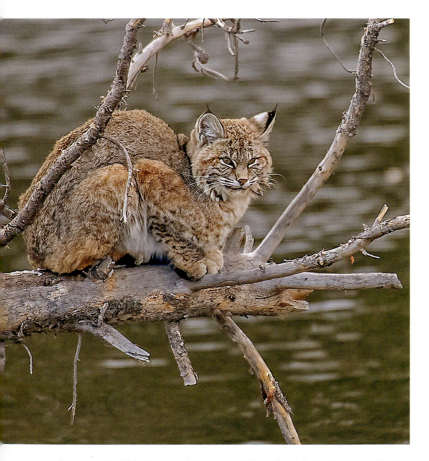

Bobcats relish duck dinners and this cat is quietly waiting for a hapless mallard to float within striking range on the Madison River in Yellowstone National Park. The cloudy late evening light forced the use of ISO 1600. We favor cameras with full-frame sensors because the sensor tends to be less noisy at high ISOs because the photosites are larger. Nikon D4, Nikon 200–400mm lens with 1.4x teleconverter at 560mm, ISO 1600, f/5.6, 1/500 second, Shade WB, manual exposure and AF-C on the back-button.

FULL-FRAME SENSOR ADVANTAGES

- More megapixels.
- Produce images with less noise.
- Wide field of view with wide-angle lens.
- Bigger in the viewfinder.

SMALL SENSOR ADVANTAGES

- Considerably less expensive to produce.
- Usually can shoot more images per second because the files are smaller.
- Smaller file size so it takes longer to fill the buffer and memory card.
- The more lightweight camera can use lighter and less expensive lenses.
- Faster flash sync speed because the shutter curtains don't have to move across a large sensor.
- Smaller field of view so the lens seems longer and makes the background easier to simplify.

THE RIGHT CHOICE ON SENSOR SIZE

Shooting a camera with a full-sized sensor or a smaller one is entirely up to the individual.

There is no wrong answer. Barbara and I tend to use full-sized sensor cameras—Nikon D4, Canon 5D Mark III—only because we commonly wish to photograph night scenes where the larger photosites of the full-size sensors tend to shine because they are less noisy.

In all honesty, we could easily shoot every image in this book with a bottom-of-the-line Canon or Nikon camera, though you would not know it from the picture quality. However, you might notice more noise artifacts in the night scenes. The top-of-the-line full-sensor pro cameras are more rugged, resist rain and snow better, and offer far more custom functions and menu choices that we enjoy using.

CAMERA BATTERIES AND CHARGERS

Your new camera probably came with a rechargeable battery and charger. These items sometimes malfunction at inopportune

times. Always have an additional battery charger and at least two extra fully-charged batteries. Modern rechargeable batteries don't have a memory, so top them off by charging them after each photo session. Batteries will degrade over time, however. If you have a battery that is a few years old and seems to lose its charge quickly, it is probably time to replace it.

Many cameras offer a power pack (this adds weight to the camera) that can be attached to the camera, which makes it possible to shoot more images before changing the batteries.

However, because we always keep extra charged batteries with us, we have never bought an additional power pack for our cameras, so perhaps you don't need one either.

MEMORY OPTIONS

TYPES OF CARDS

Your camera is designed to accept one or possibly two types of memory cards. The most common choices used by camera makers include Compact Flash (CF) and Secure Digital High Capacity (SD HC), along with a few others. Check the camera's instruction book to see what type is needed.

CARD MAKERS

We personally avoid any card when we do not recognize the manufacturer's name. We have always used SanDisk, Delkin, and Lexar cards without any problems.

CARD SPEED

Any photographer who shoots many images quickly or video will benefit from a fast card because it is better able to accept data from the camera's buffer, which allows faster shooting.

If you tend to photograph still objects at a much slower shooting speed, then inexpensive slow cards will work fine for you.

CARD CAPACITY

The more memory capacity your card has, the more images it can hold. A 32GB card will hold twice as many images as a 16GB card. Memory is cheap, so it makes sense to use larger capacity cards to avoid losing important images because the card filled at the worst possible time. As I write this in 2014, we prefer 32GB and 64GB Compact Flash cards in our cameras.

AVOIDING MEMORY CARD PROBLEMS

After our photo shoot, we turn off the camera and remove the Compact Flash card. We immediately download the images to an external hard drive using our computer. If you use your computer's hard drive, it will soon be filled. Once these images are successfully downloaded—we check for this—we put the card back in the camera we intend to use it in and format the card. Formatting the card, rather than deleting images from the card, prepares the card properly for receiving more images. If we shoot images on multiple cards, these are formatted and put into a plastic card wallet to protect them. Many card wallets are available.

We happen to use a SanDisk card wallet that holds four Compact Flash cards. If the card is formatted and contains no images, we put the card in the wallet facing up. If the card is full of images, then we store it in the wallet face down to remind us to download the images ASAP.

To avoid corruption problems, never wash your cards, don't let them get dirty, and never turn the camera off when it is writing to the card.

PROTECT THE CAMERA

WATER PROBLEMS

Cameras are not waterproof! Avoid letting your camera get wet. If you must shoot in the rain or when the snow is wet and melts on contact, cover the camera with a plastic bag or a protection device designed for this purpose. Even holding an umbrella above the camera while shooting can work wonders. Always remember that electronics and water don't mesh very well. On cold winter days, snow isn't a problem because snowflakes are easily brushed off the camera.

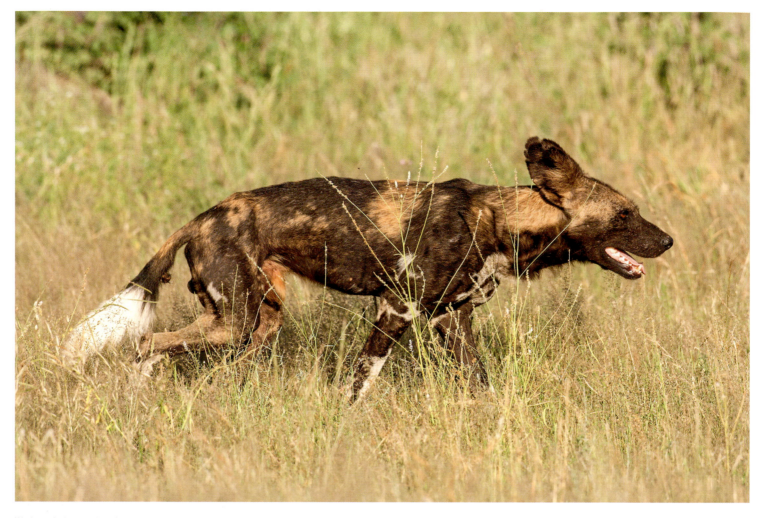

We have led more than forty wildlife photography tours to East Africa. We have seen wild dogs only once in that time. We were in Kenya's Samburu National Park when a pack unexpectedly showed up and trotted around our Land Rovers for a few minutes. When the shooting is fast and furious, being able to shoot several images per second and having a memory card in the camera that accepts many images is crucial. Canon 1D Mark III, Canon 500mm f/4 lens, ISO 400, f/7, 1/1000 second, Cloudy WB, AI Servo on the back-button focus controller.

Avoid condensation, too. If you are shooting outside on a cold day, put the camera in a small plastic bag, squeeze the air out of it, seal the bag, and take it inside and allow it to warm up for a couple of hours. On the other hand, if you are in an air-conditioned room and the outside air is warm and humid, to avoid condensation put the camera in a plastic bag and allow it to warm up to the outside temperature first before removing it. This is a common problem on Galapagos Islands photo safaris where clients stay in air-conditioned cabins.

Should you accidently drop your camera in a river or lake, remove it immediately and take the batteries out of it. Dry the camera out by putting it in a warm and dry spot. Using the heater in the car can start the drying process. Putting the camera in an oven set for about 80 degrees might help it out or use a hair dryer. Send the camera to the repair shop right away and hope for the best!

Do not allow water to condense on your camera and lenses. Water is especially harmful to camera equipment because the gear has so many electrical circuits in it. Condensation happens most often when shooting outdoors on cold days and then taking the camera equipment into a warm room. The moisture in the room condenses on the gear. It also happens, though, when photographing in warm humid environments. On a Galapagos tour you might photograph a red-footed booby; taking your camera gear outdoors from an air-conditioned room on the boat creates the same problem. In both cases, the solution is to put your gear in an air-tight plastic bag and keep it sealed until the camera gear warms up. Nikon D3, Nikon 200–400mm f/4 lens at 270mm, ISO 3200, f/4, 1/250 second, Cloudy WB, manual exposure and AF-C autofocus on the back-button.

SHOCK

Never drop camera gear, especially on anything hard like rocks and concrete. If you are prone to dropping things, then using a strap on your camera might save it. Although we never use protection filters on our lenses because they will degrade the quality of the image and tend to cause more flare problems, we always use a lens hood. Should you drop your camera and it hits on the lens hood, the cushion the hood offers might save it if you are lucky.

CAMERA STRAP, CABLE RELEASE, AND ATTACHED LENS CAP

We call this spaghetti. Although we just mentioned using your camera strap might save your camera someday, we seldom use camera straps. We find photography is far easier if we are not constantly moving the camera strap out of the way of the viewfinder or LCD display. For still subjects, we prefer to use the 2-second self-timer to fire the camera rather than a cable release to avoid the nuisance factor. Some photographers give us the shakes when we see them using a camera strap, cable release, and a string to attach their lens cap to the lens.

Having three straps hanging down to get in the way, blow in the breeze, and perhaps strike your close-up subject just isn't an efficient or convenient way to shoot images. Some photographers compound the problem by putting the camera strap around their neck while shooting on a tripod. Tying yourself to the tripod with a short leash is a difficult way to work. I am trying to be diplomatic so I won't say what I really think of the idea.

YOUR CAMERA SYSTEM

The choices you must make in equipment depend on budget, equipment you already own, and your ambitions as a photographer. Carefully consider which camera system you want to shoot with for the long haul because it is expensive to switch later on if you already have a lot of camera gear. For now let us consider some of the most effective ways to use that equipment.

Choosing and Using Lenses

LENS MAKERS

Major camera lines—Nikon, Canon, Olympus, Sony, etc.—build lenses specifically for their own cameras. It is reasonable to assume these lenses can deliver high quality images if or when you do your part and use excellent technique. Since lenses are built specifically for a camera system, it is likely they will perform flawlessly. Metering and focusing problems should be minimal. We use Nikon lenses on our Nikon cameras and Canon lenses on our Canon cameras at least 99 percent of the time, and we accept paying a premium price to acquire them.

THIRD-PARTY LENSES

We realize the price of camera gear has grown much faster than most people's income.

Affording quality camera gear is problematic for many. Fortunately, third-party lens makers, especially Tokina, Tamron, and Sigma, offer quality optics for far less money because they build their lenses with various mounts so they can be sold to multiple camera systems. This increases their market share and distributes the cost of production and engineering over far more lenses, which reduces their cost. We have tested a few third-party lenses, and the results were satisfactory. Most of our photo workshop clients use some third-party lenses with excellent success. Don't be afraid to buy lenses from Tokina, Tamron, or Sigma to save money.

The sparkling dew drops hanging in a spider web create an appealing pattern. To shoot a sharp image, conditions must be perfect—heavy dew and no breeze—and superb technique is mandatory. Normally we avoid f/32 due to diffraction, but here Barbara is using the small aperture to turn the dew drop highlights into a starburst! Nikon D4S, Nikon 200mm f/4 micro lens, ISO 200, f/32, 1/60, Cloudy WB, manual exposure and focusing.

HOW LENSES WORK

The lens is a cylindrical plastic or metal tube that houses multiple glass elements that focus the light on the sensor. Some lenses, the Canon L lenses for example, include special glass elements that are expensive to make but improve performance. Modern lenses have special lens coatings to reduce flare and improve contrast. Lenses are described by listing their focal length and lens speed and perhaps a few other things. Three examples include the Canon 180/3.5 USM Macro, Nikon 300/4.0 ED-IF, and the Olympus 18–180/3.5–6.3 ED. What do these numbers mean? The Canon lens has a focal length of 180mm. The maximum aperture is f/3.5, and it has a built-in Ultra Sonic Motor (USM) to speed up autofocusing. This particular lens is built to focus extra close, and it can reach life-size (1x) magnification. It is commonly known as a macro lens. The Nikon lens has a 300mm focal length, maximum aperture of f/4, ED designates that special extra-low dispersion glass is used, and IF means the lens has internal focusing. Finally, the Olympus lens is called a zoom lens because the focal length varies between 18mm and 180mm. The maximum aperture slows down from f/3.5 at the 18mm setting to f/6.3 when it approaches 180mm. Once again, ED stands for high quality glass that produces sharper images.

MAXIMUM APERTURE

A lens that has a maximum aperture of f/2.8 is said to be fast because it allows for good exposure at fast shutter speeds. A lens with an f/5.6 aperture is considered slow because it requires a relatively slow shutter speed to achieve a good exposure. In this example, f/2.8 is two stops faster than a lens with a maximum aperture of f/5.6. Fast lenses with large maximum apertures are heavier and far more expensive than slower lenses. For instance, the Canon 300/2.8 lens costs thousands of dollars more than the Canon 300/4.0 model, which is one stop slower and a couple pounds lighter. Are fast lenses worth it? It depends on how you want to use them.

Wildlife and people photographers prefer fast lenses that have maximum apertures of f/4 or larger. Faster lenses cost more and weigh more than slower lenses, but faster lenses permit faster focus and more accurate focus in dim light. They also allow limiting the depth of field more when selective focus is desirable. Barbara's fast Nikon 200–400mm f/4 lens proved valuable when this sow coastal brown bear suddenly stood up to identify an approaching bear. Nikon D4S, Nikon 200–400mm f/4 lens at 380mm, ISO 1600, f/10, 1/800 second, Sun WB, manual exposure and AF-C on the back-button focus control.

FAST LENS ADVANTAGES

EASIER TO SHOOT IN DIM LIGHT

Imagine photographing a leopard at twilight with a 300mm f/4 lens. Using a beanbag while shooting from a Land Rover in Kenya, you believe you will be able to capture a sharp image with a shutter speed of 1/125 second at ISO 400. If the optimum exposure at ISO 400 is f/4 at 1/60 second, then you don't have enough lens speed. If you had a faster 300mm lens that opened up to f/2.8, then you could use 1/125 second at f/2.8. The chances of capturing a sharp image using 1/125 of a second shutter speed improve considerably.

FOCUSING IS QUICKER AND MORE ACCURATE

Automatic focus is more accurate and faster when more light strikes the focusing mechanism. An f/2.8 lens allows twice the amount of light to enter the lens as an f/4 lens. Even when focusing manually, it is far easier to focus with a brighter viewfinder image and less depth of field.

SELECTIVE FOCUS

Depth of field is greatly influenced by the f/stop. F/2.8 provides a shallower depth of field than f/4, which allows the foreground and the background to be rendered more out of focus.

MORE SUITED FOR TELECONVERTERS

These optical devices fit between the lens and the camera. They multiply the focal length by the power of the teleconverter. Common powers include 1.4, 1.7, and 2x. For example, putting a 1.4x teleconverter behind a 300/2.8 lens converts it into a 420mm lens. The 1.4x teleconverter costs one stop of light, so the 300/2.8 lens is now equivalent to a 420mm f/4 lens. If you started with a slow 300mm/5.6 lens, then it would be a really slow 420mm f/8 lens, and you might lose autofocus capability altogether.

EASIER TO REACH FAST SHUTTER SPEEDS

Imagine photographing flying Snow Geese or a downhill racer handheld with a 300/4 lens.

You decide to use ISO 400 and set your f/4 lens wide open. On a bright overcast day, the optimum exposure might be 1/800 second at f/4. That is pretty fast, but handholding and panning often require a faster shutter speed. If you had an f/2.8 lens, you would gain one more stop of shutter speed when the lens is set to f/2.8. Now you could use an exposure of ISO 400, f/2.8, and a whopping 1/1600-second shutter speed!

FLASH IS EFFECTIVE AT GREATER DISTANCES

Flash is an enormously useful tool to use in outdoor photography. Wildlife and landscape photographers often require a flash to light up a distant object. The amount of light a flash can emit is limited. Being able to use f/2.8 over f/5.6—a two stop change in the lens speed—allows the flash to light an object twice as far!

FOCAL LENGTH

Focal length is a key consideration when buying a lens. A 50mm lens is said to approximate the angle of view of human vision. Focal lengths shorter than 50mm have a wider angle of view, and longer focal lengths have a narrower angle of view. The angle of view of a lens determines what will be included in the background. If you have a gorgeous sky background that is huge, then a short focal length lens is usually what you need to include it. If you want to minimize the background and eliminate unsightly distractions, then a longer focal length lens works best.

Most outdoor photographers find at a minimum they need every focal length between 24mm and 300mm. In my case, I use everything from 16mm to 800mm.

Working distance is the distance between the front of the lens shade and the subject. Longer focal length lenses provide more working distance, and this is crucially important if you wish to approach a subject without frightening it or you need the extra distance to keep you safe. If you ever photograph

This multi-colored hot spring is rarely photographed by serious photographers because it is several miles from the nearest trailhead in the southwest corner of Yellowstone National Park. We have visited this spring—our favorite—several times by riding our Tennessee Walking horses to it. A wide-angle lens captures the spectacular colors and the puffy clouds floating overhead. Canon 1D Mark III, Canon 24–105mm f/4 lens at 35mm, ISO 100, f/18, 1/15 second, Daylight WB, polarizer, manual exposure and metering.

a scorpion, rattlesnake, or poison ivy, you will know what I mean.

IMAGE-STABILIZATION

Some lenses have a built-in stabilizer that helps you capture sharper images at slower shutter speeds when shooting handheld. The optical elements in the lens move to compensate for camera-shake, thus producing a sharper image. In some camera systems, the image-stabilization is in the camera and works for all lenses mounted on the camera.

Image-stabilization is the term Canon uses. Nikon calls it Vibration Reduction and other companies use different names, but they all mean essentially the same thing. No matter what it is called, it does produce sharper images when you must shoot handheld or perhaps work on or shoot from a beanbag. The handheld rule of thumb for sharp images states the shutter speed should be equivalent to 1/focal length. This means a 300mm lens can be handheld successfully at 1/300 second and a 30mm lens needs only a 1/30 second shutter speed. Naturally, this depends a lot on the photographer since some are steadier and more conscientious about being still than others.

Camera makers often claim that image-stabilization offers three to four shutter speed gains in your ability to handhold the camera and still shoot sharp images. Thus, with a three stop gain in shutter speed, it might be possible to shoot sharp images handheld with a 200mm lens at 1/25 of a second. However, I tested this and find these guidelines to be optimistic. I am a steady photographer, and the best I can do is one shutter speed slower than the handheld guideline for focal length suggests. We all vary in our ability to hold still, so it is best to test image-stabilization for yourself. By the way, image-stabilization only helps reduce the problem of a shaking camera and does not in any way help to reduce the problem of subject motion. When photographing moving subjects, you still need higher shutter speeds to capture sharp images.

Image-stabilization is an asset and does help when you really must shoot handheld. But, don't use it as a crutch to avoid

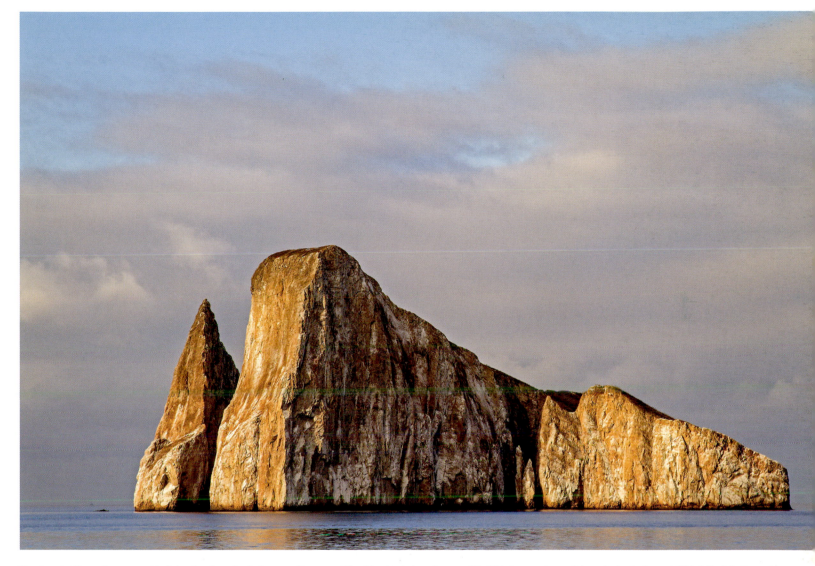

There was a time when we avoided shooting from boats because it was so difficult to shoot sharp images. All of this is now changed. In order to photograph Kicker Rock in the Galapagos, we used our best handheld shooting strategy: using a higher ISO and not stopping down as much, which allowed a faster shutter speed, using an image-stabilized lens, holding the camera as steady as possible, and shooting plenty of images to increase the chances of getting some super-sharp images.

using a tripod for image sharpness. Normally, you are better off using a sturdy tripod. However, for those times when a tripod doesn't work well—deep snow or shooting on a boat—then image-stabilization is well worth having, though it does increase the cost of your equipment.

LENS CHOICES

ZOOM AND PRIME LENSES

A zoom lens contains every focal length in its range. For example, a 70–200mm lens can be set to 70mm, 200mm, or anything in-between those two focal lengths. Most zoom lenses have a variable maximum aperture to keep the size

and price of the lens down. A 75–300mm f/4–5.6 lens starts with f/4 at 75mm and gradually slows down to f/5.6 around 300mm—a one stop loss in lens speed. A 70–200 f/4 lens has a fixed maximum aperture at all focal lengths. We prefer zooms with a fixed maximum aperture, but this again makes the lens more expensive and heavier than its variable zoom counterparts.

A prime lens has a fixed focal length. Common examples include 300mm f/4, 180mm f/3.5 macro, and a 24mm f/2.8.

Prime Lens Advantages

- They usually have a faster maximum aperture. A 300mm f/2.8 lens is two stops faster than a 75–300mm f/4–f/5.6 zoom at the 300mm setting.
- They have fewer optical elements, which makes them less prone to lens flare, and they may be slightly sharper, but the difference is negligible.
- They are usually smaller and lighter than a zoom if the lens speed is the same.

Zoom Lens Advantages

- Many more focal lengths are contained in one lens. You don't need to buy and carry so many lenses.
- Much quicker to change the composition by zooming in (zooming from 75 to 150mm for example) or zooming out to a shorter focal length.
- The image quality is superb with modern lenses, especially if they are built with the best optical glass.
- A single filter, such as a 77mm polarizing filter, works for every focal length on a lens that has a 77mm filter size.
- When used with a close-up filter for close-up photography, zooming the lens makes it easy to change the image size of the subject without forcing you to move the tripod.

WE PREFER ZOOM LENSES

We both use high quality zoom lenses for most of our photography. Years ago, we tried to do everything with prime lenses and it did not work well. I once owned 24, 35, 50, 85, and 105mm prime lenses. When I tried to photograph a

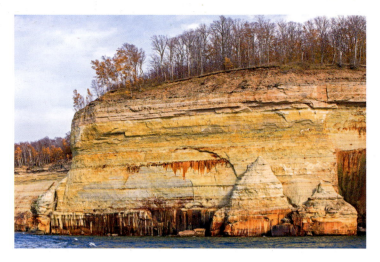

Zoom lenses have more lens elements and are more complicated to build than a prime or fixed focal length lens. A prime lens is slightly sharper than a zoom lens, but the difference is small. We don't believe in cutting corners if it produces poorer quality, but using zoom lenses—especially the high quality ones—is necessary regularly. Using a zoom lens from a boat makes it manageable to shoot these two vastly different compositions within seconds of each other as the boat motored past this colorful cliff face along Pictured Rocks National Lakeshore. Canon 5D Mark III, Canon 24–105mm f/4 lens at 70mm, ISO 500, f/7, 1/1000 second, Cloudy WB, shutter-priority with +.7 EC, AI Servo continuous autofocus on the back-button control.

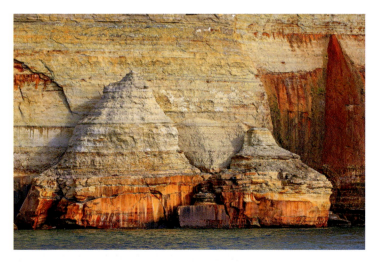

Seconds after shooting the previous image, I zoomed out to 94mm to compose these two rocks. The boat continued to motor closer so continuous autofocus is used to make the camera change focus as the subject-to-camera distance changes.

Wide-angle lenses can be difficult for photographers to use successfully because the angle of view is so wide that distractions tend to appear around the edges of the image. We had trouble with them at first, but now we watch all four sides and corners and shoot close to an attractive foreground like the small cascade at the bottom of the image that grabs your attention and starts you on your visual journey to the larger cascade in the background of Au Train falls. Nikon D4, Nikon 14–24mm f/2.8 lens at 14mm, ISO 100, f/18, 1/10 second, Shade WB, manual metering and AF-C autofocus with the back-button controller.

waterfall from the viewing platform, my composition invariably needed something else—like 72mm. Today we primarily use a few zoom lenses that cover the 16mm to 300mm focal lengths. Most of our prime lenses are dedicated macro lenses or super-telephotos. Even long prime lenses are a huge problem when it isn't possible to change the shooting distance. Once, while photographing greater prairie chickens in a photo blind, I had a 300mm f/4 and a 500mm f/4 lens. Often the chickens were too far away for the 300mm, but too close for the 500mm lens. In the blind beside me, Barbara had no problem with her Nikon 200–400mm f/4 lens no matter where the chickens were dancing. Choosing high quality zoom lenses for most of your photography is unquestionably the best way to go for most photographers.

WIDE-ANGLE LENSES

This group includes all lenses that are wider than 35mm. Excellent examples include the Canon 16–35/2.8 and Nikon 14–24/2.8. Wide-angles lenses tend to be the most difficult group to learn to use well because the angle of view is so wide that distractions around the edges of the image become common problems. If the main subject is too far away from the lens, its resulting size in the image makes it appear insignificant.

Wide-angle lenses are incredibly useful and provide a wonderful perspective to many landscape images. The secret to using them well is to shoot close—sometimes as close as one foot—to a foreground that leads the viewer into the scene. Successful examples include getting close to a nice arrangement of colorful wildflowers while including the mountains behind them or shooting from a low viewpoint in a river that leads your eye to the waterfall a little further upriver.

STANDARD LENSES

While there is no precise breaking point between lens groups, think of standard lenses as falling in the 35mm to 70mm range. These lenses approximate the angle of view of our vision. They work well for many subjects. All of these focal lengths should be included in your lens arsenal.

TELEPHOTO LENSES

This group includes lenses in the 70mm to 400mm focal lengths. As the focal length increases, five key concepts must be considered.

1. The angle of view diminishes: It is far easier to prevent distractions from appearing in the background with a narrow angle of view.
2. Working distance increases: Having more distance between the subject and the photographer is frequently advantageous. Many animals are skittish if they are approached too closely. Other subjects—rattlesnakes, running horses, lions—are dangerous if the photographer is close to them. In close-up photography, having more working distance gives you more space for modifying the light with a flash, reflector, or diffuser.
3. Perspective changes: If you stay farther away from a subject, the relative sizes of the subject and the background change. The size of the background increases with greater working distance. If you shoot closer to the foreground subject, the background objects diminish in size.
4. Longer lenses magnify the size of the subject: From the same shooting distance, a 200mm lens will magnify the size of a subject by 4x over a 50mm lens. Divide 50mm into the focal length of any lens to determine the magnification factor.

5. Photo technique must be superb: Longer focal length lenses not only magnify the subject, but they magnify any imperfections in your shooting technique. If you are wiggling the camera when you shoot, this camera-shake will become worse with increasing focal length.

SUPER-TELEPHOTO LENSES

Any lens with a focal length of 400mm and greater belongs to this group. These lenses tend to be expensive, big, heavy, and demand excellent photo technique to achieve outstanding images. Super-telephoto lenses are widely used by wildlife and sports photographers because shooting distances are often great. A sharp-tailed grouse at 25 yards, a surfer at 50 yards, or a ski jumper at 70 yards all require a super-telephoto lens to capture an image where the subject fills much of the frame. Popular lenses in this group include the Canon 500/4.0, 600/4.0, and 800/5.6, Nikon 400/2.8 and 500/4.0, and Sigma 150–500 f/5–6.3.

We have used super-telephoto lenses for at least thirty years. Currently, Barbara has a Nikon 200–400mm f/4, Nikon 500mm f/4, and an old manual focus Nikon 800mm f/5.6 lens. I use a Canon 800mm f/5.6 lens and, frequently, a Canon 200–400mm f/4 with the built-in 1.4x teleconverter.

TILT/SHIFT LENSES

These are specialized lenses that solve certain problems unlike any other lens. Landscape and architectural photographers commonly use them, but for largely different reasons. Only a few companies make them. Canon offers four fixed focal length manual focus versions that include 17, 24, 45, and 90mm. Nikon has 24, 45, and 85mm models. We own and use the Canon 45 and 90mm tilt and shift lenses.

TILT ADVANTAGES

Tilt lenses are designed to "bend" in the middle of the lens. This allows the use of Scheimpflug's geometric rule, which describes how it is possible to make the primary plane of the

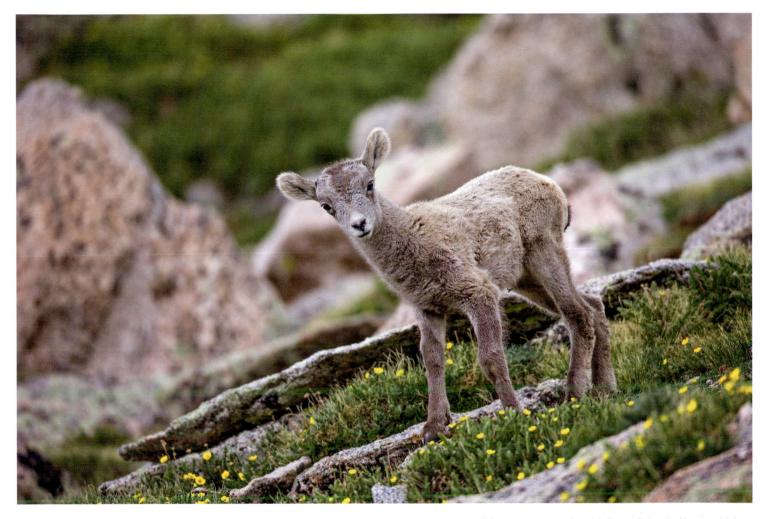

Yellow-bellied marmots, mountain goats, and rocky mountain bighorns are all accustomed to seeing humans and simple to approach on Mt. Evans, Colorado. However, bighorn lambs were wary and kept their distance. I used a huge Canon 800mm f/5.6 lens to provide the working distance needed to fill the viewfinder with this suspicious lamb. Canon 5D Mark III, Canon 800mm f/5.6 lens, ISO 1600, f/6.3, 1/1000 second, Cloudy WB, shutter-priority at +.7 EC (exposure compensation for ambient light), and Auto ISO.

subject coincide with the plane of the camera's sensor—even when they are at a 45 degree angle. Tilting makes it far easier to sharply focus the ripple patterns in a sand dune, a field of flowers, or a landscape with a nice foreground and mountains in the distance. Imagine being able to focus precisely on the blossoms in a tulip field and get them all sharp using only f/8. By stopping down to f/8 instead of f/22 for more depth of field, the image is sharper because f/8 is a sharper aperture than f/22 as it has less diffraction. Also helpful is being able

to use a shutter speed that is three stops faster to arrest any motion in the flowers caused by a breeze.

We use the 45 and 90mm Canon tilt/shift lenses quite often. Though Barbara shoots Nikon, she uses one of my Canon cameras to use the Canon tilt and shift lenses. Unfortunately, these lenses are expensive, and it is difficult to describe in print precisely how to use them—but it is simple to demonstrate how to use because you can see the effects right in the viewfinder. A simple description follows explaining how to set

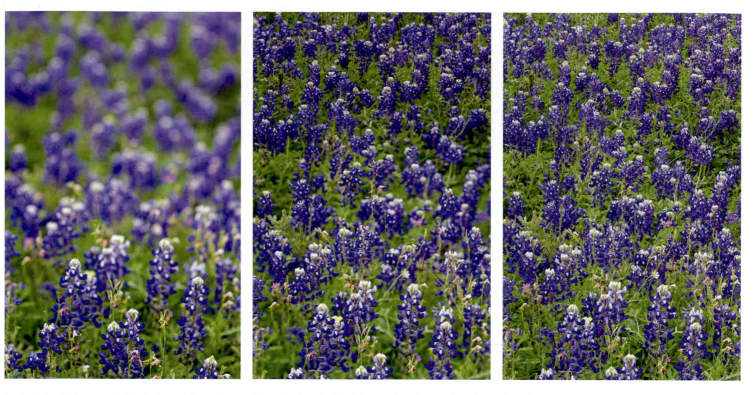

Look what a tilt lens can do. To photograph these Texas Bluebonnets, the Canon 90mm tilt/shift lens is not tilted and the aperture is set wide open. The depth of field only covers a few of the blossoms—pretty unimpressive. Canon 7D, Canon 90mm f/2.8 T/S lens, ISO 100, f/2.8, 1/160 second, Cloudy WB, manual exposure and focusing.

When the lens is tilted down a few degrees it makes the plane of focus correspond to the plane that passes through all of the bluebonnet blossoms. The lens is tilted, but the aperture remains at f/2.8. Notice the flowers are far more sharply focused, but the stems that are perpendicular to the plane of the flowers are way out of focus. Canon 7D, Canon 90mm f/2.8 T/S lens, ISO 100, f/2.8, 1/160 second, Cloudy WB, manual exposure and focusing.

To achieve the best overall sharpness, keep the lens tilted and stop down to f/16. The tilt lens does not give you more depth of field, but you do get far more control over what plane you want in focus. We love to use tilt/shift lenses, but focus stacking often is more effective and it is far less expensive to shoot since focus stacking works with any lens you own. Canon 7D, Canon 90mm f/2.8 T/S lens, ISO 100, f/16, 1/5 second, Cloudy WB, manual exposure and focusing.

the tilt. Once you do it a few times, there is nothing to it. Let's use a 90mm tilt and shift lens in this example. Point the lens at a field of tulips and focus on the closest blossom. Notice the far side of the image—the top of the picture—is most likely way out of focus as you view it through the viewfinder. Tilt the lens *down* a degree or two and refocus on the closest blossom. Look at the background and it should be more in focus. Keep adjusting the tilt down, refocus on the foreground and keep checking the sharpness of the background. When you set the proper amount of tilt, every blossom from the foreground to the distant background will be in sharp focus. If

you tilt the lens too much, the background will start going out of focus again, so you know you have gone too far. Beginners tend to tilt the lens too much. Usually 2 to 6 degrees of tilt does the trick!

SHIFT

This is a second and distinct control that solves a completely different problem. Have you ever noticed that when you point a camera upward to photograph a building, lighthouse, or even a group of trees, that the vertical lines lean inward? This makes the building appear to fall over backward. If you

keep the optical axis of the lens parallel to the ground, then the vertical lines remain vertical, but you probably cut off the top of the subject. A lens with a shift mechanism can readily solve this problem. Keep the optical axis of the lens parallel to the ground when you compose the image. If the top of the subject is cut off, use the shift mechanism built in to the lens to shift the lens to include the top of the subject. The optical axis is still parallel with the ground. Now the entire subject is nicely composed in the image.

Over the twenty-five years we have used these lenses, they have helped us effectively capture the images we seek. Be warned that they are expensive. Most photographers can get along quite fine without them. The digital age has changed things. Software is effective for straightening tilted lines that should be vertical. In addition, a fantastic new technique called focus stacking, which we will cover in Chapter 6, allows you to capture incredible sharpness and extreme depth of field in any situation in which the subject remains still. Therefore, software solutions have further lessened the need for tilt and shift lenses.

MACRO LENSES

These lenses are made to allow extremely close focus, which makes it possible to fill the viewfinder with a small subject. These are popular lenses designed for close-up photography, but they do work well for portraits, landscapes, and other subjects. Popular lenses include the Canon 50, 65, 100, and 180mm macros. Nikon calls them micro lenses. Nikon choices include 60, 105, and 200mm. Most camera systems build dedicated macro lenses for their cameras.

The most important decision to make is the focal length of your macro lens. In most cases, if lens weight and price are not problems for you, then we recommend the longer focal lengths. The Canon 180/3.5, Nikon 200/4.0, Tamron 180/3.5, and Sigma 180/2.8 macro lenses are all superb. Both Tamron and Sigma build their macro lenses with different mounts so they can be sold to different camera systems. This increases their market and allows them to charge less. We see these lenses in our field workshops, and they are perfectly capable

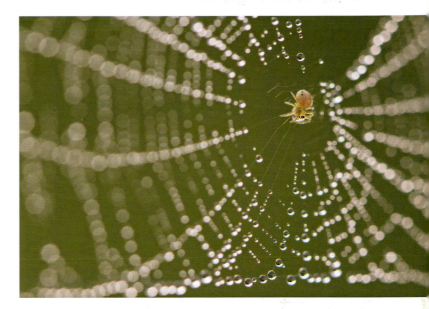

Barbara chose to shoot this web at an angle and focused on the tiny spider. She wanted the spider to be sharp, but not the dew drops. Shooting at an angle and using f/8 to reduce the depth of field accomplished her goal. We like how the dew drops become larger the more out of focus they are. Nikon D4S, Nikon 200mm f/4 micro lens, ISO 1000, f/8, 1/160 second, Cloudy WB, manual exposure and focusing.

of producing excellent results. Nevertheless, I still prefer my Canon 180mm macro and Barbara wouldn't part with her Nikon 200mm micro lens.

TELECONVERTERS

These are optical devices that fit between the lens and the camera. Since they contain optical glass, they absorb some of the light passing through the lens and the sharpness of the captured images may be slightly less. They come in various powers with 1.4, 1.7, and 2x being the most common. A teleconverter multiplies the focal length of the lens by the power of the converter. For example, a 2x teleconverter changes a 300mm f/4 lens into a 600mm f/8 lens. Notice the focal length doubles, which provides much more magnification for increasing the size of the subject in the image. That is all good, but the 2x teleconverter also costs two stops of light and the lens slows to only f/8. This means you lose two shutter speeds, which can make it difficult to capture a sharp

image. With many cameras, the autofocus doesn't work at f/8 either. Teleconverters are effective for increasing the size of the subject when there is no other way to do it—such as moving closer to the subject. However, use them only when you really need to do so. The quality will be best if you buy the lens maker's teleconverter, use it on a lens that has the best glass, and always use superb shooting technique. Do not buy inexpensive teleconverters because the quality is dismal. Be aware teleconverters don't work with all lenses. Sometimes they cannot be connected to the lens. Always check with the salesperson to make sure the teleconverter and the lens you plan to use it on are compatible.

Just for the record, Barbara uses Nikon's 1.4x and 1.7x teleconverters when she needs to and I use the latest version of Canon's 1.4x teleconverter. My Canon 200–400mm f/4 lens even has a convenient 1.4x teleconverter built in to the lens! With the simple flip of a switch, I can choose to use the built-in 1.4x teleconverter or not. Now that is convenience! With the 1.4x teleconverter in use, the lens becomes a 280–560mm f/5.6. Let's hope many lenses in the future offer the built-in teleconverter.

LENS ACCESSORIES

HOODS

Hopefully, your new lens came with a hood that is easy to fasten to the front of the lens. If not, buy one made for your lens forthwith and always use it. The hood blocks stray light from striking the front glass surface of the lens, which reduces the problem of flare. Equally important, the hood helps to keep snowflakes or raindrops off the lens and protects the lens from wayward twigs or other obstacles. Should you drop your lens, the hood might save the camera if the hood hits first. Every outstanding photographer we know considers the proper use of a lens hood to be indispensable. Make it a habit to use the lens hood. Sadly, too many shutterbugs fail to use the lens hood and their images needlessly suffer from this oversight.

FILTERS

In the film age, filters frequently were used to modify the color in the light. Now that digital software and camera white balance choices make this so easy to do, most filters are no longer necessary. Currently, there is no need to buy, carry, attach or clean filters. A few types of filters are still useful because they enable some desirable options that cannot be done easily with software—at least not yet.

UV Protection Filters

Save your money and don't buy these. Adding any glass to the lens's optical path will degrade the image quality. Putting a cheap "protection" filter on your expensive lens really doesn't make any sense. The "protection filter" probably won't save your lens if you drop it. You are far less likely to damage the lens if you are careful and use the lens hood!

Polarizing Filter

This filter is incredibly useful for darkening a blue sky and removing or reducing glare from shiny and wet objects. Even on a cloudy day, the wet rocks in a stream or along a waterfall reflect a lot of glare that hides color and detail. Using a quality polarizing filter, such as those made by Hoya or B + W, can greatly improve your images. Indeed, the filter does cost a slight loss of sharpness, but the positive effects of managing glare and darkening the sky make this trade-off worthwhile.

Using the Polarizing Filters

Many beginning photographers mount the polarizing filter on their lens but don't use it properly. The polarizer is mounted in a double ring so that it can be rotated when mounted on the lens. Mount the polarizer on the lens. Now look at the blue sky to be darkened or the glare to be removed and turn the polarizer until you see the desired effect. Now shoot the image in the normal way. You must be aware, if the first composition is a horizontal (landscape mode) and you switch to a vertical (portrait) composition, you must rotate the polarizer again to get the desired results.

Many photographers have trouble seeing the effect. If glare is the problem, look at the glare intently through the viewfinder while you rotate the polarizer. When you see the glare diminish and that area darken, that is the polarizer position you want. The same goes for the blue sky. Some crafty shooters find it is easier to use live view and look at the live image on the LCD display on the back of the camera while they rotate the filter.

Split ND (Neutral Density) Filter

The contrast in a scene, such as a dark foreground that is in the shadows with white clouds in a sunlit sky might be too high to capture in a single exposure. A variety of split ND filters are made to solve the contrast problem. Some ND filters have a sharp division between the clear and dark part, others are gradual splits, and they come in different strengths to conquer various contrast problems. They were enormously popular—and many photographers continue to use them—but advances in High Dynamic Range software and shooting methods work far better than these filters. We no longer use them, preferring to use Photomatix Pro, which is a dedicated HDR software program instead. We will cover HDR in Chapter 4.

Variable ND Filter

The waves crash heavily on the sunlit rocky shoreline. It is easy to use plenty of shutter speed in the sunshine to freeze the motion of the waves and produce many fine images of the frozen waves. Is there any way to use a long shutter speed to allow the waves to blur during a long 4-second exposure? Try using the lowest ISO on the camera—perhaps it is ISO 100. Stop the lens down to f/22 to reduce the light by one more stop. Will that do it? According to the old "Sunny 16 rule,"

proper exposure for ISO 100 in bright sunlight is about 1/100 of a second at f/16. Round it off to 1/125 second to make the stops easier to figure. Using f/22 is one stop darker. Now the shutter speed is 1/60 second and still freezes the waves too much. How can you get to a 4-second shutter speed? You could wait around until sunset. Sometime after sunset it will naturally become dark enough to allow the 4-second exposure time, but the color of the light will be vastly different. A sure-fire way to allow the long shutter speed is to use a variable ND filter. When you rotate this filter, you can select a variable amount of neutral density. For example, the Singh-Ray Vari-ND filter can be adjusted to absorb two to eight stops of light, and that includes all values in-between these two. Dial the Vari-ND filter to absorb eight stops of light. Now the shutter speed can be slowed down eight stops to 4 seconds. The optimum exposure with the Vari-ND filters now becomes ISO 100, f/22 and 4 seconds. Even though the sun is bright, the long shutter speed allows the crashing waves to blur nicely during the exposure.

CONSIDER YOUR LENS NEEDS CAREFULLY

Having a logical assortment of lenses to achieve your shooting needs requires some thought. Take your time and enjoy the process. Consider the types of lenses we use, but you do not need to duplicate our choices. A few high quality zoom lenses and a macro lens should cover most of the subjects you wish to photograph. You can photograph most subjects splendidly if you cover the 24–300mm range with a couple of zoom lenses.

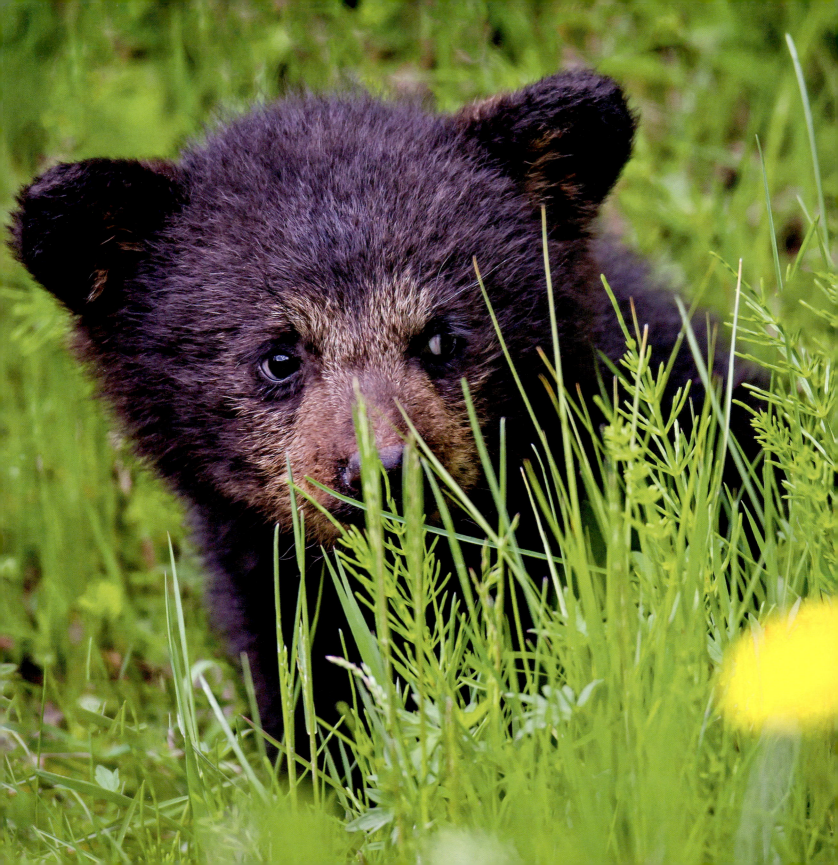

Mastering Exposure

Achieving the optimum exposure is essential for capturing the ultimate in quality images. Fortunately, two exposure aids—highlight alert and histogram—offered by your camera make shooting excellent exposures straightforward. Exposure is controlled in the camera with three variables—the f/stop (aperture), shutter speed, and ISO. They all work together to determine the final exposure. It is crucially important to be able to work comfortably with these three variables. Let us now examine the most effective ways to manipulate them in order to create the images you want in a variety of situations.

EXPOSURE GUIDELINES

Always judge the exposure by viewing the camera's histogram display. Do not judge the exposure by comparing how light or dark the image appears on the camera's LCD display. Most cameras allow you to brighten or darker the LCD, so there is no way to know whether the exposure is optimum. If you think the exposure is too dark, turning up the brightness of the LCD display makes it look fine—but it may still be seriously underexposed.

JPEGS

When you shoot an image, the camera's photosites in the imaging sensor measure photons of light. The camera runs numerous calculations to determine and record the amount and color of the light. These data are known as the RAW data. A JPEG is a file that most devices can read

The black bear cub peered from the vegetation along the road. The day was overcast and dark and I needed to keep my distance, so I used my favorite low light shooting combination of shutter-priority and Auto ISO. Canon 5D Mark III, Canon 800mm f/5.6 lens, ISO 1600, 1/800 second, f/5.6, Cloudy WB, +.7 EC, and continuous autofocus on the back-button.

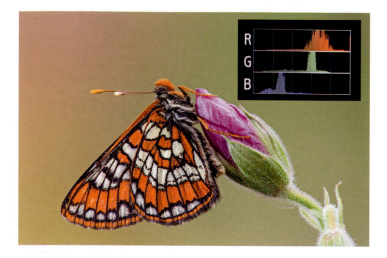

A Yellowstone Checkerspot butterfly perched on a Sticky Geranium bud. Notice the histogram. Only the red channel touches the right wall and climbs it a little, but does not reach the top. With all of the warm tones in the image, you would expect the red channel to have data furthest to the right. Notice the histogram has four vertical lines between the left wall and the right wall. Each vertical line denotes a little over one stop of light. Being aware of the histogram–stop relationship makes it quicker to get the rightmost data to closely approach the right wall when shooting JPEGs only or touching it when shooting RAW images. Canon 5D Mark III, Canon 180mm f/3.5 macro lens, ISO 200, f/16, 1/8 second, Cloudy WB, manual exposure and metering. Canon 580 II flash and ST-E2 optical controller to add some fill flash to the image.

that is created from the RAW data the camera captures. The image is sharpened, the colors are determined, and much of the RAW data is discarded to allow the data to fit in an 8-bit file. In other words, a JPEG is nothing more than RAW image data that is processed by the camera. This in-camera processing can be adjusted by the photographer by their choice of white balance, sharpening, contrast, Picture Style, and other options.

A well-exposed JPEG has its rightmost histogram data—which represent the highlights in the image—near the right wall of the histogram but not touching it. Unless there is an area in the image that has no detail anyway, do not allow the highlight alert to flash or the histogram data to climb the right wall.

RAW

Photographers who absolutely demand the highest quality usually shoot RAW images. These files include all of the data collected by the sensor and typically are 12-bit or 14-bit files, so they hold far more information than a JPEG, which only holds 8-bits of data. RAW files are preferred if you plan to process them with Photoshop, Lightroom, or other RAW processing programs. The optimum RAW exposure shows the rightmost data touching the right wall of the histogram, but not climbing the right wall—at least not very much. RAW data can be adjusted or severely changed with software to produce excellent quality images.

EXPOSURE STRATEGY SUMMARY

We will get to the details shortly, but the best way to achieve the optimum exposure in most cases is to shoot the image, check the histogram and highlight alert, then make exposure adjustments (if necessary) to meet the above exposure guidelines for JPEG and RAW images. Reshoot the image with the adjusted exposure settings.

EXPOSURE BASICS

Exposure is controlled by three variables: the aperture in the lens, the shutter speed, and the ISO. The aperture and the shutter speed determine how much light strikes the camera's sensor. The ISO determines how much the sensor data is electronically amplified.

THE THREE EXPOSURE CONTROLS

Photographers use the language of "stops" to make exposure adjustments. A stop is a measurement of the light. Shutter speeds, f/stops (aperture), and ISO are all set up to be counted in stops. A stop in one of the variables is equal to a stop in the other two. Using stops is useful because stops make it easy to adjust the exposure by counting each one. It takes a little practice to get used to it, but once you do,

using stops makes exposure exceedingly simple to control and adjust.

Shutter Speed

The camera has a shutter that can open and close to seal off the box that contains the imaging sensor to prevent light from passing through. Here's the typical shutter speed series in seconds that many cameras offer. The difference in these values is often thought of as stops. Except for B, each shutter speed listed here is one stop apart from its nearest neighbor.

B 30 15 8 4 2 1 1/2 1/4 1/8 1/15 1/30 1/60
1/125 1/250 1/500 1/1000 1/2000 1/4000 1/8000

Become familiar with this series of numbers because you will use them a lot. The letter B stands for *Bulb* exposure. This is the setting you use when you wish to shoot any exposure longer than thirty seconds. To shoot a 2-minute exposure, set the camera to B, trip the camera with a cable release and hold it down or lock it. Monitor your watch until 2 minutes pass and let up or unlock the cable release to close the shutter.

Although B is a variable shutter speed, all of the others are fixed amounts. The faster the shutter speed, the less light that strikes the sensor, assuming the aperture and ISO remain the same. Each shutter speed listed here varies from its nearest neighbor by one stop of light and doubles or halves the light. A shutter speed of 1/15 second allows twice as much light to the sensor as a 1/30 of a second shutter speed, but only one-half of the light of a 1/8 second shutter speed. Except for B, going to a faster shutter speed cuts the exposure in half for each value on this chart. For example, changing from 1/4 second to 1/15 second is an exposure reduction of two stops. The image is two stops darker and the histogram data move to the left. It is likely your camera offers intermediate shutter speeds. Often with a menu choice or custom function selection you can set the camera to 1/2 stop or 1/3 stop shutter speeds. Use 1/3 stop increments to gain precise control over your exposure. Faster shutter speeds give you the ability to freeze subject motion and shoot sharp handheld images. Slow shutter speeds allow you to capture the motion of a galloping horse or a picturesque waterfall, but make it far more difficult to capture sharp handheld images.

Apertures

To be exact, the aperture isn't the same thing as the f/stop. When a lens closes down to the shooting aperture, a series of adjustable blades move to create a tiny circular hole called the aperture. An f/stop is really a math relationship between the size of the aperture and the focal length of the lens. All identical f/stops pass the same amount of light through it. This means f/16 on an Olympus 24mm passes the same amount of light as f/16 on a Canon 180mm macro or f/16 on a Nikon 500mm lens, even though the actual sizes of the apertures on these lenses differ. Nevertheless, aperture and f/stop are freely used to mean the same thing. To avoid confusion, we will assume they are the same.

Aperture controls the image depth of field, which is the zone in front of and behind the point of sharpest focus that appears acceptably sharp to the viewer. Aperture is always a key factor in getting the image you want. Changing the aperture from f/8 to f/16 is called *stopping down* because the size of the aperture gets smaller and depth of field increases. The exposure is reduced by two stops of light assuming, of course, the ISO and shutter speed remain the same. Changing the aperture from f/22 to f/5.6 adds four stops of light and it is called *opening up* because the size of the aperture becomes larger while depth of field diminishes.

Memorize the standard f/stop series. Here it is:

f/1 f/1.4 f/2 f/2.8 f/4 f/5.6 f/8 f/11 f/16 f/22 f/32 f/45

None of your lenses has all of these. The smallest f/stop *number* is usually around f/2.8 or f/4. Although this is the smallest number, the aperture is the *largest* and it passes the most light through the lens. It is called the maximum aperture. This same lens probably stops down to f/22 or perhaps f/32. Although this is the largest f/stop number, the aperture is the *smallest*. We agree that getting used to the idea that a

The two major factors determining the depth of field are the aperture (f/stop) and image magnification. The more the aperture opens (f/16 to f/8, for example) or the greater the magnification, the less depth of field is generated and vice versa. A two-tailed swallowtail is photographed at f/8. Notice the depth of field completely throws the background out of focus and the blossom on the right is quite soft. Canon 5D Mark III, Canon 180mm f/3.5 macro lens, ISO 200, f/8, 1/320 second, Cloudy WB, manual exposure and focusing.

F/22 yields considerably more depth of field than f/8, but the background is distracting and the overall image sharpness declines slightly due to diffraction. Canon 5D Mark III, Canon 180mm f/3.5 macro lens, ISO 200, f/22, 1/30 second, Cloudy WB, manual exposure and focusing.

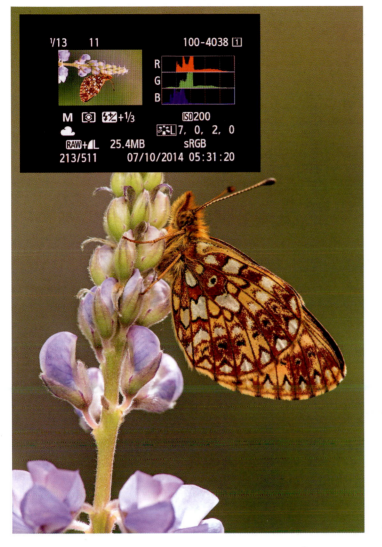

Notice the histogram for this silver-bordered fritillary appearing on the back monitor of the Canon 5D Mark III camera. Both the red and green color channels have rightmost data approximately the same distance from the histogram's right wall. This is an optimal exposure for a JPEG because the data stops just short of the right wall. If you shoot RAW files, then let the rightmost data touch the right wall and even climb it a little. Many photographers are unaware that the highlight alert and the histogram are derived from a JPEG, which is nothing more than RAW data processed by the camera. When RAW data is turned into a JPEG image, the processing tends to make the highlight alert blink and the rightmost data climb the right wall of the histogram before the RAW data is actually overexposed. Depending on the camera, you can most likely go one stop past the right wall before you start clipping the RAW data. Canon 5D Mark III, Canon 180mm macro, ISO 200, f/11, 1/13 second, Cloudy WB, manual exposure and focus, Canon 600EX flash with ST-E3-RT radio controller at +1/3 FEC.

large f/number refers to a small aperture is counterintuitive, but mathematically that is the way it works.

Each of the f/stops listed above varies from its nearest neighbor by one stop of light. F/8 delivers four times (2 stops) more light to the sensor than f/16 because the area of the aperture at f/8 is larger. Conversely, stopping down from f/4 to f/16 reduces the light by four stops, which means the sensor receives 1/16 as much light.

The depth of field is greatest with small apertures—f/16, f/22, f/32—which is useful for making as much of the image as sharp as possible. Often, though, selective focus is called for, such as in flower photography, where sharpness is desirable on only a portion of the subject or scene. Then either f/4 or f/5.6 works best to isolate the subject. The best way to handle depth of field is to memorize that f/16 and f/22 are small apertures that reduce the light passing through the lens, but deliver plenty of depth of field. F/2.8 or f/4 are large apertures that pass lots of light, but keep the depth of field shallow. Finally, your camera offers intermediate f/stop values. Set your camera to 1/3 stop increments. You do not need to memorize the intermediate values. Knowing the full stop values is good enough.

ISO

Your camera's sensor has a native ISO speed. This refers to how sensitive the sensor is to the light. The native ISO is usually ISO 100, but it may be ISO 200 in some camera models. The native ISO speed produces the highest quality sensor data, and you should use it whenever that is feasible. Sensors are not interchangeable, but cameras offer another way to give you ISO options. How is this done? The sensor is packed with photosites that measure photons of light. The photons create a tiny electrical charge that is converted into digital data with the camera's on-board analog-to-digital converter.

When the camera is set to ISO 400, the sensor data is amplified to simulate the exposure as if the ISO speed of the sensor really is ISO 400 instead of its native 100 or 200. This system works quite well, but amplifying sensor data also magnifies any defects in the data. For example, if you blow up an image

to 200 percent and look at the dark portions of the image, you might notice odd spots of color—red, green, and blue are common—and this is called noise. Amplifying the sensor data increases the noise. If you really want to see the negative effects of noise, shoot a few images using the highest ISO value on the camera. The colors will look odd and the image appears much less sharp.

Although ISO choices vary among cameras, the Canon 5D Mark III offers the typical series that includes:

Auto 100 200 400 800 1600 3200 6400

12800 25600 H1 51200 H2 102400

Except for Auto, each ISO varies from its nearest neighbor by, once again, one stop of light. Moving from ISO 100 to ISO 400 essentially quadruples the light, though remember the signal is really amplified to simulate a more sensitive sensor. More light is not striking the sensor. Most cameras offer intermediate ISO values in 1/3 stop increments. If your camera doesn't, it isn't a serious shortcoming. You do want 1/3 stop increments for aperture and shutter speed, though.

Auto is a variable ISO that enables the camera to automatically change ISO as needed. It is enormously helpful when using shutter-priority in dim light. ISO 100 is the native speed of the sensor in the Canon 5D. ISO 200 amplifies the sensor data to simulate a sensor speed that is twice as sensitive to light. Each of the remaining ISO values doubles the sensitivity of the one preceding it as you move to higher values. H1 51200 and H2 102400 require a special setting to use because these ISO values produce extremely noisy images. However, sometimes noise is acceptable when there is no other way to capture an image. If, say, it is the only way to finally get a shot of Bigfoot.

The artifacts in the image created by amplifying the sensor signals with higher ISOs are being managed better with each new camera generation. We routinely use ISO 400 to ISO 1600 for wildlife images and get favorable results of the starry night skies by using ISO 3200, f/2.8, and twenty-second exposure times.

Since the camera's native ISO delivers the highest quality data with the fewest artifacts, why use a higher ISO? Here's a key reason: Imagine photographing a deer in the soft evening light with a 300mm lens on a tripod. At ISO 100, the shutter speed is 1/30 of a second at f/4. Even shooting on a tripod, the shutter speed is not high enough to consistently shoot sharp images with a 300mm lens, and besides the depth of field is minimal. Setting ISO 800 increases the exposure by three stops of light. Now the exposure changes to 1/125 second at f/5.6, making it far more likely to capture a sharp image with a faster shutter speed and one stop more depth of field in order to sharply record more of the deer.

LAW OF RECIPROCITY

I am not a subscriber to laws because there are already far too many of them, but I do subscribe to one important one on exposure. ISO, shutter speed, and aperture in combination determine the exposure. If you add or subtract some light with one control, you can compensate the exposure with either of the other two. For example, suppose the optimum landscape exposure is ISO 100, f/8, and 1/60 second. You decide to stop the lens down to f/16 to obtain more depth of field. Changing f/8 to f/16 subtracts two stops of light. How does one compensate for this? The obvious way is to change the shutter speed from 1/60 second to 1/15 second. Or you could leave the shutter speed at 1/60 second and increase the ISO to 400. There is no reason why you can't use two controls to make the adjustment. Changing the ISO to 200 adds one stop of light and selecting a shutter speed of 1/30 second adds a second stop of light, which perfectly compensates the two stops of light lost by choosing f/16. This is an example of the Law of Reciprocity at work. It does take a while to get used to it, but it is worth the effort. Memorize the shutter speed, ISO, and f/stop series and it soon becomes rather easy.

EXPOSURE AIDS

HISTOGRAM

It is crucial to understand two exposure aids found in your camera. The most valuable one is the "dreaded" histogram because it appears complicated, when truly it is extremely simple to understand. The histogram is a simple bar graph that displays the brightness values measured by the photosites (often called pixels) in the sensor along the horizontal axis. The vertical height of the data gives you an indication of how many pixels have a specific brightness value. The higher the vertical height, the more pixels that occupy that brightness value.

Neither the horizontal nor vertical axis is numbered, but you don't need to know exact numbers in any event. The key to using the histogram to get the optimum exposure is to examine the placement of the pixel data on the histogram's chart. The histogram is generated from a JPEG file. Even if you shoot only RAW images, each RAW file has a small embedded JPEG to generate the histogram and display the image on the LCD display. Since the histogram and the highlight alert are based on a JPEG, which by convention is 8-bit data, the histogram can only display 256 brightness values. Why? Mathematically, 8-bit data is equal to two to the eighth power, which equals 256. Therefore, starting on the far left side of the histogram, the brightness value begins with zero and steadily brightens one brightness value at a time moving to the right until it reaches the maximum brightness at 255. The left side of the histogram displays the dark tones, the center shows the middle tones, and the light tones appear on the right side.

As you look at the histogram, you will notice one, two, or several mountains of data. Sometimes the data cover the entire histogram graph and sometimes they don't. There is no perfect histogram shape as it depends totally on the scene. A forest scene with dark shadows and bright highlights will have data appearing across the entire histogram because this scene is high in contrast. Rabbit tracks in the snow will display a narrow brightness range on the histogram because nearly everything in the image is the same. Notice the histogram's left and right sides, each of which it's convenient to

think of as a "wall." Normally, you do not want to allow data to climb either wall very much, which is called "clipping." Data climbing the left wall may lack detail due to underexposure. Overexposure causes data to climb the right wall. It is okay if the data touch the top of the graph as long as they do not happen on either wall. If a spike of data appears between the two walls, it merely means the histogram's graph isn't tall enough to display all of the tones at this particular brightness level.

An incredibly valid and useful exposure guideline is called "Expose to the Right" or ETTR for short. When shooting JPEGs, expose to make the rightmost data approach the right wall. With RAW files, let the rightmost data touch the right wall and maybe even climb it a little. Here are three key reasons to use ETTR.

1. Preserve Highlight Detail

Exposing to the right forces you to pay attention to the highlights by not letting them clip and seriously climb the right wall. The worst exposure problem is overexposing important highlights with detail because that detail is lost forever. How is it lost, you ask? Imagine a snow scene. Although the snow is white, some snow is slightly brighter than other areas of snow due to shadows. Most of the brightness values for the snow fall in the 200 to 255 range. If you overexpose enough, you push all of these values to the maximum 255 brightness value. Now all of the snow that originally ranged in brightness from 200 to 255 is the same brightness at 255. It all looks alike—think white copy paper—and detail is no longer discernible.

2. Collect the Maximum Amount of Data

Every stop of light the photosites receive doubles the data they capture mathematically. This is similar to the stops in shutter speed and f/stops. I will spare you the excruciating number details, but half of the data that you may need, especially if you process the image very much, are captured by the stop farthest to the right. The stop to the left of that captures one-fourth of the data. ETTR nicely captures the maximum

The drifts and snow-entombed trees are straightforward to expose. Using manual exposure, point the camera at only snow and adjust the exposure compensation control in the viewfinder to the +1.7 position on the metering scale by manually adjusting the shutter speed, aperture, ISO, or any combination. Shoot a quick shot—it does not have to be in focus—and check the histogram and highlight alert. If the histogram's rightmost data is touching the histogram's right wall and no "blinkies" are flashing, you are good to go. If not, make adjustments with your exposure controls until you arrive at the optimum exposure.

amount of image data, providing better colors and smoother tonal transitions in the image. Though less important to JPEG files, having lots of data is crucially important to RAW images when they are processed with Photoshop or other software.

3. Minimize Noise in the Shadows

Digital cameras depend on electronics. All electrical devices have signal errors. These errors show up in the image as oddly colored spots called chrominance noise, or bright spots where it should be dark called luminance noise. Using ETTR allows the photosites to measure as many photons as possible without clipping on the right wall. This produces a far more favorable signal-to-noise ratio over all portions of the image and especially in the darker areas, and, therefore, noise is automatically reduced in the image.

You don't need to remember these three reasons for using ETTR. Merely watching the histogram's rightmost data and getting it to the right as previously explained for JPEGs and RAW files takes care of everything.

HIGHLIGHT ALERT

Be certain to activate the camera's highlight alert if it hasn't been already. When you overexpose a portion of the image and view it on the camera's LCD display, overexposed areas will blink on and off. Often called the "blinkies," these flashing warnings are to be heeded to avoid losing detail in important highlights. That said, it is possible to have highlights without detail. Glare on wet rocks and lakes has no detail anyway, so don't worry about blinkies if they appear there. Even snow, especially on a dark cloudy day, has little detail in large areas because there is little to no contrast in the light, so large areas of the snow are identical in brightness. In this case, we often counsel our winter Yellowstone photo tour clients to allow a few blinkies in the snow when photographing the darkly furred bison to capture more detail in these hairy mammals.

UNDERSTANDING THE CAMERA'S EXPOSURE METER

The camera's built-in exposure meter is extremely complex and able to do thousands of calculations almost instantly. Fortunately, you don't need to know precisely how it works, so let's summarize what you truly do need to know.

The camera's exposure meter is incredibly good and it is the best meter to use. No longer do you need to use a separate handheld meter or avail yourself of the old "Sunny f/16 rule." The histogram and the highlight alert in your camera offer far better ways to achieve the optimum exposure. The camera's meter is designed to produce pleasing exposures and does an excellent job of it much of the time, but there are still plenty of situations in which the meter is found lacking. The meter attempts to determine how much light is illuminating the subject and the area surrounding the subject. It has a huge problem because there are two significant variables that

Overexposing (clipping) highlights with detail is the worst sin you can commit in exposing a digital image. However, remember that not all highlights have detail. The brilliant ball of the sun, specular highlights on water, and snow on a cloudy low contrast day have little to no detail. Additional exposure will benefit the color of a bison in a snowstorm. By allowing some of the snow to clip, you capture better color and detail in the dark furry coat. Nikon D300, Nikon 200–400mm f/4 lens, ISO 2000, f/19, 1/200 second, Cloudy WB, manual exposure and AF-C autofocus on the back-button.

The same bison as in the previous image but processed as a black and white image.

determine how much light reflects off the subject. The first variable is ambient light, which is the light that is naturally present. There is less ambient light on a dark cloudy day than when the sun shines. We all agree a black American crow that is fighting with a white ring-billed gull over a scrap of food is darker, even though the same amount of ambient light illuminates both. Subject reflectance is the second major variable. Dark subjects reflect less ambient light than light

ones. It is impossible to solve this exposure equation with two variables, so the camera is programmed to assume subject reflectance doesn't vary.

Generally, cameras are programmed to a middle tonality of 18 percent reflectance. Camera makers produce the camera to assume every scene it meters averages 18 percent gray. The theory works beautifully when this is true or nearly so. The camera meters the scene and sets the exposure automatically—if you are using an autoexposure mode—and delivers a suitable exposure in many lighting conditions. However, if you photograph a scene that is mostly made up of snow, the camera meter doesn't know the scene is mostly white. Since it has been programmed to believe it is 18 percent reflectance, the camera sets the exposure to render the snowy scene as a middle tone scene and severely underexposes it. A similar problem happens if the scene is mostly dark in tonality. That isn't as common as a light scene, but a black field of lava would cause the meter to overexpose the scene. As sophisticated as the meter is, always remember it does not know what the subject is and doesn't know what the optimum exposure should be. The meter considers a lot of factors, but in the end, it tries to make things middle tonality. The camera makers know about this exposure problem and provide an exposure compensation control to enable you to adjust the exposure when using automatic metering modes. If you are shooting in the manual exposure mode, then the compensation is done manually by adjusting the aperture, shutter speed, ISO, or a combination of these three. Find the exposure compensation control on your camera. You must look carefully, though. Automatic flash is controlled in a similar fashion with its own flash exposure compensation (FEC) control. Take time to be certain you know where the ambient light and the flash exposure compensation controls are located on the camera and which one is which.

METERING MODES

Cameras offer a few distinctly different metering modes. Depending on the camera system, they might be called a different name, but they all work quite alike. The Canon 5D Mark III offers four choices that include Evaluative (Nikon calls it Color Matrix), Center-weighted, Partial, and Spot metering. With slide film, spot metering was the best way to arrive at the optimum exposure. All of this has changed with digital due to the histogram and highlight alert most DSLR cameras have.

Which metering mode works best? Some photographers still cling to using the spot-metering mode, but it really is unnecessary and counterproductive today. In the old days with film, when photographing a snow scene or even a white gull, it worked best to spot-meter only the white snow or gull, compensate for the subject reflectance by adding about two stops of light to make the subject white again, and shoot the image. The truth is that evaluative metering, which looks at everything and then makes a recommendation, gets you closer most of the time. Simply compose the shot and quickly shoot an image. Now examine the white gull for example. Although the white feathers fill only a portion of the image—perhaps 25 percent—its white tones are still represented on the histogram. These white tones are the rightmost data on the histogram. Now adjust the exposure—if necessary—to make the rightmost data touch the right wall of the histogram if shooting RAW or approach the right wall, but not touch it, if shooting JPEGs. That's all there is to it.

EXPOSURE MODES

These modes are the method the camera uses to arrive at the exposure. Though your camera may offer several, the most useful ones by far are manual, aperture-priority, shutter-priority, and program. Aperture-priority and shutter-priority are semi-automatic exposure modes. You set the ISO and one other parameter. Then the camera automatically sets the other to obtain the standard exposure. The program exposure mode is fully automatic and sets both the shutter speed and the aperture for you. We need to examine the modes in detail and make sure you understand them.

Program

The camera sets both the shutter speed and the f/stop to arrive at the standard exposure. It works quite well, especially for evenly lit average scenes. The camera knows what focal length is being used and might well set a higher shutter speed to counteract camera-shake to achieve a sharp image when using a longer focal length lens. This is all well and good, but what if you are shooting on a tripod, using a remote release, and locking the mirror up to capture a sharp image? There is no point in using more shutter speed than necessary while losing the depth of field that you need by using program.

If you are totally mystified by your camera, then program will get you started. I even use it at times when I want to photograph my friends. Perhaps we have all had a little too much fine wine and my thinking is getting fuzzy. I put the camera on program, use a flash, and fire away. I think of the program exposure mode as the *party* exposure mode.

Aperture-priority

This may well be the most popular exposure mode among amateur and professional photographers alike. It performs exactly as it sounds like it should. You decide the depth of field that you wish to get and then you set the aperture. In this mode, the camera gives priority to the aperture you set and the shutter speed varies as needed to deliver the standard exposure. If the exposure it delivers isn't optimum as indicated by the histogram's rightmost data, use the exposure compensation control to adjust it.

Although this exposure mode is enormously popular with many photographers, Barbara and I find it to be problematic and seldom use it. Indeed, we counsel our Kenya wildlife safari clients to use shutter-priority instead. Why? Here's what happens when the client uses aperture-priority during an afternoon game drive. Leaving at 4:00 pm when the temperature is cooling down and the animals are more active, the bright sun offers plenty of light. Using ISO 400 in bright sun, the client sets f/11 for more depth of field. Since aperture-priority is set, the shutter speed floats up to 1/1000 of a second. That is a sufficiently fast shutter speed for shooting

sharp images with a 300mm lens on a beanbag in the safari vehicle. Later that afternoon, the clouds roll in and the light dims by three stops. Since the aperture is fixed at f/11, the shutter speed drops to 1/125 second. With the image-stabilization activated and careful use on a beanbag, that shutter speed will still produce plenty of sharp images. As the Land Rover cruises through the forest at dusk to return to the lodge, the driver suddenly stops and turns the ignition off to provide a steadier shooting platform. Excitedly, the driver points out a leopard lying on a horizontal tree branch only 30 yards away. The photographer quickly shoots two dozen images and then the leopard drops down to the forest floor to begin its nightly hunt. The photographer views his captured images quickly and is thrilled by what he sees. Only later, when he views his images on his laptop, does he discover that none of them are sharp. The light was two stops dimmer in the forest at sunset, and 1/30 of a second just wasn't enough shutter speed to produce sharp images. Of course, one might have realized they needed a faster shutter speed and increased the ISO, or opened up the aperture to f/4, but in the excitement of the moment, the vast majority of photographers forget to do so.

Some cameras offer options that make aperture-priority more useful. If your camera lets you set a minimum shutter speed, perhaps 1/500 of a second, for example, then aperture-priority is far more useful for action photography or still photography with long focal length lenses. With the minimum shutter speed set to 1/500 second, set f/8 for more depth of field and Auto ISO to allow the camera to set a standard exposure. Sadly, most cameras don't offer this option, but your top-of-the-line camera often does. If your camera does, it is a very good way to lock in both the shutter speed and the aperture at the same time. Then the ISO changes to achieve the optimum exposure. This feature is becoming more common and we hope all cameras soon offer the automatic adjustable ISO option!

Aperture-priority has some merit when you wish to use a certain aperture and not let it vary. Barbara has used this exposure mode quite successfully when photographing the northern lights, which can vary in intensity from minute to

minute. When using her lens with a maximum aperture speed of f/2.8, she sets aperture-priority and f/2.8. This keeps the lens wide open for all the shots and the shutter speed varies with the brightness of the shimmering lights. We are pleased to offer this one example where aperture-priority makes sense to use because in nearly all other situations, another exposure mode works far better. In other words, we can think of few situations where aperture-priority is truly the best choice. In the vast majority of photo situations, manual exposure or shutter-priority make the most sense.

Shutter-priority

This exposure mode is just the opposite of aperture-priority. Set the desired shutter speed and the camera automatically adjusts the aperture to deliver the standard exposure. Once again, if necessary, use the exposure compensation control to modify the standard exposure. Wildlife and sports photography often require using fast shutter speeds to freeze action. Shutter-priority is incredibly effective for wildlife and sports photography because it makes it possible to lock in the necessary shutter speed to ensure sharp images.

Let's return to the leopard example we used with aperture-priority. Set shutter-priority and a shutter speed of 1/1000 of a second. The aperture varies now and it floats up to f/11 in the bright sunshine—the same exposure that aperture-priority set. When it clouds over and the light dims by three stops, the aperture opens up automatically to f/4—the biggest aperture on the lens. Of course, when the light becomes two stops darker in the forest at sunset, the lens is not able to open more and the shutter speed can't change, so the images are underexposed. Nevertheless, it is better to be underexposed by two stops, rather than shoot unsharp images due to camera-shake. But there is a better answer that most photographers do not know about.

Shutter-priority and Auto ISO

When the light dims and you reach the maximum aperture of the lens, set the camera to shutter-priority and Auto ISO. With a 300mm f/4 lens, once the light dims enough to require a

bigger aperture than f/4, such as f/2.8, the camera automatically increases the ISO to 800 to maintain the exposure at the chosen 1/1000 of a second shutter speed. If and when the light dims still more, the ISO automatically goes up to compensate for it. Be aware it is possible to run out of ISOs. If the highest ISO your camera offers is ISO 12,800, and the light is so dim that it needs a higher ISO, the images are once again underexposed. When it is this dark, though, most people call it night and it is time for dinner or star photography!

Manual

Barbara and I are immense fans of the manual exposure mode and use it at least 75 percent of the time. This mode requires the photographer to set the ISO, f/stop, and shutter speed. The exposure is manually adjusted by turning dials while monitoring a simple exposure scale in the viewfinder. It is a simple procedure after you have done it a few times.

Let's photograph a landscape. Set ISO 100 and f/16 for adequate depth of field. Turn the shutter speed control until the exposure indicator that appears on the exposure scale in the camera's viewfinder aligns with the zero point in the middle of the scale. We don't have to worry about using a particular shutter speed to acquire a sharp image because landscapes don't run around and we are using a tripod. Shoot the image and check the histogram and highlight alert. If things are overexposed, the highlight alert (if activated) will make overexposed portions of the image that you view on the LCD display flash off and on. If nothing is flashing, check the histogram to make certain the rightmost data that represent the highlights are close to the right wall of the histogram when shooting a JPEG or touching the right wall when shooting RAW. If the exposure requires adjusting, simply turn the shutter speed to a new setting that makes the adjustment. For example, if the rightmost histogram data is one stop from the right wall, slow the shutter down one stop. If the original exposure is ISO 100, f/16, and 1/8 second, slowing the shutter down to 1/4 second adds the extra stop of light.

Warthogs are middle tone in reflectance. The sunlight was steadily changing in intensity as the dark clouds floated by. When ambient light levels are constantly changing, manual exposure does not work well because it does not automatically adjust for the changing light. This is an excellent time to use shutter-priority and Auto ISO. Set the shutter speed that is necessary to capture sharp images and Auto ISO. Nikon D4, Nikon 200–400mm f/4 lens, ISO 200, f/9, 1/200 second, Auto WB, shutter-priority, and Auto ISO.

THE METERING SCALE

Many photographers are puzzled by this scale when they first attempt to use it, but it is really very simple. First, find the scale in the camera's viewfinder. Sometimes this scale will appear in the LCD window, too. Find the zero point, which has always been the middle of the scale in every camera I have looked at. There is a plus side and a minus side. In some cameras, the minus side is on the left, as it should be, but other cameras have it on the right. Notice the range of stops on the scale. The Canon 5D Mark III, for example, has a metering scale on the bottom right of the viewfinder that shows plus and minus three stops in 1/3 stop

The north wind generates massive waves that slam into the rocky shoreline of Pictured Rocks National Lakeshore. Early in our digital career when we tried aperture-priority for landscape photography, we discovered that it produced erratic exposures when photographing subjects that varied in size from shot to shot such as these waves. Automatic exposure modes average the tones the meter "sees." If the exposure is perfect when the waves are small, a spectacular wave like this one causes the camera to automatically reduce the exposure because the meter "sees" more white water, which causes the camera to seriously underexpose the rocky shoreline. Returning to manual exposure solved the problem completely. Canon 5D Mark III, Canon 24–105mm f/4 lens at 70mm, ISO 200, f/18, 1/25 second, Cloudy WB, polarizer, manual exposure and autofocus with back-button control.

increments. The plus side is on the right and the minus side is on the left.

Some cameras offer the opposite arrangement and have the plus side on the left. Many Nikons are set up this way. Fortunately, most cameras give you a menu option to reverse the direction of the scale to make it more logical. How does it make more sense you ask? Adding light to the exposure moves all of the histogram data to the right, so it is logical to have the plus side of the exposure scale on the right, too.

Many beginners quickly become confused with the exposure scale when they turn the camera on and try to move the exposure indicator along the scale. They turn their shutter speed or aperture dials and the indicator doesn't move. Why? In my Canon 5D model example, the scale only shows plus and minus three stops of light in 1/3 stop increments. It is likely that when you turn the camera on and point it at the scene that the setting might be beyond the scale's range. If you start out five stops overexposed, you are not yet on the scale. With

Example of the exposure scale in the Canon 5D Mark III. The scale is especially important when using manual exposure. The scale shows plus and minus three stops of light in 1/3 stop increments. Plus or adding logically means more exposure and therefore they show on the right. Less exposure is displayed to the left. Know your scale. Some cameras have the reverse arrangement and some do not show such a wide exposure range. For example, exposure might be limited to only a plus and minus two stop range. When your camera is set to 1/3 stop increments, turning the shutter speed or aperture dial one click will move the indicator one-third stop if the exposure is on the scale. Once you get used to this exposure scale, it is pain-free to use.

most cameras, when this happens there is an arrow or a flashing light on the side of the scale (negative side in this case) to indicate you are off the scale. If you are too dark, slow the shutter speed down until the exposure indicator begins to move. Of course, if too light, then increase the shutter speed to get on the scale. After you do this a few times, it is quick and uncomplicated to manually make adjustments.

EXPOSURE CONTROL DIALS

Manual exposure is far more intuitive when the dials for both the shutter speed and the aperture are set up (when viewed from the rear of the camera) so turning them to the right adds light and turning to the left subtracts light. It really makes little sense to have to remember that to add light, which moves the histogram data to the right, the dials must be turned to the left—the opposite direction. Sadly, my Canon 5D is set up this way and is counterintuitive. Fortunately, this camera and most others provide a menu option or a custom function to reverse the dial direction. Using a menu selection in my camera, I set *Dial Direction During TV/AV* to the *Reverse Direction* choice. Though not stated, it also works in the manual exposure mode. Now turning my aperture and shutter speed dials to the right adds light, moves the histogram data to the right, and the exposure scale has the plus side on the right.

Setting up your camera this way makes the manual exposure mode far easier to use. Most cameras offer many ways to reconfigure to make them more straightforward. Examine your options—and your printed manuals—carefully!

AUTOMATIC EXPOSURE MODE PROBLEMS

We use manual exposure for nearly all close-up and landscape images. We like it for about half of our wildlife images, too. We do favor shutter-priority for wildlife in fairly neutral reflectance surroundings such as the wildlife of Kenya. And when the light dims, the combination of shutter-priority and Auto ISO is absolutely terrific. Yet, for at least 75 percent of the images we shoot, we use manual exposure because it is much more uncomplicated to arrive at the optimum exposure

and keep it there. Let's look at the problems with the automatic exposure modes.

Light through the Viewfinder

This is a common and serious exposure problem for all automatic exposure modes, yet most photographers are unaware of it! Does your camera have a switch to close off the viewfinder? Did it come with a tiny plastic curtain to do the same? Your camera maker knows there is a potentially enormous problem of underexposure if you shoot on a tripod and are not peering through the viewfinder when you shoot the image. Light enters through the lens as it should. Light also enters the uncovered viewfinder. The exposure meter measures both and assumes all of this light is entering through the lens. When you shoot the image, the light that enters the viewfinder is blocked by the mirror, resulting in underexposure.

Certain conditions make the problem worse. If the scene is mostly dark, or in the shade, and the ambient light striking the viewfinder is bright, the problem is more likely to happen and be more severe. If you are using a device that absorbs light—polarizing filters, extension tubes, and teleconverters are common culprits—the problem becomes even more acute. Conversely, if you are not using light-absorbing devices and are photographing a bright scene, but the camera is in the shade, the problem will be much less or non-existent. It is easy to check to see if there is a problem. Look through the viewfinder and note what shutter speed and aperture the camera selects. Now remove your face from the camera to unblock the viewfinder and look at the exposure settings the camera will use in the LCD window. If these two exposures differ, then you have a problem. The more they differ, the greater the problem. To illustrate this, with the camera set to aperture-priority, if the camera sets 1/60 second at f/16 when you look through the viewfinder and 1/15 second at f/16 when you stop shielding the viewfinder, an underexposure problem of two stops occurs! To solve this problem, use the devices offered by your camera maker or merely hold your hand in front of the viewfinder without touching the camera to shade it while shooting. All of these solutions are a

nuisance, though. When you use manual exposure, the problem goes away!

The problem with all automatic exposure modes is they allow the camera to change the exposure without permission from you. With manual exposure, once you set the shutter speed, f/stop, and ISO, the camera's indicator on the exposure scale may move, but the set exposure doesn't change unless you change one of the three exposure controls. Essentially, manual exposure is a superb and easy way to lock the exposure. Most cameras offer the automatic exposure lock control, but it is a nuisance to use. We nearly always use manual exposure to circumvent the light through the viewfinder problem when shooting on a tripod.

When the Background Brightness Changes

Two giraffes are feeding on the leaves of an acacia tree in Kenya's Masai Mara. One is below the horizon and the other is standing on top of a small knoll against the sky with lots of white clouds in the early morning sunshine. Both giraffes are illuminated by the same amount of ambient light. If you use any autoexposure mode and set the optimum exposure for the giraffe below the horizon, it won't be optimum for the giraffe with the white clouds in the background. Why? Remember that automatic allows the camera to change the exposure without your permission. When you compose the giraffe against the white clouds, the camera quickly averages the exposure. The white clouds make the overall scene brighter, even though the light on the giraffe remains the same. The white clouds cause the camera to reduce the exposure and the giraffe is now underexposed. If you had used manual, once the optimum exposure is set for the giraffe below the horizon, it would remain set for the giraffe on the knoll against the sky.

Anytime you photograph where the brightness of the background changes from shot to shot, manual exposure is a far more precise way to photograph. Here's one more example. I was photographing Steller's sea eagles in Japan one winter. The fishing boat I was on threw fish to the hundreds of eagles to get them to approach closely. In the early morning

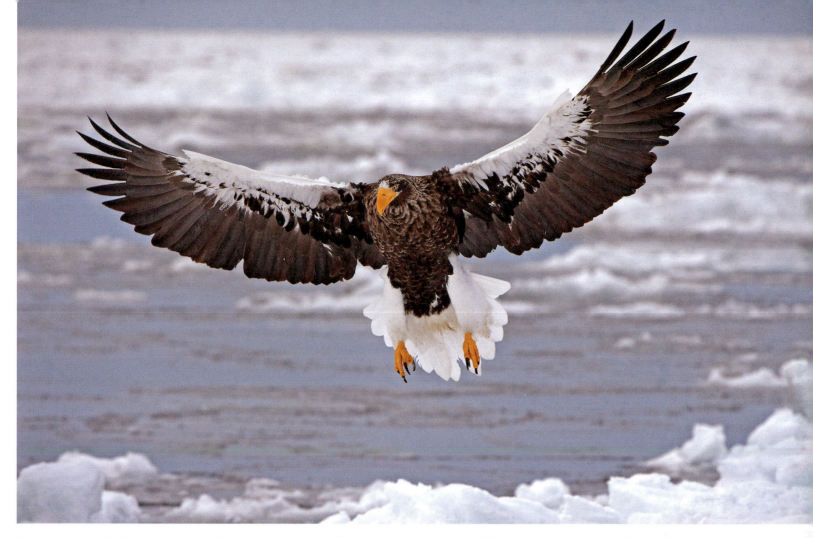

Manual exposure really shines when the tones of the background change rapidly. Autoexposure works poorly when photographing the spectacular Steller's sea eagles in northern Japan. At dawn we boarded a fishing boat and motored out to the floating pack ice a mile offshore. The Japanese tour guide unloaded fish on the pack ice. Within minutes, over three hundred eagles arrived. On this particular morning, the background varied from dull white clouds to bright white pack ice and dark ocean water. Had an automatic exposure mode been used and the exposure was set to properly expose the eagle against the sky, the camera would underexpose the eagle against the white pack ice and overexpose it against the dark ocean. By using the manual exposure mode, once the exposure is set for the white feathers in the eagle, the eagle remains optimally exposed no matter what appears in the background. Nikon D3, Nikon 200–400mm f/4 lens at 400mm, ISO 3200, f/8, 1/1250 second, Cloudy WB, manual exposure and continuous autofocus on the back-button.

sunshine, the background consisted of a light-blue sky, white ice, or dark-blue ocean water. From one moment to the next, a circling eagle could be against any one of these backgrounds. If I had used an automatic exposure mode, and set the exposure for the light-blue sky, the images would be underexposed against the white ice and overexposed when the dark-blue ocean water became the background. I didn't suffer any exposure problems because I used manual exposure instead.

When the Size of the Subject Changes

Changing the size of the subject in the viewfinder causes autoexposure problems. Compose a white egret to fill one-quarter of the image and determine the optimum exposure. What happens when you physically move closer, or zoom the lens, to make the egret fill three-quarters of the image? Remember the meter automatically averages the scene. With the white egret filling three-fourths of the image, the meter assumes the light is much brighter and sets a darker exposure that

underexposes the egret. The reverse happens, too. Compose a bison to fill one-quarter of the image and determine the optimum exposure. When the bison fills three-quarters of the image, what happens to the exposure? The meter "sees" less white snow and more black bison, so it automatically lightens the exposure to maintain the average and severely overexposes the snow. Once again, manual exposure easily and more efficiently handles these situations.

ISO Can't Adjust the Exposure

Suppose the image is one stop too dark. Will an increase of ISO 200 to ISO 400 increase the exposure? If you are using any autoexposure mode, it won't. If you are using aperture-priority and the exposure set by the camera is 1/125 second at f/8, changing from ISO 200 to ISO 400 merely forces the camera to change the shutter speed to 1/250 second to compensate for the increase in ISO. If using shutter-priority, doubling the ISO only forces the aperture to close down one stop to compensate. If you were using manual exposure, changing the ISO does affect the exposure!

Finding the Exposure Compensation Control

Some cameras are better than others for using and finding the exposure compensation control to achieve the optimum exposure. While the exposure compensation control might be simple to find in the daytime, is it easy to find at night? When my fingers are cold and stiff and I am shooting the stars at midnight, it is simpler for me when I can't see to find my separate shutter speed and f/stop dials. I always know which way to turn them to add or subtract light. Even though I am wearing a headlamp, I don't turn it on to see the camera controls because it temporarily ruins my night vision and that of all other photographers near me.

Pop-up Flash Problems

Let's see if you are ready to graduate from this exposure chapter. You are photographing people or pet portraits on a sunny day. Using aperture-priority, the ambient exposure is 1/1000 second at f/8. The sun creates harsh shadows in the subject's

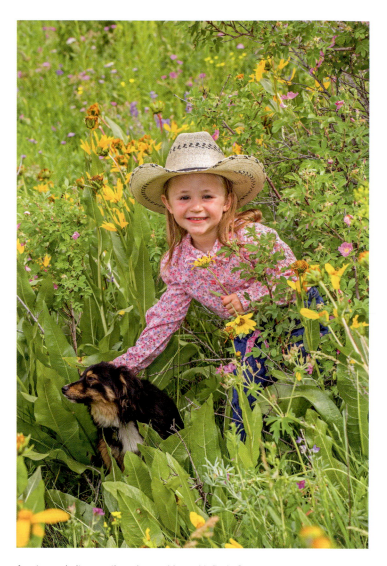

Aperture-priority sometimes is a problem with flash. Suppose aperture-priority is set and f/8 at 1/500 second is the optimum exposure. To open up the shadows under the cowgirl hat Ellie is wearing, a flash is fired at –.7 FEC. Suddenly the highlight indicator and histogram indicate overexposure. Is the flash output too much? You set less flash exposure by going to –1.3 FEC and the problem persists. Why? The overexposure is not being caused by the flash, but rather the aperture-priority mode is giving priority to the f/8 aperture and forcing the shutter to switch to the flash sync speed of 1/200 second. Ambient light is causing the overexposure! Use manual exposure or shutter-priority and set the shutter to the sync speed to avoid the problem. Canon 5D Mark III, Canon 70–200mm f/4 lens at 135mm, ISO 400, f/11, 1/200 second, Cloudy WB, shutter-priority, AI Servo with back-button focusing, Canon 600EX flash with ST-E3-RT controller and –.7 FEC.

face, so you use the camera's pop-up flash to add some light to fill in the shadows by setting the flash exposure compensation control to –1. Without the flash, the exposure is fine, but the light is too high in contrast. With the flash on, you shoot a portrait that is seriously overexposed, so you set a lower fill flash setting of minus two stops. Shoot another image and once again the portrait is seriously overexposed. What is the problem? Take some time to ponder this before reading the answer. Here's a clue. Your clever camera knows when you are using the flash. Take your time… take more time… Another clue! The camera has a flash sync speed when using flash.

The camera's sync speed when using flash varies from camera to camera, but generally it is around 1/200 of a second—sometimes a little more or less. The ambient light exposure is 1/1000 second at f/8. Since you are using aperture-priority, the camera gives priority to the aperture and won't change it. However, the camera is aware the pop-up flash is activated and defaults to the sync speed of 1/200 second in this example. The overexposure is not caused by the flash at all. The image is overexposed because the camera changes the shutter speed from 1/1000 second to 1/200 second, an increase in two and one-third stops of ambient light that causes significant overexposure. Did you get the answer? That's okay. It took a while to figure out what happened when my photo students first encountered it. Since I rarely use aperture-priority, I never personally ran into this problem. With manual exposure, I know the camera has to be set to sync speed and I set it immediately. You could also use shutter-priority and set the shutter speed to the sync speed. Then the aperture varies to maintain the optimum ambient light exposure.

MANUAL EXPOSURE PROBLEMS

Two significant problems come to mind. First, the photographer must be able to speak the language of stops easily and quickly and be able to use their exposure dials and metering scale efficiently. Second, manual exposure does not automatically adjust for changing levels of ambient light. You must be aware of changing light and monitor manual exposures by

reviewing the histogram and highlight alert from time to time. Should you add or remove a device that affects the amount of light passing through the lens—filter, teleconverter, extension tube—then adjust the exposure for them as well. There are times on a partly cloudy day when I do employ shutter-priority to monitor the ambient light because it continually changes. This also happens at dawn when the ambient light steadily brightens or at dusk when it constantly diminishes.

AUTOBRACKETING

Your camera can automatically bracket the exposure. The control varies among cameras, but it can shoot the standard exposure and it will shoot two more exposures if it is set to shoot a three frame autobracket in one stop increments. The second exposure will be one stop darker than the standard exposure and the third one stop lighter. Effectively, these two exposures, one darker and one lighter, bracket the first exposure. Many cameras allow you to set a different number of images to be included in the bracket—such as five or seven images—and the sequence—standard, darker, lighter—might be flexible, too.

Some photographers rely on autobracketing, but we rarely find a need to use it. The advantage of bracketing is if the exposure needs to be compensated, one of the exposure brackets might be the optimum exposure. The problem with that is it takes time to shoot all of the brackets, it eats up memory and fills the buffer quicker, and the best bracketed exposure might happen at the moment when the subject is poorly composed or not in sharp focus. Autobracketing is often used when shooting a series of identical compositions where the exposure needs to be varied for HDR processing, but we prefer to shoot these series manually for the greater precision it provides.

YOU CAN'T METER EVERYTHING!

It isn't possible to meter the stars in the night sky. They are simply too small individually, even though thousands of them may be in the image. As you know, stars are bright suns like

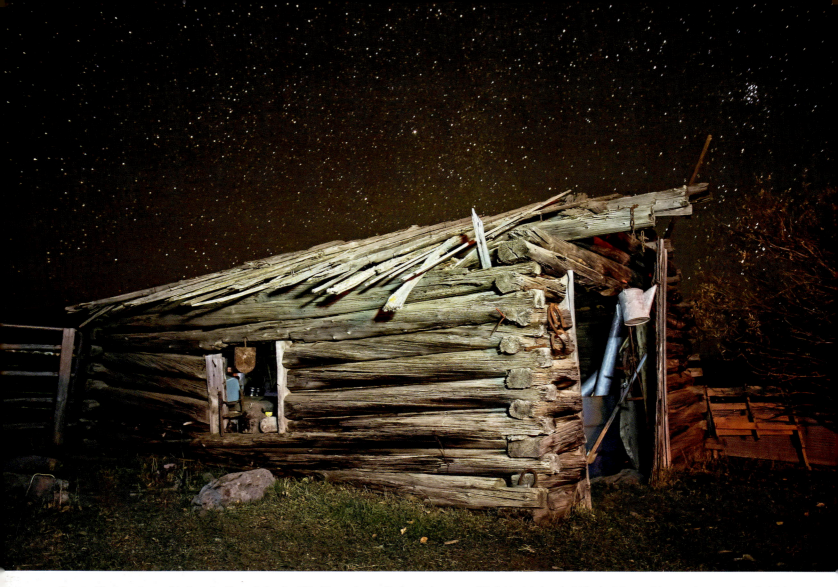

Some subjects are impossible to meter. Try metering the Milky Way and you will see what we mean. We lightpainted our neighbor's vintage cabin, meaning we used a flashlight. Trial and error over several shots taught us the length of time it took for the flashlight to illuminate the cabin. For star photography and the moon, run an exposure test. For the stars, we learned ISO 3200, f/2.8, and 20 seconds will capture plenty of them. If you want more stars, try ISO 6400, 20 seconds, and f/2 if you have a lens that fast. To photograph the moon alone, try the Mooney 11 rule—1/ISO at f/11 or any equivalent. For a crescent moon, another guideline we use is the Crescent 8 rule—1/ISO at f/8 or any equivalent. What can we say—it works! Canon 5D Mark III, Canon 24–105mm f/4 lens at 25mm, ISO 3200, f/4, 30 seconds, Daylight WB, manual exposure and metering, and flashlight to "paint" the cabin.

the one we have. An outstanding image of the starry night sky has no detail in the stars because they are overexposed dots. Your highlight alert probably won't flash—none of our cameras will show blinkies—because the spots are too small. You can learn a suitable exposure for the stars by testing, but no need to wait. Try ISO 3200, f/4 or preferably f/2.8 for more stars, and 20 seconds on a dark night. Compose the scene to get as many stars as possible and you will capture a starry night sky!

SUMMARY

We handle exposure as quickly and efficiently as possible. When photographing nearly all still subjects that are not running around—a waterfall moves, but doesn't scamper about the landscape—we use the manual exposure mode. It is easier than dealing with all of the problems automatic exposure modes create. When photographing subjects that are in motion—flying birds, running cheetahs, dog sleds sliding by—then we use shutter-priority about half of the time. When photographing in dim light where the shutter speed must be maintained, the combination of shutter-priority and Auto ISO is outstanding!

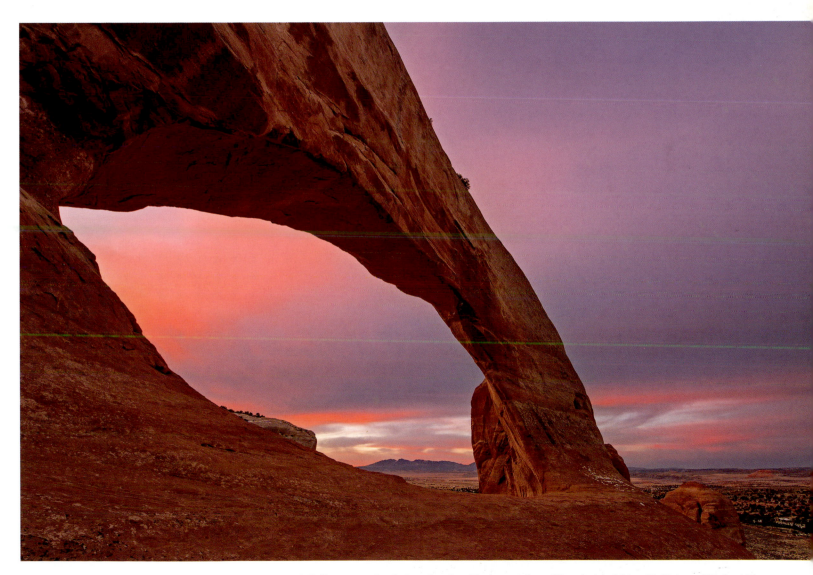

The dawn sky attractively accentuates the warm hues of Wilson Arch. Unlike many arches that require a long hike to reach them, Wilson Arch is right next to Highway 191 about 25 miles south of Moab, Utah. Nikon D4S, Nikon 14–24mm f/2.8 lens at 14mm, ISO 100, f/18, 1/1.3 seconds, 10,000K WB, manual exposure and AF-C autofocus on the back-button.

Conquer Extreme Contrast with HDR

The typical sunrise scene has a dark foreground and a bright red sky. The range of light is extremely high in contrast. The contrast is so significant that it is nearly impossible to capture detail throughout the scene. When the brilliant red sky is beautifully exposed, the foreground is too dark and lacks detail. When the foreground is exposed optimally, then the sky is hopelessly overexposed and most detail is lost. This is a common problem. The extreme contrast between a mostly white waterfall and dark-green moss on the rocks bordering it cannot be captured with detail in both.

As you look closely at a subject high in contrast, you can see detail in both the highlights and the deepest shadows, yet no camera is able to capture this light range in a single image. The camera is only able to capture detail over a range of several stops of light, but your eyes are able to easily see detail everywhere. Partly this is true because we can see a wider dynamic range of light than the camera. Also, our eyes quickly adjust for different brightness levels as we scan a scene high in contrast. Although the aperture size varies in the lens, when you shoot the image, you can only use one size at the moment of exposure to cover everything in the image.

Many scenes are plagued with high contrast. The worst cases are those that have the two major causes of contrast at the same time. The first is a scene containing both black and white objects. The contrast is due to the objects that have different reflectance values. The second source of contrast would be a bright sun illuminating one part of the scene while other parts are in deep shade. The worst contrast case occurs

Lake Ha Hand lies about 20 miles northwest of Yellowstone National Park. On a calm morning when it is lit by golden sunshine it is spectacular. The lake's outlet offers an interesting foreground to begin your visual journey into the scene. Since the foreground was still in deep shade, five images were shot at different exposures by changing the shutter speed. These images were processed with Photomatix Pro to produce a single image where detail is revealed everywhere. If High Dynamic Range techniques had not been used, most of the shadows would have been nearly black and lacked detail. Canon 1D Mark III, Canon 24–105mm lens at 30mm, ISO 100, f/22, shutter speeds of 1/30, 1/15, 1/8, 1/4, 1/2 second, Sun WB, polarizer, manual exposure and AF-C autofocus on the back-button.

The first of a two-shot exposure bracket varied by two stops of light. The first is the lightest image. Notice plenty of detail and color in shaded Sedge Meadows, while at the same time the sunlit clouds and mountain peak are over-exposed. Nikon D4, Nikon 14–24mm f/2.8 lens at 18mm, ISO 200, f/16, 1/5 second, Cloudy WB, polarizer, manual exposure and AF-C autofocus on the back-button.

The darker exposure retains detail in the sky and sunlit mountain, but the shaded foreground and creek are too dark. Nikon D4, Nikon 14–24mm f/2.8 lens at 18mm, ISO 200, f/16, 1/20 second, Cloudy WB, polarizer, manual exposure and AF-C autofocus on the back-button.

The scene after merging the first two images together with Photomatix Pro and final processing with Photoshop CS6. Detail and color are retained in both the sky and the shadowy meadow. Barbara shot two images as quickly as possible so neither the horses nor the clouds moved between the exposures. Since horses tend to move a lot, she shot several two-image exposure brackets and selected the one set in which neither had moved.

when dark objects are in the shade and light objects are lit with much brighter ambient light. In such cases, the contrast range can easily exceed ten stops of light. HDR is an acronym for High Dynamic Range and it is often called High Dynamic Range Imaging (HDRI). It is a shooting method that allows all tones in the scene to be captured, no matter how expansive the dynamic range. No longer must we accept the contrast limitations of our cameras and display devices. HDR offers everyone the opportunity to capture images that look more similar to what their eyes can see because the technique readily handles a much larger dynamic range than our cameras.

Some photographers still object to HDR because it effortlessly produces images with detail in the highlights and the shadows that no single image can capture. They claim it looks unrealistic. Indeed, HDR processing can make images look completely unnatural—even surreal—and it is dubbed the *grunge* look, but it can also make the image look far more similar to what the photographer saw with their own eyes when viewing the scene. Photographers who believe HDR is always unnatural are accustomed to viewing images that suffer from the limitations of film and single capture digital images. We no longer need to be encumbered by high contrast limitations.

A LITTLE HISTORY ON SOLVING HIGH CONTRAST

When black and white film was popular, dodging and burning were widely practiced darkroom techniques that helped to overcome high contrast problems. Ansel Adams is famous for his mastery of burning and dodging and wrote a book—*The Negative*—explaining his fabulous techniques. Black and white remains quite popular today, but most of it is currently achieved with software and digital cameras.

SPLIT NEUTRAL DENSITY FILTERS

For years graduated neutral gray-colored filters (GNDs) have been used to reduce the contrast in a scene and we used many ourselves in the past. These filters are sold in various strengths. One half is clear and the other half is darkened by various degrees of light. For example, common ones include two and three stops of neutral density. If the scene's foreground is four stops darker than the sky, putting a hard edge three stop GND filter on the lens and positioning it to make the dark side cover up the bright sky and the clear side coincide with the dark foreground effectively lowers the contrast to only one stop of light. The filter works well if the scene has a fairly straight horizon, which allows the filter's edge between the light side and the dark side to fit neatly along the horizon line. However, most horizons are not straight. If a tree pokes above the horizon, the portion of the tree is unnaturally dark relative to its base.

Some neutral density filters have a gradual break to help it dissolve into the scene and make it less obvious a filter is being used. While this helps somewhat, the horizontal edge of the filter is usually still apparent. If you have three expensive graduated neutral density filters in one, two, and three stop strengths, what do you do if seven stops of contrast must be overcome? Perhaps one might stack all three of the filters together, but image sharpness suffers because the light must pass through more glass surfaces. Graduated neutral density filters work, but their expense and shortcomings often make them an unattractive way to shoot.

A BETTER WAY TO OVERCOME CONTRAST

High Dynamic Range imaging (HDR) offers a far better way to handle extremely high contrast. HDR can handle any

Many photographers use graduated neutral density filters to control contrast. We once did as well, but have now abandoned them in favor of HDR techniques. Unlike graduated neutral density filters, HDR handles all contrast ranges if you bracket widely enough, and it does not matter where the deep shadows and bright highlights occur in the scene. The contrast in the shadows of Scott Fall near Munising, Michigan, and the sunshine on the aspen leaves do not provide a regular edge to hide the effects of a neutral density filter, but HDR deals with this situation handily. Nikon D4, Nikon 14–24mm f/2.8 lens at 14mm, ISO 100, f/16, shutter speeds of 1/4, 1/2, 1, 1/2.5, and 5 seconds, Sun WB, manual exposure and AF-C on the back-button.

HDR requires the subject to remain motionless between exposures. However, when there is movement in part of the scene that was not expected to be sharp anyway, then HDR works to control contrast. The cloudy sky above Union Falls in Yellowstone's backcountry, and the dark rocks and bushes at the bottom of the canyon, create too much contrast to be fully captured in a single image. Detail is captured everywhere by shooting two exposures and merging them together with Photomatix Pro. Canon 1Ds Mark II, Canon 24–105mm f/4 lens, ISO 100, f/16, 1/5 and 1/10 second, Cloudy WB, manual exposure and autofocus on the back-button.

contrast range and it does not matter where in the image the contrast edges occur. You do not need to carry a set of filters to handle different contrast levels and the contrast does not have to align with any edge. Even if you had to capture three large areas of dark and light, you could easily accomplish it with HDR techniques. You can easily and accurately capture three dark rocks in a sea of snow, showing the wide range of tones encompassing the scene. HDR works far better than any filter could. However, the limitation for using HDR is that the subject must remain still long enough to shoot several images without moving the camera.

HDR requires shooting a series of images of a still scene in which you vary only the shutter speed to capture the brightness range. For best results, the exposure should vary by at least one stop of light, but not more than two stops, to get a better transition between the tones. Of course, you could use increments of 1.3, 1.5, or 1.7 stops of light if you prefer. The idea is to properly expose every brightness in the scene in at least one of the images making up the exposure series. The greater the contrast range, the more images that are needed to cover that range. Although this technique works best with still scenes, it could be used when part of the scene is moving and not expected to be in sharp focus in any case. Waterfalls, rivers, and crashing waves are all commonplace examples.

SHOOTING THE HDR IMAGES

It is best to shoot the exposure series of images using the RAW format. JPEGs have only 8 bits of data. The camera

processes and discards a considerable amount of the data when compressed into an 8-bit file. This causes artifacts (flaws in the image) and doesn't offer enough values to produce fine transitions in the image. If your final goal is a JPEG, it is best to shoot the exposure bracket using RAW, then produce the HDR image, and finally convert it to a JPEG. Nevertheless, if you shoot only JPEGs, HDR still helps considerably to tame contrast.

To make the images in the exposure series align and merge with the fewest problems, be sure to keep several factors identical between images. Do not change the ISO, focus, white balance, polarizer position, or aperture. Vary only the shutter speed. You can use manual metering or aperture-priority. Both metering modes are excellent for keeping the same aperture between exposures to avoid huge depth of field differences.

Mike Nolan, owner of Timber Ridge Lodge where we host our Michigan workshops, is fond of his vintage 1954 truck that still hauls firewood. I remember the year well because I was "made" in 1954, too. I think this truck has weathered the years much better than I have—and Barbara agrees! Every autumn Mike parks the truck under the maple trees to enable our workshop members to photograph it with autumn leaves decorating it. The contrast between the light areas of the truck and the black tires is easily subdued using HDR. Nikon D300, Nikon 28–200mm lens at 56mm, ISO 200, f/22, shutter speeds of 1/2.5, 1/1.3, 1.6, 3, 6, 13, and 25 seconds, Cloudy WB, polarizer, manual exposure, and AF-C autofocus on the back-button. Processed with Photomatix Pro and finished with Photoshop CS6.

Most photographers rely on autobracketing to shoot an HDR series. Consider a typical scene in which there are seven stops of light differences between the brightest highlights and the darkest shadows. If you shoot a five-image bracket where each exposure varies from the other by two stops of light, a ten-stop range of light will be covered. When you run the five images through HDR processing software, the software selects the well-exposed parts out of each image and assembles them into a single image in which everything in the image will be beautifully exposed with ample detail.

Autobracketing is effective with some cameras. However, many cameras only offer a maximum of three images when autobracketing. Usually this is not enough to cover the dynamic range of the scene. Also, it is time consuming to bracket exposures wider than necessary. If only six stops of contrast need to be covered, then shooting five images to cover ten stops is unnecessary. Quality can suffer, too. Many photographers speed up the autobracketing process by using high speed shooting or the burst mode. They rapidly shoot the series of images. However, using burst mode to shoot the images is a terrible idea, especially with the longer shutter speeds so commonly used when doing HDR. The loss of sharpness is a serious problem due to camera-shake that is caused by the action of the mirror and the shutter. If the tripod-mounted camera shoots five shots one after the other and the exposures are around 1/15 second, the first image may be sharp, but the slight camera-shake caused by the mirror moving up and down and the opening and closing of the shutter may vibrate the camera and unnecessarily cause a slight loss of image sharpness in the remaining images. Most photographers pay little attention to this problem and like their results regardless, but why give up some image sharpness needlessly? Hopefully, everyone wants all of the sharpness they can get! Autobracketing will work when you set up the camera to wait for you to trip it with a cable or remote release between images. This allows you to wait a few seconds between shots to allow any motion that is caused by the shutter and mirror mechanisms to quiet down.

Many cameras allow you to shoot only three-image exposure brackets. It is possible nonetheless to cover a wider dynamic range. Set the exposure compensation control to +2, shoot the three-image bracket using two stop increments and now you have a series of exposures that are 0, +2, and +4 stops of light. Next set the exposure compensation control to –2 and shoot another three-frame bracket to produce three additional exposures at –4, –2, and 0 exposure compensation. You must delete one of the two duplicate exposures at the 0 compensation. Five exposures will be left covering a range of –4, –2, 0, +2, and +4 stops—an eight stop contrast range! For many outdoor scenes, this range covers the contrast quite adequately. However, some scenes may well have a higher contrast range.

MANUAL HDR EXPOSURE BRACKETING

We prefer to shoot our HDR image series manually without using autobracketing. This is our procedure. This works perfectly for all cameras and is not dependent on any camera capabilities for autobracketing because you bracket the exposure manually by changing the shutter speed. Also, there is no need to worry if you are covering the dynamic range of the scene because you are assured of doing it by monitoring the histogram data. It is such an obvious, effective, and painless way to shoot the exposure series that it is surprising this method of doing it is not more widely known and utilized. Try this series of steps:

1. Set the ISO, white balance, focus, aperture, and polarizer position (if used). Do not change any of these while shooting the HDR series. Only the shutter speed should vary to accomplish the exposure changes. It is possible to use flash as a portion of the light. Be sure to make certain the flash angle and output doesn't change from one shot to the next.

2. Shoot on a tripod to get the optimum sharpness and to lock in the composition, which allows the software to align the elements in the image hassle free. Most HDR programs offer some ability to align the images when you shoot handheld, but everything works so much better when using a sturdy tripod. Even when using a tripod, however, movement can still be a problem. Running water, crashing waves, soft ground, and wind can all move the tripod. Wind can make grass and branches blow, so watch out for subject movement as well.

High Dynamic Range imaging techniques are efficient for handling the high contrast at sunrise and sunset. As the first red rays of sun light up the mountains to the west of Lake Ha Hand, the color reflects splendidly in the calm water. A three-shot exposure bracket varied by two stops each adequately handled the contrast range. The exposure for the first shot slightly underexposed the white snow on the mountain. Then the shutter speed was slowed by two stops for the second image. Finally, add two more stops of light to capture detail with less noise in the darkest portions of the scene by slowing the shutter speed down two more stops. We prefer doing this manually, rather than using autobracketing. By carefully processing the image, we think it appears exactly as it did while we were standing there viewing the scene. Canon 5D Mark III, Canon 24–105mm f/4 lens at 38mm, ISO 200, f/16, shutter speeds of 1/8, 1/2, and 2 seconds, Cloudy WB, manual focus and exposure. The three exposures are merged with Photomatix Pro and final processing is done in Photoshop CS6.

3. Before shooting the first image, put your hand in front of the lens and shoot an image to indicate the beginning of the HDR series. Otherwise, when editing, you may delete the first image before you realize it is an exposure bracket and then have to waste time retrieving it from the bit bucket.

4. Expose first to preserve detail in the brightest highlights. The best way to do this is to determine the starting exposure that produces no flashing highlights (blinkies) on the LCD display when the highlight alert is activated and the rightmost histogram data fall about one stop short of the right wall of the histogram.

5. To get slightly smoother contrast transitions in the image, use one stop brackets and slow the shutter speed down by one stop for each exposure. Be sure to turn the shutter speed control gently to avoid jarring the camera and changing the composition slightly. Using one stop increments will require you to shoot more images, so it takes more time to shoot the series and later process it using software. Remember the guideline for HDR is to shoot the exposure brackets in at least one stop increments, but no more than two stops.

6. Continue to slow the shutter speed down one stop at a time and continue to shoot images until the leftmost histogram data are about two stops from the left wall of the histogram. The highlights will be pitifully overexposed and blinkies will be prevalent, but the goal is to capture excellent detail in the deepest shadows with little noise. Expose to get the leftmost data away from the left wall to reduce noise in the darkest shadows.

7. When the leftmost histogram data move two stops to the right of the histogram's left wall, the image set is concluded. It assures capturing detail in the darkest and brightest tones and everything in-between. The number of images making up the series depends entirely on the difference in brightness of the blackest shadows and the brightest highlights. At least one image in the series captures every brightness level.

8. Photograph your hand once again to mark the end of the HDR image series.

PROCESSING THE HDR IMAGES

CAMERA PROCESSING

Some cameras offer in-camera HDR processing. Try HDR if your camera offers it. For example, if you have a Canon 5D

Mark III, go to the *HDR Mode* menu selection to find five choices: *Disable HDR, Auto*, ± 1 EV, ± 2EV, and ± 3EV. The *Auto* setting allows the camera to automatically determine the bracketing amount in stops. Otherwise, you make the choice of one, two, or three stops. The *Effect* can be set to produce *Natural, Art Standard, Art Vivid, Art Bold*, and *Art Embossed*. Use these to determine how the image appears. *Art Vivid* accentuates the color whereas *Natural* is more subdued. *Continuous HDR* can be set for *1 Shot Only* or *Every Shot*.

When set for *1 Shot Only,* the camera allows a three-image exposure bracket, processes the images, and creates the HDR image. It then reverts to normal shooting. You must reset the camera to be able to shoot another HDR image. *Every Shot* keeps the HDR mode activated for additional shots. The *Auto Image Align* offers two choices—*Disable* or *Enable*. When shooting handheld, be sure to set *Enable*. The last decision is *Save Source imgs*. The default choice is *All Images*. If you do not wish to keep the source images, then set *HDR img Only*. The camera discards the source images and keeps only the combined HDR version. Keep in mind you may want to retain these source images to be processed with another HDR software program. Due to technical reasons, the final in-camera processed HDR image is outputted as a JPEG and cannot be saved as a Canon CR2 RAW file.

I have used this feature and it surely helps control high contrast situations, but the results certainly are not of the same quality as HDR images processed with dedicated HDR software. In-camera HDR is a respectable place to start, but for the ultimate quality and flexibility, plan to use a more robust HDR processing program, such as those that follow.

SOFTWARE SOLUTIONS

Once you shoot a series of images that capture detail in all of the tones found within the scene, the images are processed with software. During this process, the brightnesses are tone mapped to shrink the dynamic range of light in the scene. This allows everything in the image to appear with detail. Process the images carefully to avoid introducing artifacts that include noise, ghosting, and haloes. Said another way,

tone mapping must be done to enable detail in the bright and dark areas to be preserved and viewable.

There are many outstanding HDR software programs that work well. A short list follows, but you can find others by searching for "HDR software choices" on the Internet.

Canon Digital Photo Professional www.usa.canon.com

EasyHDR www.easyhdr.com

HDR Efex Pro www.google.com/nikcollection

Oloneo HDR www.oloneo.com

Photomatix Pro www.hdrsoft.com

Paintshop Pro X6 Ultimate www.corel.com

SNS-HDR www.hdrlabs.com

Photoshop – Merge to HDR Pro www.adobe.com

SOFTWARE OPTIONS

HDR processing software has been available for several years and continually improves. Photomatix Pro is considered the gold standard, but now there are many programs that are first class. You may already have one and not even know it. Indeed, the latest version of Canon Digital Photo Professional that is packed with new Canon cameras has a useful HDR program to get you started. Endless ways to process your HDR images are available. It is possible to make the images appear real, completely out-of-this-world, and everything in-between. The processing details are beyond the scope of this chapter. Entire books are devoted to HDR and tons of excellent free information is available on the Web. Go to the website for Photomatix Pro (www.hdrsoft.com) and look under *Resources* for excellent leads to terrific information.

A summary of the way to process images using Photomatix Pro follows. This is a fully-featured program that provides numerous options and tweaks. It is not difficult to get a fine result, but it takes experience to gain control over everything it can do. Here is the basic process from beginning to end.

1. Shoot the Images
 Bracket the exposure with a minimum of one stop exposure increments, but not more than two stop increments. Use a tripod to keep

the images aligned. However, Photomatix has an alignment feature to help position the images that are shot handheld.

2. Launch Photomatix Pro

3. Load the Bracketed Images

A straightforward way to load the images would be to select the files using Windows Explorer and drag them into Photomatix Pro. Another way is to use the *File* menu and click on *Load Bracketed Photos*. A dialog box will ask you what to do with the files. Select *Merge for HDR Processing* and click *OK*.

4. Preprocess and Merge the Photos

Align Source Images offers two choices. If you shot the images handheld, check *By Matching Features*. If shot on a tripod, check *By Correcting Horizontal and Vertical Shifts*. If any objects or people move in the images, check *Reduce Ghosting Artifacts*. Now choose between *Automatic* or *Semi-Manual* with the latter choice producing the best results most of the time. If the loaded images are RAW files, check *Reduce Noise* and *On Source Images*.

5. Click on *Preprocess*

The *Settings* window allows you to adjust the process, method, and settings. There are two processes. *Tone Mapping* is applied to the merged 32-bit HDR image. It offers far more versatility and many different "looks." The two tone mapping methods offered include *Details Enhancer* and *Tone Compressor*. The second process is *Exposure Fusion*, which combines the source images directly and tends to produce more realistic-looking images. Try both ways to see which you prefer.

6. Press the *Process* button and save the results

The six steps are the basics for using Photomatix Pro software. There are many more options available for fine-tuning the image. The basics are pretty straightforward. Even I could do it without any help and I was absolutely computer illiterate (slightly better now) when I first tried it in 2011.

SINGLE IMAGE HDR

High Dynamic Range remains the best way to capture brightness extremes found in many scenes that make them impossible to capture with a single image. It is effective for still scenes, but ghosting and alignment problems must be dealt with when objects move during the exposures. It is

Many photographers object to HDR because they think it makes the image look artificial. Evidently, too many HDR images have been overdone and some have come to believe unrealistic images are the norm. HDR techniques can look real or unreal. It all depends on the processing skills and the intent of the photographer. Barbara deliberately overdid the hot air balloon at the Wooden Shoe tulip field in Woodburn, Oregon, just for fun. It is called the *grunge* look. We don't want most of our HDR images to look this way, but it is fun to process a few this way. Nikon D4, Nikon 14–24mm f/2.8 lens, ISO 200, f/16, shutter speeds of 1/20 and 1/80 second, Sun WB, AF-C on the back-button and manual exposure.

The contrast between the red sunrise behind our campsite in the Lee Metcalf Wilderness northwest of West Yellowstone, Montana, and the shaded meadow is too immense to capture in a single image. Running the exposure bracket through Photomatix Pro resulted in this image. Since the software selects mid-tones out of each of the images in the bracket set, usually the final result produced by HDR software is too low in contrast. Nikon D4, Nikon 14–24mm f/2.8 lens, ISO 200, f/13, shutter speeds of 1/10, 1/15, 1/20, 1/40, and 1/80 second, 10,000K WB, AF-C on the back-button and manual exposure.

The final image after Barbara worked her magic in Photoshop CS6 and added a bit more contrast by brightening some of the lighter areas in the scene.

possible to take a single RAW image and process it twice to help tame contrast problems. Process the RAW image to retain excellent detail in the highlights. Process it once again to get the best detail in the darkest shadows. Take these two results and process it with HDR software. The result should be better than merely processing one of the images, but don't expect it to be as good as literally shooting a series of bracketed exposures. Of course, if objects in the image are moving, then it is not possible to shoot multiple exposures while keeping the objects in the same spot, so you do not have a choice and single image HDR processing remains the best solution.

STILL MORE PROCESSING

We find the results of running a stack of images through HDR software agreeably reduces the contrast range to more accurately reveal what our eyes can see. However, the final result is quite often a little too low in contrast. This occurs because the software selects the well-exposed portions of the images. Bright whites and dark blacks are often lacking in the final HDR result. Oddly enough, a little contrast is useful in the final image. Barbara runs the final result from the HDR processing through Photoshop to reset the black and white points to add a little more contrast, which results in having more detail over a wide dynamic range.

HDR offers the opportunity to subdue high contrast. HDR is one of the top six most powerful new photo techniques to come and be a true game-changer during my forty-year career as a full-time outdoor photographer. Be sure to take advantage of it. You may be curious about the other five game-changers. We will cover the game-changers later, but to tweak your interest, they include panoramas, focus stacking, high ISOs for the night sky, in-camera multiple exposures, and sophisticated uses of wireless flash for landscape and close-up photography.

While enjoying a ranger-led tour of these protected ruins in Mesa Verde National Park, Barbara used her widest focal length lens inside this tiny underground room. Due to the wide dynamic range, she shot eight exposures in one-stop increments and combined them into one image using Photomatix Pro. Nikon D4S, Nikon 14–24mm f/2.8 lens at 14mm, ISO 100, f/18, 1/4, 1/2, 1, 2, 4, 8, 15, 30 seconds, Cloudy WB, manual exposure and AF-C autofocus on the back-button.

Shoot Sharp Images

It is simple to shoot soft images. Flawed shooting technique prevents many shutterbugs from taking full advantage of their quality lenses. Let's describe George, a fictional photographer who is doing everything wrong. Because George thought he could get a deal he bought a 28–200mm lens from an unheard-of company that makes third-party equipment. George then mounted a cheap UV filter on the lens to protect it and lost the hood because he never intended to use it. He never cleans the lens with either a cloth or blower because he doesn't worry about dirt accumulating on the UV filter. George uses aperture-priority and never considers using a tripod because he "knows" he is steady. He keeps the autofocus on the shutter button and keeps all of the twenty-one autofocus points active. Although George loves his images and his friends say they are great, when carefully scrutinized, not one of the images is tack sharp because his shooting practices are dreadful.

Is it actually necessary to devote an entire chapter to shooting sharp images? Sadly, in reality, most images are not as sharp as they could be. Lenses are excellent today, but they do have optical problems that limit sharpness. That said, few photographers see the flaws in their lenses because their shooting technique is by far the most consequential limiting factor. Make it a goal to acquire super shooting methods that allow you to capture sharp images. Although there is a lot to be aware of, once you acquire superb shooting habits, you will simply and consistently shoot tack-sharp images.

We highly recommend using a tripod to shoot sharp images whenever possible. We almost always shoot on a sturdy tripod, but one exception is when we photograph the East Channel Lighthouse in Munising Bay. Anytime you are shooting in or on a boat rocking in swells makes tripod use pointless. Instead, we used the best hand-holding technique we know. This technique includes using higher ISO than normal and opening up the lens to allow a faster shutter speed, activate the image-stabilization on our cameras, use autofocus carefully to stay locked on to the lighthouse, and shoot plenty of images to increase the chances of getting some really sharp ones. Nikon D4, Nikon 28–200mm lens at 110mm, ISO 400, f/8, 1/125 second, Cloudy WB, manual metering and autofocus with the back-button control.

START WITH A CLEAN LENS

The lens focuses the light onto the imaging sensor. If there is any debris—dust, hair, water spots—the light that should pass through the lens can't at that spot, and the image loses a little color and sharpness. You should always keep the glass surfaces of the lens clean. When not using the lens and it is not attached to the camera, keep the front and rear protective caps on the lens. Covering a lens helps to keep dirt off the glass surfaces and protects the lens from scratches. When the lens is mounted on the camera and you are not shooting, put the front cap on the lens.

No matter how careful you might be there is often a bit of dust on the lens. When this happens, take the front and rear caps off, and blow the dust off both ends with a Giotto Rocket blower. If the lens looks clean, then mount the lens on the camera and install the lens hood to reduce flare problems and protect the lens. If blowing the debris off with the blower does not work, then *gently* rub the lens with a clean microfiber cloth to loosen the debris. Blow the lens off again. That usually works, but if it doesn't, then put lens cleaning fluid on lens cleaning tissue paper and rub the lens again. Be gentle doing it. Begin in the middle of the lens and slowly move to the outer edge by rubbing in a circular motion. Then rub the lens with a microfiber cloth, and always blow off any debris that might remain with the blower. Following this procedure always works for us. If you get something truly sticky on the lens, then you might have to take it to a repair facility.

Making sure the glass surfaces of your lens—front and rear elements—are clean will produce better quality images. Lens cleaning equipment is inexpensive and simple to use. There is simply no excuse for shooting with dirty lenses. Make it a habit to keep the lenses clean at all times.

HANDHELD PHOTOGRAPHY TECHNIQUES

Barbara and I hope you want the highest quality images possible. These qualities include excellent light, effective composition, optimum exposure, and super image sharpness.

At the beginning of our photo careers, we were keenly aware we were competing against the best photographers in the world. We knew we could not cut quality corners and still succeed in such a competitive business. We never cut corners and hope you will not either.

We use a sturdy tripod for all images we shoot whenever it is feasible to use one. We shoot 95 percent of our images on a tripod, but there are certain instances when a tripod or even a monopod do not work. Photographing from a bobbing boat requires handheld shooting because you are better off using your body to absorb some of the rocking motion. That said, it is lazy to shoot handheld when it is easy to use a tripod. Too many photographers do that and, as a result, their images suffer. When you must shoot handheld, though, use these strategies to shoot sharp images. Although regular tripod use is crucial, there are situations where handheld shooting is necessary. Many places—butterfly houses, museums, and archeological sites—do not allow tripod use because it is a tripping hazard to other visitors or they think using a tripod means you are a professional photographer. Some places do not want you to sell images shot at their facility. Tripods are essentially not usable on boats that are either under sail or bobbing to and fro. There are times when a large boat is at anchor in quiet waters and a tripod could be usable, however. I have paddled my kayak into the mud to increase the stability and used a tripod effectively. Plenty of viewing platforms do not accommodate tripod use. Especially when shooting wide-angle lenses, it is challenging to get the tripod-mounted camera in a spot to exclude the railing, such as the Lower Falls in Yellowstone National Park from the brink viewpoint. When you must shoot handheld, though, use these strategies to shoot sharp images.

THE 1/FOCAL LENGTH RULE

Some of us are naturally steadier than others. The very fact that your heart is beating means your body is never completely still. You wiggle, and this causes camera-shake anytime shooting handheld. This formula provides a widely used guideline (we are not at all fond of rules) that says,

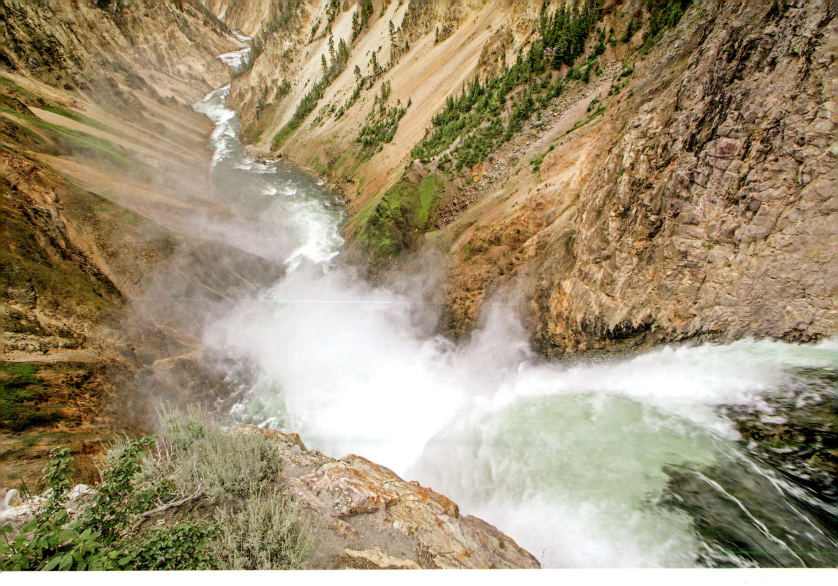

The viewing platform has limited space where the Lower Falls leaps off the cliff in Yellowstone National Park. It is nearly impossible to shoot straight down the falls with the camera mounted on a tripod. I shot handheld with my left hand on the fence. I used my right hand to hold the camera so it rested on my left hand to reduce camera-shake and to shoot a sharper image. Canon 1Ds Mark II, Canon 17–40mm f/4, ISO 200, f/8, 1/100 second, Cloudy WB, manual exposure and autofocus using the back-button.

"the shutter speed should be equivalent to 1/Focal Length to ensure sharp images when handholding the camera." Translated to a 15mm lens, it indicates a shutter speed of 1/15 second, a 100mm lens needs 1/100 of a second shutter speed, and a 300mm lens needs a shutter speed equal to 1/300 of a second. Longer focal length lenses require more shutter speed because they magnify the image still more, which also in turn magnifies camera-shake. The understanding is that as long as you keep the shutter speed up to the 1/focal length equivalent, camera-shake will not cause unsharp images.

Please keep in mind this guideline is meant for camera-shake problems only. It does not apply for arresting subject motion. Flying birds, galloping horses, racing cars and runners will all require shutter speeds much faster than this guideline suggests.

CROP FACTOR

This guideline is often modified for cameras with a small sensor. If you have a 1.6x crop factor camera, a 100mm lens behaves more like a 160mm lens (1.6 x 100mm = 160mm). Then a shutter speed of 1/160 second is warranted. Crop factor cameras do not change the focal length, and they do not give you greater magnification. The smaller sensor merely crops in-camera what would have been captured with a full-frame sensor. The crop factor changes the angle of view of the lens but doesn't actually magnify the subject. Nevertheless, you must adjust the effective focal length for small-sensor cameras when using the guideline.

With a background in competitive rifle shooting where steadiness is crucial, I am probably more steady than most—as long as I have not just consumed three cups of coffee. I have tested this 1/focal length shutter speed guideline and find it indeed works quite well for me. Nevertheless, for my quality needs and to err on the side of sharp images, I increase my shutter speed at least one stop faster than the guideline suggests. When handholding a 30mm focal length, for instance, I use at least 1/60 second. If using a faster shutter speed for small-sensor cameras truly does matter, this modified guideline takes care of it.

WATCH OUT FOR ZOOM LENSES

If you are using the 1/focal length guideline, be careful when using a zoom lens. Be aware that when you have a 28–200mm zoom, for example, a shutter speed of 1/28 second works at the 28mm setting, but you need 1/100 second at 100mm and 1/200 second at 200mm.

BRACE THE CAMERA

Miner's Castle is the most photographed rock in Michigan. From the elevated viewing platform, the rock makes a pleasing image when isolated against the dark gray stormy waters of Lake Superior. An exceptional 24mm image is easy to capture by handholding the camera and composing the shoreline to lead up to Miner's Castle with a vertical composition. What amazes us is the percentage of photographers

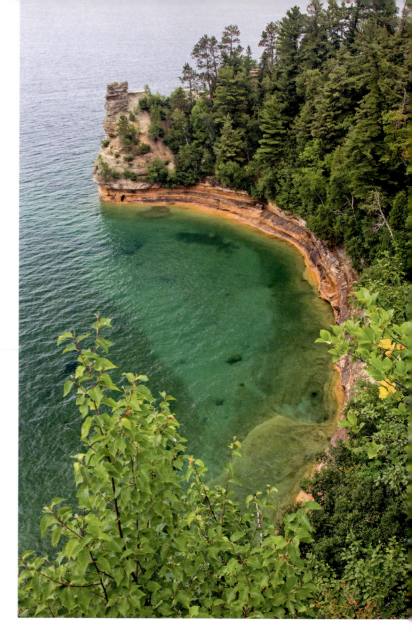

Using a wide-angle lens is a popular way to compose the Lake Superior shoreline with Miner's Castle—the most photographed rock in Michigan—at the top left of the image. To make this composition, you must use the railing to steady the camera and shoot handheld, because it is not possible to get a tripod-mounted camera into the optimum position. Most shutterbugs merely lean over the railing a little and shoot handheld without steadying their camera and therefore their images are not nearly as sharp as they should be. Canon 5D Mark III, Canon 16–35mm f/2.8 lens at 18mm, ISO 400, f/11, 1/25 second, Shade WB, manual exposure and autofocus using back-button control and polarizer to reduce glare on the water.

who shoot handheld and lean over the railing a little to compose the shot. We agree you can't use a tripod because it is nearly impossible to set it up on the platform in the required position. But wait! There is a convenient railing to rest your hand on. Then stabilize the camera by resting it on your hand and shoot the image. Using your hand as a convenient and always available "beanbag" eliminates nearly all of the camera-shake! When handholding, always use a fixed solid object to stabilize the camera whenever possible!

FAVOR HIGH SHUTTER SPEEDS

Be willing to use a little higher ISO, perhaps ISO 400, and don't stop the lens down quite as much to allow the use of a faster shutter speed when handholding. Image sharpness will noticeably improve.

IMAGE-STABILIZATION

Many wildlife species are easily photographed from a boat because they don't fear danger coming from the water. If you ever visit the Galapagos or Antarctica, you will surely need to photograph from small Zodiacs at times. For these and similar situations where handheld photography is necessary, using lenses or cameras that have built-in image-stabilization can be incredibly helpful. Depending on the system, most stabilize the lens by moving glass elements in the lens to counteract camera-shake. Others use a different method in which the sensor moves to reduce camera-shake. We regularly use Canon and Nikon lenses that offer image-stabilization (IS) when handholding. It is excellent new technology that continues to improve. Makers claim that their image-stabilization equipment allows the use of two to four stops lower shutter speeds. If they claim four stops, it suggests you can use a shutter speed of 1/25 second with a 400mm lens. Here's the math. A 400mm shutter speed, when reduced four stops becomes, 400 – 200 – 100 – 50 – 25. Because equipment makers tend to be optimistic, please do not believe these claims. Believe me though, image-stabilization does work and it helps considerably. With my Canon image-stabilized lenses, I routinely use 1/24 second with my image-stabilized 24–105mm lens when zoomed to 24mm. In other words, with

IS, I feel confident of literally using the 1/focal length guideline. And remember, image-stabilization is similar to the 1/focal length guideline in that it only applies to camera-shake. It does nothing to arrest subject motion when only faster shutter speeds or short flash durations help the situation.

WHEN YOU DO NOT NEED A TRIPOD

Wide-angle lenses reduce magnification, which allows the use of slower shutter speeds while handholding. A favorite winter subject are the "ghost trees" on Two Top Mountain near West Yellowstone, Montana. In late January and early February, these trees are entirely encased in snow and ice. It is an awesome sight and a spectacular photo subject. The Canon 24–105mm zoom lens with image-stabilization is ideal for photographing these trees handheld. A tripod could be used in the soft snow by packing it down, but why bother? On a favorable morning, it is likely to be below zero and tripods get cold and are slow to use in deep soft snow. The morning sun is bright, so there is plenty of shutter speed to even use f/16 for depth of field. A few years ago, I tested and compared shooting on a tripod and shooting handheld and could find no difference in image sharpness. When shooting at f/16 with a shutter speed of 1/250 second and an image-stabilized lens at 24mm, it is pointless to use a tripod to obtain sharpness. Of course, if you are shooting multiple images for a panorama, focus stacking, or HDR, then using a tripod is best.

TRIPODS

A bewildering variety of tripods are available. How do you decide which one is best for you? There is no easy answer because the answer depends on the kind of images you shoot, how much weight you are willing to carry, and how much you are able to spend. Here's a list of guidelines to consider:

- If the tripod legs are not long enough to support the camera at eye level when standing, you will detest having to stoop over every time you shoot on it. When the legs are fully extended it does not hurt to have the camera supported a little higher than eye level. If you are shooting on a slope, the downhill leg must reach further, so the camera will

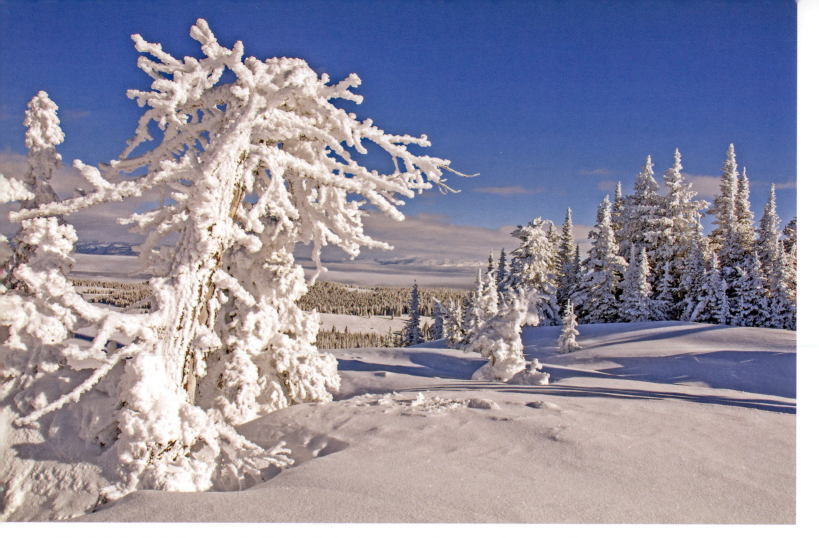

The entire forest on Two Top Mountain near West Yellowstone, Montana, becomes encased in ice and snow by late January. These trees photograph best with short lenses against a bright blue sky. Since the sun is shining and the lenses are short, there is no need to use a tripod because the shutter speed needed is quite fast. Nikon D4, Nikon 14–24mm lens at 20mm, ISO 200, f/11, 1/400 second, Sun WB, manual exposure and autofocusing using back-button control.

be lower than eye level. If the legs are extra-long, you can avoid this occasional problem.

- You will find many delightful subjects on or near the surface of the ground. If you are photographing a mushroom, frog, salamander, or many wildflowers, you will need to put the camera near the ground. Therefore, it is crucial to have a tripod that is specifically made to allow the legs to splay out flat. Most tripods do not permit spreading legs all the way out, so check this closely.

- The legs must splay out at different angles independently of each other. You do not want a tripod that does not permit this independent setting because it makes it difficult to use on a slope.

- Avoid tripods with a long center column. The column is used to elevate the camera. That sounds like a good idea, but the camera is not stable when mounted on top of a long center column. Also, the center post column can make it difficult or impossible to shoot near the ground when you splay the legs, because the column strikes the ground before the camera is low enough.

TRIPOD SUGGESTIONS

Tripod models constantly change. That is good and bad news. It is advantageous that the tripod makers are continually working to build better products. It is not so good for me

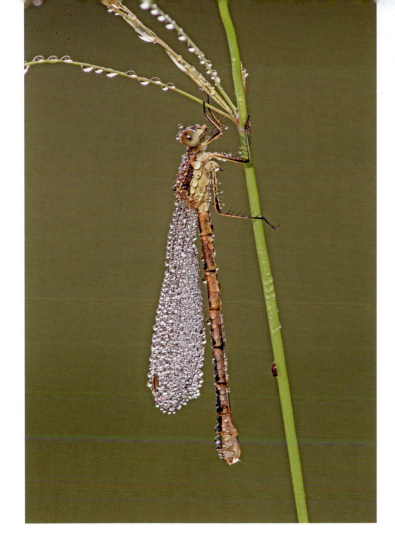

A tripod must be able to spread its legs widely to easily allow photographing the many attractive subjects that live on or are found near the ground, such as this dew-laden damselfly. The ambient light is underexposed by about 2/3 of a stop and the Canon 600EX flash is used with the ST-E3-RT radio controller. The FEC is set to +.7 stops to optimally expose the damselfly with the flash. Canon 5D Mark III, 180mm f/3.5 macro, ISO 160, f/18, 1/10 second, Cloudy WB, manual ambient exposure and manual focusing.

because it makes it difficult to suggest models when a favorable model is discontinued so quickly. For the record, we use Gitzo tripod legs—models 1340 and 1325—but both are now discontinued. The most similar current models to the ones we use are the GT3532S (Systematic Series 3 carbon fiber tripod, 3-section compact level) and the GT3542LS (Systematic Series 3 carbon fiber tripod, long 4-section, eye level). If you are looking for a tripod, go to www.gitzo/tripods and look at

the Systematic tripod line. These tripods are well made, come in different sizes, and do not have a center column. Current models we find appealing include the two just mentioned and the GT3330LS, GT25325, GT2542LS, and GT25425. Gitzo makes Mountaineer tripods and the lighter-weight, smaller Traveler series. These tripods are not inexpensive, but they are well made and will last a lifetime. We have used our current tripods for at least ten years and they continue to operate flawlessly.

Manufacturers make most tripods out of aluminum and they work adequately. We still prefer the more expensive ones made of basalt or carbon. These are not only a little lighter and stronger and more rigid, but also the legs slide in and out a little more smoothly. Really Right Stuff (RRS) makes quality tripods, so please consider their products. They are well made and carefully designed to meet the needs of outdoor photographers. Once again, you only get what you pay for. All quality tripods are expensive. Manfrotto builds a line of tripods that are less expensive as do many other companies attempting to fit the needs and budgets of all photographers. We see a lot of different tripods in our field workshops and most are quite functional. Still, for our work and personal reasons, we continue to prefer our Gitzo tripods.

TRIPOD LEG COVERINGS

Many photographers buy specially made leg covers to make the legs easier to carry and to separate your warm hands from cold tripod legs on chilly days. Some leg covers are made in camouflage fabric to attempt to hide tripods from skittish wildlife or human onlookers. Barbara uses leg covers on her tripod, but I prefer not to do so mainly because it adds extra mass and weight and makes it more difficult to access the leg locks. If warmer and softer tripod legs sound good to you, search the Internet for "tripod leg covers" to find an abundance of products.

TRIPOD HEADS

There is a bewildering variety of heads made for your tripod. We have seen hundreds of different tripod heads over the

years and dislike nearly all of them. Many are flimsy, poorly designed, difficult to use, or simply don't do what photographers need them to do. Your images will suffer when you try to shoot with a lousy tripod or inadequate head mounted on a good tripod. The vast majority of serious photographers use sturdy ball heads for everyday shooting and the Wimberley Gimbal head for photographing action when panning is necessary, especially when using super-telephoto lenses. Rather than trying to discuss a huge variety of tripod heads that possibly might work, let's narrow it down to a few of the very best choices.

A ball head is a very simple head that is sturdy and allows you to comfortably and quickly reposition the camera. Most heads have only three controls. One control loosens the head to allow the camera to pan in all directions. A second control sets the tension on the ball. With added tension the ball head does not move quite as easily, which helps some photographers hold their camera when the ball is not tightly locked. I have no difficulty holding the camera on a loose ball head, so I always keep my tension control knob set to no tension. The third control lets the ball head pan horizontally. I don't use this feature a lot either because it is easy enough to pan the camera by loosening the ball and panning the ball. However, if you are shooting a panorama image and must keep the images level, or if you use a Gimbal style head for panning with a telephoto lens, then it is crucial to have the pan control.

We use the fabulous Kirk BH-1 ball heads (www.kirkphoto.com) and have done so for decades. They are solid, reliable, and simple to use. The BH-1 ball head weighs 32 ounces and costs $385. The smaller BH-3 model is 20 ounces, costs $285, and can support up to 15 pounds. If you don't use any lenses larger than a 300/2.8 lens, then the Kirk BH-3 model is all you need.

Another line of excellent ball heads is made by Really Right Stuff. Though slightly more expensive than Kirk's, the BH-55 and BH-40 are excellent. All of the ball heads mentioned here are enormously popular with serious photographers who want good equipment that will be reliable to use forever. As

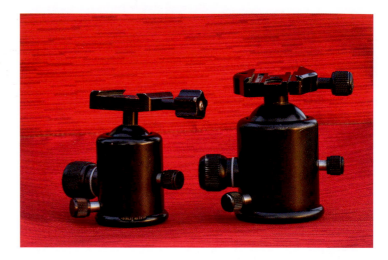

We use Kirk ball heads (www.kirkphoto.com) with exemplary success. Kirk ball heads always work well for us and we never have trouble with them. The smaller one on the left is the BH-3 model ($285) and the larger one is the BH-1 ($385). If you do not have mammoth lenses—500mm f/4 for instance—then the smaller and less expensive BH-3 is the one you need.

a starting point, look first at the offerings by Kirk Enterprise Solutions and Really Right Stuff. There is another good reason to use these particular ball heads. A number of accessories that assist you in shooting excellent images are made to work with these ball heads. Kirk, Really Right Stuff, and Wimberley all make L-brackets, camera plates, and lens plates that precisely fit the quick release mechanism on these ball heads. Do not buy any tripod head where its quick release mechanism only works with a few items made by the tripod head builder. You do not want to lock yourself out of being able to use the fine products of these three companies.

WIMBERLEY HEAD

Wimberley (www.tripodhead.com) originated their world famous head that excels at allowing a photographer to easily pan with moving subjects. Their unique head is designed to balance the lens perfectly. When set up properly, the head does not need to be locked in place. It allows the photographer to pan the camera with a big lens up, down, left, or right, and keep it perfectly stable. If you let go of the camera, the equipment remains suspended in place. Panning with

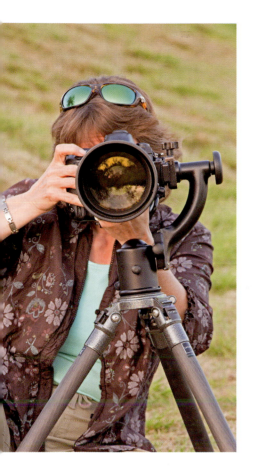

top: Many top-of-the-line telephoto lenses have two image-stabilizing modes. When handholding and you want to stabilize the lens in all directions, select Mode 1. If you are panning, then select Mode 2. In this case the duck is swimming to the right, so you would pan from left to right. In Mode 2, the camera doesn't attempt to stabilize the image in the horizontal direction, but it does stabilize the image to reduce vertical camera-shake.

left: The Wimberley Sidekick ($250 – www.tripodhead.com) conveniently and quickly converts the Kirk BH-1 ball head into a Gimbal head. Once the lens and camera are balanced, it is effortless to pan in any direction with the touch of a finger. If you let go of the equipment, the camera and lens remain in perfect balance. Every serious shooter we know uses some sort of Gimbal head to make action photography much easier!

moving subjects is now extremely easy. There is no better head for panning than the Gimbal style head, but they are a little bulky for immobile objects—landscapes and close-ups for instance—where the ball head still works best.

The Wimberley Head Version II ($595) is the ultimate for panning images shot with telephoto lenses. To save a little money, the lighter and more compact Sidemount Wimberley Head ($495) is quite effective. If we used telephoto lenses most of the time, we would always use the Wimberley Head Version II. Instead, we both like the Sidekick ($250), which quickly and easily converts our Kirk BH-1 ball heads into a Gimbal style head. It is very efficient, even for our heavy 200–400mm zoom lenses.

TRIPOD HEAD ACCESSORIES

L-BRACKETS

These brackets are indispensable. L-brackets are made for all of the popular cameras. The bracket screws into the bottom of the camera. It provides two quick release attachment points, one on each side of the "L." To mount the camera horizontally on the tripod head, slide the plate that provides a horizontal orientation into the ball head's clamping mechanism. To shoot a vertical composition, take the camera off the tripod head and mount it on the other side of the L. Now the camera is mounted vertically on top of the tripod head. No longer is it necessary to take the tripod head and flop it over to compose a vertical shot. Doing that destabilizes the camera and is incredibly inconvenient. It is far preferable to

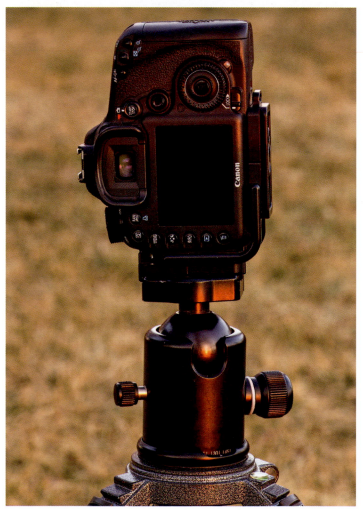

L-brackets are incredibly useful for supporting the camera both horizontally and vertically on a suitable tripod head that is built to accept them. Kirk Photo makes outstanding ball heads and exceptional L-brackets that are custom designed for your camera. Rather than flopping the camera over to the side to shoot a vertical on a tripod and destabilizing the whole setup, merely mount the camera vertically on top of the tripod and keep the center of gravity over the tripod legs. It seems like such a simple thing, but none of the serious photographers we know would photograph without using L-brackets! Essentially, the L-bracket has a quick release plate on two sides.

Mount the camera horizontally as shown in the top image or vertically as seen in the bottom image.

mount the camera either horizontally or vertically on top of the tripod head.

QUICK RELEASE PLATES

If you don't use the L-bracket, then at least get a quick release plate that is made for your camera. These plates are solid. When properly attached, nothing wiggles, and they don't come loose. You must use an Allen wrench (key) to remove them. Using a generic quick release plate that doesn't fit snugly and comes loose by itself is a continual nuisance and a major reason for unsharp images! Some lenses come with a built-in tripod mount (collar). Collars are commonly found on large zoom and telephoto lenses. If the lens has a tripod mount, always attach the tripod mount to the tripod head and not the camera body. This arrangement balances the lens and camera on the tripod head more appropriately. Plus, the lens is easily rotated from horizontal to vertical compositions and every angle in-between by loosening the tripod mount, rotating the lens, and then locking the mount again. The quick release plates made for a specific lens's tripod mount are by far the most convenient way to change camera positions.

Wimberley, Kirk Enterprises, and Really Right Stuff offer a wide assortment of L-brackets and quick release plates that work well with the ball heads discussed. Visit their websites for product and purchasing details.

SHARP SHOOTING TECHNIQUES

AVOID EXTRA GLASS AND USE THE LENS HOOD

The lens is built to provide the finest quality with the lens hood installed on it. Adding any extra glass elements will

degrade the image quality slightly. The image will be less sharp and the colors may be less saturated due to increased flare. Using a lens hood reduces the flare problem considerably, but it still exists. Adding more glass surfaces only makes the flare problem worse. To obtain best results, avoid adding extra glass to the optical path. Do not use UV or skylight protection filters unless absolutely necessary. Perhaps when shooting in salt spray it might be an appropriate place to use a protection filter. Do not use teleconverters or any other filter unless the reason to do so outweighs the small loss of image quality. Of course, the excellent benefits of polarizing filters for reducing glare and darkening a blue sky are routinely desirable. If you must use a teleconverter to make the subject larger in the viewfinder and find no other way to get that magnification, then teleconverter use outweighs the negatives. Sadly, too many photographers always have a "protection" filter mounted on their lens, don't use their lens hood, and use a teleconverter even when not needed. Do not be one of them!

IMAGE-STABILIZATION

For sharper images when you must shoot handheld, use image-stabilized lenses or, in some cases, cameras that have a stabilized image sensor. Many image-stabilized lenses have more than one mode. Be certain to use it correctly. For example, some of my Canon lenses have Mode 1 and Mode 2. Mode 1 stabilizes the image by reducing camera-shake in both horizontal and vertical directions and is the mode to use for still objects. If you are panning with the subject left to right, for example, then use Mode 2. The lens doesn't stabilize the image in the horizontal direction but does help reduce vertical camera-shake. Should one be panning vertically—not a common occurrence—the image is stabilized in the horizontal direction.

It usually is best to turn off image-stabilization when shooting on a tripod. If the camera is perfectly still on a tripod and the image-stabilization is turned on, it may activate to try to reduce non-existent camera-shake and actually create the problem image-stabilization is trying to eliminate. However,

when you are shooting a big lens on a tripod, or shooting in the wind, then camera-shake may still be present and image-stabilization helps. Some of the new lenses detect when they are tripod-mounted and deactivate automatically. Just to be certain, you might test your lenses on a tripod and compare your results with the image-stabilization turned on and off.

The camera battery is used more quickly when using image-stabilization. If you want to keep shooting and don't have a spare battery, turn image-stabilization off when it isn't needed to conserve battery power.

NO WIGGLES

L-brackets, lens and camera quick release plates, and tripod heads must be tight and stay tight. If any of these devices have any wiggle in them, find out the reason why and fix the problem. It is critically important to avoid all wiggles or your images will be less sharp than they could be. It is worthwhile to put all of your gear together at home and check for loose connections before shooting images. There should be no loose connections! If there are, find a way to tighten them.

ENVIRONMENTAL PROBLEMS

Wind, soft ground, and tripods used in rapidly flowing water or crashing waves can easily create camera-shake. We like shooting in rivers, too, but always find a place where the tripod legs are out of the water or at least anchored in relatively quiet water. The soft ground in a bog requires you to hold perfectly still when shooting, and even shifting your weight can cause the earth to tremble and shift your tripod, causing a change in focus. And many photographers are oblivious to the enormous problems wind can cause even with heavy tripods. When you must shoot in the wind, hold on to your tripod-mounted camera in order to add the mass of your body to the system. It helps steady the tripod and tame the wind. Then use a faster shutter speed to arrest the camera-shake caused by both the breeze and your "quivering" body. When in doubt, use faster shutter speeds.

Shooting sharp images of animals such as this bounding white-tail deer with lenses longer than 200mm requires three key factors. You must shoot using superb technique, focus precisely on the animal's face, and use fast shutter speeds to minimize camera-shake and overcome subject movement. You will shoot many unsharp images if any one of these factors is compromised. Remember the acronym TFS, which stands for technique, face, and shutter speed. Nikon D3, Nikon 200–400mm f/4 lens at 360mm, ISO 1000, f/5.6, 1/1000 second, Cloudy WB, manual metering and continuous autofocus on the back-button.

OPTIMUM APERTURES

Most of your lenses include the apertures of f/4, f/5.6, f/8, f/11, f/16, and f/22. You will remember the largest f/stop numbers—f/16 and f/22—are the smallest aperture in size and provide the most depth of field. F/4 and f/5.6 produce shallow depth of field, but the apertures are the largest. There are optical problems at both ends of the f/stop range, but the worst problem is diffraction, which is most severe at the smallest apertures—f/22 and f/32 are the culprits. The best quality for most lenses is two to three f/stops down from their maximum ("fastest") aperture—f/8 to f/11. Therefore, it makes sense to use these apertures any time it is feasible. Naturally, if you want to limit the depth of field or need more shutter speed, feel free to shoot "wide-open" at f/4.

Diffraction happens when light strikes the very edge of a solid object. Due to the wave nature of light, it bends a little when it strikes an edge. Since f/22 is a tiny aperture, a relatively high percentage of the light passing through the aperture hole strikes the edge of the opening and is diffracted, which causes a loss of sharpness. Although technically f/22 produces more depth of field than f/8, the overall image will be less sharp at f/22 due to the deleterious effects of diffraction. Surprisingly enough, using f/22 and even f/32 is widely practiced by many photographers. To be honest, if you only shoot at f/22 and nothing else, the images look good. But had you used f/11 and compared the result against f/22, the sharpness differences would be considerable even when using excellent technique. By the way, we compare our images for sharpness by viewing

them on the computer and enlarging by 100 percent the spot where the sharpest focus should be.

The problem of diffraction really hit home when I was working on our book, *Close Up Photography in Nature*. Using the best technique I know, I ran a test by photographing a lichen growing on a rock. I shot images at f/11, f/22, and f/32. I also shot a set of four images at f/11 where the focus was varied slightly to allow it to be assembled with focus stacking software. The results: F/32 was terribly soft due to diffraction.

F/22 was sharper but still suffered from too much diffraction. F/11 was wonderfully sharp, but the depth of field didn't cover the relatively flat lichen completely enough. The focus stacked image had superior depth of field and incredible sharpness. It was the clear sharpness winner and we will explain focus stacking in Chapter 6. The bottom line is that there is a trade-off between image sharpness and depth of field. Stopping the lens down to f/22 produces more depth of field, but the image is less sharp overall. If the lens stops

Use a long lens to successfully photograph the backlit mountain goats on Mt. Evans, about 50 miles west of Denver, Colorado, while they are perched on a sheer cliff enjoying the morning sunshine. With a long lens especially, even on a tripod, keep the shutter speed fast, focus carefully, and shoot plenty of images. Canon 5D Mark III, Canon 800mm f/5.6 lens, IS activated even on a tripod due to wind vibration, ISO 400, f/8, 1/1000 second, Sun WB, manual metering and automatic back-button focusing.

down to f/32, don't use it, stop at f/22. If the lens stops down to f/22, then use f/16 as the smallest aperture. It is simple for lens makers to produce lenses with smaller apertures. This means if your lens stops down to f/22, the only reason the lens maker did not also include f/32 is because the quality is so appalling due to diffraction that everyone would complain and demand their money back.

FIRING THE CAMERA

Never jab the shutter button to fire the camera. A quick jarring movement will surely cause a loss of image sharpness no matter whether shooting handheld or using on a tripod. Always be gentle when pressing the shutter button and avoid all jerky movements. Firing the tripod-mounted camera presents many strategies. Let's look at the most suitable options.

KEEP THE SHUTTER SPEED FAST

Outdoor photographers commonly photograph wildlife and outdoor sports with long lenses that are mounted on a tripod. Since camera-handling speed is essential and panning with the action is often required, shooters hang on to the camera while they press the shutter button to shoot the images. It is true that the shooter's body will cause the camera to vibrate slightly if they are touching the camera or tripod. However, sharp images are still achieved without difficulty if the focus is accurate and the shutter speed sufficient. My guideline for shooting sharp images of still objects when touching the camera on a tripod where subject motion doesn't need to be frozen is to use the 1/focal length guideline for the shutter speed. With a 500mm lens, we consistently shoot sharp images even when hanging on to a tripod-supported camera by using 1/500 of a second shutter speed. If you are extremely careful about pressing the shutter button gently and shoot many images, even 1/250 second will produce suitable results. Essentially, the fast shutter speed freezes the minuscule camera-shake that occurs when you fire the camera using your finger.

A CABLE OR REMOTE RELEASE

Using a fast shutter speed isn't usually an option when shooting landscapes and close-up images. Due to the need for the depth of field at f/16 or thereabouts, shutter speeds slower than 1/60 second are usually necessary. In this case, don't touch the tripod, lens, or camera to avoid causing camera vibration. Instead, use a cable release that attaches to the camera with a push button trigger on the other end. Hold the cable release gently and do not pull on it, which could put tension on the camera. Gently push the button to fire the camera. We have done it this way for most of our careers.

Lately, many wireless devices are available to trigger the camera without being connected directly to it. Remote releases use radio or optical signals to trip the camera—even from a distance. They are incredibly handy and our preferred way to work now. Check the products offered by your camera maker to see if they sell one. Most likely they do. Third-party camera equipment makers such as PocketWizard also make controls for all of the popular camera lines.

TWO-SECOND SELF-TIMER

Every camera has a self-timer. Set the self-timer, press the shutter button, and do not touch the camera or tripod while the camera counts down 10 seconds and fires the camera. Using the timer allows you to support the camera on a tripod, trip the camera, and run over to get in the image. The self-timer is an effective way to trip the camera. But, having to wait 10 seconds for the shutter to fire to make an image you do not wish to be in wastes a lot of time.

Hopefully, for merely firing the camera without touching it at the moment of exposure, the self-timer on most cameras can be set to 2 seconds. With the 2-second self-timer in use, gently push the shutter button and remove your finger, any vibration caused by pushing the shutter dissipates over the 2-second wait, and the camera fires to produce a sharp image.

The timer is an efficient and convenient way to trip the camera. However, when the goal is to catch the peak of the action, such as a wave crashing into a rock, then the timer works ineffectively because it is almost impossible to time

the action and trip the shutter precisely 2 seconds before peak action. For the same reason, when you are bedeviled with wind-induced motion in a wildflower, then you must use a cable or remote release to fire the camera as soon as the subject becomes immobile. There is no way to know if the subject will still be motionless 2 seconds later if you use the self-timer.

MIRROR LOCK-UP

Another source of unsharp images is the movement of the camera's mirror. The mirror allows you to see the image properly oriented in the camera's viewfinder. The mirror is quite heavy and clunks when you release the shutter. Mirror movement causes a little camera vibration that is most deleterious at shutter speeds in the range of 1/4 to 1/30 second. Usually, 1/15 second is the most problematic shutter speed. Therefore, numerous cameras provide a way to lock the mirror in the upright position prior to shooting the exposure. When you do this, the exposure, composition, and focus must be set ahead of time because you cannot see through the viewfinder. Locking the mirror up ahead of time is simple to do and indeed yields sharper images.

However, if you are using a shutter speed faster than 1/30 second or slower than 1/4 second, you probably won't gain anything by using mirror lock-up. Why? I tested shutter speeds for the mirror slap problem decades ago and came up with these results. If the movement of the mirror causes the camera to vibrate for 1/15 second, then the camera is vibrating for 100 percent of the exposure at 1/15 second. When the shutter speed is one second, then the camera still vibrates, but only for 1/15 second and the other 14/15 of the exposure burns in a sharp image because the mirror slap vibrations have dissipated. At faster shutter speeds, the rapid shutter speed tends to freeze the minuscule camera motion caused by the mirror, so once again the image is sharper. We routinely lock the mirror up anytime we are shooting between 1/4 second and 1/30 second.

Another way to eliminate the mirror slap problem is to use live view. When live view is activated, the image appears on the LCD display on the back of the camera. To do this, the mirror is raised, so it is already up at the moment of exposure, thus eliminating the mirror slap problem. Therefore, if you don't have mirror lock-up in your camera, use live view to achieve the same result.

FOCUS ACCURATELY

MANUAL FOCUS

Focusing the lens manually was standard procedure when I started in photography in 1970. Cameras had focusing aids built in the viewfinder to help find the optimum focus. We used manual focus and the results were fairly acceptable. When autofocusing lenses began to appear, it seemed like autofocus was an answer in search of a problem. Many photographers still believe in manual focus, especially for still subjects. However, few photographers over forty have the eyesight they did at twenty years old. It is naive to think you can manually focus the lens quickly and accurately because most cannot in reality.

We still use manual focus to sharply focus the lens for many subjects, but do wholeheartedly embrace autofocus technology. Still, there are occasions when manual focus is the only answer, so it must be practiced and perfected. When possible, use live view, scroll the focusing box over to the spot where you want the sharpest focus, magnify that box, and manually focus on the precise spot that must be in sharp focus. Using a magnified live view image is clearly the best way to focus the lens manually and accurately. Manual focus is necessary in the following situations:

- Heavy snow: falling snow confuses the autofocus system causing the focus to jump back and forth.
- Tilt/shift lenses: these and some specific other lenses (Canon 65mm macro) do not have autofocus.
- Dim ambient light: if the light becomes too dark, autofocus becomes inaccurate and may stop working altogether.
- Focus stacking: any time a series of images is shot when the focus is changed a little between them, manual focus is by far the best way to go.

Autofocus may "see" the heavily falling snow instead of the Elk and tends to jump back and forth without locking on the subject. When the snow is falling, if the focus hunts, switch to manual focus. If the subject is still, it is helpful to use a magnified live view image to make it easier to manually focus in a snowstorm. Nikon D4, Nikon 200–400mm f/4 lens, ISO 1000, f/8, 1/125 second, Cloudy WB, manual metering and focusing.

Tilt and shift lenses and the Canon 65mm macro do not have autofocus capability either. To make this pattern of a Pale Tiger Swallowtail, Barb manually focused on the subject. She manually focused seventeen different times because this is a focus stack. Canon 5D Mark III, Canon 65mm macro, ISO 100, f/8, 1/3 second, Cloudy WB, manual exposure and focus, processed with Helicon Focus.

- Panoramas: focus should not change between images making up the pan, so use manual focus to lock the focus.
- HDR: use manual focus and do not change the focus between the HDR set of images.
- Close-up and macro: high magnification images require the precise focus on the most important part of the subject and manual focus does this best.

AUTOFOCUS

Autofocus technology is absolutely amazing. Autofocus is fast, convenient, and incredibly accurate when used correctly. Unfortunately, countless photographers fail to take advantage of their camera's autofocus controls because they don't realize how many useful options are available in their camera.

MULTIPLE AF POINTS

Your camera has many AF points in the viewfinder. While that is good it can also lead to poorly focused images if you don't use the AF points properly. When you make only one AF point active, this affords great precision. The default setting most likely activates all of the points and that is what most use. If your camera has twenty-one AF points, it covers a wider area but the camera usually focuses on the closest object, which may not be the spot you want in sharp focus. If you use multiple AF points and photograph a person standing with their shoulder pointed at you, their shoulder is closer to the camera than their face and the camera focuses on the shoulder, which produces a face that is not as sharp as it could and should be! Fortunately, when the camera is set up so that only a single AF point can be selected, having multiple AF points to choose from is helpful because it is more likely there will be a single AF point that corresponds to the spot where sharp focus is needed, especially when photographing action.

FOCUSING MODES

Single-shot AF

Camera makers use different names but single-shot AF means the same thing. Point the camera at the subject, press the

shutter button down halfway, which allows the camera to focus on a spot in the image, and then press the shutter down all of the way to shoot the image. This focus mode is perfect for motionless subjects because the focus stays locked when the shutter is held down halfway. In turn, you can lock the focus, change the composition a little without the camera refocusing on the background, and then shoot the image.

The technique of locking the focus works precisely in single-shot AF when you are handholding the camera and holding the shutter button down halfway. It doesn't work well at all when shooting on a tripod. Most cameras refocus if you fire using either a 2-second self-timer or a cable/remote release. The shot rapidly turns into a focusing disaster because when you focus on a rock in the foreground and recompose, the focus spot changes. Some photographers notice this problem, and once they achieve sharp focus, they spend the time to turn the autofocus off, but that quickly becomes a nuisance. Yet another problem with the one-shot autofocus is that the default setting on many cameras is set for focus-priority. If you focus on that rock, recompose and lock the focus and the AF points are not on an object in focus, the camera may refuse to shoot. Focus-priority only allows the camera to shoot when the objects that coincide with the activated AF points that appear in the viewfinder are in focus.

Fortunately, all of the cameras we see in our field workshops can be set to shooting-priority and that setting allows the camera to fire without any regard to the focus. This is precisely the setting you need!

Continuous Focus

One-shot focusing does not track moving subjects. Canon calls the second focusing mode AI Servo, while other camera systems use the term "continuous focus" to track action. If the activated AF points are on a moving subject, the camera automatically changes the focus to keep the subject in focus—more or less. If the action is too fast, you may not stay on the target, or if an obstacle appears between the subject and the camera, you will lose focus. Still, continuous autofocus is helping photographers sharply focus action. Continuous focus

Mountain goat kids actively play together. An excellent way to hit sharp focus is to use back-button focus and select a single AF point in the middle of the image. Point the AF point at the face of the lower baby goat, press the AF control button in to focus, let up on the button to lock the focus, recompose and quickly fire off a burst of images. This may sound like a lot to do, but, with practice, it takes 2 seconds or less. The focus stays precisely on the face if the subject doesn't move and neither do you. If the focus control is on the shutter button, the camera will refocus the lens when you recompose, and the focus will change to the middle of the image where the top youngster's shoulder is found, and not the face where you certainly want the sharpest focus. Canon 5D Mark III, Canon 200–400mm f/4 lens at 300mm, ISO 400, f/14, 1/400 second, Cloudy WB, shutter-priority with a +1/3 exposure compensation set.

The seabird exhibit at Oregon's Newport Beach Aquarium is a delightful place to photograph a few species of seabirds. Comical tufted puffins swam by us frequently at close range. When the subject is constantly moving, be certain to keep the camera set to continuous autofocus to allow the camera to automatically change the focus as the subject's distance changes. Nikon D4, Nikon 200–400mm f/4 lens, ISO 800, f/7.1, 1/640 second, manual exposure and continuous autofocus on the back-button.

is the reason for seeing so many great action images today. Continuous autofocus is terrific and continues to improve with each new camera introduction.

Set the camera to continuous autofocus, point the activated AF point (or points if more than one is enabled) at the subject, and hold the shutter button down halfway, which initiates continuous autofocus. Simply hold the shutter button down

and pan with the subject while shooting a burst of images. You will get plenty of sharp images if you pan smoothly and the shutter speed is fast enough. This focusing mode will be a problem when the subject stops, however.

Jungle Jim is in Kenya photographing a handsome male African lion that is slowly walking toward the safari vehicle. Using continuous autofocus, Jim selects a single AF point

or perhaps a small group of points that coincide with the lion's face as he shoots. The lens continually stays focused on the eyes. Then the lion stops walking, Jim recomposes and shoots, but the AF points are now on the lion's chest. The lion's chest is in focus, but the eyes are slightly soft because the depth of field at f/5.6 is not adequate. In almost all cases, the animal's eyes should be tack sharp because viewers tend to look at the face first. Of course, Jungle Jim might have noticed the AF points were no longer on the face. He could have switched to other AF points at that moment that did coincide with the face, but, like most photographers, Jim forgets in the excitement of the moment.

Had he been using one-shot focus, Jim could have focused on the eyes, held the shutter button down halfway to lock the focus, recomposed while still holding the shutter button down, and shot the images. The focus stays locked on the eyes. But, what happens if the lion begins to walk again? One-shot focus doesn't track moving targets, so he must quickly change the focusing mode to continuous autofocus. Unfortunately, there is never enough time to switch between these focusing modes and still have the subject available to photograph. Surely there must be a better way to handle the autofocus!

BACK-BUTTON FOCUSING

For decades we have used a technique that we dubbed back-button focusing in order to describe it. Most cameras allow the user to change the autofocus control from the shutter button to a dedicated autofocus button located on the rear of the camera typically approximately an inch just to the right of the viewfinder. Some cameras now have a designated AF-On button. Back-button focusing is incredibly efficient to use, *once you get used to it*, plus it is extraordinarily precise. Unfortunately, your camera manual does not name it that and may not use any term that you can recognize, but cameras of all brands have it. The quickest way to find back-button focus will be to go to any Internet forum for your camera system and ask the followers if the camera model (be sure to say what model it is) has the option of back-button or thumb

focusing. The camera probably has. Hopefully someone will tell you how to activate the feature. Back-button focusing is normally set with a custom function or menu option. If your camera has a designated AF button on the rear of the camera, you probably must use a menu item to turn the autofocus off on the shutter button.

If at any time you find the camera refuses to shoot the image when using back-button focusing, search for a focus-priority setting that can be changed to shooting-priority. This option may or may not be on your camera. If the camera has this feature it can be located in many places, but look first in any custom functions or menu choices that involve focusing.

Activate back-button focusing, put the focus mode on continuous, and leave it there. You don't need one-shot or single focus anymore. Select a single AF point in the viewfinder or perhaps a small cluster of AF points. When a subject is still, point the AF point at the most important area where sharp focus is desired, press the button on the rear of the camera that controls the autofocus to make the lens focus on that spot. Let up on the button to lock the focus, recompose, and shoot the image. The focus will remain where you want it. Should the subject unexpectedly begin to move and you need continuous focus—it is no problem. Point the AF point at the subject, press the AF control button down, *and hold it down*, to make the autofocus track the subject while shooting images at the same time. Read the following carefully.

Hold the back-button down when you are tracking action while shooting. Let up on the button anytime you wish to lock the focus. Now you have a single focus or continuous focus any time you want it by using your right thumb to hold the button down or let up on it. That is the reason some shooters call it thumb focusing. The right thumb controls the focus. Back-button focusing takes a little time to get used to and your brain has to accept that your right thumb controls the focus, but once it does, you will wonder how you ever focused images before.

With some practice, back-button focusing offers tremendous control that is fast and precise. This is an actual example of the way I used back-button focusing to photograph the

The problem with using many active AF points in the camera is clearly demonstrated. Autofocus tends to focus on the closest object, so the leaves are sharply focused and the Shoebill Stork at the San Diego Safari Park is ridiculously out of focus. Canon 5D Mark III, Canon 200–400mm f/4 lens, ISO 400, f/8, 1/250 second, shutter-priority and autofocus.

To avoid focusing on objects in the foreground, many photographers use manual focus. However, there is a better way, called back-button focusing. With the focus control only on a button on the rear of the camera and not on the shutter button, select only one AF point to be active. Then point that AF point at the forehead of the Shoebill Stork, press in the back-button control to make the lens focus on that spot, and, when it does, let up on the button to lock the focus. Now recompose and shoot a sharp image because pressing the shutter button does not cause the lens to focus on the grass in the center of the frame.

extremely rare Brewer's Duck—a bird John James Audubon painted from the only specimen he ever found. The Brewer's Duck was living at a pond east of San Diego, California. It had become habituated to humans. With my camera set to a single active AF spot, continuous focus, and autofocus activation on the back-button (AF-On button) of my Canon 5D Mark III, I panned with the swimming duck with my Canon 200–400mm lens and selected the AF point that corresponded

Even John James Audubon saw only one Brewer's Duck during his lifetime. We were thrilled to find this one at Santee Lakes in California. At the time, Audubon wondered why the bird that he named after his friend was so rare. He did not know for certain if it was a distinct species or not. It turns out this duck is a naturally occurring cross between a mallard and a gadwall. Nikon D4, Nikon 200–400mm f/4 lens, ISO 400, f/11, 1/800 second, Sun WB, manual metering and back-button continuous focusing.

with its head. With the back-button held down to activate focus, I fired off a burst of images every time the composition was appealing. Occasionally, the duck stopped swimming. When this happened, I pointed the active AF point at its head and pressed the AF-On button in to make the lens focus on the head. Then I let up on the button to lock the focus, recomposed to make a more pleasing composition, and fired numerous shots to capture many pleasing images of this rare bird. Why is the bird so rare? Although Audubon couldn't prove it at the time, a Brewer's Duck isn't a true species. Occasionally mallards and gadwalls hybridize in the wild and produce an oddly colored duck called the Brewer's Duck.

Audubon named the duck after his friend, Thomas Brewer of Boston.

When photographing fast action that is somewhat erratic, it is difficult to keep a single AF point on the head or body of the target. Activate a single AF point and the surrounding AF points to have more active AF points, which help you stay focused precisely on the spot in which sharp focus is desired. If the background is blue sky or all white clouds with little contrast, often it is possible to activate all of the AF points and the lens will focus on the subject—more or less—and not focus on the background. Should the background have contrast in it—the water in an ocean or lake, white clouds

in a blue sky, forest—then most cameras will focus the lens on the background if the active AF points don't stay on the subject. With a little experience, you'll find out what works best for you.

Let's summarize how to use back-button focusing. No matter what term your camera manual uses to refer to it, be sure to track it down and set it. Activate a single AF point in the viewfinder. Normally the middle point is the most accurate one. Set the camera to continuous autofocus. With a motionless object, direct the AF point at the spot where you want the sharpest focus and press in the back-button focus control. When the spot is focused, lift your thumb off the AF button to lock focus, recompose if desired, and shoot the image. To focus an active subject, select an AF point that corresponds to the spot where you want the sharpest focus, which is usually the face of a human or animal, hold the back-button AF control down and keep it held down to maintain focus tracking, and shoot a burst of images with the camera set to shoot as many images per second as possible.

Your camera provides numerous ways to control autofocus precisely. Be sure to examine each one of them thoroughly. The options vary from camera to camera, but specific options are crucially important to use! Always remember the key to sharp images is to use excellent shooting technique, favor faster shutter speeds, and focus precisely on the spot where you desire tack-sharp focus.

I was photographing black-capped and mountain chickadees that were darting in and out of the sunflower feeder. Due to their speed, I shot handheld to keep up with the energetic little birds. Suddenly, all of the chickadees froze in place as a northern pygmy owl landed on the branch next to me. I slowly moved the camera over to frame this bird-eating owl and shot several images before the owl flew off. Canon 7D, Canon 300mm f/4.0 lens with image-stabilization turned on, ISO 400, f/5.6, 1/500 second, Cloudy WB, manual exposure with continuous autofocus on the back-button.

Focus Stack for More Depth of Field and Sharper Images

Photographers constantly have the problem of simultaneously obtaining depth of field and image sharpness because it is always a trade-off. The sharpest aperture on the lens is typically two to three stops down from the maximum (largest) aperture on the lens. With a 200mm f/4 lens, for example, the sharpest apertures are in the f/8–f/11 range. Due to the laws of physics, though, the greatest depth of field is always at the smallest aperture (largest f/stop *number*), which is f/22 or perhaps f/32. In simple terms, these f/stops refer to a tiny hole in a lens that is called the aperture. As the hole the light passes through gets smaller, a larger percentage of the light touches the edge of the hole and bends. This bending of light is referred to as diffraction and causes a loss of sharpness. Diffraction is a far more serious problem than most photographers realize!

I recently tested the diffraction on my Canon 180mm macro lens for a new book—*Close Up Photography in Nature*. I was horrified by how bad it is at f/32. Even f/22 produced underwhelming results. Although the depth of field is optically greater at f/32, the image sharpness is far less than f/11 due to diffraction. Although photographer opinions vary, I feel that the f/32 stop is worthless on this lens and probably most other lenses as well. I am critical about sharp images, perhaps more so than most, so others may find f/32 acceptable. While it is undemanding for a lens maker to build this lens with an even smaller aperture, they do not do so because at f/45 everyone agrees the image is mush due to diffraction. I just happen to think "mush" happens long before that.

Barbara spent hours wrangling water drops and placing flowers to manipulate them to appear in the water drops. She did this indoors to eliminate all breezes, shot by window light, and used a photo background. Thirteen images were shot to cover the depth of field and these were combined with Zerene Stacker software. Canon 5D Mark III, Canon 65mm macro, ISO 500, f/8, 1.6 seconds, Cloudy WB, manual focus with a Kirk focusing rail and manual exposure.

Stopping the lens all the way down creates other problems. Shooting at f/32 requires a shutter speed three stops slower than f/11. Instead of being able to use 1/4 second at f/11, f/32 would require the use of 2 full seconds to produce the same exposure. This slower shutter speed becomes a problem when photographing handheld or fighting a persistent breeze blowing the subject. Smaller apertures have yet another serious problem, too. A small aperture not only increases the depth of field covering the subject that is often desirable, but a small aperture will bring background details that often cause unsightly distractions more in focus. And do not forget about flash. Stopping the lens down makes it more difficult for the flash to illuminate distant objects. Far-off subjects are not a problem in close-up photography, but it is a recurrent problem in landscape photography.

TILT/SHIFT LENSES

In addition to using impeccable technique, you would typically align the most important plane of the subject with the

The tulip fields at the Wooden Shoe tulip farm (www.woodenshoe.com) near Woodburn, Oregon, were exciting to photograph when the ideal weather conditions of bright overcast and calm winds prevailed. A Canon 24mm tilt and shift lens was used, but the lens was not tilted to coincide with the plane of the blossoms. Notice how the flowers in the rear quickly go completely out of focus. Canon 5D Mark II, Canon 24mm f/2.8 T/S lens, ISO 400, f/2.8, 1/2000 second, Shade WB, manual exposure and focus.

plane of the camera's sensor in order to achieve greatest sharpness. However, certain special lenses make aligning the plane unnecessary. Canon and Nikon offer several lenses that bend and shift. Lenses that bend are frequently called tilt lenses and they do amazing things. When the lens is tilted the precise amount and in the proper direction, it is possible to make the plane of focus align perfectly with the plane of the subject without having both of them parallel to each other. For example, it is simple to make a tilt lens sharply focus a field of tulips or wildflowers. Tilt lenses are incredibly effective for adjusting the plane of focus when the angle is not too extreme. We have used tilt/shift lenses for decades with excellent results.

Tilt/shift lenses, also referred to as perspective control lenses, are not meant for all photographers. Not only are they expensive, but also there is a learning curve to master to properly use them. The written instructions that come with the lens are difficult to comprehend because the instructions use too much math and diagrams. However, we find it is simple to show workshop clients how to use these lenses. Another problem is that focal length choices are limited and tilt lenses

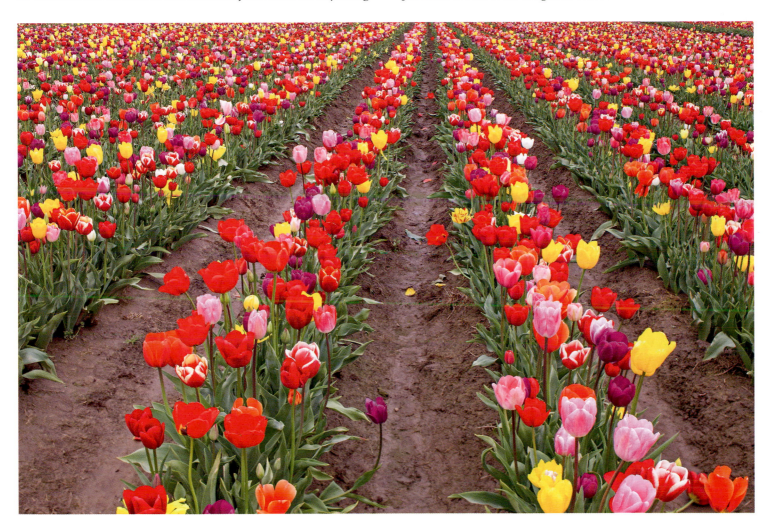

The Canon 24mm T/S lens was tilted a few degrees downward to make the plane of focus on the sensor coincide with the plane of the blossoms. By also stopping down to a modest f/13, instead of f/22, to keep the shutter speed fast, all of the blossoms are now in focus. Tilt and shift lenses are terrific for obtaining better depth of field. Because new focus stacking techniques are now used, T/S lenses are less necessary. Canon 5D Mark II, Canon 24mm T/S lens, ISO 400, f/13, 1/100 second, Shade WB, manual exposure and focus.

Thick frost crusted this cone and everything else in our yard on one frigid February morning. To get all parts of the tiny cone in sharp focus, Barbara shot twenty-four images by varying the focus distance and used Zerene Stacker to combine the images into one super-sharp image. Canon 7D, Canon 65mm macro, ISO 200, f/8, 1/4 second, Shade WB, Kirk focusing rail to change the focus between shots, manual focus and exposure.

Remember a total of twenty-four images were shot to create the focus stacked image. This is the first one in the series where the closest point—the frost on the twig—is sharply focused. Notice f/8 does not capture a great deal of sharpness.

The focus is midway through the stack and only a small area at the top of the cone is sharply focused.

The final shot of the stack where the frost furthest away on the cone is sharply focused.

only help increase sharpness in one plane. If you align the plane of focus with the flowers in a field, it is easier to get all of the blossoms sharply focused, but their stems are now more out of focus because the stems are in a plane that is nearly at right angles to the plane of the blossoms.

FOCUS STACKING TO THE RESCUE

Focus stacking enables you to achieve unlimited depths of field in all planes when using the sharpest apertures on your lens. For simplicity, remember that focus stacking requires you to shoot a series of images in which the focus slightly overlaps from one image to the next. The set or stack of images, in which a small slice of the subject is sharply focused in at least one of the images, is combined with focus stacking software. Specific stacking software aligns the images, selects the sharp portions in each image, and merges them into a single image so that everything that was in focus in at least one of the images is now pleasingly sharp.

This technique is beginning to become more widely known while the software for processing stacks of images continues to improve as photographers gain experience with it and offer feedback to the software gurus who create it. Focus stacking does not produce unrealistic images. It actually does what our eyes do when you view a scene. We see things in focus because our eyes instantly refocus on where we are looking. Unless you have vision problems, you live in a focused world. Your eyes are not limited to a single snapshot in time at a given aperture. Focus stacking solves the problem all cameras have because they must be focused on a certain spot with only a set amount of depth of field to cover it. By shooting a series of images where the focus is changed slightly between them, this wonderful technique enables us to capture unlimited depth of field.

FOCUS STACKING ADVANTAGES AND DISADVANTAGES

Major advantages:

- Easy to do
- Relatively inexpensive
- Offers unlimited depths of field
- Works with any lens that can be manually focused
- Sharply focuses all planes
- Enables keeping the background completely out of focus while the subject is entirely in focus
- Enables faster shutter speeds
- Helps distant objects to be lit by flash
- Produces images that are unique
- Fun to do.

Minor disadvantages:

- Important elements must remain motionless
- Works best on a solid tripod
- More time needed to shoot images
- Software required to combine images
- Focus rail recommended for higher magnifications.

SOFTWARE CHOICES

Several software programs perform focus stacking. The more recognized programs include Photoshop, CombineZM, Zerene Stacker (zerenesystems.com), and Helicon Focus (www.heliconsoft.com). We use Zerene Stacker and Helicon Focus and are partial to both. We process our focus stacks through both programs and then select the result we like best. Sometimes we like Zerene Stacker the best and sometimes Helicon Focus best, but most of the time we cannot see the difference, so we do not favor one over the other. Each software program offers ways to customize how it works to suit your specific needs.

THE FOCUS STACKING PROCESS

SELECT THE SUBJECT

A completely motionless subject is always best for this technique. Subjects that move, such as creeping caterpillars and flowers swaying in the breeze, do not work. Flowers, mushrooms, frost, lichens, frogs, or naturally chilled insects photographed on cool mornings all make excellent prospects. We regularly use a Plamp to hold the subject as still as possible in case the air is moving the least little bit. The Plamp

Jumping spiders are plentiful residents inside and outside our winter home near Twin Falls, Idaho. They are active even on cold winter days. Around freezing most spiders become sluggish. We spotted this jumping spider perched on some tree bark. Because the bark wasn't photogenic, we moved it carefully—they do bite—to this colorful stone. The spider held still for a few minutes, which allowed a focus stack of forty-eight images to be shot. Zerene Stacker and Helicon Focus both did an outstanding job combining these images. Nikon D4, Nikon 200mm micro lens, ISO 200, f/8, 1/2 second, Cloudy WB, manual focus and metering.

is attached to a small tripod (we use a $30 tripod lawn sprinkler) and the other end is attached to the object supporting the subject. Sometimes a little movement in the subject is not a problem. While Barbara was photographing a jumping spider on a rock outdoors on a cool morning, the spider raised a couple of its front legs. It wasn't a problem because she had already shot twenty-five images to cover most of the spider and was now focusing on its rear legs. The focus stacking software selects the sharp areas in each image. Since the legs that moved during the series of exposures were completely out of focus, the software ignored them and no leg movement was visible in the final result.

While focus stacking is outstanding for close-up and macro images, it also works for any subject that holds still. If you have a motionless animal—even an elephant or a flock of shorebirds resting on the beach—focus stacking works. Landscapes lend themselves to this marvelous technique, too. Imagine shooting in a slot canyon with a near foreground and more distant background. You are able to focus stack all of the way through the depth that needs capturing. You could even shoot HDR and focus stacking sets simultaneously and use focus stacking technique for panoramas. The possibilities are endless.

Focus stacking is incredibly useful in low light photography. If you are trying to shoot a sharp image of Delicate Arch in Arches National Park, eastern Utah, at dusk when the light is dim, a single exposure using f/22 (to get the near foreground in focus as well as the arch) at 8 seconds will be difficult. It is easier to shoot a focus stacked set of images using the sharpest aperture on the lens—f/8 for instance—because the image will have less noise at 1 second and f/8, than at 8 seconds at f/22.

Focus stacking empowers you to solve the depth of field problems in the landscape that cannot be solved either by stopping down or using the tilt mechanism found on some perspective control lenses. I still vividly remember trying to photograph the reflection of Yosemite's El Capitan in a park valley meadow three decades ago. If I focused on the reflection, the flowers surrounding the pool of water were severely

out of focus. If I focused on the flowers, the reflection became completely out of focus. I was never able to shoot them both as sharp as I wanted because the flowers and El Capitan are so far apart in distance that the depth of field from a single exposure could not cover it. Today, with focus stacking, it would be simple to capture. Focus on the flowers in the near foreground, select f/11, meter, and shoot. Next focus a little bit further away, perhaps on the far side of the pool, and shoot another image. Finally focus on the reflection in the pool and shoot another image. Run the focus stack of images through the software program to get both the flowers around the pool and the reflection perfectly sharp. It works like magic!

For years, I wanted to shoot lily pad patterns when they are surrounded by fall color reflections. If I focus on the lily pads and stop down to get all of them sharply focused (and they still are not perfectly in focus), the colorful reflections also show more detail and become distracting. My goal is to focus the lily pads sharply, but keep the reflections as out of focus swirls of color. If I shoot wide open, I get the swirls of color, but only some of the lily pads are in sharp focus because the depth of field is too limited. I have done some shots like those I envisioned by using a Canon 90mm tilt and shift lens. By tilting the lens and making the plane of focus coincide with the plane of the lily pads while shooting wide open, I was able to get the image I was seeking. Unfortunately, most of the lily pads require a longer focal length lens optically to reach them—since I can't walk on water. With focus stacking, you are able to use any lens— even a 300mm or 500mm—and shoot wide open. First, focus on the nearest spot you want in focus, and shoot. Then focus a little further in and shoot another image. Continue the process until the farthest spot that you want in sharp focus is in focus. Process the stack and all of the lily pads are in focus while the color reflections remain unfocused swirls of color!

EXPOSURE

Use manual exposure when shooting multiple images that will be combined into one. Do not allow the exposure to change in any way within the set of images. The ambient

The eroding sandstone on the east side of Miner's Beach at Pictured Rocks National Lakeshore is incredibly attractive, especially when a wide-angle lens is used close to the ground. Since the depth of field isn't capable of covering this scene when the lens is only a foot away from the foreground, two images were shot in which the focus was varied between the two. These images were combined with Zerene Stacker software. Canon 5D Mark III, Canon 16–35mm f/2.8 lens at 21mm, ISO 100, f/8, 1/6 second, Daylight WB, polarizer, manual focus and exposure.

Focus stacking is far more effective than a tilt lens when photographing the landscape because most landscapes have multiple planes that must be sharply focused. Tilting a lens only helps the sharpness in one plane. Focus stacking sharply captures all planes. This is a two-image focus stack. Munising Fall cascades over a cliff face, which is sharply focused. In the second shot, the tree is sharply focused and the waterfall isn't. To bring out detail in the maple tree in the foreground, I fired a flash to brighten it. Helicon Focus combined these two images to make the one shown here. Canon 5D Mark III, Canon 24–105mm lens, ISO 400, f/11, 1/6 second, Cloudy WB, manual focus and exposure, Canon 600EX flash with ST-E3-RT flash controller.

Use a polarizing filter to darken the blue sky and remove glare from the yellow aspen leaves. First determine the exposure. Second, focus on the aspens using continuous auto-focus on the back-button by pointing the single activated AF point at the trees. Press down on the button to make the lens focus on the aspens. When it does, then release the button to lock the focus. Next compose the image and make certain the horizon line is level horizontally. Shoot the first image. Now activate an AF point that corresponds to the rocks and press the AF control button to focus on the rocks. Shoot the second image. Now merge both images together with Helicon Focus or Zerene Stacker and everything is sharp. Canon 5D Mark III, Canon 24–105mm f/4 lens at 84mm, ISO 100, f/11, 1/15 second, Daylight WB, Polarizer, manual exposure and AF-Servo on the back-button control.

light or light from a flash must also stay the same. Set ISO 100 or 200 to minimize noise. What about the aperture or f/stop? Set the aperture somewhere between f/8 and f/11. This sounds counterintuitive because you might think you should stop down to f/22. Since the goal is to extend the depth of field, why not use f/22 or f/32? A good question—with a crucial answer! There is no point in stopping down to a small aperture to gain depth of field that will be covered in the stack of images only to suffer the image-softening effects of diffraction. The sharpest apertures on your lens are probably around f/8 to f/11. These "crisp" apertures produce excellent sharpness so they are the ones to use. Finally, adjust the shutter speed until achieving the optimum exposure as shown by the histogram and highlight alert.

FOCUS

Use manual focus. Autofocus modes are difficult to work with when you need a small focus change. Decide the spot where you want the sharp focus to begin. For example, suppose a jumping spider is quietly perching on a stone. Do you want all of the stone in the foreground to be sharp or only the stone slightly in front of the spider? It is your choice. You do not have to make everything sharp in the image—only those portions in which you want sharp focus. When you have determined the starting point for sharp focus, shoot the image using excellent technique—tripod, remote release, and mirror lock-up. Focus the lens a little deeper into the scene and shoot another image. Remember, the increment changes do not have to be exactly the same, but you do want some overlapping sharp areas between consecutive images. You may be wondering how we shoot it. We manually change the focus only enough *until we see it change* and then we shoot another image. Keep focusing and shooting deeper into the scene until you capture the furthest spot in which you want sharp focus. Some subjects with limited depth only require a few images and some demand fifty or more. We commonly shoot stacks of thirty to forty images when we photograph a small jumping spider or tiny flower blossom where we need magnification greater than life-size. Larger objects need fewer images to cover the desired depth of field. Remember that at any given aperture, the greater the magnification, the shallower the depth of field. This requires a larger image stack to sharply cover the depth.

FOCUSING STRATEGIES

We primarily use two methods to change the focus. Here's the first way. With our 100mm, 180mm, and 200mm macro lenses, we typically turn the focusing ring on the lens a little at a time between shots. It is quite natural to do and works well. Just be careful to avoid bumping the tripod-supported camera because it may cause a change in the composition and then the images will not align well—although most focus stacking software programs can align images if they are not too far out of alignment.

A focusing rail is a second and perhaps a better way to accomplish the focus changes. Mount the camera on the rail. Turn the knob to move the camera back and forth in as tiny an increment as needed. The focusing rail is by far the best way to work when you approach and exceed life-size (1x or 1:1) magnification. Indeed, with my favorite lens for high magnification images—the Canon 65mm macro—the focus rail must be used because this lens has no focus ring. Instead, the ring changes the magnification to cover the range of 1x to 5x. Some stack shooters think that one focusing method is better than the other. However, we have not yet found a reason to use one focusing method over the other as they both seem to work equally well. Making the focus changes is straightforward on the focus rail, but you must have one. It does take time to mount it on the tripod head and then attach the camera to it. We honestly like the Kirk FR-2 focus rail ($300) for being precise. Please go to www.kirkphoto.com for information. To summarize, there are two ways to change the focus:

1. Turn the focus ring manually on the lens.
2. Mount the camera or the lens's tripod collar, if it has one, on a focusing rail and change focus by moving both the lens and the camera back and forth along the rail.

LENS CHOICES

Focus stacking works with any lens for landscape as well as close-up photography. You could take a 70mm lens and focus on an arch in California's Alabama Hills and then focus on the Sierra Nevada Mountains far behind it and merge the two together. In close-up photography, any macro lens works nicely. To shoot especially high magnifications that are greater than life-size, use a shorter macro lens and focus it all the way out to 1x. Now add extension tubes to the optical system to reach magnifications greater than life-size. Some of you who have read our books and articles may be surprised that we do not automatically go to our long focal length macro lenses. Short macros are efficient at high magnification. The wide angle of view of a 50mm macro isn't that much of a problem because the depth of field at f/11 or any aperture is so tiny

We have been leading photography workshops inside Yellowstone National Park since 1995. During that time we have been to Artist Point at least one hundred times. Until 2013, we photographed this view of Lower Falls by stopping the lens down to f/18 and focusing on a tree in the foreground. The depth of field did not fully cover the scene and the sharpness was diminished by stopping down to f/18. We now use focus stacking to completely cover the depth of field and to make an overall sharper image. Wow, so much has changed! Six images were shot. The focus is varied from foreground to background and then merged into one final image with Helicon Focus to produce tremendous overall sharpness. Canon 5D Mark III, Canon 24–105mm lens at 98mm, ISO 200, f/11, 1/250 second, Cloudy WB, manual focus and exposure.

at life-size and greater that no object distractions will appear in the background because everything is completely diffused from being so far out of focus. The main problem might be bright spots from the sky. Find a shooting angle that allows you to capture a uniform color in the background.

PROCESSING THE STACK OF IMAGES

HELICON FOCUS

Using PhotoMechanic, I download the images from my CF card to a 1.5TB external hard drive. Next I open the Helicon Focus 5.3 software program. When the window opens, on the right side of the screen under *Run*, press the *Browse Folder Tree* icon. Find the stack of images that you want to process. When you select them, the images will appear in the window. If you shoot RAW and JPEG simultaneously as we do, then select all of the JPEGs or all of the RAW images by checking the box. Helicon Focus works easily with RAW or JPEG files. Press the *Run* button and the software takes a minute or two to process the images and this depends on how many images there are. Eventually, the image will appear that incorporates all of the sharp portions of each image in the stack into a single image showing tremendous depth of field. Name this file and then save it.

Under the *Parameters* button, there are three methods one can use to process the stack.

These methods include:

A. w.average
B. depth map
C. pyramid.

Some methods work best with certain images. For example, jumping spiders have lots of detail and method C will work best. I always run every stack through the depth map and pyramid options and decide from there. I tried the w.average option, but always preferred one of the other two, so I no longer use the A option. Options are available for adjusting some processing controls.

ZERENE STACKER

There are many excellent articles and tutorials about this software and image stacking on the Zerene Stacker website. We do not have space to go into detail in this book, but included here is a short description about how to process images. The images that make up your focus stack are your *Source* images. When you open the program, add the *Source* images to the list of *Input Files*. You can drag-and-drop the images with Windows Explorer or Macintosh Finder. Alternatively, you can add the images with *File > Add File(s)* in the Zerene Stacker menus. Now make a stacked image with *Stack > Align & Stack All (PMax)*. Last, save the result by clicking on *File > Save Output Image*.

Zerene Stacker offers another method to combine the images called DMap, so you can process the images both ways. PMax is very good at preserving fine detail, but it tends to increase noise and contrast and alters the colors somewhat. DMap does a better job of keeping the original smoothness and colors, but it isn't as good at finding and preserving detail.

Which software program is best?

We cannot declare a favorite because both programs give us excellent results. We did an abundance of focus stacking for our new book—*Close Up Photography in Nature*—and used processed stacked images from each program. The worst part for us is viewing all of the images we have taken in the past that could have benefited tremendously from focus stacking had we only been using it sooner!

CONCLUSION

Focus stacking facilitates your ability to obtain far more depth of field and overall sharper images than previously possible. It is simply astonishing to have such enormous control over the depth of field. Although photographers tend to use focus stacking to get everything sharp, it also works the other way. Now you can use focus stacking to photograph a flower with lots of depth and get everything sharp. But, if you stop shooting the stack at the back edge of the flower, the background remains completely out of focus, which is usually just what

Focus stacking is effective for limiting the depth of field, too. To isolate this blossom against the cactus pad immediately behind it, Barbara shot using f/4.5 for a shallow depth of field. The background is nicely blurred, but a single shot at f/4.5 does not sharply record the entire blossom. Therefore, she shot a six-image stack of images at f/4.5 and changed the focus slightly between images to fully cover only the blossom. Using Zerene Stacker, she merged the six images together to make a sharp overall image of only the blossom while leaving the background pleasingly out of focus. Nikon D4, Nikon 200mm f/4 micro lens, ISO 400, f/4.5, 1/8 second, Cloudy WB, manual metering and focusing.

you want. Indeed, the background is far more out of focus than it would be if the flower were shot with a single exposure at f/22.

Although most photographers use focus stacking primarily for close-up photography, it is incredibly useful in all types of photography anytime it is possible to shoot multiple images of a still object. We frequently use focus stacking for landscapes. And we can visualize situations in which it is possible to use it in wildlife photography when the animal is motionless. Hopefully, future cameras will offer built-in focus stacking and allow you to program the camera to automatically shoot stacked sets of images. It would be phenomenal if the number of images and the incremental changes in focusing could be set as well. Focus stacking does work with our tilt/shift lenses as well. Consider a field of tulips. Tilt the lens so the plane of focus coincides with the plane of the flower blossoms. The stems go more out of focus because the plane of focus of the stems is nearly at right angles to the plane of the flower blossoms. Now focus stack your way through the stems to record them sharply up and down. Finally, merge all of the images together for the ultimate in overall sharpness.

Over time, new uses for focus stacking will surely surface. Focus stacking is one of the most useful techniques that have become available during our forty-year photography careers. Do not be left out! Go to the Zerene Stacker and Helicon Focus websites, view the tutorials and download the free trial software. Search the Internet for "focus stacking" articles, tutorials, and picture examples. Get started now and you will surely have fun!

Winter brings snow and ice to our home. We still enjoy photographing plants, so Barbara bought this poinsettia to use as a subject and photographed it indoors with soft window light. To capture all of the depth in the subject and achieve the ultimate in image sharpness, thirty-one images were shot where the focus was varied slightly between them. This series of images (stack) was assembled into one with Helicon Focus software. Nikon D4S, Nikon 200mm f/4.0 micro, ISO 100, f/18, 1/2 second, Cloudy WB, manual focus for thirty-one images and the manual exposure mode.

The Magic of Light

Every photographer we know is convinced they are able to see the light. By watching thousands of clients shoot in the field and viewing untold images that are brought from home, in truth we know most shutterbugs really do not "see" the light. They see only when there is adequate light to photograph, but they simply do not comprehend the way the color of the light, the direction of the light, and the contrast in the light work together to produce truly photogenic light that consistently results in beautiful images.

I was lucky in two ways early in my photo career. First, by my early twenties, I already knew that my passion was photographing natural things. Forty years later, that passion has only intensified! Second, Larry West and John Shaw, my first and only photo instructors in the mid-1970s in Michigan emphasized light repeatedly. I made it a habit to always photograph a subject when the light was superb, or I modified the light with a diffuser, reflector, or flash to make it far more suitable for good images. If the light is unattractive and I cannot make it better, then I do not shoot pictures. Instead, I use the time to scout for subjects and plan to revisit them when lighting conditions are optimum. Shooting only with exquisite light is a sure-fire way to capture many gorgeous images.

Mastering the exceptional shooting habits explained in this book is crucial for success. Learn your camera gear well and use it efficiently. Sometimes fabulous light lasts for lengthy periods of time, but, at other times, spectacular light is fleeting. Should a rainbow suddenly appear in your landscape, you may only have seconds to capture the colors before a cloud blocks the sun and the rainbow fades away!

The pink-hued clouds at sunset contrast beautifully with the blue tones of the snow encasing these Lodgepole Pine trees along the boardwalk through Midway Geyser Basin in Yellowstone National Park. The trees are bent and twisted from the snow and dense frost because the steam from warm springs continually adds new frosty layers. Nikon D300, Nikon 18–200mm lens, ISO 640, f/13, 1/200 second, Sun WB, manual metering and AF-C autofocus with back-button control.

Most landscapes photograph best when the light is dim, either early or late in the day, on a cloudy day, or even at night. Bright undiffused midday sun is usually unfavorable for most scenes because the contrast is too great and the color is undesirable. The Milky Way is framed with the cattails at the bottom and a large aspen tree on the left. Nikon D4, Nikon 14–24mm f/2.8 lens, ISO 3200, f/3.2, 20 seconds, 3700K WB, manual metering and focusing.

THE QUALITIES OF LIGHT

QUANTITY

The amount of light is what most photographers notice first and that is what they "see." If the light is bright enough, they know it is possible to shoot images. If the ambient light is dim, consequently they can't shoot images. The quantity of light isn't much of a limiting factor anymore. The qual- ity produced by high ISOs such as ISO 1600 and ISO 3200 nowadays allows you to photograph action while shooting in quite dim light. On a tripod, you can make fine landscape images by moonlight and even capture the millions of stars that make up the Milky Way. No matter how dim the ambi- ent light, you can always find subjects to photograph. Even if the ambient light is almost non-existent, you can always use flash to shoot images.

There are times when the ambient light is too bright for your photo purposes. If you are trying to show the motion of flowers blowing in the breeze or waves crashing on the beach, bright overcast or direct sun is too bright to allow the slow shutter speeds necessary to show motion. It is possible to use a variable neutral density filter to reduce the ambient light enough to be successful. It is undemanding to plan to be at a spot when the ambient light is sufficiently dim by arriving a little before dusk. Obviously, as the sun sets, the light diminishes to the point when long exposure times become necessary.

COLOR

Ambient light varies considerably in color. Everyone knows sunlight is redder early and late in the day when the sun hovers low in the sky. The visible light spectrum is made up of red, orange, yellow, green, blue, indigo, and violet. The longer red and orange wavelengths penetrate more of the atmosphere when the sun is near the horizon. The shorter wavelengths of green through violet do not penetrate the dirt particles and water molecules too well and most are filtered out of the light. Since the sunshine is made up of a preponderance of red light at dawn and dusk, the light has a strong reddish tint to it, which is beautifully photogenic for many subjects—though not all. Red light is superb to photograph mammals, mountain landscapes, farm scenes, and considerably more, but terrible to photograph blue subjects such as bluebonnet wildflowers.

Overcast days may be bright or dark, depending on how thick the cloud cover is at the time. In both cases, clouds tend to scatter blue light, so the light takes on a slightly blue cast that appears in your images. As you look at the subject in blue light, you may not see the blue colorcast as our brains modify the look of what we see because human skin isn't blue. However, your camera captures the excess blue light and it actually appears in the image. Imagine a fine bright sunny June day! The sky is cobalt blue and the sunshine on the subject produces neutral colors—neither too blue nor red. Why is the sky blue? Dust particles and water molecules scatter much of the blue, indigo, and violet rays of light because these short wavelengths do not penetrate obstacles effectively. This scattered light reflects in all directions. Some of it strikes the earth and your eyes. The sky is blue because the light it reflects is primarily blue in color. Therefore, should you photograph anything in the shade, especially open shade in which there are no overhead obstacles, such as a tree canopy, to block the light, the ambient light does have a pronounced blue unpleasant colorcast. Fortunately, there are simple ways to conquer it.

The color of your surroundings dramatically affects the colors the camera captures. Photograph a white mushroom in a green beach-maple forest during summer and you will notice a strong green colorcast in the image. Leaves are green because they primarily reflect green light while absorbing other colors. A red barn reflects red light, a yellow American goldfinch reflects yellow light, and a white ring-billed gull reflects all colors to produce white light. The color of the light and the subject combine to produce colors that the camera sensor captures. For this reason, we prefer using the RGB histogram built in our camera to avoid overexposing an important color. The most difficult situation for the camera's sensor is a colored subject that matches the color of the light illuminating it. A red barn in the red light of dawn, a green flower in the green light of a summer forest, or a patch of blue flowers in the blue light of open shade are all situations where it is easy to overexpose the prevailing color with an averaging histogram. If you use the RGB histogram, you will immediately see when a primary color—red, green, and blue—is overexposed. Reduce the exposure to compensate.

White Balance Controls

Digital imaging offers numerous advantages. One benefit includes being able to change the colors in your images using camera settings called White Balance. The options vary among cameras. Different makers may use varying names for the same thing. Most cameras offer the following choices: Auto, Daylight (Sun), Cloudy, Shade, Tungsten, Fluorescent, Flash, Custom White Balance, and Color Temperature. These

Grasshoppers are lethargic on cool dewy Michigan mornings. The light in the shade has a strong blue colorcast, which is undesirable for this warm-toned grasshopper. Canon 7D, Canon 180mm f/3.5 macro lens, ISO 100, f/16, 1/2 second, Daylight (Sun) WB, manual focus and metering.

The Shade white balance option adds yellow to the image, which reduces the blue colorcast making this grasshopper more naturally colored. The only change to the shooting data is the Shade white balance option.

selections allow you to modify the color of the images captured by your camera at the time they are shot rather than changing it later with software.

JPEG vs RAW

There is no wrong answer because it depends on your needs. A RAW image is simply an image data file that contains all of the data the sensor collected and contains largely unmodified information collected by the sensor. True, the original photons of light the sensor measures are analog data digitized (turned into numbers) by the camera's on-board analog-to-digital converter, but the white balance choice does not modify the colors. A JPEG starts as RAW data, but the camera processes the data by adjusting the colors, sharpening the image,

perhaps applying picture styles, and then finally shrinking the data down by discarding much of them to produce an 8-bit image that can be read by everything. RAW files require proprietary software to view them. They keep all of their data so they are much bigger files that offer the greatest opportunity to adjust with image processing software.

If RAW is largely unprocessed data, and you shoot only RAW, how is it that you can see the image on the LCD display as soon as you shoot? All RAW files contain a small embedded JPEG so you can see the image, generate a histogram, and allow the highlight alert to function. Setting in-camera processing parameters—picture styles and white balance choices—does affect the embedded JPEG, but not the RAW data file. Since the image displayed on the camera's LCD is derived from a JPEG, white balance does also affect the histogram and the highlight alert somewhat.

Does it matter whether you shoot RAW or JPEG? Yes, but it also depends on your needs. If you want the images already processed because either you do not have time to process them yourself and/or do not want to learn how to do it, then JPEG is perfect for your needs. JPEGs are smaller files so they take up less space on the camera's memory card, fewer data are quicker to load to the computer, and the camera's buffer is less likely to fill up, so you can shoot longer bursts of images. Photographers who demand the best image quality and greatest processing flexibility prefer RAW. Serious fine-art printmakers customarily want to start with RAW data. If you occasionally want both RAW and JPEGs of the same image, then most cameras allow you to set *RAW + JPEG*. That is what we do, although, we are considering the use of RAW only. It is easy enough to change the RAW image into a JPEG. Every image printed in this book began as a RAW file. Barbara processes the image with Photoshop and then converts it back to a JPEG for use in the book. Barbara does not start with a JPEG because if it is overly processed it tends to pick up artifacts.

Picture Styles

Your camera may offer a way to affect the overall color balance of your images. Canon calls these picture styles. For example, the Canon 5D Mark III offers six picture styles: Standard, Portrait, Landscape, Neutral, Faithful, and Monochrome. These settings do not change the RAW data, but they do change the appearance of the JPEG image. That includes the embedded JPEG in the RAW file. The appearance of the image will be different, even if the camera is set to RAW only. Nevertheless, for purposes of deciding what images I wish to keep or discard, I like my JPEGs to be attractive. Therefore, I tend to use the Landscape Picture Style because greens and blues appear more vivid. Picture Styles will affect the resulting histogram, but the change in histogram data position isn't great and is nothing to worry about.

Choosing the White Balance

Auto

The camera will automatically adjust the white balance for the prevailing light by neutralizing colorcasts. Many photographers who shoot only RAW and plan to adjust the colors while processing RAW images leave their cameras set to Auto. This approach eliminates the need to switch to different white balance settings. The RAW file allows one to adjust the colors in the image significantly with no loss of quality!

Daylight (Sun)

Choose this Daylight WB when photographing in direct sunshine to match the light better. If the sunlight is red, then you will get this usually desirable colorcast in the image.

Cloudy

The light has a bluish colorcast on an overcast day because the clouds scatter a high proportion of blue light. To reduce the excess blue in the image, set Cloudy WB. The camera adds yellow, neutralizing the blue.

The vintage tractor driving across the tulip field at the Wooden Shoe tulip farm benefits from using the Sun (Canon calls it Daylight) white balance option to avoid colorcasts because the ambient light is from a warm-colored light source—the sun. Nikon D4, Nikon 14–24mm f/2.8 lens, ISO 400, f/16, 1/250 second, Sun WB, manual metering and autofocus on the back-button control.

Shade

On a sunny day, the light in the shade is considerably blue because shady spots are illuminated primarily with reflected blue light from the sky. Set the white balance to Shade to make the camera add even more yellow than the Cloudy WB option to neutralize more blue light.

Tungsten

Household lamps tend to have a reddish colorcast. Tungsten reduces the red, but this WB choice isn't widely used by outdoor photographers.

Fluorescent

Use the Fluorescent option when shooting under fluorescent lights to minimize the green that prevails with this light source.

Flash

Electronic flash may have a slightly blue colorcast. To reduce the blue, set the Flash WB. Some flash units have a yellow-filtered flash tube to eliminate the colorcast. The Flash WB option is very similar to the Cloudy WB.

Custom White Balance

If you shoot JPEGs only, then this Custom white balance option is your best choice for getting the most realistic color. The process varies from one camera to another, but they all set it in a similar manner. Set the camera to Custom WB, photograph a white sheet of paper in the same light as the subject, select the image of the white paper, and the camera analyzes the white paper target and neutralizes any colorcast that is present. When the light is too blue, the camera creates a Custom WB to eliminate the excess blue from the image. If the light is too green, it removes that color. When you photograph a white flower on a cloudy day in the green forest, multiple colorcasts are present. The light is too green from the leaves and too blue from the overcast. Using the Cloudy WB will reduce the blue colorcast problem, but merely warms up the green colorcast. Custom WB neutralizes both colorcasts at the same time!

If you move to another location where the colorcasts in the light are different, repeat the process of photographing the white paper and selecting that image to create a new Custom white balance. We do not use Custom WB very often because it is time-consuming and we would have to carry a white piece of paper with us. Since we shoot RAW, it is simple enough to adjust one or more colorcasts with software. We do not worry about the JPEG we capture simultaneously. If we shot only JPEGs, however, then we would use Custom WB frequently.

Color Temperature

To regularly use this option you need an expensive color temperature meter. Perhaps that is the reason many cameras do not offer it. If you have the Color Temperature WB option and desire red sunrises or sunsets, follow this procedure: Set the Color Temperature WB. When you do, it allows you to set the color temperature. Dial in the highest value possible. On my Canon cameras, it is 10,000K. Use this color temperature to add an abundance of magenta to the images. It truly pops the red colors in sunrise and sunset images.

We did indeed find a use for the opposite end of the scale when we photographed the San Xavier Mission near Tucson,

Yogi and Barbara are dramatically silhouetted in their kayak on Pete's Lake one brisk autumn morning near Munising, Michigan. The thick fog makes all of the highlights white. To add some pinkish tones, the Kelvin (K) white balance option is selected and then 10,000K is set. The pink can be increased in post-processing, but we prefer to do it in the camera. Some cameras do not offer the Kelvin white balance option. In such cases, use the Shade WB. Canon 1D Mark III, Canon 70–200mm lens at 168mm, ISO 400, f/16, 1/500 second, 10,000K WB, manual exposure and AI Servo AF on the back-button control.

Warm-colored lights from nearby Tucson, Arizona homes and passing cars generate a sickly yellow colorcast on Mission San Xavier del Bac. I pondered how to neutralize the intense unwanted yellow when Barbara figured out the solution. I was beginning to arrive at this answer on my own, but Barbara—as usual—was thinking a few minutes ahead of me. How do you think the yellow light problem was solved in the camera? Canon 5D Mark III, Canon 70–200mm f/4 lens at 122mm, ISO 1600, f/6.3, 25 seconds, Cloudy WB, manual focus using live view and manual metering.

Instead of using the Cloudy WB and making the light even more yellow, Barbara set the Kelvin (K) white balance option and dialed in 2500K. We frequently use the 10,000K white balance option to enhance the red skies of sunrise and sunset. Now to subdue light that is too warm, we discovered setting 2500K accomplishes the job quite adequately. Switching to 2500K is the only change I made from this version and the previous yellow one that is far too yellow.

Arizona. We were shooting the mission at midnight with the stars' trails behind it. Passing cars on the adjacent road weakly illuminated the white church with their headlights from time to time. This yellow light produced a sickly amber colorcast in the church. While I was trying different white balance presets, Barbara quickly found that using the K white balance option and setting it to 2500K produced wonderful colors. To summarize: use high K values in the 8000 to 10,000 range to make the light redder. To reduce warm colorcasts, set the K white balance to a smaller number, such as 2500K, to neutralize warm colorcasts.

LIGHT DIRECTION

Front Light

The light comes from the direction of the photographer and strikes the subject. This light direction is inherently low in contrast because the shadows fall behind the subject, making

Clepsydra Geyser is a photographer's delight because it continuously erupts and remains in what geyser experts call a constant "wild phase." Late afternoon sun pleasantly side-lights the Yellowstone National Park geyser, which reveals depth because some shadows are visible. A steady and helpful south breeze blows the water and steam north allowing the geyser's cone to be visible. Canon 1DS Mark III, Canon 70–200mm f/4 lens, ISO 200, f/4.5, 1/3000 second, Cloudy WB, aperture-priority with exposure compensation set to +.7 EV, autofocus on the cone of the geyser using back-button control.

The sow coastal brown bear nurses her cub at Hallo Bay, Alaska, in late evening light. The soft back light gorgeously highlights the fur rimming the bears with a warm glow. Nikon D4, Nikon 200–400mm f/4 lens at 320mm, ISO 1250, f/10, 1/640, Sun WB, manual exposure and AF-C on the back-button focus control. Note: AF-C means continuous autofocus on a Nikon camera.

them mostly invisible to the camera. Front light is good for showing subject colors and shapes because shadows do not obscure anything. However, the low contrast light is undesirable for showing texture because some shadows are needed to reveal surface texture. The most common light used is front light. As a result, photographers who use it will produce less dramatic images. Although front light is more popular, backlight and sidelight always produce more spectacular images when those choices are appropriate for the subject.

Sidelight

This light strikes the subject at an angle to the camera. Light coming from the side is excellent for showing texture and details in countless subjects. For instance, sand dunes photograph best with the early morning or late evening sunshine that hits the dunes at an angle to the photographer because the sidelight creates soft shadows that nicely highlight the undulating lines in the dunes. The texture in butterfly wings readily shows when the butterfly is slightly underexposed with the ambient light and the flash is aimed at right angles to the camera–subject axis to skim the light across the wings.

Sidelight is a gorgeous light when the subject has texture and the contrast isn't too great. Often, flash or reflectors can be used to reduce excessive contrast.

Backlight

Light direction comes from behind the subject. Successful photographers frequently use gorgeous backlight to capture stunning images. Beginners tend to forget to use it because it does take a while to perceive the possibilities of backlight. All subjects that are translucent or have hairy or fuzzy edges work well with backlight. Shadows created by backlight falling on the side of the subject facing the camera tend to increase the contrast greatly. Fortunately, digital capture, especially when using RAW, handles high contrast reasonably well. You can use flash, reflectors, and HDR techniques to manage and subdue high contrast. Another possible problem is that backlight comes directly at the lens, and even using a lens hood may not eliminate flare caused by the light hitting the front glass directly.

Backlight tends to cause high contrast, so it doesn't work as well with dark subjects because a dark backlit subject with a light background is often too high in contrast. Conversely, light subjects, mountain goats or gulls for example, photograph beautifully when backlit against a darker background. The white fur of the goats, even though in the shadows, still reduces the inherent contrast.

Cross Light

Cross light comes from two main directions and crosses at the subject location. It is incredibly effective with smaller subjects from a great-horned owl to a tiny insect at twice life-size magnification. We use it frequently and with great success. Find a subject that is nicely backlit. The side facing you is the shadowed side. Now use a flash or reflector to illuminate the shaded side of the subject. When properly exposed, you still get the gorgeous rim lighting from the backlight while the second light nicely fills in the shadows to lower the contrast and sometimes provide a catch-light in an animal's eyes. Since a

reflector or flash is typically required, it is only possible to light objects that are not too large.

Diffused

Since the light comes from all directions, this light is somewhat similar to front light because it is very low in contrast. Diffused light is the typical light you find on a dark cloudy day, but it is present in shaded spots, too. It doesn't reveal texture well at all but does show overall shape and color because nothing is lost in the shadows. It is quite easy to add contrast by using flash, which helps reveal texture. Underexpose the ambient light a small amount and properly expose the subject with a flash that is held to skim the light across the subject.

CONTRAST IN THE LIGHT

A bird that is photographed in high noon sunshine is high in contrast because the top of the bird is lit with bright sunlight while the bottom is in shadow. The difference between the sunlit portion and the shadows will easily exceed three stops of light. The contrast tends to appear harsh when viewed in the image because if the highlights are well-exposed, the shadows may suffer from a lack of color and detail. If the shadows are beautifully exposed, then the sunlit portions of the bird are overexposed and lack color and detail. The light must have less contrast in order to successfully capture color and detail everywhere in the bird. Fortunately, you can often control high contrast with photo accessories or software.

Diffuser

If the subject is fairly small, putting a white diffuser between the sun and the subject will instantly diffuse the light and lower the contrast. Be sure to keep the diffuser out of the background in your image and diffuse the light on both the subject and the background. If you diffuse the light on the subject while the background remains in bright light, the background will be overexposed unless you use HDR or use a flash to light up the subject.

Anise Swallowtail butterflies regularly visit our flower gardens. The bright overcast light softly illuminates the butterfly without causing troublesome high contrast. Canon 5D Mark III, Canon 180mm f/3.5 macro lens, ISO 200, f/18, 1/5 second, Cloudy WB.

While photographing this butterfly, a weak shaft of sunlight beautifully rim lights this handsome creature. The sunlight behind the butterfly and the overhead cloudy skies lighting the front of it work together to provide a pleasing cross light. The natural cross light lasted only a minute before once again the sunlight became thoroughly diffused by dense clouds. Canon 5D Mark III, Canon 180mm f/3.5 macro lens, ISO 200, f/18, 1/6 second, Cloudy WB.

Brilliant sunshine warms the skin, but the contrast in the light is usually detrimental to making attractive images. Observe the overexposed highlights in the Claret Cup cactus spines and the glare on the blossoms. Canon 5D Mark III, Canon 180mm f/3.5 macro lens, ISO 100, f/16, 1/25 second, Daylight (Sun) WB, manual exposure and focusing.

A dense white sheet nicely diffuses the harsh sunlight to produce a light that is much lower in contrast. This allows the camera's sensor to record detail everywhere easily. Diffusing the light does indeed change the white balance from the warm color of sunshine to a bluish colorcast. Therefore, to compensate for the excess blue in the light when the Claret Cup cactus blossoms are diffused, the white balance is changed to the Shade WB option. Canon 5D Mark III, Canon 180mm f/3.5 macro lens, ISO 100, f/20, 1/4 second, Shade WB, manual exposure and focusing.

Reflector

The Photoflex 5-in-1 MultiDisc is excellent for modifying the light. The product works especially well because it has four different colored reflecting surfaces and a white diffuser all contained in one compact package. We like the 22-inch size for packing, but the 32-inch size works better for shooting images when we need a diffuser. The disc has a bendable metal frame and folds up to a small size for convenient packing. The colored fabric surfaces include soft gold, gold, white, and silver. We normally prefer the soft-gold side, which is a combination of silver and gold, since the warmer reflected light looks appealing on most subjects. If we do not want to warm up the light, though, then the white side works perfectly. It also has a built-in white translucent side that doubles as a useful diffuser.

Bounce the light off the reflective surface by angling the reflector until you are able to see the shaded side of the subject begin to brighten. Adjusting the reflector angle slightly gives you some control on the amount of reflected light striking the subject. You may also change the distance between the reflector and the subject to adjust light output. Reflectors are simple to use and effective when the ambient light is reasonably bright. If the light is dim, then it is more difficult to reflect enough light to do the job. In such cases, it is better to use a flash.

Electronic Flash

Flash is incredibly useful, precise, versatile, and tremendously underutilized by most photographers! Think of the flash as a small sun that is eager and able to deliver light any time you need it. Use fill flash to lower the contrast. The procedure is not complicated. Determine the ambient light exposure first using the histogram. The dark shadows remain dark. Now set the flash to a minus compensation, −1 flash exposure compensation (FEC) is a good place to start, point the flash at the subject and shoot. Look at the image and scrutinize the shadows. If the shadows are now too light, reduce the flash output by setting −1.7 FEC and try again. If the shadows are not light enough, then set zero compensation and shoot

again. Usually in two or three shots you'll arrive at the correct amount of flash that pleasingly reduces the contrast by adding light to the shadows without overdoing it.

HDR

High Dynamic Range imaging (HDR), covered in Chapter 4, works perfectly well for lowering the contrast of motionless subjects. Shoot a series of images in which the exposure is varied by at least one stop, but not more than two stops of light, and combine the different exposures with HDR software. Some cameras offer built-in HDR capabilities.

Photoshop's Shadow/Highlight Controls

Photoshop has a marvelous tool that will precisely adjust the shadows and highlights in your images independent of each other. It is so effective that routinely it is not necessary to shoot a series of images with different exposures. Now, when the contrast isn't too extreme, a single image can be adjusted with software to lower the overall contrast, allowing detail in both the shadows and the highlights. Less expensive and easier to use software such as Lightroom also offers these adjustments.

Graduated Neutral Density Filters

These filters are various densities of gray on one-half of the filter and clear on the other half. Graduated neutral density filters are used to lower the contrast in landscapes. If the sky is bright and the foreground shadowed, place the dark-half side of the filter over the bright sky and the clear side over the dark foreground to lower the dynamic range of light and capture good color and detail through the scene. These filters still have many devotees and deservedly so, but HDR and other solutions are making neutral density filter use less appealing and far less necessary. We no longer use them, preferring HDR or balanced flash to reduce the contrast.

Polarizing Filters

The blue sky is often too light compared to the rest of the scene. Use a polarizing filter to remove polarized light in

the sky and to darken it. The sky is not uniformly polarized. A polarizer will not significantly darken the sky when you are shooting toward the sun or directly away from it, but it will have an immense effect when you are shooting at that portion of the sky that has the greatest amount of polarized light.

To locate that region of polarized light, point your finger at the sun and form a right angle with your thumb. Rotate your hand both ways to draw an arc while keeping the finger pointed at the sun. The arc that your thumb points at is the area of the sky with the most polarized light and where the polarizer will have its greatest effect.

Glare off shiny subjects, especially when wet, causes high contrast problems. Polarizers are quite useful when photographing ponds, lakes, and oceans. Use a polarizing filter to remove this glare. Generally, glare is polarized light and easily removed with the filter, but glare on metal is not polarized and can't be removed with the polarizing filter. Remember to

buy a good polarizing filter brand such as B + W or Hoya, and turn the filter on the lens to see when the sky darkens or the glare minimizes. If you set the polarizer for a horizontal composition, remember to turn the polarizer when you recompose to make the scene a vertical, or the polarizer will not remove the polarized light.

BOTTOM LINE

Photographing anything in light that is inherently unsuitable for the subject produces plenty of dreadful images. Your images will improve dramatically when you spend your time shooting attractive subjects when they are beautifully bathed in splendid light using techniques that deliver sharp images! In other words, do not shoot in horrible light unless you are able to modify the light to make it photogenic.

Kenya's Samburu National Park is a good place to photograph the uncommon greater kudu. This stunning buck posed beautifully in the late evening light. Canon 7D, Canon 500mm f/4.0 lens, Auto ISO 800, f/7, 1/250 second, Cloudy WB, shutter-priority exposure mode with Auto ISO, continuous autofocus on the back-button control.

Close-up and Macro

A close-up image can be many things. A tight shot of the face of a horse is certainly a close-up image, but its face covers quite a large area. Generally, photographers consider close-up photography to be frame-filling images of fairly small subjects. Close-up photography is loosely considered to be photographing anything between one-tenth and life-size magnification, which is also written as 1:1 or 1x. When the magnification is greater than life-size, most photographers use a special name for this range: macro photography. However, this distinction is arbitrary and seems unnecessary to us as the techniques and equipment used to do both are essentially identical. Perhaps the reason there is a dividing point at life-size is most macro lenses stop at life-size magnification. To shoot greater than 1x, additional equipment is needed.

MAGNIFICATION DEFINITION

Magnification is the ratio between the subject and its image size on the sensor. It is equal to the image size divided by the subject size. If the subject is 10 inches wide in real life, but its size on the camera's sensor is only 1 inch, the magnification is 1 inch/10 inches = 1/10x. If the subject is 1 inch wide in real life, and .5 inch on the sensor, it means the magnification is the image size/subject size = .5 inch/1 inch = 1/2x or half life-size. Anytime the size of the subject equals the size of its image on the sensor, the magnification is life-size. Should the image of the subject on the camera's sensor be twice as large as the subject, then image size/subject size = 2x or twice life-size. Let's not

Sulfur butterflies are readily attracted to flower blossoms. We think their tall antennae and bulbous compound eyes make them look comical and we speculate over what they think of us. Nikon D4, Nikon 200mm micro lens, ISO 200, f/32, 1/5 second, Cloudy WB, manual focus and exposure.

This sleeping Pearl Crescent butterfly allowed me to demonstrate magnification. Neither image was cropped in the printing process. The butterfly was photographed with the macro lens set precisely to 1/2x or half life-size magnification. This indicates the image of the butterfly on the camera's sensor is one-half the size of the actual butterfly. Canon 5D Mark III, Canon 180mm f/3.5 macro, ISO 100, f/16, 1/2 second, Cloudy WB, manual focus and metering.

Now the Pearl Crescent butterfly is shot at precisely life-size, 1:1, or 1x magnification—utilizing three different ways to write it. The image of the butterfly on the sensor and the actual butterfly are exactly the same size. Notice the butterfly fills the frame far more when shot at 1x magnification, showing that the size difference between 1/2x and 1x is greater than you might expect. A Canon 580 II flash was used with FEC +.7 stops to optimally expose the butterfly and leave the background darker. Canon 5D Mark III, Canon 180mm f/3.5 macro, ISO 100, f/16, 1/2 second, Cloudy WB, manual focus and metering, Canon 580II flash and ST-E2 flash controller.

get too specific about the numbers. You rarely need to know the precise magnification you are using.

WAYS TO FOCUS CLOSER

Lenses have a focusing ring that allows you to focus between infinity and some closer distance. This distance varies from lens to lens. For example, the Canon 200–400mm lens focuses down to 6.56 feet—the minimum focusing distance—and no closer. The magnification at 400mm at 6.56 feet is only .15x, which simply means you cannot fill the frame with a 2-inch wide butterfly. All lenses have a minimum focusing distance, so how do you focus closer to achieve higher magnification? Fortunately, there are a multitude of ways to enter the realm of close-up photography. Let's look at them.

MACRO LENSES

Camera makers offer specially made lenses that focus closer than most regular lenses and reach a magnification up to

1x by merely focusing closer. They are specially made to be optically super sharp when used at close focusing distances. These lenses are ideal for close-ups and with accessories they can easily reach the macro range, which is greater than life-size magnification. Here is a short list of current macro lenses from which to choose:

Canon 50mm/2.5	Pentax 50mm/2.8
Canon 65mm/2.8	Pentax 100mm/2.8
Canon 100mm/2.8	Sony 50mm/2.8
Canon 180mm/3.5	Sony 100mm/2.8
Nikon 60mm/2.8	Tamron 90mm/2.8
Nikon 105mm/2.8	Tamron 180mm/3.5
Nikon 200mm/4.0	Tokina 100mm/2.8
Olympus 50mm/2.0	Sigma 180mm/2.8

Scan the list carefully. Notice there are many macros in the 50mm, 100mm, and 180mm focal length range. Which one do you choose? The longer focal length macros in the

The angle of view determines how much of the background is covered by the lens. The short focal length used here captures the yard, wooden fence, aspen forest, and the sky all at the same time. Including the chaotic background, draws attention away from this handsome silver-bordered fritillary butterfly. Therefore, we think the background and focal length are undesirable. Canon 5D Mark III, Canon 24–105mm f/4 lens at 45mm, ISO 200, f/16, 1/4 second, Cloudy WB, manual focus and exposure.

The Canon 180mm macro lens "sees" far less background than a shorter focal length. The 180mm lens isolates the butterfly against an uncluttered green background. Having details in the background isn't always undesirable, but in most cases a background free of distractions is desirable. For this reason, we shoot the bulk of our close-ups with the Canon 180mm macro or the Nikon 200mm f/4 micro lens. Canon 5D Mark III, Canon 180mm f/3.5 macro lens, ISO 200, f/16, 1/2.5 second, Cloudy WB, manual focus and exposure.

180–200mm range are heavier, more expensive, and bulkier than the shorter macros. Therefore, it is not surprising that many photographers choose a macro in the 50–100mm range. Is that a good idea?

Long Macro Lenses

For serious close-up photography, the longer 180mm and 200mm macro lenses are far superior for most applications. The 180mm and 200mm macros offer a narrow angle that captures a small field of view. These macros make it effortless to isolate a stunning subject against an uncluttered homogeneous background without distractions. Longer lenses provide more working distance defined as the distance between the front of the lens hood and the subject.

Extra working distance helps to avoid scaring a nervous subject, keeps you safer if photographing a potentially dangerous creature like a scorpion or spider, and provides more room to set up the tripod without bumping the subject. Finally, all of the longer macro lenses have a built-in tripod collar (lens mount), which makes it easier to shoot horizontal and vertical images on a tripod.

100mm Macros

For serious close-up photography, the longer 180mm and 200mm macro lens advantages of greater working distance, smaller angle of view, and a tripod mount make them the best choice by far for most subjects. Many photographers still cannot afford the high cost and/or don't wish to carry the weight of the larger lenses. The next best option is a macro in the 100mm focal length range. If you are very careful with the 100mm macro, you can avoid busy backgrounds that often are marred with unsightly distractions. Always pick a shooting angle so that the background is far away and uniformly lit and colored. Although the working distance is only half of what you would get with a 200mm macro, most of the time it is enough to allow excellent photography if you are attentive.

Though we don't know of any 100mm macros that have a built-in tripod mount, using an L-bracket on the camera makes it simple to change composition from horizontal to vertical or vice versa, so not having a tripod mount is not a serious problem with the shorter macros. And should you be using a camera with a small sensor, the crop factor changes the angle of view to approximate that of a longer lens. For example, a 100mm macro used with a camera that has a 1.6x crop factor has the same angle of view as a 160mm lens— which is approaching that of the longer macros. That said, our first choice remains the 180mm and 200mm option for serious photography.

50mm Macros

These are the least expensive and lightest of the true macro lenses. Like all of the others, it probably can focus close enough to achieve life-size (1x) magnification. These lenses are terrible choices for most close-up photography because the angle of view is so wide that it is nearly impossible to avoid distractions in the background and the working distance is far too little. These short macros are truly despicable for most close-up shooting. They are suitable for copy work and photographing small objects in the studio where it is easy to control the background. They also do work for high magnifications around life-size and greater. Why high magnification? Once you reach life-size magnification or greater, the depth of field is minuscule, even at f/16. The background becomes a homogeneous color in which everything in it is completely out of focus. When the subject allows a close approach with the 50mm macro, then it can work. If you already have a 50mm macro—keep it for focus stacking use at high magnification. If used with a focusing rail and extension tubes, it does a fine job when shooting at magnifications of 1x and greater.

Canon 65mm Macro

This unique macro lens is specially made to achieve super-high magnifications. It begins with a magnification of life-size (1x), and by turning a ring, the lens steadily increases its magnification from 1x all the way to five times life size (5x). If your goal is to fill the viewfinder with a mosquito, dew

drop, the eyes of a horsefly, or any other tiny object, this is the perfect lens for doing it. The lens really has no focusing mechanism of its own. Turning the ring changes the magnification instead. Therefore, mount the lens on the camera and then attach the camera to a focusing rail. With the rail firmly mounted on a tripod, move the tripod until the lens is nearly focused on the subject when the desired magnification is set. Use the geared focusing knob to move the entire lens/camera assembly back and forth until sharp focus is achieved. We are attracted to subjects that require magnifications greater than life-size, so we commonly use this lens with great success. For high magnification images where focus stacking is the best way to acquire the necessary depth of field and image sharpness, the 65mm macro on a focusing rail is a superb combination. I'll say more about focus stacking later in the chapter.

This lens is dedicated to Canon cameras. No other camera makers build anything similar. Therefore, even users of Nikon, Sony, and others often buy the Canon 65mm macro and an inexpensive Canon Digital Rebel camera just to use this fine lens for their high magnification close-ups! You might consider contacting your camera maker to suggest they build a similar lens that reaches magnifications greater than life-size. If they get enough feedback, perhaps other camera makers will consider making a lens similar to the Canon 65mm macro.

EXTENSION TUBES

Macro lenses are specially made to focus from infinity to life-size magnification. Since the greatest built-in magnification is 1x, how is it possible to shoot using magnifications greater than life-size? Inserting one or more extension tubes into the optical path between the lens and the camera is the answer. Extension tubes can be purchased individually or in sets. Canon offers a 12mm and 25mm extension tube that preserves autofocus and automatic metering. Nikon offers several tubes, but they do not preserve autofocus—a serious problem at times. A third-party extension tube maker, Kenko, builds extension tubes for Canon, Nikon, Sony, Minolta,

Barbara is a dedicated Nikon shooter, nonetheless she borrowed my Canon 7D in order to use my Canon 65mm macro lens because it is impressive for high magnification images. Twenty-one images were shot where the focus was changed slightly. The stack of images was combined into a single sharp image with Helicon Focus. At magnifications of life-size and greater, it is easiest using a focusing rail to change the focus in tiny increments. Canon 7D, Canon 65mm 1–5x macro, ISO 400, f/8, 1/15 second, manual exposure and metering, and a Kirk focusing rail FR-2.

Extension tubes and teleconverters are placed between the lens and the camera. Extension tubes are a mechanical spacer with no glass within them, which enable the lens to focus closer to increase magnification without significantly undermining the optical quality of the lens. Teleconverters contain glass and they work by increasing the magnification by the power of the converter. The magnification is greater, but image quality is reduced slightly because glass is added to the optical path. Teleconverters and extension tubes can be used together to achieve even higher magnifications. For the greatest magnification, put the teleconverter on the camera first and then add the extension tube and finally the lens.

and other camera systems. The set of Kenko tubes includes 36mm, 20mm, and 12mm tubes. They can be used singly or combined to reach greater magnification.

Extension tubes are hollow metal tubes that are light-tight when inserted between the lens and the camera. The tube adds extra lens extension in the optical path, which enables the lens to focus closer than normal. Being able to focus closer while maintaining the focal length is what increases the magnification. There is little loss of image quality because no extra glass is added to the optical path. The quality is superb! Of course, with an extension tube in use, it is impossible for the lens to focus to infinity. But that is okay because you are shooting a close-up anyway. The more extension that is added, the greater the magnification that can be reached. Extension tubes cost some light, but even that is not a huge problem. Just for reference, a 50mm extension tube used behind a 100mm lens costs one stop of light. This same amount of extension behind a 50mm lens costs two stops of

light. However, shooting on a tripod and using higher ISOs largely negates this small light-loss problem.

To reach magnifications greater than life-size, focus the macro lens out to life-size and then add an extension tube or multiple tubes to reach greater than life-size magnifications. The more extension tubes added, the greater the magnification. Don't overdo it, though. Combining three or more extension tubes can make the whole system unstable. Sometimes the metering connection among all of the tubes fails, which causes a loss of accurate metering.

CLOSE-UP LENSES

Another way to reach greater magnifications is to add specially made close-up lenses to the front of a macro lens. These close-up lenses screw on to the front of the lens, just like any other filter. They optically shorten the focal length, which is undesirable, but they do enable greater magnification. Avoid using the cheap ones. Canon offers the double-element 500D series in 52mm, 58mm, 72mm, and 77mm sizes. If your lens has any of these four filter sizes, then buying the one that fits will work fine on any lens, including non-Canon lenses. If the filter's thread size doesn't fit any of these filters, buy a filter adapter to make it fit. For example, if the close-up lens filter size is 77mm and the lens filter threads are 72mm, you can use an adapter that has 72mm threads on one side and 77mm threads on the other. This adapter ring allows you to attach a larger filter to the front of the lens. Never attach a smaller filter as you may encounter severe problems with dark corners in the image because the filter ring appears in the field of view of the lens.

These close-up lenses work especially well on zoom lenses that include 300mm in their focal length range. Optically, a close-up lens shortens the effective focal length. For example, a 75–300mm zoom might become only a 220mm focal length when zoomed to 300mm with a close-up lens attached. Still, it gives much greater magnification while retaining the narrow angle of view of a 220mm lens and the working distance is quite convenient. Close-up lenses do not work well on short zoom lenses—such as a 24–105mm—because the angle

Close-up lenses are clear filters that attach to the front of the lens. They have a focal length and increase the magnification of any lens on which they are used. The longer the focal length, the greater the magnification. High quality close-up lenses don't cost you any light and the image sharpness remains quite good. Canon offers the 500D series of close-up lenses in four sizes and Nikon has the 3T, 4T, 5T, and 6T. Both Canon's and Nikon's produce acceptable results. Beware of the many inexpensive close-up lenses that are sold, because they do not produce sharp images.

Barbara used a Nikon 5T close-up lens on the front of her Nikon 200mm micro lens to help her fill the frame with the tiny Western Green Hairstreak butterfly. The 5T has 62mm threads, which makes it suitable for her micro lens that accepts 62mm filters. The 5T close-up lens is high quality. Join that combination with Barbara's excellent shooting habits in order to produce a sharp image. She underexposed the ambient light by one stop and used a Nikon SB-800 with the SU-800 flash controller mounted in the camera's hot shoe to optimally expose the miniature butterfly. We call this technique *main flash*. Nikon D4, Nikon 200mm micro lens, ISO 100, f/22, 1.3 seconds, Flash WB, and Nikon 5T.

of view is too wide and the working distance is minuscule. One nice advantage of using a close-up lens on a zoom lens is that once the subject is focused, the lens magnification can be changed without moving the tripod. Zoom the lens to change

the composition, touch up the focus, and you are good to go. With any fixed focal length lens, changing the magnification requires moving the tripod forward or backward a little.

SHOOTING SHARP IMAGES

The greater magnifications that close-up images require make it mandatory that your shooting technique is flawless or your images will not be as sharp as they could and should be. Making the following shooting strategies a habit will help considerably.

FOCUS MANUALLY WITH A MAGNIFIED LIVE VIEW

Autofocus is effective for many subjects, especially when a button on the rear of the camera is used to control it, but it fails miserably in close-up situations. Autofocus works by detecting contrast and sharply focusing it. However, many small subjects exhibit little contrast. A tulip's uniform yellow blossom has little contrast. Autofocus will have a difficult time "seeing" it. Because depth of field is so extremely limited in close-up photography—even at f/16—precise focus must fall on the most important part of the subject. If photographing a frog, focus precisely on the frog's eye, not on its nose or throat. If the eyes are not tack sharp, the image suffers. By focusing manually, you have precise control over what is in sharpest focus.

STOP DOWN TO F/16

Stopping the lens down to f/16 is a reasonable compromise between achieving depth of field with the smaller aperture while minimizing the serious problem of diffraction that does occur at f/16, but becomes steadily worse with smaller apertures.

AVOID F/22 AND F/32

"Diffraction" is the term used to describe the deleterious effects on image sharpness when light passes through a tiny aperture. The more light that grazes the edge of the small aperture hole, the more light that is diffracted, which causes a loss of sharpness. The sharpest apertures on the lens are typically two to three stops down from the maximum aperture. If the lens is a 200mm f/4 lens, for example, expect the sharpest apertures to be f/8 to f/11.

USE A SELF-TIMER, CABLE RELEASE, OR REMOTE RELEASE

Shooting the camera handheld or touching the camera while tripping a tripod-mounted camera will cause a slight loss of sharpness due to camera-shake. Camera-shake is especially likely when using shutter speeds slower than 1/125 second, although shorter lenses don't suffer as much at this shutter speed. Shooting on a tripod, using a self-timer, cable release, or a remote release separates your trembling body from the camera, which, in turn, produces sharp images. That said, we generally shoot lenses longer than 200mm on a tripod while holding on to the camera with both hands when photographing animal action because we need to change the composition quickly or pan with the subject. Sharp images are obtained by always favoring high shutter speeds—usually 1/250 second or faster—to freeze the slight camera-shake. However, when shutter speeds fall below 1/60 second, we never trip the camera while touching it or the tripod.

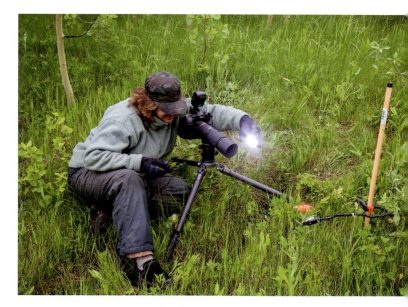

Please believe that quality is not a matter of running around photographing everything that moves handheld with a short focal length lens in bright sun. Close-ups demand the ultimate in precision and care. Notice Barbara is using a tripod, tripping the camera with a cable release, using a Plamp to support the flower, adding highlights with a flash, and using many camera settings that allow her to capture sharp and well-exposed images.

Using an inexpensive tripod lawn sprinkler, two Plamps are attached to it and then to the delphinium flower both above and below the area to be photographed. The Plamps solidly secure the blossom without hurting it, to prevent the slight breeze from wiggling the blossom too much.

AVOID RUSHING WATER AND WIND

Setting up a tripod in rushing water or where buffeted by high winds will surely cause camera-shake and produce unsharp images. Avoid running water and wind. If you must shoot in such conditions, hang on to the camera and tripod to add your body mass to the whole system to reduce vibrations, use faster shutter speeds, and turn image-stabilization on.

USE MIRROR LOCK-UP OR LIVE VIEW

The mirror is placed in the optical path to send the light reflected from the scene upward to allow you to see it in the viewfinder. The mirror must move out of the way at the moment of exposure. This motion can cause the camera to quiver. The problem is especially troublesome when using shutter speeds in the 1/4 to 1/30 second range.

USE A PLAMP TO HOLD THE SUBJECT STILL

Wimberley makes an incredibly useful device called the Plamp. Attach this plastic clamping device to a simple tripod to support it. Attach the other end to a small subject to brace it and hold it still. We generally use a Plamp by fastening it to

Here's the delphinium flower that was stabilized with the two Plamps. Canon 5D Mark III, Canon 180mm macro f/3.5 lens, ISO 100, f/22, 1/1.6 second, Cloudy WB, fill flash with Canon 600 EX flash and ST-E3-RT radio controller.

the stem of a flower just outside the image where it holds the flower motionless. Plamps are incredibly useful. We don't see how any serious close-up shooter can do without having at least one Plamp. We often use two Plamps at one time. If the flower blossoms are blooming up and down a flower stalk, we attach a Plamp below and above the blossoms we want to photograph. At other times, we attach one Plamp to the

flower stem and another Plamp to a differently colored flower behind the subject to move it over a little (without picking the flower) to add a splash of color in the background.

Do not attach the Plamp to the tripod supporting the camera. If you do and then quickly move the tripod, you will jerk the subject and possibly harm it. Moreover, you will certainly ruin the image. Inexpensive tripods that are too flimsy to support a camera work perfectly as a Plamp holder. We use inexpensive lawn sprinkler tripods as Plamp supporters!

USE FLASH TO FREEZE CAMERA AND SUBJECT MOTION

Electronic flash emits an easily controlled light that has a very short duration. Even when the flash is used at full power, the flash duration might only be 1/700 second or perhaps even less. Of course, these short flash durations vary among flash models, but all of them are rather short. Short flash durations freeze subject motion and camera-shake, no matter what shutter speed is being used. Obviously, if you are mixing ambient light and flash together with a long shutter speed—1/30 second for example—you will get a sharp image of the subject from the flash exposure and could get a blurry second image from the ambient light exposure should the subject be moving too much.

SHOOT WHEN THE AIR IS CALM

It helps to plan your photo outing for those times when the breezes are minimal. Wind rarely occurs at dawn and dusk, but windless times can occur any time, especially on a cloudy day. We shoot most of our close-up images early and late in the day. We frequently use our 6- by 10-foot greenhouse to photograph flowers during breezy weather because all air movement and light are controlled without difficulty. In the greenhouse we photograph plants that we buy from garden nurseries or we pick in our garden.

USE FOCUS STACKING AND SHOOT AT F/11

When using a tripod-mounted camera to photograph a subject, the best way we know to capture the sharpest possible image is to shoot using an aperture of f/8 to f/11. These are the sharpest apertures on the lens. Of course, the depth of field is less at f/11 than f/22 and probably will not completely cover the subject. The best way to handle this is to shoot a set of images in which the focus is changed slightly from the front of the subject to the rear. Change the focus in tiny increments from front to back. Combine all of these images into a single image with focus stacking software. Focus stacking is remarkable for achieving the ultimate in sharpness.

IDEAL CLOSE-UP LIGHT

Perhaps it is less complicated to describe what *is not* considered terrific light for close-ups. Bright, direct sunshine is great for suntans, but appalling for lighting close-up images because it creates too many black shadows that obscure subject details. When the exposure is lightened to reveal shadow details, consequently the highlights are overexposed and lost. The soft low contrast light found on bright cloudy days is perfect for most close-up images. Even if the day is rather dark, the dim light still works fine because you can use higher ISOs to keep shutter speeds reasonable. Cloudy skies produce light that is low in contrast, which is especially ideal for small subjects. Even if the day is sunny, find subjects in the shade or under a canopy of trees to use low contrast light.

Our weather preference for nearly all close-up subjects is bright overcast light and no breeze. Flowers, butterflies, amphibians, mushrooms, and reptiles all photograph well in these conditions.

GOLDEN SUNLIGHT AT DAWN AND DUSK

The golden sunshine early and late in the day is well known for producing outstanding landscape and wildlife images. It also works for many small subjects where the golden-colored light enhances the subject. This is true for all warm-colored subjects such as orange butterflies, brown mushrooms, or

Butterflies were sitting still on a cool spring day in British Columbia. The pale tiger swallowtail flew in to the lilac bushes where we were photographing hummingbirds. When dense clouds covered the sun, the butterfly became dormant. Nine shots were taken to produce a focus stack set of images that were then processed with Zerene Stacker software. Nikon D4, Nikon 200mm micro lens, ISO 100, f/4, 1/60 second, Cloudy WB, manual focus and exposure.

red flowers. Golden light is effective for most colors, but not all. Blue flowers may look oddly colored when bathed with yellow light.

Of course, even the red light at dawn and dusk remains high in contrast, but it is easy to use light modifiers to reduce the contrast. A very successful strategy is to use a gold-colored reflector to bounce light into the shadows. Use a technique we call cross lighting to light the subject beautifully. Photograph the subject with the golden sunshine backlighting it. The warm light nicely rims the subject, separating it dramatically from the background. Of course, the side of the subject facing the camera is dark because backlight causes the shadows to face the camera. Now hold a reflector with a gold-colored side near the camera. Carefully adjust the angle of the reflector to bounce the sunshine back to the subject. This effectively opens up the shadows to reveal detail, yet the natural back-light still produces a wonderful rim light. We call this cross lighting because the golden sunshine and the bounced light from the reflector travel in opposite directions and cross at the subject's location.

REFLECTORS

Buy some gold-colored aluminum foil, crinkle it up, spread it out again, and paste it to stiff cardboard. A homemade light modifier is quite suitable for reflecting sunlight back to the subject to reduce contrast by adding light to the shadows. Although it worked perfectly for years, we now prefer to use a Photoflex 7-in-1 Multidisc in the 32-inch size. It is round with a steel frame that pops open easily. Zippered fabrics can be changed to different colors to produce a variety of light-modifying effects. The colors include white, silver, gold, soft gold, translucent, SunLite, and black. White reflects light with the most natural results because it does not add a colorcast. Silver increases specular highlights and increases contrast, so we rarely use it. Gold greatly warms up the colorcast on the subject. It can be pleasing, but often it is too much. Soft gold combines gold and silver in a zigzag pattern to produce a warmer overall look, but not as strong as only the gold surface. Translucent serves as a wonderful diffuser that reduces contrast. SunLite has a less reflective surface than soft gold to prevent it from being too directional and powerful. Black, which is sometimes referred to as negative fill light, may be used to reduce the light on the background.

DIFFUSERS

Any white piece of cloth can be a diffuser if it isn't too thin or thick. You want the cloth to reduce the light by two to three stops. The translucent side of the Photoflex 7-in-1 Multidisc works well for this purpose. Diffusing the light changes the colorcast a little. Since the white balance is so easy to control with digital cameras, merely shading the subject and its background is effective on a sunny day. Of course, with the subject shaded, much of the light on the subject is reflected blue light from the blue sky, but to avoid the excessively blue colorcast, simply set the camera to the Shade WB. The camera adds yellow to the image and minimizes the blue colorcast.

FLASH

Electronic flash is exceptionally useful in close-up photography. The use of flash includes the following:

- Reduce contrast
- Increase contrast
- Improve the color
- Highlight the subject against a darker background
- Balance out the light between the foreground and the background
- Freeze subject and camera motion.

Consider each one of these ways to use flash because it is crucially important to master flash.

We use flash in the vast majority of our close-up images. Flash is easiest to use if you avail yourself of the wireless off-camera flash equipment all camera systems offer. Using the flash off-camera—meaning it is not mounted on top of the camera in the hot shoe—is the best way for creative freedom and ease of use. For most images, it is best to mix ambient light with flash, which is a straightforward process. First decide what the ambient light should do. Should the ambient light properly expose the subject, or should it underexpose the subject? Once the role of the ambient light is determined, bring in a flash and use the flash exposure compensation control (FEC) to make the flash do what is necessary.

Reduce Contrast

Perhaps this is the most uncomplicated use of flash to understand. Determine the optimum ambient light exposure in the normal way by using the rightmost data of the histogram and the highlight alert. As a starting point, set the flash exposure compensation to −1.3 stops. All cameras have an FEC somewhere, but some flash units allow you to set it directly on the flash, also. Keep the flash close to the lens and point it at the subject. Shoot the image. View the resulting image on the LCD monitor to see if the shadows are filled enough and the image looks first-rate. If so, you are done. If the shadows are filled too much, reduce the fill light from the flash by setting the FEC to a more negative number—perhaps minus two stops—and try again. Keep adjusting the amount of fill light from the flash with the FEC until you get the shadow density you desire. If the fill light from the flash is not enough, increase the fill flash by setting a less negative FEC. In other words, if −1.3 FEC does not fill the shadows enough, increase

The cool morning enticed this caterpillar to slumber on the twig of a leatherleaf bush in a dewy northern Michigan bog. A Plamp was used to steady the twig occupied by the caterpillar. By carefully adjusting the shooting viewpoint, it was possible to shoot toward the rising sun, which was diffused by a thin cloud layer to backlight the caterpillar and highlight its tufts of hair. Canon 5D Mark III, Canon 180mm f/3.5 macro, ISO 100, f/16, 1/2 second, Shade WB.

To bring out more color in the caterpillar and open up the shadows created by the backlight, a gold reflector was used to bounce the light from the sun back to the subject. We call this *cross lighting* and use it frequently with considerable success. The light from the eastern sky and the reflected light from the gold-toned reflector cross right at the subject's location. Cross light provides the look of backlight while retaining detail and color in the side of the subject facing the camera. Canon 5D Mark III, Canon 180mm f/3.5 macro, ISO 100, f/16, 1/2 second, Shade WB, and gold-toned reflector.

the fill flash by setting –.7 FEC, which is a two-thirds stop increase in fill light from the flash.

Increase Contrast

Although contrast is often a problem for photographers, a little contrast can easily add impact to the image and help separate the subject from the background. We use flash a lot to add a rim light from the side or behind the subject.

On a dark cloudy day, the light is indeed low in contrast. Determine the optimum exposure for the ambient light. Now set the flash to zero FEC and angle the flash to make it side-light, or, better yet in most cases, backlight the subject. Shoot the image and check the results on the camera's LCD display. If the flash is too strong and creates too much contrast, reduce its output by setting more negative compensation, such as minus one stop, and try again. Keep adjusting it until you

This attractive group of claret cup cactus were growing in the Sonoran Desert south of Tucson, Arizona. The bright overcast light produced soft shadows, but the large blossoms still created objectionable shadows below them. Canon 5D Mark III, Canon 24–105mm f/4 lens, ISO 200, f/18, 1/4 second, Shade WB.

Flash opened up the shadows. In this case, the ambient light remains the primary light source because the flash is only set to +1/3 FEC exposure compensation. The weaker light from the flash merely opens up the shadows to reveal the color and detail already contained within. Canon 5D Mark III, Canon 24–105mm f/4 lens, ISO 200, f/18, 1/4 second, Shade WB, Canon 600EX flash controlled with the ST-E3-RT radio controller.

arrive at the result you want. If the flash does not add enough contrast, then try a plus compensation, such as + 1 FEC, to increase the amount of light from the flash. In all cases, be sure to use automatic through-the-lens metering for the flash portion of the exposure. Then, should you unknowingly change the distance between the subject and the flash by a few inches, the flash will automatically compensate for this change in distance. By the way, for nearly all of our mixing flash with ambient light in close-up photography, we use manual ambient light exposure in conjunction with automatic flash exposure. They are two different systems and quite independent of each other.

These two fritillary butterflies make a fine composition as they perch on the lupine. Canon 5D Mark III, Canon 180mm f/3.5 macro lens, ISO 200, f/18, 1/4 second, Shade WB, manual exposure and focusing.

A flash was held to backlight the butterflies, but not appear in the image itself. We love how the backlighting from the flash that is set to FEC +1 nicely rim lights the delicate creatures and bleeds through the wings. Canon 5D Mark III, Canon 180mm f/3.5 macro lens, ISO 200, f/18, 1/8 second to darken the background, Shade WB, Canon 600EX flash with ST-E3-RT flash controller, manual ambient light exposure and focusing with automatic TTL flash metering at the same time.

Improve the Color

Although image colors are easy to adjust with software or the white balance settings in the camera, flash is useful for changing the color as well. Flash emits a light that is similar to direct sunshine or a little bit bluer. If you are photographing in a green forest that is reflecting a preponderance of green light from the leaves, a little flash can reduce the green colorcast. It is also possible to tape gelatin filters over the flash head to create desirable colorcasts. Taping a red gel over the flash will make its light have a far redder colorcast.

Balance the Light between the Foreground and the Background

We often use flash in landscape photography, but we need it frequently for close-ups. A flower is growing in the shade and the background is a sunlit meadow or blue sky. The difference between the shaded subject and sunlit background is at least three stops of light and in all probability more. Expose for the subject in the shade and the background becomes overexposed. Expose for the bright background and the subject becomes underexposed. What to do? You could shoot a series of images where the exposure is varied by changing the shutter speed and merging these images together with HDR software. However, due to breezes or subject movement, shooting sharp HDR images can be challenging.

The easiest way to balance out a dark foreground with a bright background, or sometimes vice versa, is to use flash to light one portion of the image. If the subject is shaded and the background is bright—the most common situation—set the ambient exposure for the background and use flash to optimally illuminate the foreground. If the background is dark and the foreground light, set the ambient light to nicely expose the foreground, and use the off-camera wireless flash to light the background. Naturally, if the background is huge, then a single flash isn't able to emit enough light. However, often in close-up photography the background is small enough that it is possible to light it agreeably with a single flash.

Freeze Subject and Camera-shake

Short flash durations make it easier to shoot sharp images. Although you have to use the flash sync speed, which might only be 1/200 second (this varies a little among camera models), if the bulk of the light illuminating the subject is from the light from the flash, and its flash duration is only 1/1000 second, that is similar to using a shutter speed of 1/1000 second. Using flash tends to eliminate or reduce the image-softening effects of both camera-shake and subject motion. Of course, if a large percentage of the total exposure is from the ambient light, then you can get a secondary soft image from the continuous light source that makes the image less sharp overall.

Since close-up subjects are close to the camera, and therefore the flash, it is possible to use shutter speeds that are faster than sync speed when using flash. Set high speed flash sync and then you can use any shutter speed in conjunction with the flash. High speed sync works by having the flash emit a series of tiny flashes to effectively light the entire image as the shutter operates. Since this series of flashes must be accomplished with a single charge in the flash's capacitor, the overall output is less, but the close flash-to-subject distance allows this to work. Check your flash manual to see how to set high speed flash sync.

SUMMARY

Close-up photography is incredibly enjoyable and straightforward to do. Gorgeous subjects are everywhere. While not everyone can afford an expensive safari to Kenya to photograph wildlife, anyone can find and photograph fields full of wildflowers, butterflies, and other insects in the garden, and numerous other attractive subjects are easily and inexpensively discovered.

I intended this chapter to hit the highlights to get you started. Our *Close Up Photography in Nature* book is entirely devoted to photographing small subjects, so you might wish to obtain a copy.

Teton Max is my large Tennessee walking horse who is always looking for his next meal. This makes him easy to photograph because he readily approaches people and hangs around hoping for a handout. During a heavy snow-storm, Barbara shot handheld to make a tight close-up image of a big subject. Nikon D4S, Nikon 70–200mm f/2.8 lens at 200mm, ISO 800, f/8.0, 1/400 second, Cloudy WB, manual metering and AF-C autofocus on the back-button.

The Power of Flash

Cameras come equipped with a built-in pop-up flash or a hot shoe for mounting a flash on top of the camera. They are convenient and useful features that too many shutterbugs ignore. Using a flash efficiently and wisely is a skill every photographer must master. Flash is incredibly helpful in lighting many subjects better. Unhappily, many shutterbugs are afraid to use flash, either because it seems complicated or they do not perceive the need for it. We use flash in at least 50 percent of our images because it solves many lighting problems, helps to create stunning light, improves the colors, and makes it easier to capture sharp images. If you belong in the camp where you feel flash is intimidating or unnecessary, it is time to get over that misguided notion and master flash techniques. Everyone's images can benefit markedly when flash is used wisely!

FLASH ADVANTAGES

1. Ambient light is fickle. Sometimes you have enough of it to shoot, but sometimes you do not. Flash is ready to serve you whenever you need it and the correct amount is always available.
2. Ambient light can fluctuate with little notice. Flash does not vary if you let it fully charge, and it is easy to control its output with the flash exposure compensation (FEC) control.
3. With a little practice, flash is simple to mix with ambient light to effectively light objects.
4. It is elementary to point the flash head precisely at the spot where light is needed.
5. The color of the light emitted by an unfiltered flash head is similar to midday sunshine. Using flash will reduce the colorcasts in the ambient light. For example,

Three Nikon SB-800 flash units froze the wings of this male rufous hummingbird. The bird was enticed to a sugar-water feeder hanging under a dark tent at the Bull River Guest Ranch located in Cranbrook, British Columbia. The camera shutter speed had nothing to do with stopping the wings' movement. Instead, the flashes were manually set to 1/16 power, which generates a flash duration around 1/10,000 of a second. Since no ambient light was bright enough to appear in the image, the flash duration acts as the shutter speed. Nikon D300, Nikon 200–400mm lens at 320mm, ISO 200, f/18, 1/200 second, Flash WB.

Attractive light is crucial for making awesome images. This Western White butterfly was underexposed by two-thirds of a stop and a flash was aimed at the splendid butterfly from behind to backlight it. Canon 5D Mark III, Canon 180mm f/3.5 macro lens, ISO 100, f/20, 1/5 second, Daylight WB, manual metering and focusing using a magnified live view image.

the green colorcast that appears in a white mushroom when photographed in a green forest is significantly reduced when flash is added to the light mixture.

6. The short duration of a typical flash burst tends to freeze subject and camera motion—producing an overall sharper image.

7. Using off-camera flash so it strikes the subject from the side is a superb way to reveal texture.

8. Make the subject more prominent by using flash as the main or primary light, which also darkens the background.

9. When the ambient light is quite diffused and shadowless, sometimes it helps to use flash to increase the contrast.

10. Flash works exceptionally well as a backlight to rim a subject with a bright edge of light.

11. With the ready availability of wireless flash controls, it is simple to fire more than one flash simultaneously to create spectacular light.

FLASH BASICS

Although flash appears complex and provides many features, it is actually a pretty simple device. The flash has a capacitor that stores energy that is drawn from batteries or sometimes AC current. When the flash is fired, the energy is dumped into a gas-filled tube and the gas ionizes, which creates a very brief but tremendously bright flash of light. At full power the flash emits the most light, and the amount of time the flash lasts varies from one flash to another, but a typical flash duration falls in the 1/700 to 1/1000 second range. Essentially, the flash burst is instantaneous. The amount of light from the flash striking the subject is primarily controlled with the aperture and ISO selection, along with the flash exposure compensation control, which is found on the camera, the flash, or sometimes both.

When the flash fires, there is no way to have a small "burn." The gas ionizes all at once. However, the flash can reduce its output by turning the "burn" off sooner, which shortens the time the flash emits light. The length of time is called the flash duration. Many flashes have power ratio controls that allow you to manually set the flash to full, 1/2, 1/4, 1/8, 1/16, 1/32, 1/64, and 1/128 power. With the Nikon 910 flash, for example, here are the power level flash durations (in seconds):

Full Power 1/800
1/2 1/1100
1/4 1/2550
1/8 1/5000
1/16 1/10,000
1/32 1/20,000
1/64 1/35,700
1/128 1/38,500

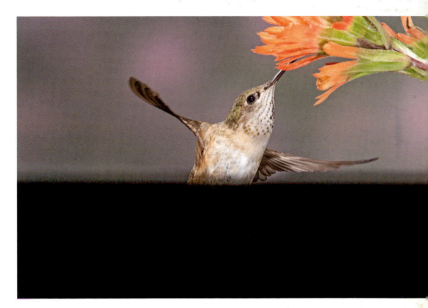

Other flash units tend to have similar—though not identical—flash durations at these power levels.

THROUGH-THE-LENS FLASH METERING

The camera has two internal exposure mechanisms, one for ambient light and another for light from a flash. These systems operate independently of each other. When you use the exposure compensation control to adjust the ambient light exposure, it affects only the ambient light and not the flash exposure. Through-the-lens flash metering is similar to ambient light exposure. When using the flash on automatic with through-the-lens flash metering, the camera fires the flash and turns off automatically when the flash makes the subject middle tone in reflectance. Therefore, if you are photographing a light-toned subject, the flash system will underexpose it to make it middle tonality. To compensate for this, set the flash exposure compensation (FEC) control to a positive choice—such as +1—and then the flash will increase its output to make the subject one stop brighter.

SYNC SPEED

Your camera has a sync speed for flash. It varies among cameras, but a typical sync speed is 1/200, 1/250, or 1/320 second. Consult your camera manual for the exact speed. Attaching a flash to the camera or raising the pop-up flash, if the camera has one, to determine the sync speed usually works. Cameras are quite sophisticated these days. When they detect a flash is being used, they typically change the shutter speed to the sync speed automatically.

Don't be confused by the sync speed! It exists only because the camera has two shutter curtains. Quite often the camera

The camera's sync speed is the fastest shutter speed that can be used with flash (unless high speed sync is invoked) to properly expose the entire image. Most of the time the camera detects when a flash is being used and automatically defaults to the sync speed if the shutter is set too fast. However, in this case, PC cords were used to wire the three flashes together and the camera does not recognize these cords. The bottom half of the female calliope hummingbird image is dark because the shutter curtain was closing when the flash fired as the shutter speed was set faster than the sync speed. Canon 1DS Mark II, Canon 300mm f/4 lens, ISO 125, f/18, 1/640 second, Flash WB, manual metering and continuous autofocus on the back-button.

sync speed for flash is 1/200 second. At that shutter speed *and all slower shutter speeds*, a shutter curtain opens all of the way, which exposes the entire sensor to the light passing through the lens. The flash unit waits for the shutter to fully open and fires the flash as soon as it opens. Then a second shutter closes to prevent any more light from striking the sensor. The flash works perfectly with the camera at the sync speed and all slower shutter speeds, but not shutter speeds faster than sync speed.

Why does the normal flash not work with shutter speeds faster than the sync speed? When the shutter speed is 1/1000 second—for instance—the first curtain begins to open and expose some of the sensor. Shortly after the first curtain starts to move and before it fully uncovers the sensor, the second curtain "chases" after it to obtain a fast shutter speed. Essentially, there is a rapidly traveling opening that is much

smaller than the sensor. At no point in time is the entire sensor fully exposed. Since flash is almost instantaneous, only that part of the sensor that is exposed when the flash fires receives the light. Any part of the sensor that is covered by the following second shutter curtain receives no light from the flash. With continuous ambient light the entire sensor is exposed as the opening between the shutter curtains passes over it, but it is a problem for flash because the light isn't continuous. Fortunately, modern cameras automatically default to the sync speed whenever they detect a flash is being used.

Did you notice only the trailing second shutter curtain can block a portion of the sensor from being exposed? Why does the first shutter curtain not cause the problem? In the normal camera setup for flash, the camera fires the flash only when the first shutter curtain fully completes its journey. There are a few other simple sync concepts to learn, which will be discussed later.

GETTING STARTED WITH FLASH

THE POP-UP FLASH

Most cameras include a pop-up flash found conveniently on top of the camera. This is appropriate because you cannot forget the flash, and it is always ready to be used. Unfortunately, the top of the camera is one of the least favorable locations for effective lighting. When you use the pop-up flash or a separate flash mounted in the hot shoe as the only light source, it produces unflattering light with no shadows, and the background tends to become black. Nevertheless, the pop-up flash can be quite useful for filling in the harsh shadows that are created by strong ambient light, and it works well for controlling an off-camera flash if it can be programmed to be the flash controller. Start by learning to use the pop-up flash, but plan to soon move on to using off-camera flash for best results.

THE INVERSE-SQUARE LAW

This law describes how light from a point source—such as a flash—spreads out and diminishes over distance. It states, "The intensity of the light from a point source (the flash)

is inversely proportional to the square of the distance from the source." If you are a normal person, that statement is completely nebulous. Here's how it works. Assume you are photographing a person and the optimum flash exposure is f/8. The person stands 10 feet from the flash. The background is a brick wall 20 feet from the flash. The wall is twice as far away as the flash. The light from the flash spreads out over distance. How much weaker is the light from the flash on the wall? Since the wall is twice as far as the person, many photographers think the flash is one stop weaker, or said another way, half as powerful. Naturally, that is the wrong answer. The light from the flash is two stops weaker because the continually spreading light from the flash must cover four times as much area—a two stop loss of light. In other words, the light on the wall is only 1/4 as strong as that on the person. The background appears dark because it is two stops underexposed, but not yet black. A dark background is assured—unless you take countermeasures, some of which I will soon describe. If the background is more than 40 feet away, the light spreads out so much that it fails to light the background and it appears black in the image. Let's do the math. The background is now four times as far as the subject. Four squared equals sixteen and the inverse of that is 1/16. The background is now four stops darker than the person.

FILL FLASH

Any time you photograph a subject that is backlit or sidelit, or when the light is high above the subject, you usually create harsh shadows. Use the pop-up flash to reduce the contrast by allowing it to add light (open up) the shadows. It is simple to do. *When using flash, first decide what you want the ambient light to do.* In this case, determine the optimum ambient light exposure in the normal way by using the histogram's rightmost data as a guide. Once you have the optimum ambient light exposure, notice all of the harsh shadows in the subject. You want the pop-up flash to add light to the dark shadows, but not overpower the ambient light. Set the flash exposure compensation (FEC) to a negative value such as −1.3. The through-the-lens flash metering system will turn the flash

Flash is nearly always beneficial when photographing people. This rugged cowboy is adept at cooking on a wood fire, but you would never know how handsome he is with the deep black shadows obscuring his face. Canon 5D Mark III, Canon 24–105mm f/4 lens at 47mm, ISO 400, f/10, 1/80 second, Daylight WB.

Using a flash makes it painless to conquer the shadow dilemma. First I manually set the ambient light exposure for the background. Next I set my flash to a plus one stop flash exposure compensation to make the flash nicely illuminate the cowboy's face and delicious breakfast he was cooking. Canon 5D Mark III, Canon 24–105mm f/4 lens at 47mm, ISO 400, f/10, 1/60 second, Daylight WB, Canon 600 EX flash mounted on the camera at +1 FEC.

off automatically when its portion of the entire exposure is 1.3 stops underexposed. Filling the shadows with more light makes them less dark. If the fill flash makes the shadows too light, decrease the amount of light emitted by the flash by merely setting a more negative FEC amount of –2 FEC. If

more fill flash is needed, then add more light from the flash by setting –.7 FEC, which increases the fill flash by two-thirds of a stop from a –1.3 FEC setting. With most systems, FEC is easily set on the camera, but some flash units allow it to be set on the flash. With my Canon Speedlites, I prefer to set it

The incredible tulip fields at the Wooden Shoe tulip farm will delight any photographer. Fortunately, the owners are photo friendly and allow photographers to be in the fields at first light and stay until after dark. Barbara set her ambient light exposure to produce nice colors and detail in the sky. Of course, the windmill was too dark, but no worries. She used her Nikon SB-800 flash and the flash exposure compensation control to beautifully illuminate the structure. Then she added the full moon that was floating overhead to the image by double exposing it into the scene. She used a Nikon 200–400mm lens zoomed quite far out to make the moon large and used the always reliable Mooney 11 rule to expose it, which is 1/ISO at f/11 or any equivalent exposure. She used a shorter lens to expose the windmill. This is a perfect example of balanced flash where the windmill is lit by the flash and the sky is illuminated with ambient light exclusively. Nikon D4, Nikon 24–85mm lens, ISO 400, f/10, 1/15 second, Cloudy WB, manual metering and back-button autofocus, Nikon SB-800 flash.

on the flash since I am usually holding the flash in my hand to aim it at the precise spot where I need light.

Fill flash is well-named, which makes it easy to remember what it does. When you use fill flash, the ambient light is always the primary or main light illuminating the subject. The flash is the minor or secondary light that is weaker than the ambient. The flash fills in the dark portions of the image with its light, but does little to the highlights that are brightly lit with the ambient light.

MAIN FLASH

A pop-up flash, or a separate flash mounted in the camera's hot shoe, isn't the best location for a pleasing main flash because the light strikes the subject directly and produces few shadows. Shadowless light is flat. The subject lacks the suggestion of depth. Nevertheless, let's consider it to illustrate the importance of using main flash.

Once again, start by determining the optimum ambient light exposure in the usual way. Perhaps the best exposure occurs using ISO 200, f/11, and 1/125 second. In this case, though, let's underexpose the ambient light to darken the background and make the person being photographed stand out from a slightly darker background. How do you darken the background? If you are using manual exposure, there are three ways to do it with camera settings. If the sync speed is 1/250 second for the camera, you can increase the shutter speed to 1/250 second from 1/125 second, stop down the lens from f/11 to f/16, or lower the ISO one stop to ISO 100. All three ways darken the ambient exposure by one stop.

Let's bring in the flash. Activate the flash, set a positive +1 flash exposure compensation, and shoot. If the setting produces an excellent exposure, you have the optimum settings. If the flash exposure is not enough, set a higher positive FEC (+1.7 perhaps) and shoot another image and again check it. Should the +1 FEC be too much, then set a less positive FEC (+.3 FEC for example) and shoot another image to check the effect it has on the subject. Usually, after a couple of tries, you determine the optimum amount. After you do this a few times, it all becomes second-nature and natural to do.

If you prefer to use an automatic exposure mode such as aperture-priority or shutter-priority, here's how to use main flash. Set the ambient exposure compensation control to make the overall image one stop underexposed. Now, activate the flash, set positive FEC, shoot the image, check the histogram. Continue to check the histogram and adjust the FEC until the optimum exposure is achieved.

Watch out for a common problem with aperture-priority, however. When using aperture-priority with either fill flash or main flash and the subject suddenly becomes overexposed, what is the likely cause of the overexposure problem? If the ambient light exposure is 1/500 second at f/11, and then you turn the flash on, the camera detects a flash is being used and defaults to the sync speed of 1/250 second in this example. The camera cannot adjust the aperture when using aperture-priority because that exposure mode gives priority to the aperture, so the shutter speed drops to the 1/250 sync speed—a plus one stop increase in the ambient light. The overexposure is from the excessive amount of ambient light. Solve the problem by stopping down the aperture one stop to f/16. Now the ambient light exposure is f/16 at 1/250 second.

Let's recap main flash because it is so important. Main flash is exactly what it is called. The flash is the main light on the subject while the ambient light is now relegated to fill light status.

Main flash is an incredibly powerful technique, especially when using off-camera flash—but it's one that most photographers never learn. Do not be one of them. Using a flash to highlight key objects in the scene is an outstanding way to emphasize them, and using it produces many exceptional images. Some photographers call it "killing the ambient." Flash nicely exposes the key objects in the scene while the ambient light is somewhat underexposed.

SELECTING YOUR OFF-CAMERA FLASH SYSTEM

DEDICATED FLASH CORD

Every camera system offers a dedicated cord that attaches to both the camera hot shoe and a flash made by your camera

maker. Dedicated cords permit the same automatic flash controls that you would usually have when the flash is mounted in the camera's hot shoe. The dedicated cord allows you to move the flash to a more favorable position, which produces more pleasing light. Dedicated cords come in various lengths with longer cords being more useful than shorter ones. However, these cords do not work as well for backlighting the subject because the cord usually isn't long enough and it gets in the way.

WIRELESS FLASH

Wireless is easily the preeminent way to go for nearly all flash applications. It is straightforward to use, so don't be intimidated. Fortunately, your camera system offers excellent flash units that are fully dedicated to your camera, with wireless controls for using them. Wireless controls offered by your camera maker are reasonably priced. Indeed, if your

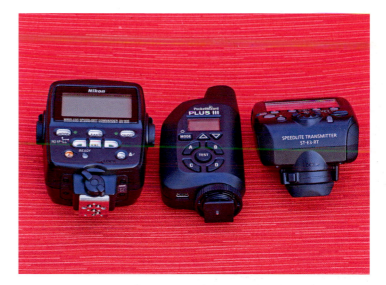

We strongly suggest using wireless flash control because it makes using one or more flash units considerably easier. Every camera system has a way to control its flash wirelessly and some third-party companies build them as well. Here are three examples. From left to right is the Nikon SU-800, PocketWizard Plus III, and Canon ST-E3-RT. Research the options carefully. Many Nikon cameras don't need the SU-800 because their pop-up flash can be programmed to be the flash Commander. The PocketWizard device requires two units to transmit and receive the signal, which increases the cost considerably. The Canon ST-E3-RT only offers radio control signals for their 600EX-RT flash and doesn't work with the other Canon flashes.

camera has a pop-up flash, you may already have it. Check the camera manual to see whether the pop-up flash can be programmed to be a Master or Commander flash control. Nikon has made it possible to program the pop-up flash to be the Commander flash controller for quite a few of its models. Most other companies do the same. Canon has been a laggard in this regard, so only a few of its models—the EOS 7D, 60D, and 70D are three examples—offer built-in wireless flash control.

Options for Wireless Flash

1. Program the camera's built-in pop-up flash to be the controller. Pop-up is the simplest and least expensive option if your camera offers it. It does work well with both our Nikon and Canon cameras that have the feature. Of course, some top-of-the-line cameras do not have a pop-up flash and some models that do are not programmed for it.

2. Use two flashes at once. Usually, the more advanced flash units allow them to be set to either a Commander (Nikon) or Master (Canon) controller or a Remote (Nikon term) or Slave (Canon). Mount the flash set to be the controller in the hot shoe and use the other one remotely and off-camera.

3. A separate flash controller is a common accessory among camera companies. Currently, Canon offers two of them: the Speedlite Transmitter ST-E2 (optical controls) and the ST-E3-RT (radio control only) with the new Canon EOS 600EX-RT Speedlite. Nikon offers the Nikon SU-800 Wireless Speedlight Commander Unit that Barbara uses on her Nikon D4 with excellent success.

4. Many third-party camera accessory makers build wireless flash controls for most current camera systems. These can work well, but often they are cheaply made and don't work perfectly. Many of our clients buy an inexpensive wireless flash control prior to attending our workshop only to discover there is no through-the-lens metering, which is a significant shortcoming. Others are made so poorly that they break down quickly.

Good systems are expensive. The PocketWizard system is highly regarded but is expensive. If you already have this or another wireless flash system, then go ahead and use it. If you are buying a wireless system, always consider getting the equipment made by your camera maker first!

WIRELESS FLASH TECHNIQUES

Fill Flash

Using the off-camera flash to fill in dark shadows created by ambient light is quite similar to having the flash mounted on top of the camera. Keep the flash near the lens and fire it directly at the subject to open up the shadows and reduce the contrast. Use some negative FEC to avoid overfilling the shadows. After you shoot the first image, check the shadows on the camera's LCD monitor and adjust the FEC as needed to get what you desire.

Main Flash

Off-camera flash offers excellent benefits when the flash is fired while held away from the camera using wireless controls. Use the flash to add contrast when the ambient light is too low in contrast. It is particularly effective for photographing animals, portraits of humans, and flowers. Remember that main flash means the flash is the strongest light source and the ambient light is the weaker fill light. Here's how to highlight a subject with main flash techniques:

1. Forget the flash initially. Underexpose the ambient light exposure by about one stop.

 Getting this exposure is straightforward. Using the ETTR guidelines for JPEG or RAW, determine the optimum ambient light exposure by setting the exposure to make the histogram's rightmost data approach (JPEG) the right wall of the histogram or touch the right wall if shooting RAW. Now decrease the exposure by one stop of light. If using an automatic exposure mode—aperture or shutter-priority for example—set the exposure compensation control to deliver one stop less light to the sensor. For example, if the exposure compensation (EC) is set to +2/3 stop, setting the EC to −1/3 stop does the trick. If the EC is originally set to zero EC, then setting it to minus one stop underexposes the ambient light by one stop of light.

2. Now turn on the flash, set the flash exposure compensation control (FEC) to zero and place the flash at an angle to the subject to create some slight shadows that suggest depth and avoid the dreaded red-eye effect that on-camera flash so often creates. Shoot the image and check the histogram. If the histogram's rightmost data move back to

the right wall, then you have achieved the optimum exposure from the flash. More likely, the rightmost data are shy of the histogram's right wall, so increase the flash output by setting a positive FEC so use plus one stop FEC, for example. Shoot another image and check the histogram. Keep adjusting the FEC value until the rightmost data that represent the significant highlights follow the ETTR guidelines. Should the rightmost data climb the right wall, then reduce the FEC by setting a less positive value or even a negative value if need be.

Michigan's famous White Birch Forest is located in Pictured Rocks National Lakeshore. Peak color usually develops plus and minus a few days around October 15. This picturesque group of birch trunks makes an outstanding vertical image on a calm overcast afternoon. Canon 5D Mark III, Canon 24–105mm f/4 lens at 105mm, ISO 400, f/20, 1/20 second, Cloudy WB, manual metering and AI Servo back-button focusing.

To make this group of birch trunks stand out more from the background and to increase the saturation of the colorful leaves, underexpose the ambient light by about one stop of light and then use automatic flash with the exposure compensation control to properly light the birch tree trunks in the foreground. Canon 5D Mark III, Canon 24–105mm lens at 105mm, ISO 400, f/20, 1/20 second, Cloudy WB, manual metering and AI Servo back-button focusing, Canon 600EX flash with ST-E3-RT radio control in the camera's hot shoe with +1 FEC.

3. With a little practice, this entire procedure only takes a minute or two and a couple of shots to get both the ambient light and the flash light set to produce the lighting contrast desired. The finished image shows the subject nicely highlighted with a flash while a more subdued ambient light serves as the fill light and prevents the background from appearing black.

Backlighting

An excellent way to use flash is to beautifully backlight the subject. It is especially effective for all subjects that are hairy or fuzzy because flash nicely highlights the edges of the subject with a magical rim light. If the subject is translucent—fern leaf, many light-toned butterflies, flowers—always use either ambient light or flash to light it from behind. This accentuates the most details in the subject.

Many photographers fail to use backlight to their advantage. When it works and the contrast is not too extreme, backlight will produce many memorable images. Let's describe how to use backlight in two different ways.

Flash Produces the Backlight

Determine the optimum ambient light exposure for the subject. Now position the wireless controlled flash behind the subject. Make sure the flash unit itself does not appear in the image—only the light from it. Sometimes a flash can be concealed behind the subject. More often, though, the flash must be held slightly off to one side behind the subject to keep it from appearing in the image. The flash is being used to rim the subject with light. It also reveals details in a translucent subject. Set the flash to +1 FEC as a starting point and shoot the image.

Now view the image on the camera's LCD monitor to see if you like the results. If the flash is not strong enough, then increase the FEC to +2 FEC and try again. Should the flash be too strong, then reduce the FEC value. Keep adjusting the FEC and shooting the image to check the result until you obtain what you want.

Ambient Light Creates the Backlight

Choose a shooting angle that allows the ambient light to nicely backlight the subject. Set the ambient light exposure to make the light rim the subject. Although tastes vary, most photographers want the backlight to elegantly highlight the subject's edge. The ambient light exposure must be bright enough to show the rim light, but not so strong that the edges of the subject are grossly overexposed. Especially when the ambient light is quite bright, the side of a non-translucent subject facing the camera will be significantly underexposed. Place the off-camera flash to light the side of the subject facing the camera, but keep it to one side of the camera to allow the flash to create some tiny shadows that suggest depth. Adjust the FEC until you get the desired effect. In this case, the flash nicely illuminates the side of the subject facing the camera while the ambient light gorgeously backlights it at the same time.

Cross lighting

These two uses of flash for backlighting describe an incredibly effective lighting strategy we call cross light. When flash creates the backlight, the ambient light nicely illuminates the side of the subject facing the camera. The light from the flash and the ambient light cross at the same time and place at the subject's location. If ambient light is the backlight, the flash is used to nicely expose the side of the subject facing the camera. Once again, the two light sources cross right at the subject. In both cases, cross light splendidly illuminates the subject on the side facing the camera and simultaneously rims it stunningly with backlight. Learn to use cross lighting and use it frequently. Your images will benefit substantially when you do!

GETTING IN SYNC WITH FLASH SYNC
SYNC SPEED

Earlier we explained the reason your camera has a sync speed for flash. You'll remember that the camera has two shutters. At the sync speed the shutter opens, and, when fully open, the flash instantly fires. Then, at the end of the exposure, the

The interesting branches of this maple tree make a first-rate pattern against the rosy dawn sky. Expose to make the red channel histogram's data touch the right wall. Autofocusing is quick and accurate by pointing a single activated AF point at the maple tree's trunk so the AF point "sees" part of the trunk and part of the sky—a contrast edge—and press the back-button focus controller in to hit sharp focus. Then let up on the button to lock the focus, recompose and shoot. Canon 5D Mark III, Canon 24–105mm f/4 lens, ISO 100, f/13, 1/2.5 seconds, Cloudy WB, manual exposure with AI Servo AF on the back-button control.

The backlight from the eastern sky leaves the side facing the camera in complete darkness. To obtain more detail in the leaves and branches, I fired a flash to light up this area by setting the flash exposure compensation control (FEC) to +1/3 stop. I used a Canon 600EX flash and the ST-E3-RT flash controller to accomplish this. However, any pop-up flash could also add light to the foreground. Be alert to avoid over flashing the foreground, which will make the light look unnatural.

second shutter curtain closes to seal the imaging sensor into complete darkness once again. *You can use flash at the sync speed or any slower shutter speed.* Read that last sentence again! Remember, you can use flash at any shutter speed that is the sync speed or slower. That includes shutter speeds of 1/4, 1/15, 2, 4, and even 30 seconds! You can set the camera to *Bulb* and shoot a 4-minute exposure if you wish and fire the flash one or more times during that exposure. It is often necessary to use shutter speeds slower than sync speed to allow the ambient light to illuminate the background. As a reminder, you cannot use a shutter speed faster than the sync speed because the two moving shutter curtains create a slit that makes it impossible for the entire sensor to be exposed by the instantaneous light from the flash.

SLOW SPEED SYNC

This is a fancy name for merely using flash with a shutter speed that is slower than the sync speed of the camera. Most cameras do not offer it as an option because it is always available when you use manual exposure. In the manual exposure metering mode, set the aperture and the shutter speed slower than the sync speed and the flash works nicely. Of course, the slower shutter speed allows the ambient light to expose parts of your image more. On some cameras, when using an automatic exposure mode it is necessary to set slow speed sync to enable the choice of slow shutter speeds. Otherwise, the camera defaults to the sync speed or perhaps a range of shutter speeds. For example, the Canon 5D Mark III camera offers three options when using aperture-priority that include: Auto, 1/200–1/60 sec., and 1/200 sec. (Fixed). The Auto setting allows the camera to automatically set any shutter speed between 30 seconds and 1/200 second—the sync speed for this camera. The 1/200–1/60 sec. option keeps the shutter speed within this range to help prevent subject blur and camera-shake. The third option—1/200 sec.—keeps the shutter speed at the 1/200 sync speed. This more effectively helps to reduce camera-shake and subject motion that might be recorded by the ambient light, but often the background goes black.

Most cameras use menu choices to set the range of shutter speeds you want to use with flash and do not provide for a slow speed sync option. In the manual exposure mode, we can deftly set any shutter speed without any difficulty. However, if you own a camera that offers slow speed sync, then you probably have to use it to allow a slower shutter speed.

HIGH SPEED SYNC (HSS)

Admittedly, until now, I lied by omission. Your camera probably allows successful flash use when using shutter speeds faster than the sync speed. What happened to the small slit between the shutters? How can this be? Depending on the camera maker, this important tool is referred to by different names. Canon dubs it High speed Sync and Nikon refers to it as Auto FP High speed Sync. When the camera is set to high speed sync (HSS), any shutter speed can be used with the flash—including the fastest shutter speed on the camera. If you set the shutter speed to 1/1000 second—for example—the camera changes the way flash works.

Rather than firing a single large burst of light, the flash fires a rapid series of low powered flashes during the fast shutter speed to effectively expose the entire sensor as the small slit between the two shutter curtains passes over the sensor. Why not use high speed sync all of the time? The flash must fire a series of flashes very quickly on one charge of the capacitor. Therefore, the power of the flash diminishes so that it cannot illuminate objects very far away. The faster the shutter speed used, the less powerful the flash becomes.

Use high speed sync when it is desirable to limit the depth of field by shooting with large apertures such as f/4 or f/5.6. Often, the ambient light is clearly too much to properly expose the subject if the shutter speed cannot be faster than the sync speed. For instance, suppose the optimum exposure is 1/500 second at f/4 with ISO 200. If you wish to use flash as a fill light to open up the harsh shadows created by direct sunshine, you cannot if you are restricted to the sync speed for flash. However, with high speed sync, you can shoot with the faster 1/500 second shutter speed and the flash can fill in

Clouds of Mormon fritillaries fed on the flowers in our field. They were too active to use a tripod, so I slowly stalked them to approach within camera range and shot handheld. By using f/4.5 and ISO 400, a fast 1/400 second shutter speed was obtained. The ambient light was underexposed by one stop and flash was used as the main light to properly expose the butterfly. To allow the flash to successfully light the entire subject at this shutter speed, I set high speed sync on the flash controller. Canon 5D Mark III, Canon 180mm f/3.5 macro lens, ISO 400, f/4.5, 1/400 second, Flash WB, handheld using high speed sync with the Canon 600EX flash and Speedlite Transmitter ST-E3-RT.

the shadows. You could even underexpose the ambient light and make flash the main light.

REAR-CURTAIN SYNC

Flash can be beneficial for improving the light on a moving object. Perhaps you want to mix ambient light to show the motion of your running dog while using the flash to freeze the dog at the same time. If you use the default sync speed on your camera, you may find the results are weird. The flash fires as soon as the shutter is fully open, which means the flash freezes the running dog at the beginning of the ambient light exposure. As you continue to pan with the scampering dog during the remainder of the ambient light portion of the exposure, the blurry dog appears in front of the frozen flash image of the dog. The image appears quite unnatural. Would it not be more pleasing to have the blurry ambient light exposure of the dog behind the sharp image of it?

Set the camera or flash to second-curtain sync. It is another fancy term to denote a very simple flash control. Setting the camera on second-curtain sync changes the time when the flash fires.

Rather than the flash firing as soon as the shutter fully opens, the flash fires immediately prior to the second shutter's closing. The ambient light portion of the exposure is recorded first. The sharp flash image is captured at the end of the ambient exposure. The dog is captured sharply by the flash. The blurry ambient exposure that shows the motion appears behind the dog—not in front of it.

MULTIPLE FLASH

Mixing a single flash with ambient light works exceedingly well to stunningly light a wide variety of subjects. Nevertheless, there are times when it is necessary to use multiple flash because the lighting control it provides is highly desirable. Multiple flash is necessary in cases when a single flash as the sole light source would produce extremely contrasty light. Multiple flash is fairly uncomplicated to use when using wireless dedicated flashes that permit through-the-lens flash metering. However, because multiple flash provides many assorted options, it is an immense topic that is beyond the scope of this book. Still, it is worthwhile to get you jump started using two flashes at one time.

SELECTING YOUR MULTIPLE FLASH SYSTEM

When looking for flash equipment, always consider first every item your own camera maker offers. Canon shooters are wise to consider Canon products first, Nikon shooters should look at Nikon flash gear, and so forth. Because I shoot Canon and Barbara shoots Nikon it is no surprise I use Canon flash gear when I use up to seven flashes at once to photograph hummingbirds, and Barbara does the same with her Nikon choices. Some third-party flash makers offer quality flash gear. However, proprietary gear is superior to use and it makes little sense to go any other way. Be cautious of inexpensive third-party equipment. You get what you pay for.

Inexpensive flash gear is inexpensive for a good reason. Quite often it fails at precisely the wrong time and often the equipment is difficult to use.

FIRING TWO OR MORE FLASHES SIMULTANEOUSLY

Wireless

The beauty of using wireless flash is that not only is it extremely convenient but also easy to fire two or more flashes simultaneously. Whether you use a camera's pop-up flash, a hot shoe mounted flash to send out a signal, or a dedicated flash controller in the hot shoe such as the Canon ST-E2 or Nikon SU-800, a wireless signal will fire one flash or fifty flashes if they are set to receive the wireless signal and the signal is not blocked. If the wireless system is dedicated to your flashes, then you can control the flash output from the camera and maintain through-the-lens flash metering—both enormous advantages that you do not want to be without.

Other Wireless Choices

Be cautious of the inexpensive wireless controls available. Typically, a controller (transmitter) is mounted in the hot shoe and the receiver is attached to the flash. When the shutter is tripped, the transmitter sends a signal to the receiver on the flash to fire now and the flash instantly fires. Low cost systems typically do not provide for through-the-lens flash metering or allow adjusting the flash light output from the camera. The system merely tells the flash to fire and offers nothing more. Is it worth the savings? We say NO!!!

Optical devices called "slaves" can be attached to the flash either by attaching them to the hot shoe mount on the flash or wired into the PC terminal if the flash has one. They are simple to use. If you are using three flashes to light the subject, attach a slave to each. Then use your pop-up flash to fire all three of the remote flashes at one time. When a slave device "sees" the instantaneous flash of light from the pop-up flash, it fires the flash to which it is attached. During the first twenty years of my career, I used slaves regularly in multiple flash photography. Now that dedicated wireless controls are

so readily available, I see little reason to use them. Slaves are inexpensive, but they don't offer through-the-lens flash metering or any other control either. They merely fire the flash.

Multiple flash can be used in numerous creative ways. You will need two light stands to support the flashes. It is best to use small ball heads on the flash stands to allow you to easily change the angle of the flash. Use fully-charged batteries in the flash. It is always ideal to use rechargeable batteries, which are far less expensive than disposable batteries when you consider how many times they can be recharged. Let's describe two of the most common ways to use two flashes efficiently. Then we talk about the two ways to adjust the output right after that.

Flash as the Main and Fill Light

The form of the subject is revealed by the shadows the light creates. When flash is the main light, it is desirable to put it at an angle to create some shadows in the subject to show form and texture. Placing the main flash slightly above the subject and off to the side at about a 30 degree angle to a line connecting the lens and the subject is a good place to start. However, a single flash produces extremely dark shadows. To reduce the contrast to a more desirable level, use a second flash close to the lens, but make it two stops weaker in light output. The main flash still creates shadows, but the fill flash makes it less severe by "filling in" the shadows so they are only about two stops darker than the bright side of the subject. Consider next the way to control the flash output. Let us look at the two easiest ways to adjust the light output between the two flashes.

Adjust the Distance between the Flashes

An easy way to make the fill flash two stops less powerful is to double the flash-to-subject distance. If both the main flash and fill flash are identically set, the fill flash will be two stops weaker when twice as far from the subject as the main flash due to the Inverse-square Law. If you want the fill flash to be only one stop weaker, then multiply the flash-to-subject distance of the main flash by 1.4 and put the fill flash at that

distance. To make the fill flash three stops weaker, multiply by 2.8.

Here's a simple chart to follow. If the main flash is 6 feet from the subject, use the following distance factors to reduce the fill flash.

Fill flash	Multiply distance of main flash by this factor	Fill flash distance:
1 stop weaker	1.4	8.4 feet
2 stops weaker	2	12 feet
3 stops weaker	2.8	16.8 feet
4 stops weaker	4	24 feet

Use Flash Ratios

Most likely your dedicated flash recommends the "dreaded and scary" flash ratio controls. Beginners find flash ratios next to impossible to understand, but they are quite uncomplicated once you start using them. Using the dedicated wireless controls in your camera or on the wireless controller mounted in the camera's hot shoe, use flash ratios to control the light output. Before doing this, set the main flash to Group A and the fill flash to Group B. Set the Group A flash that is mounted on a light stand 6 feet from the subject, slightly above it, and 30 degrees to the right of the imaginary line that connects the subject to the camera. Now set the fill flash 6 feet from the subject but close to the line connecting the subject to the camera. Put it on the left side and at the same height as the camera. Notice both the main flash and the fill flash are the same distances from the subject.

To explain the ratio control, let's use two Canon 580 Speedlites and the ST-E2 flash controller mounted on top of the camera. Notice the A:B symbol at the top of the controller. Just because A is on the left does not mean the Group A flash must be left of the camera. It can be placed anywhere. The B Group flash does not have to be to the right of the camera either. In this example, I have them on the opposite sides to emphasize this point. Now using the ratio controls, set the main flash (A) to be two stops stronger than the fill flash (B). Look at

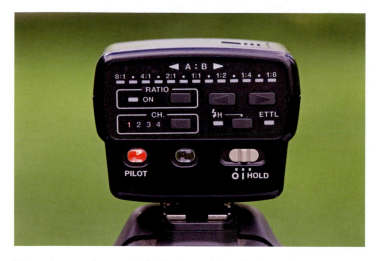

When using more than one flash, this Canon wireless flash controller will allow you to vary the output between the flash units. Notice the ratio control on the rear of the ST-E2. Do not be confused by these numbers. In the middle of the scale, notice where it shows 1:1. Try using two flashes and assign one to Group A and the other to Group B. With the flash ratio control set to 1:1, both flashes emit the same amount of light. If you change this ratio by moving to the left and selecting the 2:1 ratio, the A flash emits twice as much light as the B flash. Move left to 4:1 and the A flash emits two stops more light or four times as much light as the B flash. Finally, going all the way left to 8:1 means the A flash now emits three stops or eight times more light than the B flash. The ratio control can be moved to the right to enable the B flash to emit more light than the A flash.

the ratio scale that appears just below the A:B on the ST-E2. The 1:1 ratio means both flashes will contribute equally to the exposure. Look to the left on the scale and notice the 2:1 ratio. The A flash emits twice as much light as the B flash. It is one stop stronger. Now select the 4:1 ratio on the left side of the scale. The main flash (A) is four times as strong as the fill flash (B). That is a two stop difference—exactly what we want. If you require the fill flash to be three stops weaker than the main flash, set the flash ratio to 8:1. The main flash is now eight times stronger than the fill flash—a difference of three stops.

CONCLUSION

The best way to use automatic flash with flash ratios is to get familiar with them. Once you use ratios a few times, it all becomes intuitive and second-nature. Flash is an amazing tool for upgrading and improving your images. Do not be fearful to use flash. Once you understand the basics, the opportunities for using flash to make exquisite images explode and continue to expand as you gain experience. No longer are you restricted by whatever the ambient light offers you. Flash makes it uncomplicated to create a spectacular light that solves most lighting problems. We think of our flash as a "sun in the box" that we completely control. Mastering flash has opened up a whole new world of possibilities for us. We know it will for you as well!

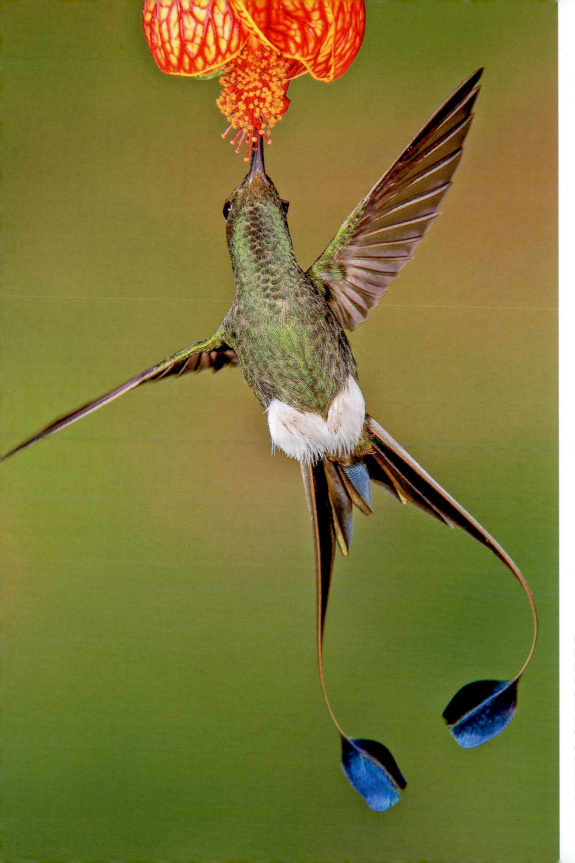

Booted racket-tails are spectacular humming-birds that are frequent visitors to the Tandayapa Bird Lodge near Quito, Ecuador. Here they were attracted to a hummingbird feeder that is disguised with a flower; Barbara used four Nikon SB-800 flash units set to manual and 1/16 power to use the short flash duration to freeze the wings. The background is a photo of an out of focus forest. Nikon D3, Nikon 200–400mm f/4 lens at 350mm, ISO 200, f/20, 1/200 second, Flash WB, continuous autofocus with the back-button control, and SU-800 flash controller to fire all of the flashes simultaneously.

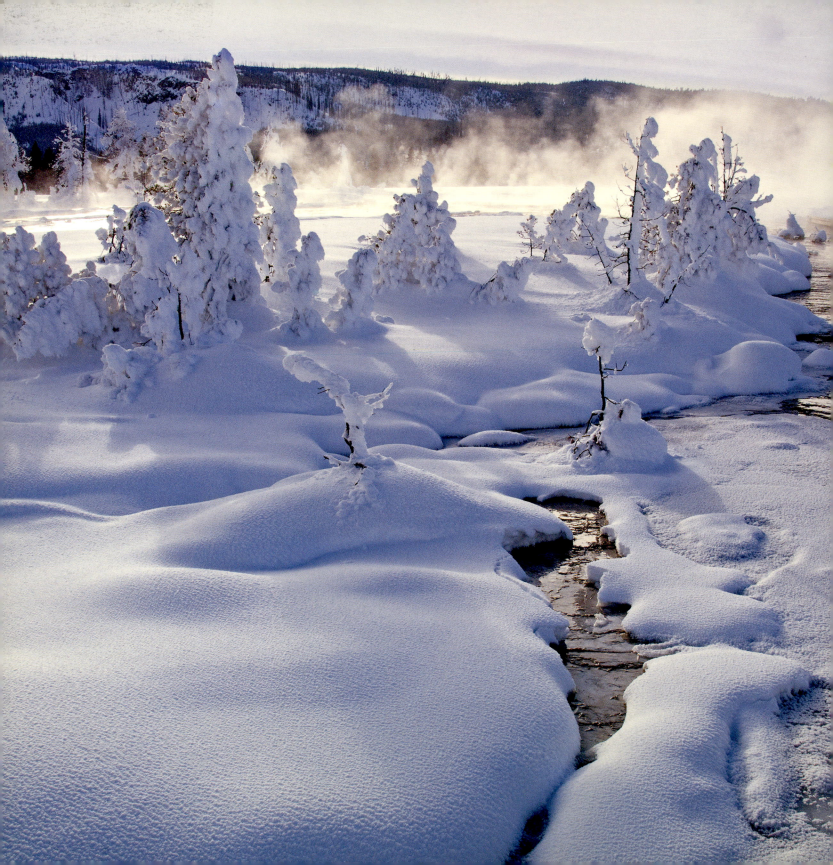

Compose Pleasing Images

LET'S BE HONEST

All too often we hear photography enthusiasts say, "I have trouble with the technical side of photography, but I have a naturally great eye for composing fine images." It is true that some folks tend to see excellent images quicker than others, but most of us (nearly everyone) has to work hard to see pleasing compositions effortlessly and quickly. Beginning and intermediate photographers often overestimate their natural compositional abilities. Why? The technical material is either excellent or terrible. Exposure is either optimum or it is not. Focus is either precise or it is not. Depth of field for the subject is either suitable or it is not. It is easy to decide whether the technical aspects are well done or not.

Composition is clearly a matter of personal preference. If you like horizons passing through the head of the subject, distracting backgrounds, unappealing foregrounds, ugly subjects, crooked horizons, and other problems that most successful photographers strive to avoid, who am I to say that this choice of "seeing" should be avoided? The same goes for composition. Barbara and I feel the technical photo information is straightforward, but seeing excellent compositions is far more difficult. During our forty-year careers, we never assumed we had a naturally good "eye" for successful images. Instead, we worked diligently to develop our compositional style and ability to see and perceive the possibilities. This process continues to evolve. Our abilities to see desirable images constantly improve from week to week, even after all of these years of doing photography full-time as a passion and to earn a living. Here are a few things we have learned.

It is difficult to describe being in a Yellowstone geyser basin on a sunny day in January. The clash of hot water and frigid air temperature creates a mesmerizing scene. We have led over one hundred week-long photo tours in Yellowstone over the years and despite that still enjoy photographing these mystical scenes. This image was made a few years ago. Today Barbara would use manual exposure and focus stack the scene to achieve the ultimate in sharpness. Nikon D300, Nikon 24–70mm lens at 28mm, ISO 400, f/18, 1/250 second, Sun WB, aperture-priority, autofocus using back-button control.

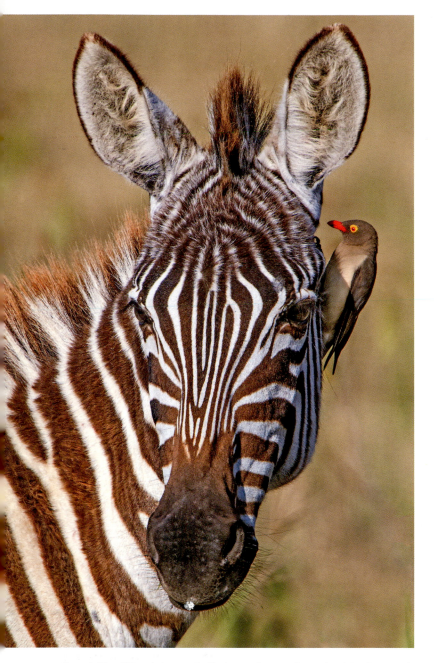

Kenya's Masai Mara is famous for the tremendous number and variety of mammals effortlessly photographed in the rolling grasslands. While making this simple portrait of a Burchell's zebra, the image suddenly became far more interesting with the arrival of a red-billed oxpecker hunting for insects to eat. This simple clean composition is our goal that we strive for. Nikon D300, Nikon 200–400mm lens with a 1.4x teleconverter at 650mm, ISO 400, f/10, 1/800 second, Cloudy WB, manual exposure with autofocus on the back-button control.

COMPOSITIONAL GUIDELINES

SIMPLIFY THE IMAGE

Beginning photographers tend to snap away at any subject that attracts them with little regard to all of the objects included in the image. Accomplished photographers are careful to select the best shooting viewpoint and use proper equipment to eliminate unnecessary elements from the image. If the background is busy with distractions, they figure out a way to prevent or at least reduce this problem. If the foreground is especially attractive, they choose a lens and shooting angle to beautifully accentuate the foreground. In most cases, it is best to simplify and isolate the main subject that drew your attention initially while at the same time eliminating or minimizing other elements competing for your attention. Look at the images that appear in this book. Notice the way all are well-illuminated strong images that are clean and simple. The key subject is never hard to discern in any of the images.

COMPOSE HANDHELD

When shooting landscape images with short focal length lenses, it is effective to choose the lens you think works best. Then walk around and look closely and often through the camera's viewfinder before mounting the camera on the tripod to find the strongest composition. The tripod makes it more difficult to attempt a variety of different compositions because it is clumsy and takes too long to adjust the legs. Handholding is fast and convenient. Once you see an outstanding composition in the viewfinder, mount the camera on the tripod and fine-tune the composition. Composing handheld and subsequently bringing the tripod in works especially well when photographing large subjects with short lenses. It's just the opposite when using big and heavy lenses that are difficult to handhold, or shooting close-ups where precision is crucial. Then it is best to compose with the camera already attached to the tripod.

Attaching an L-bracket to the bottom of the camera that provides a quick release plate in two places works extremely well. If the lens being used has its own tripod collar, then be sure to buy a quick release plate custom made for the lens's

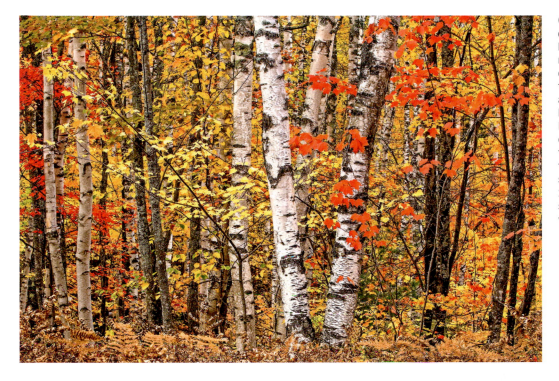

Our autumn photo workshop clients are initially overwhelmed and struggle with photographing Pictured Rocks National Lakeshore's magnificent White Birch Forest when it is at peak color. How does one make sense out of all of the white birch trunks amid the intense yellow and red colors? This is a perfect time to hand-hold the camera and walk through the forest looking for the best color patterns and groups of tree trunks. Once an exciting image is spotted in the viewfinder, mount the camera on a tripod and use the best technique possible to shoot an impressive image. Nikon D2X, Nikon 28–200mm lens at 78mm, ISO 200, f/16, 1/2.5 second, Cloudy WB, manual exposure mode with AF-C autofocus using back-button control.

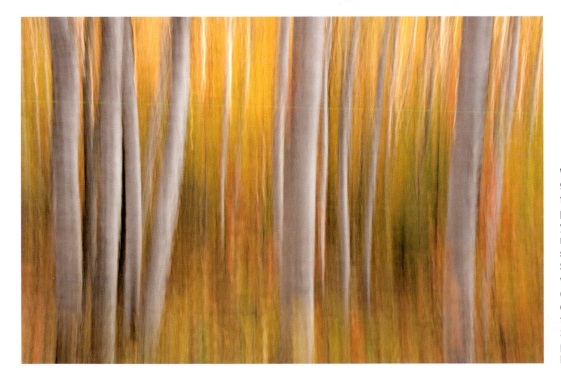

We use a sturdy Gitzo tripod to make more than 90 percent of our images. However, there are times when blur is our goal. We love the blurry pattern created by the white birch trunks and yellow maple leaves. Barbara focused on the nearest tree trunks and panned her camera slowly up to emphasize the vertical tree trunks. She shot numerous images because her results varied with the shutter speed in use and how quickly she panned the camera. This is one occasion where there is no reason to use a tripod! Nikon D300, Nikon 24–70mm lens at 38mm, ISO 200, f/11, 1/1.6 seconds, aperture-priority, Cloudy WB, autofocus using AF-C and back-button control.

Anytime action is implied or real, it is compositionally successful to compose the subject to allow it to move into the image. Barbara and her two horses—Bandit and Joker—are too centered with equal amounts of room in front of and behind the two horses. I used ISO 800 to reach a shutter speed of 1/800 second to capture a sharp image. Canon 1D Mark III, Canon 70–200mm f/4 lens at 160mm, ISO 800, f/5.6, 1/320 second, Cloudy WB, manual exposure, AI Servo AF on the shutter button.

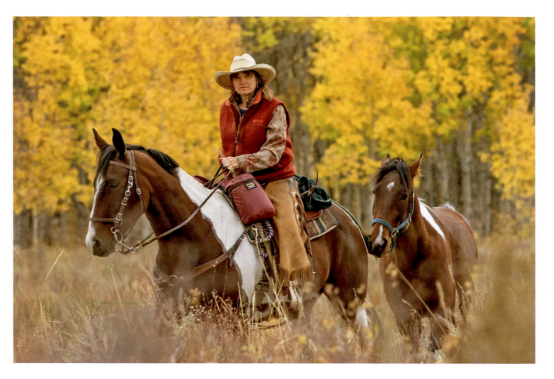

Cropping the image on the right side leaves additional space on the left to allow this exceptional pair of horses and gorgeous rider (I hope to win points here) to canter into the image. In most cases, be sure to avoid removing any portion of the main center of interest—Barbara and the two horses—when cropping the image.

tripod collar. Using a tripod head that accepts these quick release plates makes it simple to attach or remove the camera from the tripod head. This may seem like a small point, but the convenience is immense and greatly appreciated once you have it.

KEEP THE HORIZON LEVEL

To eliminate crooked horizons, avoid tilting down to one side of the image. A lake should be level in the image, not tilted down to one side. A duck swimming on calm water should be level with the surface of the water. It isn't easy to determine when things are perfectly level by just eye-balling it. Use the level in the camera—if your camera offers it—or attach a level to the hot shoe and level the camera with that. Some cameras let you insert another viewing screen in the camera that offers lines to keep things level. This works so well that many cameras now enable you to turn on built-in grid lines in the viewfinder. Even with the leveling aids, many images are not perfectly level. Fortunately, image processing software offers leveling tools that make it a breeze to level the image later. Don't overdo it, though. Often a portion of the image must be eliminated to make things level. If you hope to produce a large print, you don't want to lose too many photosites and reduce the resolution.

SUBJECT PLACEMENT

Don't Center the Subject

Beginners tend to place a dominant subject squarely in the center of the image. In the old days before multiple autofocus points, this happened a lot because the only focusing point or focusing aid was in the middle of the viewfinder. Now that cameras have multiple autofocus points, it is a mystery why the practice continues. Perhaps it is just human nature to center the subject. A dead center (bull's-eye) composition tends to be boring and becomes monotonous when nearly every subject is centrally situated in the image. Usually, the natural lines in the image suggest placing the main subject somewhere else. Always look for a reason to place the subject off-center because that entices everyone who views the image to visually wander through it.

There are exceptions when a dead center composition is desirable. Placing a snarling African Lion big and dead center in the image grabs your attention immediately. When photographing an animal or human in action, if it is running from left to right, place the subject on the left side of the image to give it room to visually "run" into the image. Do the opposite when the subject is running right to left. The problem is that composing a moving target is quite difficult. All too often if you try to put the subject on one side of the image or the other, you accidently cut off part of the subject. To reduce the problem of cutting off legs and tails—the two parts most likely to be cut off—put the subject dead center in the image. Now crop the image a little to allow the subject to appear to be moving into the image. This tactic works tremendously well for flying birds and airplanes. If the birds are flying to the right, focus them in the image by shooting a little looser than you might otherwise if they were still stationary, and then crop some of the image behind them. Don't overdo making the subject smaller to allow for cropping. If you make the subject too small in the image, you might not have enough photosites on the primary subject to make a large print due to the resolution being inadequate.

The Rule of Thirds

This well-known "rule" for composing a more pleasing composition is a useful guideline that works most of the time. It is uncomplicated to follow. Divide the image into thirds both horizontally and vertically. The lines intersect in four spots called *power points*. These points suggest a suitable place to put the main subject in the image, rather than in the middle of the image. This does not mean all four power points work for most images, because they don't. You still must identify the natural flow in the image. For example, if you compose a river scene that includes a waterfall in the top left corner, the waterfall is the dominant subject. Placing it on the upper left power point while letting the river meander diagonally toward the lower right power point makes the most sense. In the case of animals, the natural flow is nearly always in the direction the animal is looking. If a bird is looking to the left,

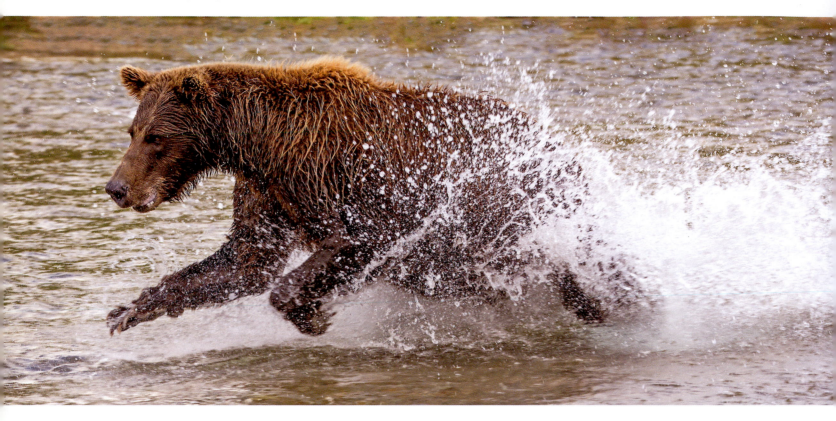

It makes perfect sense to compose this coastal brown bear by allowing more space behind it even though the animal's face is pointing out of the image and the bear's head is close to the edge. The frothy splashes reveal the energy being exerted as the bear attempts to run down a salmon that is desperately trying to avoid a "dinner date" with this ravenous bruin. Nikon D4, Nikon 200–400mm lens at 240mm, ISO 800, f/8, 1/400 second, Cloudy WB, AF-C using back-button focus control.

then the two most obvious power points to consider for placing it would be on the lower right and the upper right. This allows the bird to look through the composition.

An excellent way to use this power point guideline is putting Polaris (North Star) on one of the power points when shooting star trails. Polaris remains stationary while all of the other stars rotate around it—a very pleasing effect.

Remember this "rule" divides things up into thirds. It works for landscapes, too. If the sky is the most dramatic part of the image, then compose the scene so the sky occupies two-thirds of the image and the foreground fills one-third, which would produce a pleasing composition. Should the foreground be more interesting than the sky, let the foreground occupy approximately two-thirds of the image and let the sky fill the

remainder. Don't get too hung up on percentages, though. We commonly allow the foreground to fill 70–90 percent of the image and use little sky when it isn't especially attractive. When the sky is boring, we compose it out of the image altogether.

LANDSCAPE OR PORTRAIT ORIENTATION?

The landscape orientation is a horizontal composition. Most photographers shoot far more horizontals than verticals because the camera naturally fits our faces better when it is held horizontally and the camera controls are easier to use. A vertical image is routinely called a portrait orientation and works best when the subject is taller than it is wide. A tall giraffe is an obvious vertical whereas a short and wide white

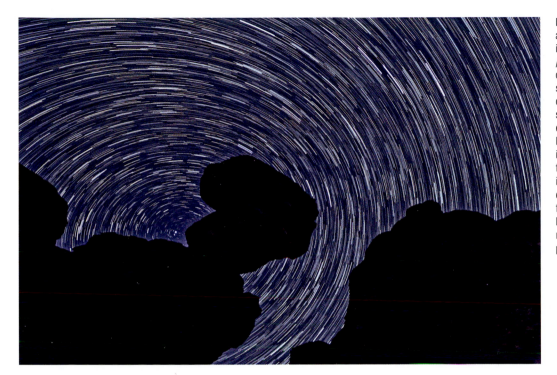

Divide the image into thirds both horizontally and vertically with imaginary lines. These lines intersect at four points that are commonly called *power points*. Often placing the main subject on one of these points makes a stronger composition than placing the primary subject dead center in the image. The dominant object in this scene—the famous Balanced Rock in the southern Idaho desert—is effectively placed on the lower left power point. The power point concept is not a rule, but when used, it at least keeps you from putting the main subject in the center of the image, which is considered the dreaded "bull's-eye" composition. Nikon D4, Nikon 14–24mm f/2.8 lens at 14mm, ISO 3200, f/2.8, 20 seconds, Incandescent WB, manual exposure mode and manual focus. Ninety images were merged to produce this image using StarStaX software.

The four lines illustrate the *power point* composition guideline. Using it works well to keep you from positioning too many subjects in the middle of the image. This guideline doesn't say "all of the power points work at the same time" because they almost never do. If you had a ground squirrel standing upright and looking to the right, use the left power points to allow the squirrel to peer into the image.

rhino usually fills the image nicely as a horizontal or landscape image. This is only a guideline! A lofty giraffe could make a fine horizontal if composed loosely enough to avoid cutting off any of the giraffe while allowing the animal to look into the landscape scene. An equally fine image could be a tight vertical portrait of a rhino peering directly at you.

Many subjects—especially landscapes—work splendidly as both landscape and portrait oriented images. Indeed, an attribute of a skilled photographer is the ability to find horizontal and vertical compositions of the same subject. Highly experienced photographers accomplish successful images using different focal lengths, too. Shooting the scene in different ways allows you to select the more successful images later.

THE IDEAL NUMBER OF SUBJECTS

When I first began to shoot images in 1972, a well-meaning photo friend gave me an article that listed and explained the "rules" of composition. One of the rules stated that the

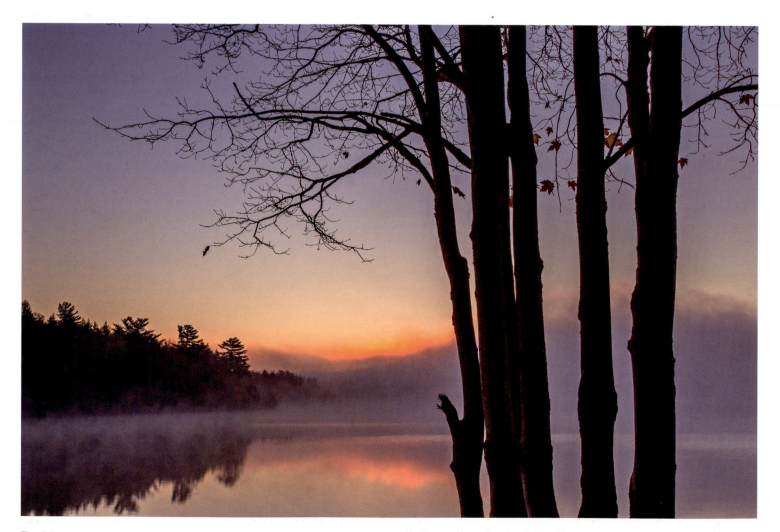

The rising sun creates a pink colorcast in the fog drifting over Pete's Lake in northern Michigan. The horizontal composition emphasizes the far eastern shoreline that comprises white pine trees and fog. Canon 5D Mark III, Canon 24–105mm f/4 lens at 34mm, ISO 200, f/18, 1/50 second, 10,000K WB, manual exposure mode, AI Servo AF using back-button control.

number of subjects should be odd numbers. One, three, five, seven, and so on work as the correct number of subjects. Even numbers—two, four, six, etc.—did not. When I asked the reason why, it was that you could visually divide a group of two deer into one and one and four blossoms into two and two. Of course, I countered that I could easily divide a group of three mushrooms into two and one or five apple blossoms into three and two or four and one. This "rule" never really made sense to me. However, I do agree that an odd number of subjects often appears to fill the image more pleasingly than an even number, so now I notice odd numbers of attractive subjects quickly. Nevertheless, when I find an attractive even number group of subjects, I shoot them anyway and they still make appealing images.

LINES

Horizontal lines are everywhere in our world. The flat horizontal line of the far horizon is a common one. Horizontal lines tend to be quiet and provide a solid base to support the main subject. They are not good for suggesting movement, but do work as a solid anchor. If you find overlapping horizontal lines—perhaps a series of sand dune ridges—then these lines definitely add significant interest to the image.

Vertical lines suggest rapid movement and help subjects to "tower" in the image. Vertical images of the vertical lines towering trees produce or the walls of buildings are quite effective in well-composed images. Look for vertical lines and use them whenever it makes sense. Diagonal lines suggest strong movement and are quite pleasing in a first-rate composition. River scenes work well as a diagonal with the river flowing from the upper part of one corner of the image down to the opposite lower corner. Always consider using diagonals when you find them in the scene. Usually choosing the appropriate viewpoint allows you to use them to best advantage. The well-known "S curve" composition for a river is effective when the river is diagonal in one portion of the image and then turns back the other way to make another diagonal line that appears similar to the letter "S" in shape.

Many scenes can be successfully composed horizontally and vertically. In the previous image, the horizontal composition emphasizes the white pine trees and the foggy shoreline. The vertical composition emphasizes the sky and the upright trunks of the red maple trees in the foreground. Canon 5D Mark III, Canon 24–105mm f/4 lens at 45mm, ISO 200, f/20, 1/30 second, 10,000K WB, manual exposure mode, AI Servo AF using back-button control.

The boiling water discharged from the hot springs carves twisting patterns in the snow. The strong diagonal line beginning in the lower right corner that meanders to the upper left corner drew Barbara's attention. The steam from the hot pool and the trees in the background complete the composition. Nikon D300, Nikon 18–200mm lens, ISO 200, f/13, 1/60 second, Sun WB, manual exposure and back-button autofocus.

EFFECTIVE VIEWPOINTS

Selecting the optimum spot to shoot the image is essential for producing desirable images consistently. Sadly, most shutter-bugs photograph everything from eye level while standing. Others always shoot close to the ground, even when it makes no sense. Skilled photographers are quick to react and adjust their viewpoint for the situation.

A high viewpoint from an airplane, hill, or even from a step-ladder is terrific when you want to emphasize the landscape in front of you. Shooting down on a huge field of tulips, cracked mud, or autumn-colored leaves float-ing on a pond is effective. For example, sections of Grand Prismatic Spring in Yellowstone National Park photograph best from a high hill on the south side of this colorful thermal

A high hill on the south side of Grand Prismatic Spring in Yellowstone National Park is a superb vantage point in the late afternoon sun. The swirls of color in the spring and the patterns are nicely captured by shooting down at it. Quite often it is possible to choose the viewpoint. At times an eye-level standing viewpoint works best. Occasionally being low to the ground is the best choice and frequently a high viewpoint, especially for landscapes, produces the best images. A polarizer is necessary to remove most of the glare from the hot spring in order to reveal its color. Canon 20D, Canon 300mm f/4 lens, ISO 200, f/22, 1/45 second, Cloudy WB, manual exposure and autofocusing using back-button focus.

feature. Use a polarizer to remove the glare and make the stunning colors truly pop. Aerial images of the spring are incredibly spectacular, although it's costly to rent an airplane and you must also obtain special permission from the park to fly close enough to shoot it properly.

The viewpoint you obtain if you stand will still work for many situations. If you don't have a nearby strong foreground, then there isn't much of a reason to get down lower. Of course, if you are silhouetting a tree against the sunrise and getting lower puts more of the tree trunk up against the sky, then get lower. Standing up is a suitable viewpoint when you have a strong foreground and are using a wide-angle lens. By shooting down on the foreground, more of the foreground can be seen in the image. Many photographers immediately get

Too many photographers go on a once-in-a-lifetime safari to Kenya and photograph everything from the roof hatch of their safari vehicle. This high viewpoint works fine for the larger animals like elephants and giraffes, but the smaller animals and birds on the ground aren't nearly as appealing when this high aerial viewpoint is used. When photographing the smaller animals like this Kirk's dik-dik, use the lowest vehicle window to bring you closer to the animal's height to produce a more intimate image. Nikon D300, Nikon 200–400mm lens at 340mm, ISO 1600, f/4, 1/1000 second, Cloudy WB, aperture-priority.

down low with a wide-angle lens, but if you are too low, you lose much of the foreground.

Shooting close to the ground is worthwhile for many scenes and subjects. It is incredibly effective for photographing a waterfall where the shooter can be in the river. We love the viewpoint we get with a 16mm lens that is only about 1 foot from a rock in the river that leads the viewer's eye up to the waterfall in the background. Many enchanting subjects— salamanders, frogs, mushrooms, snails, flowers, lichens, etc.—are found living on the ground or close to it. Often the low on the ground viewpoint is the best shooting viewpoint. A common mistake we see many Kenya wildlife safari shooters make is photographing everything from the roof hatch on top of the safari vehicle. This high viewpoint works for a tall African elephant, reticulated giraffe, and a hooded vulture that perches in a tree, but makes little sense for a bat-eared fox, dwarf mongoose, or black-bellied bustard that is most likely on or close to the ground.

For wildlife photography, the optimum shooting angle is typically at the level of the animal's eyes or slightly below. It makes the animal more dominant in the image. It is easier to get the low viewpoint by using a telephoto lens because by increasing the shooting distance, you do not have to be as physically close to the ground.

SELECT A SUITABLE BACKGROUND

Images are most pleasing when the background is uncluttered and doesn't compete with the subject for the viewer's attention. Distracting backgrounds are enormous problems in the images of beginning photographers and occasionally even those of more experienced shooters. Normally, it is best to seek a background that is a homogeneous color and is slightly darker than the subject. A bright background behind the subject is distracting and unappealing. Naturally, there are exceptions. A tree or animal silhouetted against a spectacular rosy sunset makes an outstanding image, and the sky is clearly the brightest portion of the image. An appropriate background is often an out of focus meadow, forest, blue sky, or water. Avoid backgrounds where the horizon line passes

through the subject. I've seen far too many images of animals where the horizon line cuts through the head or neck. Try for all sky or all meadow backgrounds. Controlling the background is crucial for capturing compelling images with ease as well as consistency. Let's look at several key tricks for controlling the background.

1. Select a shooting angle in which the background is a uniform color and evenly lit.

2. Use a longer focal length lens. The angle of view, and thus the field of view, diminishes as the focal length increases. It can be difficult to capture a photogenic background with a 50mm lens because the angle of view is wide, but a 500mm lens has such a small angle of view that you have to work hard to make the background look horrible.

3. Shoot using apertures in the range of f/2.8 to f/5.6 to allow the shallow depth of field obtained with these apertures to keep the background out of focus.

4. When shooting close-up images, it is easy to insert an out of focus background behind the subject. Shoot some images of flower groups that are completely out of focus, make a print of the unfocused flowers, and insert the print behind the subject. The background remains out of focus even when you stop down to f/22 to photograph the subject.

5. Find a subject where the background is farther away. If you have two equally good flower blossoms but one has other objects 1 foot behind it and the other has nothing behind it for 20 feet, the second one with the more distant background will have a more diffused background at all apertures.

6. Use focus stacking to minimize background distractions. Selective focus is a popular technique for isolating a single subject—a flower blossom for example—amid other flowers that may be in both the foreground and the background. It requires you to shoot using the f/stops on your lens that have the shallowest depth of field. The maximum aperture on the lens—f/2.8 or f/4 in most cases—provides the least amount of depth of field. Of course, even when you shoot using the maximum lens aperture, the depth of field most likely still will not cover the single blossom either. If you want the primary subject to be completely sharp while keeping the foreground and background as unfocused as possible, use focus stacking. Set the lens to the maximum aperture. Now focus on the leading edge of the flower and shoot the image. Focus slightly deeper into the flower and shoot another image. Keep this up until you shoot the final image in which the rear

Calypso orchids grow on damp hillsides in the forest during June near Island Park, Idaho. Since they stand only about 7 inches tall and live amid many other plants, the small orchids are usually photographed with a chaotic background. This would have been the case here, too. Fortunately, a photographic background that I deliberately shot out of focus for hummingbird photography doubled nicely to use as a clean background about 6 inches behind this gorgeous group of orchids. I focus stacked this group of blossoms by shooting nine images to achieve the ultimate in depth of field and overall image sharpness. Canon 5D Mark III, Canon 180mm macro lens, ISO 100, f/8, 1/10 second, Cloudy WB, manual focus and exposure, Helicon Focus software merged the images.

Yellow-bellied marmots commonly rest on rocks near the summit of Mt. Evans in Colorado during late June. Once when I found an individual marmot who did not mind being approached closely, I selected a shooting viewpoint that would produce an uncluttered background. Canon 5D Mark III, Canon 800mm f/5.6 lens, ISO 400, f/11, 1/400 second, shutter-priority, autofocus using the back-button control.

of the blossom is sharply in focus. Take this stack of images and run it through focus stacking software. The blossom will be completely sharp while the foreground and background remain out of focus.

7. When you have an opportunity to select a more suitable background, be sure to take advantage of it. When I am directing my driver in Kenya, I determine the location to stop by taking existing light into consideration, the clear open path to the animal in mind, closeness to the subject, and the available background choices. If you move the subject around—perhaps a potted flower, horse or child—always pick a spot where the background is pleasing. When photographing a wild-flower, often a Plamp can be used to slightly bend the stem forward or backward without harming the flower to achieve a more pleasing background because it allows a different shooting angle.

Obviously, there are many ways to control the background. It is important to prevent the background from ruining the image. Once you find a potential subject, always consider the background and do what is necessary to subdue it. Your images will benefit from your foresight!

AVOID EDGE CLUTTER

Once you have controlled the background, always scan the edges, especially all four corners, of the image for unsightly distractions. Chaotic lines and bright blobs—whether in focus or not—are common distractions that are never beneficial to the image. Try to eliminate them by selecting a different shooting angle or by physically removing them from the image, which is often called gardening. In close-up photography, removing offending distractions is easy and quick. Admittedly, cleaning up a less than desirable background can be done with software such as Photoshop. When photographing larger objects, moving the shooting viewpoint is usually necessary.

DEPTH ADDS DRAMA TO THE IMAGE

The images you capture in the camera are two-dimensional. There is a width and height, but no depth. Fortunately, depth can be suggested in many images with the wise use of lenses and light. Use a wide-angle lens close to the subject to create a large looming foreground that quickly diminishes the size

Beginning with the near shoreline, the rock starts the viewer's journey into the image of Bow Lake in the Canadian Rockies. Having interesting objects in the near foreground is an excellent way to convey depth. The contrast in the light on this scene is significant, so seven exposures were shot by varying the shutter speed one stop. Nikon D300, Nikon 18–200mm lens, ISO 200, f/18, shutter speeds of 1/1.3, 1/2.5, 1/5, 1/10, 1/20, 1/40, and 1/80, Cloudy WB, manual exposure and AF-C using the back-button focus control.

of the objects in the background. Sidelight and backlight also suggest depth because the shadows these light directions create reveal textures and shapes.

Changing the perspective suggests depth, as well. If you photograph a subject up close with a wide-angle lens, the object will appear to be much larger relative to other objects in the background. This change in perspective suggests there is considerable depth between the foreground and background. Conversely, if you stay further away from the subject in the foreground and use a longer focal length lens, the background appears larger relative to the foreground.

MORE ON PERSPECTIVE

In photography, perspective refers to the relative size of the foreground and background objects. If you stay further away from the foreground and use a longer focal length lens, the objects in the foreground appear to be smaller relative to the background objects. If you move in close to the foreground and use a wide-angle lens and make the foreground object the same size as it was in the other image, the perspective changes because the background objects appear smaller.

A common assumption is that different focal length lenses change the perspective. They do not. Perspective is changed only by changing the shooting distance. Using a real world example, staying further away from an old rustic cabin and shooting it with a longer focal length lens makes the mountains in the background tower above the cabin. If you move in close to the cabin and use a short focal length lens, the cabin appears much larger than the mountains behind it, even though in both images the cabin is composed exactly the same size and in the same position. Perspective is only changed by adjusting the shooting distance. It cannot be altered by staying in one spot and using different focal lengths.

SHOOT STUNNING PANORAMAS

A panorama is a tall or, more often, an extremely wide scene that is appealing over its entire length. Most scenes are not good panorama prospects, but some subjects demand the panorama treatment. Examples of ideal panorama themes include

This old farm house in central Texas is meticulously framed with the tree in the foreground. Nikon D3, Nikon 28–200mm lens at 56mm, ISO 200, f/16, 1/80 second, aperture-priority, Cloudy WB, manual focus and metering.

Notice the tree appears larger compared to the size of the house in this image. What you are seeing is a change in perspective in which the size of the foreground and the size of the background alter relative to each other. To make this image, Barbara moved closer to the tree and shot the scene with a 32mm focal length. To change the perspective, move the shooting position closer or further away from the foreground. To make the background larger relative to the foreground, stay back and use a longer focal length. To enlarge the foreground relative to the background, move closer to the foreground and use a shorter focal length. Nikon D3, Nikon 28–200mm lens at 56mm, ISO 200, f/16, 1/80 second, aperture-priority, Cloudy WB, manual focus and metering.

autumn colors perfectly reflected in a still lake, rolling sand dunes, the red rock canyons of Utah's Bryce Canyon National Park, a gorgeous raging mountain stream that leads up to a waterfall, a series of buildings in a well-preserved ghost town, meadows abounding with a kaleidoscope of multi-hued wildflowers, rolling prairies, or coastal beach scenes. A panorama could be wildlife, too. A huge flock of snow geese roosting on a pond or a flock of shorebirds resting on the beach could work as a panorama, but only if their movement is minimal.

Panoramas work whenever interesting elements occupy the length of the scene and everything is close to the same distance from the camera and illuminated with attractive light. Advanced photographers may consider combining HDR and focus stacking techniques to create a panorama.

How to Shoot a Panorama

1. Level the Tripod

A successful panorama requires the photographer to shoot two or more images to cover the scene. It is important to make certain the camera is level. The tripod must be level on the ground, so use a tripod with a built-in bubble level. Carefully adjust each of the three legs until the bubble is centered in the level. Leveling takes a little while to do as slight changes in the legs greatly affect the bubble level. Take your time and move the legs in small increments.

When panoramas became popular several years ago and easy to shoot with digital capture, some tripod head makers began building leveling heads for the tripod. These devices make it easy to level the mount that supports the tripod head in only a few seconds. If you plan to shoot a lot of panoramas, be sure to get a leveling head (also called leveling base) that works on your tripod legs. For example, Gitzo, Acratech, Manfrotto, and others all build devices to aid in quickly leveling the tripod head. Since products come and go, search the Internet for

Au Train falls is a series of cascades over a 200 yard section of a river near Au Train, Michigan. This cascade shot was taken with a 24mm wide-angle lens placed close to the foreground to emphasize it while nicely composing the falling water in the background to impart a strong sense of depth to the image. This cascade is extremely wide, so Barbara shot eight vertical images from left to right and overlapped each by 30 percent. She combined them into one panoramic image with the Photomerge feature in Photoshop CS6. Nikon D300, Nikon 24mm lens, ISO 200, f/16, 1/1.3 seconds, Shade WB, manual exposure and autofocusing with the back-button technique.

"leveling base" and "leveling head" and many current choices will appear that fit all budgets.

2. Level the Camera on the Tripod

Shooting on a level tripod does not automatically mean the series of images will be level when you shoot. The camera on the tripod head also must be level. We use and recommend sturdy ball heads. Therefore, the camera must be level on the ball head or any other tripod head you use. Leveling the tripod head is easier to do than leveling the tripod legs. Loosen the tripod head and then use a Double Spirit Level from Hama mounted in the camera's hot shoe. Level the bubble to make the camera level from right to left. It is helpful to level the camera from the front to back as well, but often the composition requires the camera to be tilted forward or backward slightly to accommodate the composition. If so, then don't worry about leveling this direction and the results should be fine. Some cameras offer a built-in horizon level. If your camera offers this feature, then activate the level to make it appear on the camera's rear LCD display. Now adjust the angle of the camera until it is level as shown by the built-in leveler.

3. Use Manual Exposure

Do not allow the exposure to change in any of the images that will be part of the final panorama image. It is best to do this by using the manual exposure mode. In this mode, the camera cannot automatically change the exposure, unlike all the automatic exposure modes.

Should you use aperture-priority, for example, the camera might use f/16 (the aperture you set) and 1/30 second for the exposure when the camera is pointed at the darkest side of the scene.

Perhaps it is darker because deep-green pine trees occupy this area. As you shoot images and pan the camera to fully photograph the expansive scene, the subjects change to bright yellow aspen trees ablaze in their autumn glory and all of the trees are reflected in still water. Now the camera is "looking"

at a larger percentage of light tones. It automatically adjusts the exposure to compensate for this, creating an underexposure problem. The sky becomes considerably darker above the aspens. In the final panorama image, the brightness of the sky will vary tremendously from dark to light across the image and look unnatural. Determine one exposure for the entire scene. Remember the worst exposure sin you can commit with the digital image is to overexpose important highlights with detail—the yellow aspen leaves in this example—because you lose all detail in the leaves. Therefore, set the exposure for the brightest part of the scene where highlight detail must be kept using the ETTR guidelines. Use that exposure for all of the images.

4. Don't change the ISO, Exposure, White Balance, and Focus

While shooting the set of images that will make up the final panorama, keep all of these options the same. However, we sometimes change the focus slightly when one side of the scene is significantly closer than the other side and we obtain favorable results. It is possible to combine focus stacking with a panorama image. If you are shooting three images to encompass the entire scene, determine where the first image begins, using focus stacking to cover the depth of field, then move the camera over and overlap the first image by about 30 percent and focus stack the next image. Do the same for the third shot. Combine the left, middle, and right sets of focus stacked images separately. Then take the three focus stacked images that represent the left, middle, and right portion of the scene and stitch them together with software.

Lock in the white balance. If one part of the image is primarily yellow in the golden sunshine and the other is blue water in the shade, keep the same white balance setting for both. That requires using a preset WB value such as Cloudy, Shade, or Sun. In this example with sun on the aspens, use the Sun WB. Auto WB automatically varies so it will change the colors from one side of the image to the other. Therefore, avoid Auto WB for pans.

Barbara shot nine vertical images to cover the wide expanse of the Milky Way as seen from Lake Ha Hand in the Lee Metcalf Wilderness. She overlapped each image about 30 percent—more or less—because this judging overlap is difficult to do in the dark. She stitched the nine images together using Photomerge in Photoshop CS6. Did you notice we use 3700K as a white balance choice for our star shots? If your camera has the K white balance option, select it and then dial in 3700K. If not, try the tungsten white balance option. Nikon D4, Nikon 14–24mm 2.8 lens at 14mm, ISO 5000, f/2.8, 20 seconds, 3700K WB, manual exposure and focus.

5. Focusing

We use back-button focusing, but manual focus works fine, too. Back-button focusing is quick and prevents the lens from focusing on the wrong spot when the shutter is tripped with a cable release. If you use manual focus, it is best to use a magnified live view image to determine precise focus.

6. Shooting the Images

It does not matter if you start on the left or right side of the scene. Pick whichever side works best for you. Composing the scene is a little counterintuitive. For a horizontal panoramic image, set the camera on the tripod to the vertical (portrait) orientation. That seems odd because you want to cover the horizontal expanse of the scene. Use the portrait orientation and don't compose too tightly to give you more room above and below the part of the scene that will occupy your final image. If you shoot horizontal images or compose too tightly as a vertical, often one side of the image is slightly cut off if the camera and tripod are not perfectly level. For example, you do not want the top edge of the image to cut into your spectacular trees on one side of your panorama. Do exactly the reverse of this if you are shooting a vertical pan.

An image shot to be part of a multi-image panorama usually makes a silly composition. To avoid deleting it later because

the composition makes no sense and you forgot you were shooting a pan, shoot a quick out of focus image of your hand in front of the lens to mark the start of a pan series. Then shoot the first image. Pan the camera over so the second shot overlaps the first by about one-third and shoot another image. Overlapping allows the software to align the elements in the image to create one continuous image where everything lines up properly. Keep overlapping shots until you capture the final image. Then photograph your hand again to mark the end of the set.

This entire process might sound like a lot of work with scores of things to remember, but once you do it a few times, it is uncomplicated and regularly yields satisfying images that will make you happy, look excellent on your web page or print on the wall, and add variety to your portfolio.

Assembling the Panoramic Image with Software

There are plenty of ways to do it. Although Photoshop can do it, the software is expensive and the learning curve is high. Barbara excels at Photoshop and easily makes it dance to her commands. I can proudly state that I am one of the best Photoshop launchers around because I can double-click on the program icon as well as anyone, but, after that, what happens next is and will most likely remain a total mystery to me. I prefer to use dedicated stitching software that is easily understood to make my own panoramas.

Canon Photo Professional

Every new Canon camera comes with the latest version of Canon's proprietary software called Canon Photo Professional. It offers a way to assemble panoramas with JPEG images, so it is limited in what it can do, but it is a place to start.

Other Software Choices

Search the Internet for "panorama software" and you'll find plenty of options, including free software. Although we have not tried any of these, well-known software includes www. arcsoft.com, www.ptgui.com, and www.panavue.com. Free

stitching is available at www.thefreecountry.com. If running computer programs makes you nervous, I can sympathize with you. Fortunately, stitching images together to produce a panoramic image is one of the simpler processes. Even I can do it!

THERE ARE NO RULES!

This chapter presented a set of guidelines that will help you compose more compelling images and do it consistently. I made many suggestions here, but, remember, there are always valid exceptions. Avoid making photo composition too scientific. Composition is the way the elements in a scene are arranged to make a pleasing image. It is subjective! You like what you like, everyone will develop their own vision, and it constantly changes over time as we all gain experience and new photo techniques become available.

As I write this, my interest in reshooting the geysers in Yellowstone has been rekindled because now I can easily photograph geysers erupting against the stars in the night sky while using a radio-controlled flash or a strong flashlight to illuminate the geyser from the side or behind. I now look forward to returning to Bryce Canyon to focus stack the incredible rock structures while using HDR techniques at the same time. Perhaps I will combine HDR, focus stacking, and a panorama all in one image. The opportunities to compose and shoot exceptional images that were virtually impossible only a few years ago are now readily available.

Always carefully think about what makes the best composition. Be willing to change how you view things and consider new angles. Keep things simple. Find attractive subjects in a favorable situation. Use excellent technique to capture memorable well-composed images. And most of all, do not assume you are naturally good at composing. Most of us need to refine our "photographic vision" in the beginning. The process is ongoing throughout our photo careers. For many—if not most photographers—composition is more challenging than all of the technical aspects in photography. Look at the many excellent photos that appear in books, magazines, and

on the Web. When you find an image you like, ask yourself why you like it. Is it the subject, viewpoint, lighting, technique, sharpness, or softness, or is it something else? Most likely, the images that appeal to you are a combination of these and other factors. It is a fact that some people are naturally more gifted at seeing a fine image and making a strong composition. Barbara is naturally better than I am, but I've improved tremendously over the years and continue to do so. Here's the best news! Everyone can learn to compose dramatic images, as with the more technical aspects of photography, you must continually strive to improve—and you will. It is a fun and rewarding learning process!

Sharply focusing on this African white pelican as it glides over Lake Nakuru while simultaneously composing it nicely to include the reflection is not an easy task, especially when handholding a 500mm lens. Notice the 1/2000 second shutter speed that was used to make the image sharp. Fortunately, dozens of pelicans flew the same flight path for ten minutes providing numerous opportunities to get it right! Canon 7D, Canon 500mm f/4.0 lens, ISO 400, f/5.6, 1/2000 second, shutter-priority with +.3 exposure compensation, continuous autofocus on the back-button.

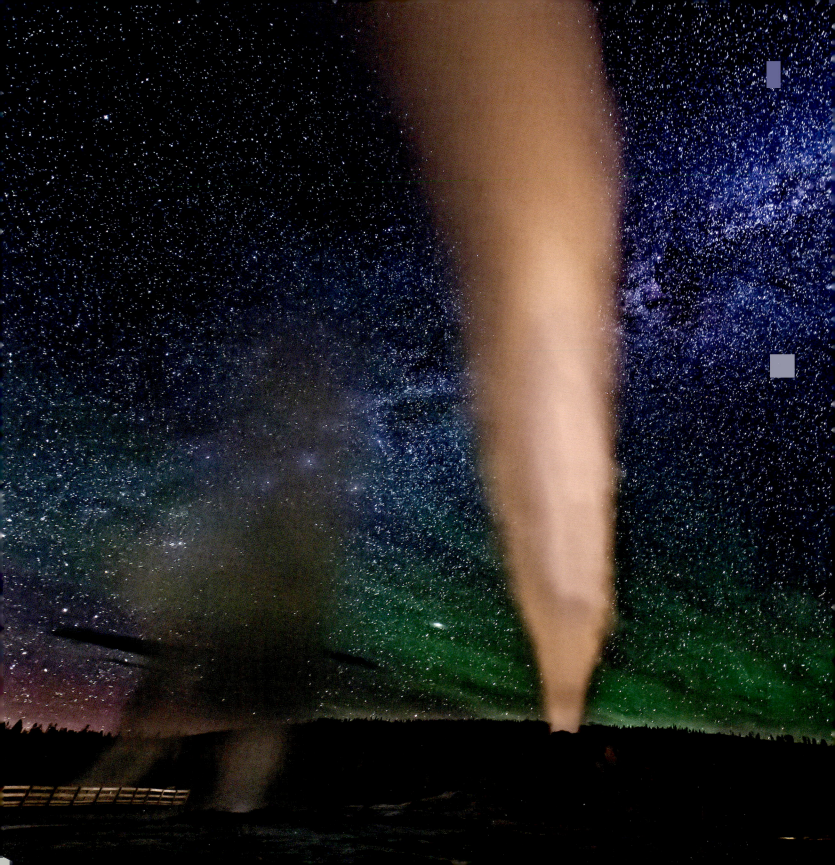

11

The Night Sky

Capturing the starry night sky as pinpoints of lights or producing star trails to reveal the motion of our rotating earth is now easily available with all digital cameras. Recent camera and software innovations have created an entirely new world of photo opportunities. Now modern cameras deliver remarkable photos using ISO values between ISO 800 and 3200, making it possible to capture images that were nearly impossible to obtain until recently. Advances in wireless flash, live view for precise manual focusing, light painting, and multiple exposure capabilities have added tremendously to what can be accomplished. As I write this, a whirlwind of potential photo prospects swirl in my head and I can feel the excitement boiling over within the community of dedicated night photographers. Due to the instant feedback that cameras offer and the fact that it does not cost anything to shoot images once you have the equipment, incredible new photo strategies have surfaced that produce dazzling images. The ranks of dedicated night sky photographers are beginning to swell. If you see someone staggering around due to lack of sleep, remember they could well be a night sky photographer!

PHOTO EQUIPMENT

CAMERA

Even though all digital cameras take night shots, some are more suitable for this purpose. Exposures exceeding one second plus the need for ISOs greater than 800 are typical of night photography. A camera that shows less noise at high ISOs and longer exposures is

Yellowstone's Castle Geyser generates dramatic 40-minute eruptions that shoot water and steam 70 feet into the air. Unfortunately, eruption intervals occur about 12 hours apart, so you don't get many opportunities to photograph this impressive geyser. Castle is a predictable geyser, but the prediction window is plus or minus 2 hours. If Castle Geyser is predicted to erupt at midnight, it could be any time between 10:00 pm and 2:00 am. Castle is worth waiting for! The green in the sky is not the northern lights. It is a phenomenon called *airglow*. Nikon D4, Nikon 14–24mm f/2.8 lens, ISO 3200, f/2.8, 20 seconds, 3700K WB, manual exposure and focusing.

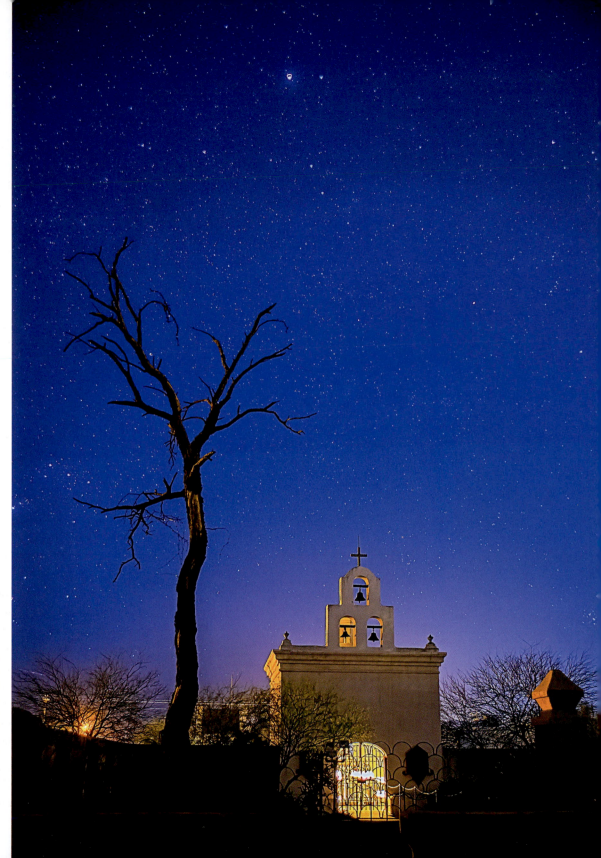

Mission San Xavier del Bac is located on the southwest side of Tucson, Arizona. It is an historic Spanish Catholic Mission that remains in use today. A fast lens is needed to allow a less noisy ISO option. Nikon D4, Nikon 14–24mm f/2.8 lens at 32mm, ISO 1600, f/3.2, 3700K WB, manual focusing, four exposures were shot by varying the shutter speed (1.6, 3, 6, and 13 seconds). These exposures were processed using Photomatix Pro to reduce the contrast in the scene and create one final image.

very desirable. Both of us use full-frame sensor cameras— Nikon D4 and Canon 5D Mark III— because their larger pixel sizes produce a more favorable signal-to-noise ratio, which, in turn, produces an image with less noise. The camera should be able to meter down to 30 seconds and have separate button (non-menu) controls for the ISO, aperture, and shutter speed. It helps to be able to find instantly the three controls just mentioned only by touch, plus the live view, live view magnifying control, and image playback button in complete darkness. Practice until you can do it easily! Turning a flashlight on to see camera controls ruins your night vision temporarily and could adversely affect other photographers near you.

If you are recording star trail images that require shooting a series of images over an hour period, it makes sense to operate two cameras at the same time to use your time efficiently. If you own two or more cameras or plan to shoot many star trails, consider getting a second camera to shoot so two different compositions can be captured simultaneously.

Nearly everyone attaches a camera strap to the camera without thinking about it. Straps always get in the way, especially when shooting on a tripod in the dark. Consider removing the strap for night photography. We never use a camera strap when we shoot on a tripod, which is most of the time, so we rarely have them attached to the camera.

Always have extra fully-charged batteries with you, especially for night photography. When many images are shot over a long period, the sensor is activated for long exposure times and the outside temperature can be cool. Any or all of these factors will drain battery power. Many cameras offer a battery pack that can be added to the camera. We never saw a reason to acquire one until we started shooting night images. Now these battery packs look appealing because the camera can shoot much longer before a battery recharge is needed.

Live view is invaluable for manually focusing in the dark. We use small extremely powerful flashlights to light up the foreground subject. Next we activate live view, scroll the rectangular box that appears over to the area where we want sharp focus, magnify that spot by 5x or 10x, and manually focus on the object. Live view makes it simple to manually hit sharp focus. The small flashlight we use to light the foreground is an LED Lenser M7 (www.ledlenser.com). It works tremendously well to light up subjects or objects over 600 feet away. Since the foreground object that must be in focus is usually much closer than 300 feet, it is quick to sharply focus on the foreground on the blackest night with this flashlight. It costs a little over $100 and uses four rechargeable AAA batteries.

LENSES

A night sky image looks impressive when it includes numerous stars—the more the better. Wide-angle lenses from 15mm to 35mm all work well, especially if they have a maximum aperture of f/4, or preferably f/2.8, and faster. For my night shooting, I mainly use the Canon 16–35mm/2.8 and Canon 24–105mm f/4. Barbara uses the Nikon 14–24mm/2.8 zoom. High quality zoom lenses are effective for night photography where you are composing foregrounds of different sizes in the scene. Any lens with a single focal length between 15mm and 35mm that has a lens speed of f/2.8 or faster is an excellent choice for the night sky.

Why do lenses with a maximum lens speed of f/2.8 or faster work so well for capturing the stars? The more starlight sent to the camera's sensor, the larger the number of stars that appear in the image. Some stars are bright and some are dim. Big apertures allow the sensor to collect more photons of light from dim stars. When enough photons (particles of light) are collected, the star becomes visible in the image. A large aperture is one of three major ways to gather more stars in the image. Using a higher ISO magnifies the sensor data and will reveal more stars, too. The third way is to point the camera at a part of the sky that has plenty of stars, such as the Milky Way. The combination of a big aperture—such as f/2.8—and a high ISO choice of 1600 or 3200 allows more stars to appear in the sky. What about the shutter speed?

Using longer shutter speeds to increase the exposure of the stars helps only up to a point. Depending on a few variables— pixel size, focal length, area of the sky in the image—once

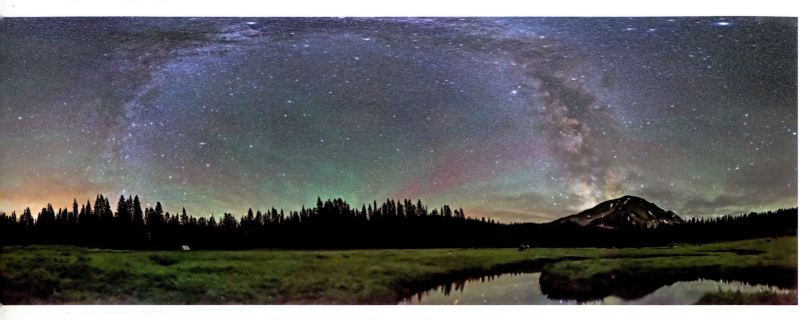

It is truly amazing how many stars make up the Milky Way. Barbara shot thirteen vertical images and made certain to overlap each image by about 50 percent to create this horizontal panorama of Sedge Meadows in Montana's Lee Metcalf Wilderness where the skies are truly free of light pollution. This is her first attempt at making a star panorama and it was literally thirteen "shots in the dark." Nikon D4, Nikon 14–24mm f/2.8 lens, ISO 6400, f/2.8, 25 seconds, 3700K WB, manual exposure and the lens was set to infinity focus.

an 8 second shutter speed is reached, keeping the shutter open does not increase the brightness of the stars or how many are recorded, but it does increase the brightness of the atmospheric light. Why? Remember that stars move because the earth is spinning. After a few seconds, the photons of light from a star that strike a pixel move on to the next pixel because the star moved relative to the sensor and no more photons of light strike the first pixel. Instead, other pixels are being illuminated and the process continuously repeats itself.

TRIPOD

A sturdy tripod is mandatory for night photography due to the long exposure times that are necessary and the number of images that must be shot to create star trails. The tripod maintains the composition and frees up your hands for holding a flash or flashlight to paint the foreground with light. Although a lightweight tripod can be used, a heavier tripod is better if any breeze is blowing. Wind will vibrate a tripod, resulting in a loss of sharpness. Indeed, if it is windy at all, don't waste

your time photographing the night sky unless you can find shelter out of the wind. When there is wind, remember that it may be possible to open a window in your home or take up a position on the quiet side of the forest edge or by a large rock to avoid the wind.

LOCKING CABLE RELEASE

Photographing an attractive tree or rocky outcrop with thousands of stars sharply recorded in the night sky is simply done by using f/2.8, ISO 3200, and 8 seconds as a starting point. Shoot the image and adjust the ISO up or down from there. There is no need to use mirror lock-up when shooting an 8-second exposure because the mirror slap problem is most acute between shutter speeds of 1/4 to 1/30 second.

You can trip the camera smoothly by using the 2-second self-timer option when photographing stars as points of light. However, if you plan to capture star trails, then it is necessary to shoot dozens of exposures at regular intervals. The least expensive and most convenient way to do this is to buy an

inexpensive locking cable release. Set the camera to continuous shooting and press the button on the cable release to fire the first image. Then lock the release in the fire position. The camera will keep shooting images until the camera batteries quit or the memory card fills to capacity. As an example, I use the Canon Remote Switch RS-80N3 for night shooting.

Canon offers the far more expensive Timer Remote Controller TC-80N3, but I find no compelling reason to buy it.

Some shooters use intervalometers to control their cameras. They indeed work, but they are more expensive and somewhat more difficult to use than a locking cable release. However, some cameras—like Barbara's Nikon D4—have the

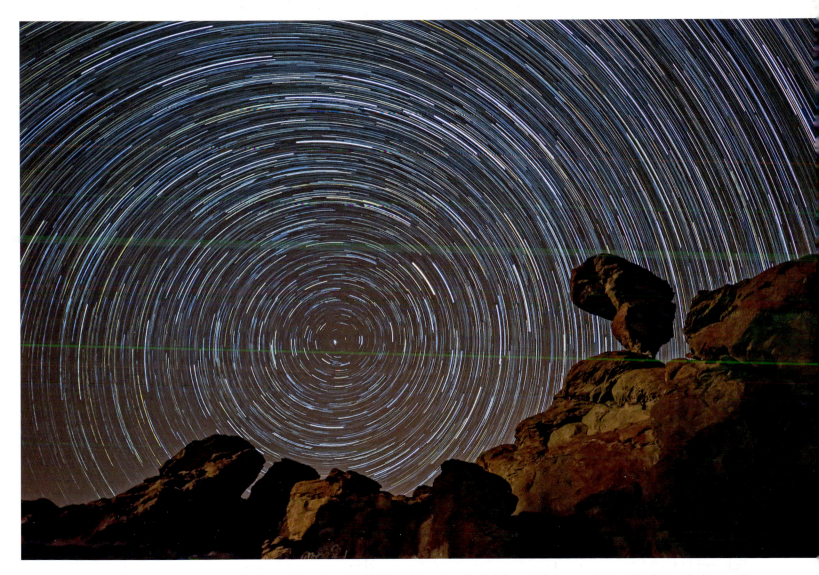

Enormous Balanced Rock near Castleford, Idaho, is supported only by a tiny pedestal. This high desert scenic site is free and always open to the public. One hundred consecutive images were shot at 20-second intervals. Barbara used StarStaX software to combine the images into the one you see here. StarStaX is available as Freeware at www.markus-enzweiler.de/software/software.html. Nikon D4, Nikon 14–24mm f/2.8 lens at 24mm, ISO 1250, f/3.5, 20 seconds, 3700K WB, manual metering and manual focus on infinity.

intervalometer built in to the camera, so there is no reason not to use it. Intervalometers allow you to set the shutter speed and number of images to be shot. Once the camera shoots the set number of images, it stops shooting. The locking cable release requires the photographer to be at the scene with the camera in order to stop shooting images—which is no big deal.

WIRELESS FLASH OR A STRONG FLASHLIGHT

Often it is desirable to light the foreground to make the color and foreground details visible against the starry sky. Through-the-lens flash metering with a dedicated flash is incredibly effective. However, in many cases, it is better to use a flashlight to use light-painting techniques to light things up. Light painting works extremely well because using an exposure of at least 4 seconds leaves plenty of time to paint the foreground with light. When shutter speeds are 1 second or less, then flash works far better for lighting things up.

HEADLAMP

Wearing a tiny headlamp to provide light is helpful for moving about unfamiliar terrain. The headlamp straps to your head. Numerous models are available, so there are plenty of choices. Any sporting goods store will surely stock various headlamps because they are incredibly popular with hunters, fishermen, and other outdoor users.

FOCUSING

Let's explain three options for focusing on the foreground during night photography.

1. Arrive before dark and focus on the subject in the normal daytime manner. Once everything is in focus, turn the autofocus off and tape the focus in place to avoid accidently changing the focus. Wait for night to arrive and the stars to appear. It will be quite a long wait as the sky must get very dark in order to successfully photograph the stars.
2. Use a bright flashlight to light the foreground. Manually focus on the foreground using a magnified live view image. This is our standard procedure and works incredibly well using our powerful flashlights.

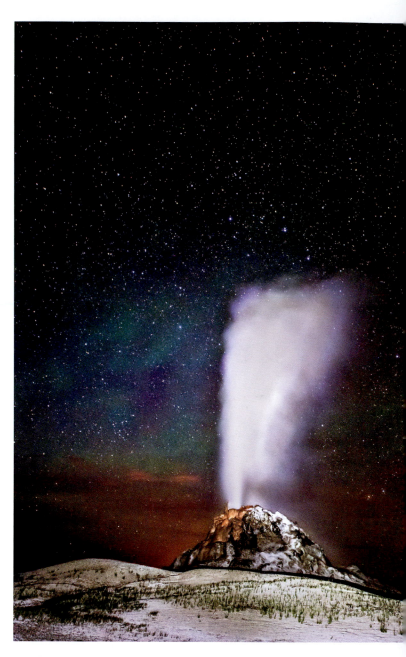

White Dome Geyser erupts for 2 minutes at 30- to 40-minute intervals. The massive cone is 20 feet high and the water shoots up to 30 feet into the air. The geyser is found along the Firehole Lake Drive in Yellowstone National Park. We selected this geyser to be the first one to photograph at night because it is photogenic and provides several possibilities to photograph it over 3 hours. Being able to photograph the frequent eruptions helped us quickly learn to photograph geysers. Nikon D4, Nikon 14–24mm f/28 lens at 14mm, ISO 6400, f/2.8, 25 seconds, 3700K WB, manual exposure and manual focus by setting the lens to infinity.

3. With the wide-angle lenses most commonly used for night photography, infinity focus isn't that far away. In many cases, if the nearest foreground is 20 or more feet away, merely setting the lens manually to infinity focus works perfectly. We use this option a lot!

In any case, always shoot an image and check the sharpness on the camera's LCD screen. Usually the stars are not sharply focused when focusing on the foreground. That is not a huge problem, however. If the stars are a little out of focus, they are bigger and therefore look more prominent and brighter in the image. If shooting star trails, the out of focus stars are not sharp in any case and the trails are wider because points of light look larger when not in focus.

STARS AS POINTS OF LIGHT

IMAGE FORMAT

Use whatever image format you normally prefer. We always shoot landscapes with our cameras set to capture a large RAW and high quality JPEG so that we have the option of using either file type. Currently, we have little need for RAW when producing star trails because the software we use does not handle RAW, but works only with JPEGs. Eventually, we may switch to software that handles our RAW files.

WHITE BALANCE

We get nice results using Tungsten because we like the blue colorcast in the night sky. The best way to decide for yourself is to shoot the starry sky with all of your white balance choices. If your camera offers the Kelvin white balance choice, many night shooters use settings in the 2800°K–4000°K range.

EXPOSING THE STARS

The light of the stars on a clear dark night is relatively constant. However, the brightness of the atmosphere that affects the overall sky brightness varies considerably. Use manual exposure, open the lens to its maximum aperture (hopefully f/2.8), set the exposure to 8 seconds, and ISO 1600. Shoot an image and review it on the camera's LCD. If it looks acceptable,

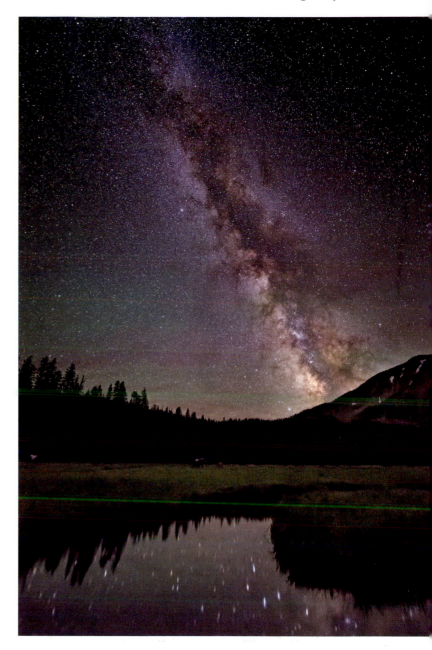

The stars of the Milky Way reflect brightly in a bend of Alp Creek in Sedge Meadows of Montana's Lee Metcalf Wilderness. Nikon D4, 14–24mm f/2.8 lens at 24mm, ISO 6400, f/2.8, 25 seconds, 3700K WB, manual exposure mode and manual focus.

then you are in business. If the sky is too bright, darken the exposure by lowering the ISO or reducing the shutter time to 4 seconds. If the image is too dark, add more exposure by going to ISO 3200 and shoot again. If possible, try to avoid going to higher ISOs to reduce the noise problem. Keep making adjustments until you arrive at the desired exposure. Remember, after about 8 seconds, the stars don't get much brighter because they "scamper" over to another pixel, but shutter times certainly affect the brightness of the reflected light in the sky.

PREVENTING STAR TRAILS

If you want the stars to be rendered as pinpoints of light, there is a rough guideline to go by to avoid star trails. Divide the focal length of the lens being used into 500 to determine what the exposure time can be before the stars begin to show a trail. With a 20mm lens, you can use a shutter speed of (500/20) 25 seconds. With a 50mm lens, the shutter speed must be reduced to only (500/50) 10 seconds. Only a rough guide can be estimated because stars move faster in different areas of the sky. Due to the rotation of the earth, stars due east and west seem to move the fastest, while stars in the southern and northern skies tend to show considerably less movement. Indeed, the North Star (also called Polaris) does not appear to move at all and the stars near it show greatly reduced movement. In practice, we use the "500 guideline" as a starting point, shoot the image, and then magnify the image on the LCD to see if star movement is a significant problem or not. We suggest you do the same.

THE DEPTH OF FIELD PROBLEM

It is artistically pleasing to light an object in the foreground to succeed in making it stand out against the stars. However, the greatest problem is having too little depth of field. If you shoot at the maximum aperture of the lens in order to capture as many stars as possible, then depth of field is too shallow to adequately cover the foreground object. What to do? I spent a year pondering this dilemma off and on until the answer finally dawned on me recently one evening while photographing.

We have a rusty old hand plow that we use as a decoration in the garden. I thought it would be a fine subject to isolate against the stars in the sky. When I shot using f/2.8, I captured a multitude of stars, but the shallow depth of field at f/2.8 did not come close to covering the depth in the plow. When I stopped down to f/16, the depth of field was wonderfully adequate for the plow, but I could not capture many stars due to insufficient exposure. I struggled with this dilemma for a period of time until I suddenly remembered the multiple exposure options on the Canon 5D Mark III.

The answer involved using the multiple exposure control to shoot two exposures to produce one image. I set the camera to ISO 3200, 20 seconds, and f/16. I focused on the plow and illuminated it with a weak headlamp (my batteries were fading) for the entire 20-second exposure. The f/16 aperture produced plenty of depth of field to sharply capture the plow and eliminated most of the stars from the sky. In the second exposure, I used ISO 3200, 20 seconds, and f/2.8. I used my headlamp to manually focus the lens to infinity in order to sharply focus the stars without changing the composition in any way. Then I turned off the headlamp and shot the image. The camera beautifully combined the two images to produce a well-exposed plow at f/16 and a gorgeous star background at f/2.8. The takeaway of this example is to shoot a double exposure to get the depth of field that is required for the foreground. While I do not know if or how multiple exposure works on other cameras, the key point is to realize that it is possible with the Canon 5D Mark III and possibly your camera to shoot one exposure at f/16 and then change to f/2.8 for the second exposure. Also, I could have shortened the shutter speed for the star portion of the image to 8 seconds. I needed 20 seconds for the plow portion of the image to give me time to paint the plow with the light from my headlamp.

My solution for the old plow is a real game-changer idea that will be incredibly useful going forward. Being able to properly expose and sharply focus both the foreground and the background in night photography using the multiple exposure option opens up a whole new world of possibilities. You must be able to use your camera controls easily in the dark without

We bought this antique rusting hand plow to use as a photo prop because it makes an intriguing shape against the night sky. The plow was precisely placed on a rock to isolate it nicely against the stars. When we posted an image of this plow on our Facebook page, some of our visitors said they used a plow like this one when they were young. Does that make them antiquated, too? No, it just means they get senior discounts. Canon 5D Mark III, Canon 16–35mm f/2.8 lens at 22mm, ISO 3200, f/2.8, 20 seconds, Tungsten WB, manual exposure and focusing using live view.

I was pondering how to get more depth of field in the foreground, while still being able to focus sharply and to expose the starry sky beautifully and meanwhile do it all in the camera. The solution finally dawned on me when I was making this image and it has become a tremendous game-changer on how I approach photography. Remembering the multiple exposure option on my camera, I set it to two shots and the multiple exposure control option to *Bright*, which preserves highlights. In the first exposure, I set the camera to 10 seconds, f/8, and used a flashlight to focus on the plow and finally "paint" it with light. At these exposure settings, few stars were bright enough to appear in the image. I needed the 10-second exposure time to give me time to paint the plow with the flashlight. In the second exposure, I focused to infinity and changed the exposure to f/2.8 and 20 seconds. Although the plow is now out of focus, it doesn't affect the image because it is greatly underexposed. By learning that I can change the f/stop, shutter speed, and focus between the two images that make up the double exposure, I now have far greater freedom over how I make images. I wish I could have changed the ISO, but I found no way to do it. I changed the f/stop, shutter speed, and focus between each exposure with the aid of a dim red headlamp. Canon 5D Mark III, Canon 16–35mm f/2.8 lens at 22mm, ISO 3200, Tungsten WB, manual exposure and focus.

I made this image over a period of two days. When I created the previous image the night before, the crescent moon sank below the horizon earlier in the night and was not available to add to the scene. Being pleased with how the multiple exposure option helped me out the night before, I studied it carefully the next morning and discovered I could select any image that resides on my memory card and use it to be the first of a multiple exposure. Sounds promising! An hour after sunset when the crescent moon was still hovering above the horizon that night, I set the camera to multiple exposure, selected the plow image to be the first of a double exposure (the camera copies it and does not modify the original), and shot the moon with a long lens to make it large in the image. When I first shot it and shared the image with Aaron Priest—a night sky photo expert—he told me I was an "idiot" in an adorable fashion. In my original image, stars occupied the black area of the moon. He said, "If stars were in front of the moon, all of us would need stronger suntan lotion." Barbara used Photoshop to remove the stars from the front of the moon and make this area dark as it should be. Thank goodness for smart people pointing out flaws that should be obvious! The moon was shot with a Canon 200–400mm lens set at 400mm. Exposure for the crescent moon is 1/ISO at f/11, which I call the Mooney 11 rule. Using ISO 400, this equates to 1/400 second at f/11 or 1/800 at f/8, which is what I used.

being able to see them. In the plow shot, I was changing both the focus and the aperture from one shot to the next in the double exposure. I do admit I turned on my headlamp to look at the focus scale on my lens to set it to make the stars sharply focused. To focus the plow, I shined my strong flashlight on it and used live view to obtain sharp focus.

While you are thinking about it, check your camera to see if it offers multiple exposure options. If so, try shooting some double exposures and see if the shutter speed, aperture, white balance, and ISO can be changed from the first image to the second of the double exposure. Knowing what can be changed offers new opportunities for shooting creative images. In my case with the Canon 5D Mark III, I can change the shutter speed, aperture, and white balance, but not the ISO.

Photographing this plow was a little tricky at first. I was changing the aperture and the focus between shots. It is easy to forget to change one of them, especially in the dark. I shot a number of multiple exposure pairs that allowed me to compose the plow vertically and horizontally. Each double exposure gave me another chance to vary the light painting on the plow. Realizing—finally—that I can change the depth of field between shots profoundly changes the way I take night photos. With my camera, both the shutter speed and the f/stop can be changed between exposures, but I could not find a way to change the ISO. If I could, then I would use ISO 400 to reduce the noise when shooting the plow portion of the multiple exposure. Check your camera to see if it has a multiple exposure mode. Look carefully to see exactly what can be changed between shots. If the f/stop is changeable, there are tremendous opportunities for sharply recording both the foreground and the background.

How did the crescent moon magically appear in my image? Did I pop the moon in with Photoshop or some other software? No way! That would be too complicated for me. Instead, I discovered—it is always wise to read the manual—that the Canon 5D Mark III allows you to select a previously shot image that still resides on the memory card to be the first image of a multiple exposure. I selected the image. Then the camera copied it to create an entirely new image while leaving the original image intact. Then I used a 400mm lens 24 hours later to add the crescent moon into the image's upper left corner. The exposure for the moon is ISO 400, f/8, and 1/500 of a second. Think of it as a delayed triple exposure. I could not shoot a photo of the moon on the night I photographed the plow because it had already set below the western horizon. If your camera offers multiple exposures, be sure to fully understand your options because being able to shoot multiple exposures opens up an incredible new way of photographing!

STAR TRAILS

Decades ago, I remember shooting star trails with Delicate Arch, Balanced Rock, and other famous rock formations in Utah's fabulous Arches National Park. I used Kodachrome 25 and exposed a single frame for 1–3 hours at a time. The longer the exposure, the longer the star trails. When I launched into digital in 2003, star trails seemed impossible to make. Long exposure times do not work well with digital cameras. As exposure times increase, the sensor heats up and creates even more noise in the image. For a decade, we believed we could not do star trails anymore. However, with the introduction of inexpensive and free software, star trails can be captured better than ever! We find the software is easy to use and intuitive while greatly minimizing the problem of noise. We are enjoying our night shooting immensely and hope you will, too.

Here are the steps to splendid star trails.

1. CHOOSE A DARK NIGHT WITH FEW CLOUDS

A dark night allows the faintest stars to appear. Avoid light pollution that is so common in urban areas. Dust in the air also reduces the clarity of the stars. For a darker sky, avoid those times when the moon is up and especially if it is larger than a crescent. The more light in the atmosphere, the fewer stars that can be captured. Remember, this is only a guideline. Some stars are much brighter than others. Even when photographing the San Xavier Mission in Tucson with all of the city lights and car headlights occasionally lighting the mission, we were able to get pleasing star trails.

The star trails behind a section of Mission San Xavier del Bac show it is possible to make star trails even when there is plenty of light pollution from other homes in the area, headlights from cars driving by, and the city lights of Tucson. Light pollution makes it difficult to capture images of the faintest stars, but bright stars still record nicely. It is possible to have so many star trails that it makes the starry background too cluttered. Nikon D4, Nikon 200mm micro lens, ISO 800, f/4, 30 seconds, 3700K WB, manual exposure mode and focus. Eighty-seven images were combined using StarStaX software to produce the star trails. Notice a lower ISO 800 and f/4 was used to prevent overexposing the mission because there was considerable light on the mission from nearby homes.

We are lucky to live near West Yellowstone, Montana, because the air tends to be quite clear with little dust. We often drive to nearby mountain peaks around 9000 feet for a better view of the night sky and excellent photo prospects.

2. COMPOSE THE SCENE

Select a scene in which the foreground is far away so it is close to infinity focus. This allows you to sharply focus both the scene and the stars. If the foreground is close, then focus on it and let the stars be slightly out of focus. Unfocused stars

are not a problem when creating star trails because the stars are not sharp anyway and the trail merely becomes a little wider and more prominent—nothing wrong with that.

3. DETERMINE THE EXPOSURE USING THE ISO, F/STOP, AND SHUTTER SPEED

As a starting point, try ISO 1600, f/2.8, and 20 seconds. Adjust the exposure as needed. The goal is to capture a nicely silhouetted foreground in which the shape readily shows up against the sky with plenty of stars. Remember the number of stars is primarily determined with the ISO and f/stop, not the shutter speed. The shutter speed is useful for controlling how bright the sky background will be and any moonlight that might be illuminating the foreground.

If you stop down to f/8, you will lose some of the fainter stars, but you can still capture the brighter ones. Sometimes having too many star trails makes the image appear too cluttered with white lines. Stopping the aperture down to reduce the number of star trails can result in more pleasing star trail images.

4. SHOOT THE IMAGES

Set the camera to continuous shooting and use a locking cable release or intervalometer to shoot multiple images over a long period of time. At a minimum, shoot continuously for 45 minutes, but an hour or more is often better. We usually use 20-second exposures and don't worry if the stars show movement during this period because we want trails in any case. In other words, during an hour of shooting, the camera fires a shot every 20 seconds and continues 180 times.

Using the intervalometer on her Nikon D4S, Barbara sets the shutter speed and the total number of exposures to be captured and the camera does the rest. With my Canon 5D Mark III, I use a $20 locking cable release and press the cable release to fire the first exposure and lock it.

The camera continuously shoots another exposure every 20 seconds until I stop it. Usually, we go back to the car or sit on a rock on a warm night to talk, drink coffee, or take a short

The camera was focused ahead of time on Castle Geyser's cone while awaiting the eruption that occurred around midnight. Barbara used a flashlight to illuminate the cone to permit manual focusing using a magnified live view image. Then she used a flashlight to "paint" the tower of steam and water with light. The light illuminating the right side of the geyser that created the pleasing sidelight came from car headlights in a nearby parking lot. The green glow in the sky is real. It is called *airglow* or *nightglow* and comes from a very weak emission of light from the earth's atmosphere that prevents the night sky from ever being completely dark. Nikon D4S, Nikon 14–24mm f/2.8 lens, ISO 3200, f/2.8, 20 seconds, 3700K WB, manual focus and exposure.

nap while waiting for the time to elapse. Then we return to check the camera, create a new composition, and wait again. Sometimes we each shoot two cameras simultaneously when photographing the geysers at night in Yellowstone National Park. Why? Old Faithful Geyser, for example, erupts about every 75 minutes. The peak of the eruption is only optimum for about 1 minute. With two cameras each, at least each of us gets two compositions during the eruption before we have to wait another 75 minutes for the next one. We learned to photograph geysers at night by photographing White Dome Geyser first since it erupts approximately two or three times an hour, so that gave us more chances to experiment.

If you leave your camera, make sure it is stable. Cameras sometimes are destroyed when the owner walks away from a tripod-mounted camera and the wind blows it over. A sudden rainstorm can be disastrous as well. Though human thieves are less of a problem in remote areas at night, it is always a concern. If you are shooting near a lake, watch for big waves and the rising tide could be a dangerous problem at the ocean. Fog and dew can form on the lens, so watch out for those possibilities. A clear and dry area works well for night photography.

The key to excellent star trails is to shoot enough images to make the trails long enough and to compose an attractive scene. When you process the stack of star images, you do not have to use them all. If you have too many and the trails are too long, you can select fewer images to include in the final image, but if you do not have enough, then you are out of luck.

Remember that Polaris does not move and the nearby stars rotate slowly around it. Use the Big Dipper constellation to find Polaris. Locate the two outer stars of the Big Dipper that are furthest away from the handle or the right-hand side of the dipper's bowl. Follow the line these two stars suggest upward above the dipper's bowl. When you see a faint star, you have found the North Star (Polaris.) Remember that Polaris is a faint star. Beginners have trouble finding it because they fixate on the brighter stars. It is effective to compose Polaris to make it nearly touch part of your foreground subject, or

to be in the middle of a rock arch with the stars circling around it.

PROCESS THE STACK OF STAR IMAGES

Search the Web for star stacking software. Plenty of inexpensive and free software choices are available. We are currently using StarStaX, a free software download that is producing excellent results for us and it is uncomplicated to use. To download this software, go to www.markus-enzweiler.de/software/software.html. Load the images into the software and press *Run*. The software looks at each image and adds the stars from each image in the stack into one image, producing star trails. Getting gaps in the star trails is a frequent problem. The software gives you a way to fix the gaps. It is easy enough to use that even I can do it without any help—admittedly a tiny bit of help—from Barbara, who is adept with computers.

NORTHERN LIGHTS

Everyone is dazzled when they see the northern lights dancing in the night sky. They are tremendously fun to photograph, but success depends on being at the right place when they happen and using impeccable camera technique. Northern lights are connected to solar storm activity on the surface of the sun. Some years are better than others. March and October tend to be the best months for seeing them. Northern lights can sometimes be seen as far south as Texas, but usually Alaska, Canada, and the northern tier of states are the most likely places to see them. Of course, other countries in the far north, especially Iceland and Finland, get fabulous displays of these dancing colorful lights in the night sky.

Barbara spent time in Alaska around Denali and managed to get a few periods of good northern lights. It is not easy as the lights are only somewhat predictable, but sun activity is closely monitored by weather Internet stations, especially www.spaceweather.com. When northern lights do happen, the display might last for only a few minutes or possibly a

The North Star (Polaris) doesn't appear to move in the sky because the earth's axis of rotation points almost directly at it. This makes Polaris an especially useful star to use as a center of interest. Barbara carefully composed this Balanced Rock scene so Polaris touches the edge of the famous rock. Notice the stars nearest Polaris don't move nearly as much as stars further away. Nikon D4, Nikon 14–24mm f/2.8 lens, ISO 3200, f/2.8, 20 seconds, Incandescent WB, manual exposure mode and manual focus. One hundred images were merged to produce this image using StarStaX software.

few hours. Naturally, the sky must be mostly free of clouds to be able to view them. To improve your chances, spend a week or more in Fairbanks during March and stay up all night when it is clear. There is a good chance you will get to photograph the lights in Fairbanks. Be sure to scout out shooting locations during the day and be ready to shoot at dark. Some photo instructors run northern lights photo tours to the best locations around the world. A web search will lead you to them.

The best northern lights viewing is during the winter months when it is dark most of the time. Although solar activity occurs all year long, northern lights are not viewable during much of the spring, summer, and early fall because the daylight is too bright. That means northern lights photography requires shooting in freezing to frigid temperatures. Proper warm dress is crucial to allow you to shoot when the temperature is thirty below zero and the wind is blowing. With fully-charged batteries, cameras work just fine in such cold, but you might not.

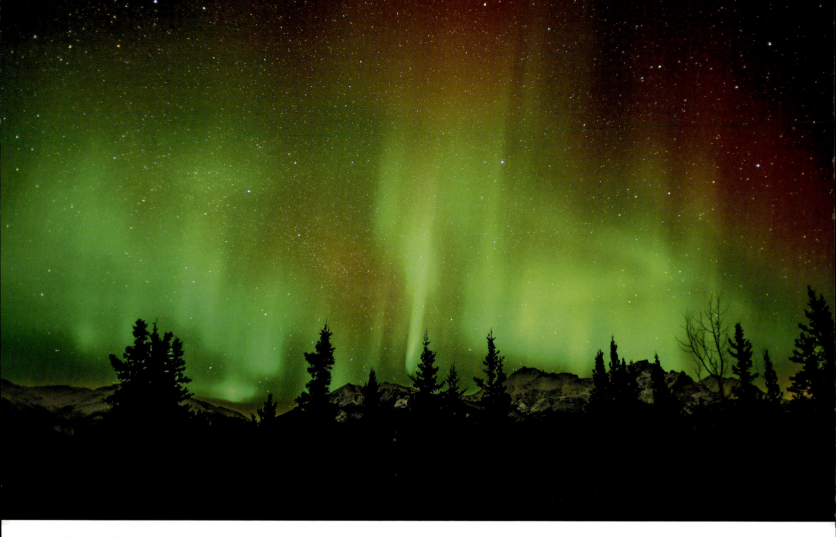

Northern lights are caused by the collision of solar wind and magnetospheric charged particles with the atmosphere at high altitude. These captivating light displays are commonly seen at high latitudes with Fairbanks, Alaska, Finland, and Iceland being particularly outstanding places to view them during the months between September and March. Although the aurora is fascinating to watch and photograph, the challenges are many. The sky must be clear, it can't be too windy, the aurora must happen, and it is usually bitterly cold. Barbara managed to get one good display over a ten-day period near Denali National Park and she stayed up all night waiting for it to happen! Nikon D4, Nikon 14–24mm f/2.8 lens at 24mm, ISO 1250, f/2.8, 20 seconds, Cloudy WB, manual focus and exposure.

Optimum viewing times seem to fall between 10:00 pm and 3:30 am. I have seen a few northern lights displays along the south shore of Lake Superior in Michigan's Upper Peninsula, and all of them occurred during this time period.

EQUIPMENT

All of the camera gear used for star photography doubles nicely for northern lights. We are not big fans of aperture-priority, but it is effective here as the brightness of the display can vary considerably from moment to moment. Set the aperture wide open to the maximum f/stop on the lens and let the shutter speed vary. In aperture-priority, the camera maintains

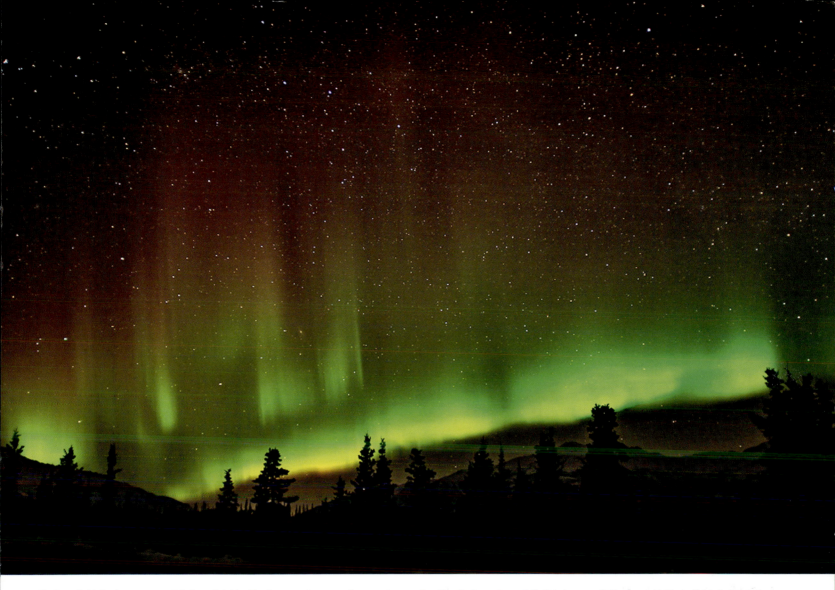

Northern light displays are somewhat predictable. Monitor www.spaceweather.com to see when the displays are most likely to happen. At the correct latitude, light displays occur quite often. A good way to photograph the aurora is to spend a week or two in Fairbanks, Alaska, during mid-March, which is a time of peak activity. On any clear night, watch the skies and be ready to shoot when it happens because the light display can suddenly quit at any moment. Nikon D4, Nikon 14–24mm f/2.8 lens at 24mm, ISO 1250, f/2.8, 20 seconds, Cloudy WB, manual focus and exposure.

the set aperture and the shutter speed varies to adjust for brighter or darker northern lights displays. Use the exposure compensation control to follow the ETTR guidelines for optimum exposure.

COMPOSING THE IMAGE

We almost always include a foreground scene to give scale to the dazzling light show above it. Since most of the northern lights shooting is done in the winter, a snowy landscape is typical and works just fine. Finding a mountain or some tall trees to isolate against the sky works wonders to add interest to the lights dancing in the sky above it. If you turn a light on in the cabin, or even light a tent pitched in the snow, it gives a strong sense of being there.

Northern lights is an enormous topic that could easily fill an entire book all by itself. An excellent detailed source

of information for photographing the northern lights is an e-book, *How to Photograph the Northern Lights with a Digital Camera*, by Patrick J. Endres.

WHEN DO YOU SLEEP?

Since clear or partly cloudy night skies offer such a splendid photo opportunity to photographers, the challenge is to get enough sleep. The golden light at sunrise and sunset is well known for its photogenic qualities, so all photographers want to shoot then. If you shoot at dawn and dusk and the night sky, then how do you get enough sleep? Some night shooters sleep during the midday hours, but we discovered this sleeping pattern does not suit our natural biological rhythms well. Instead, we photograph during the first 4 to 6 hours of the evening and then retire for the night. Of course, if something spectacular is happening—northern lights, lunar eclipse, or a meteor shower—then we stay up all night.

The optimum time for photographing the night sky in the northern hemisphere is between September and April when the dark of night comes early in the evening. Also consider the higher latitudes because night comes earlier and lasts longer. Obviously, the southern hemisphere is best between March and September during their long night period. Early sunsets and long nights make it more convenient for photographing the night sky while still getting a "good" night's sleep! Should you be near the equator, you'll get approximately 12 hours of daylight and 12 hours of night year round, which is good for stars, but you won't see the northern lights there. All too often we night photographers suffer from sleep deprivation, but a few nights of cloudy skies will mercifully let us catch up!

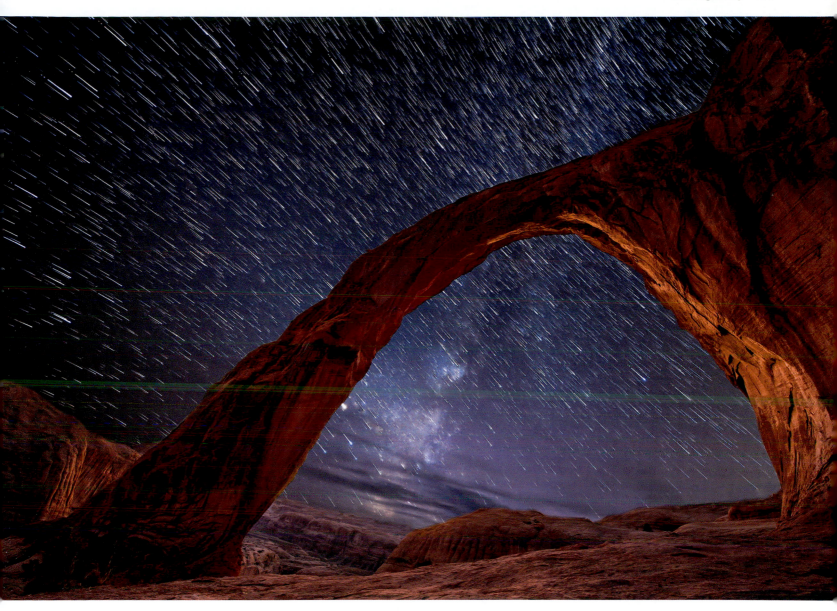

Magnificent Corona Arch lies just outside Moab, Utah. We photographed it first in the golden light of dusk and then waited a couple of hours for the sky to darken to show the stars prominently. This is a complex shot that is fully described on our instructional Facebook page. Here's a summary of the process. Barbara shot the arch late in the evening. Without moving the camera, she waited two hours for the sky to reach astronomical darkness. Then she shot more than 100 consecutive images to combine later with StarStaX software to show star trails. However, she used only thirty-three images to produce this image, plus the image of just the arch at sunset. These images were combined with Photoshop CS6. Nikon D4S and Nikon 14–24mm f/2.8 lens at 14mm for all shots. For the single arch image at sunset, she used ISO 100, f/16, 1.6 sec., 10,000K WB, manual exposure mode and AF-C on the back-button. For the star images two hours later, she used ISO 3200, f/2.8, 15 seconds, 3200K WB, manual exposure and manual focus.

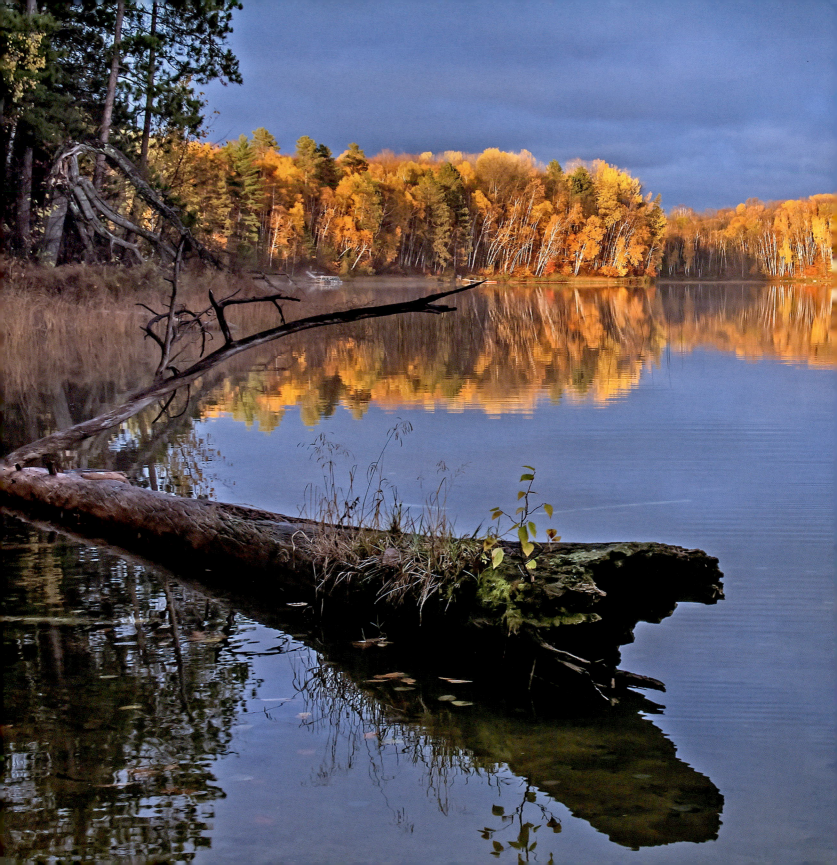

Our Digital Office

THE EVOLUTION OF OUR BUSINESS

Our office procedures and software choices have been greatly influenced by the path our business followed over three decades. In the 1980s and 1990s we primarily earned our living by sending thousands of images to stock photo agencies. They rented these images to various users for one-time use, and we received a portion of the sale price—a commission of 50 percent. We sold many images directly to calendars, magazines, book publishers, and as many other users as we could find where we would get all of the sale price. Of course, there is plenty of overhead—postage, packaging materials, film and processing costs, travel expenses, equipment costs, insurance, and much more. The net profit was always much less than the gross income from these sales.

Selling images is tedious, time-consuming, and definitely not enjoyable work. We think most photographers will agree with us that the fun part of the nature photography business is shooting the images. The work begins when you must edit, sort, label, organize, find, and store the images. Selling images became more and more competitive as ever-increasing numbers of photographers began flooding the limited marketplace with them. At the same time, the price paid for images began to fall rapidly when the supply of "usable" images vastly exceeded the demand. With the advent of digital, stock photo agencies began offering deals to clients if they bought a lot of images. This arrangement kept the income flow up for stock agencies, but it proved devastating for most individual photographers. Many images are used on websites and for other digital uses, so the number of sales greatly

Autumn colors vary from year to year. Sometimes leaves change color early and sometimes later. Moccasin Lake is in Hiawatha National Forest south of Munising, Michigan. The lake is noteworthy because it has two periods of peak color. How is this possible? Early in the color season the maple trees turn crimson, which produces brilliant-red reflections in the lake. Eventually the maple leaves fall to the ground and then the aspens turn bright yellow fully ten days later creating an entirely different color show. Nikon D300, Nikon 24–70mm lens at 36mm, ISO 200, f/11, 1/25 second, Cloudy WB, Manual exposure mode, and back-button focusing. Today we would use a three shot focus stack using f/8 to sharply focus this scene.

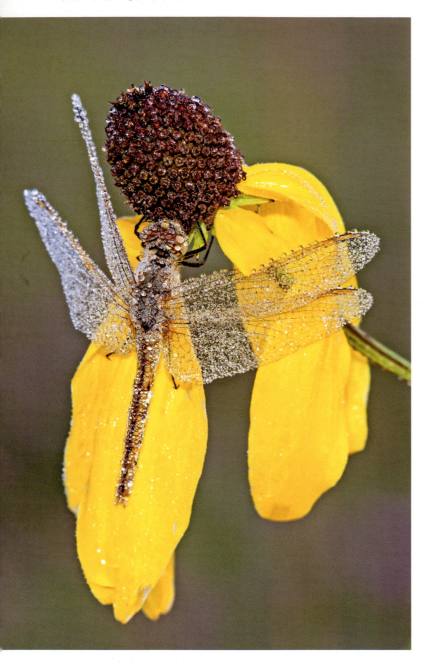

Many photo workshop clients are eager to photograph dew-laden dragonflies and other sensational subjects in the dew-drenched meadows of northern Michigan. When insects are laden with dew and naturally chilled, most of them cannot move until they dry off and warm up, providing plenty of time to make images of them. A Plamp is used to stabilize the subject to keep it perfectly still. Canon 5D Mark III, Canon 180mm macro lens, ISO 100, f/14, 1/5 second, Cloudy WB. Flash is used as the main light and the ambient light is underexposed about one stop to darken the background slightly.

increased, but the low per image fees being paid demolished that income that so many photographers relied on to earn a living. By 2005 we began to see our stock sales declining. Fortunately, our nature photography business rapidly evolved away from selling images to teaching nature photography. Now that nature and outdoor photography education is our first and only priority, our office and software choices now reflect that change.

I taught my first photography workshop in 1977 through a community enrichment program in Lapeer, Michigan, and continued teaching workshops in a small way over the next several years. I always had phenomenal student response to my teaching methods. Teaching came naturally to me and I enjoyed it. By 1990, Barbara joined me, and our photo workshop business absolutely exploded. We loved spending quality time with our clients in the field helping them become marvelous photographers, and they rewarded our efforts by telling their friends and becoming repeat customers. Indeed, many of our clients have taken every course we offer. As we gradually transitioned to digital around 2003, the demand for our exotic photo tours, field workshops, and one-day instructional seminars became so large that we discontinued all efforts to sell images—no time for it—and concentrated on teaching photography because it was far more fun, intellectually challenging, and emotionally rewarding.

As I write this in 2014, we remain committed to teaching photography. We cherish the challenge of figuring out ways to use the latest equipment and software innovations to help us and our students capture stunning images. We share our strategies through magazine articles, teaching, and instructional photography books such as the one you are reading now—the fifth in a series. Although our decision to spend our efforts on teaching was motivated entirely by our interests, it proved to be dumb luck, too. The abundance of cheap "good-enough" digital images that are available on the Web for commercial use seriously curtailed the income that could be realized by stock image sales. Many photographers who once earned their living primarily from stock photo sales suffered a problematic decline in income as prices being paid

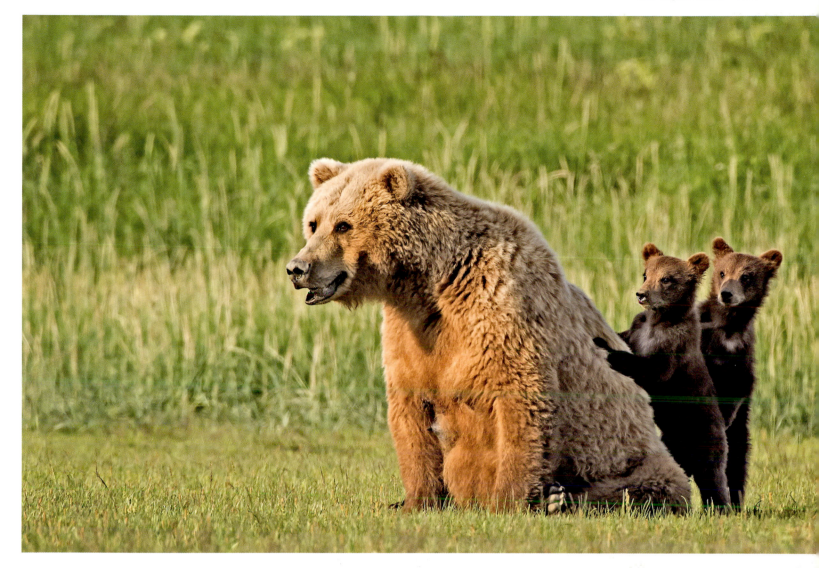

The coastal brown bears at Hallo Bay, Alaska, are habituated to humans. The bears are not afraid of us and do not consider humans to be on their menu because they prefer grass, clams, and fish. This sow bear is reacting to a massive male bear wandering in her direction. Boar bears sometimes kill cubs and sub-adults, so the sow remains ever watchful and will ferociously defend her young. The cubs are aware of the danger and seek refuge behind their mother. Nikon D4S, Nikon 200–400mm lens with a 1.4x teleconverter at 550mm, ISO 1600, f/10, 1/800 second, Manual exposure mode, Sun WB, AF-C autofocus with the back-button control.

for images sharply declined while the cost of doing business soared. Fortunately, this unhappy trend had little impact on us because we had already abandoned photo sales. The digital era greatly increased the number of people who now wanted excellent digital images. Everyone has a digital camera now. It may only be a cell phone or iPad camera, but many eventually go on to buy a DSLR. When they do, they become a potential customer for us and everyone else who teaches photography workshops and classes.

We mention our emphasis on teaching because it definitely affects the software choices we make, how we organize our images, and what we keep. Both Barbara and I are addicted to

being in the field shooting images and teaching people how to do it. Barbara is brilliant at making computers achieve what she wants them to accomplish and uses all programs skillfully. On the other hand, I prefer spending my time working at tasks other than using computers. I get easily befuddled by their constant changes. Fortunately, Barbara is still willing to come to my rescue, or I would have booted my computer out the window years ago.

Barbara has no interest in teaching Photoshop or any other software program because she already spends enough time in the office and I am obviously unqualified. Plenty of other photographers are eager to teach this subject and more qualified than we are by a wide margin, so we'll leave that portion of the workshop market to them. Therefore, our software choices are focused on helping us select the images we wish to keep, storing them in a logical manner, processing RAW images when necessary, and software that lets us do High Dynamic Range imaging and focus stacking.

EDITING AND STORING IMAGES

We shoot images today for the same reason as when we started doing it more than forty years ago. It's enjoyable! Aside from that, we shoot images to illustrate our magazine articles, books, and the "slide" programs we present during our indoor seminars and field workshops. We need quality images to illustrate the techniques we use. But, we also need images to show what not to do. Normally, we get some "clunker" images without trying to do it on purpose. (All photographers shoot bad images, but good photographers don't show them.) At times we deliberately shoot bad images because we are unlikely to accidently make the mistake that we wish to illustrate. For instance, photographing a woodland waterfall illuminated by bright sunshine isn't something we would accidently do because we know the contrast is far too great.

Since we need images that are shot in bad light for teaching purposes though, we sometimes photograph a waterfall in bright sunshine specifically to illustrate the problem of high contrast.

Our shooting strategy is always to shoot plenty of images when the opportunity presents itself and do it as well as we possibly can. For example, I shot at least 7000 coastal brown bear images around Geographic Harbor in Alaska, and Barbara shot similar numbers. At times, two dozen bears were eagerly catching salmon all around us. The spawning salmon swam up the shallow streams and the bears chased them down. The action of running bears pouncing on swimming salmon is spectacular! Of course, I have no need for 7000 images of this and don't wish to store all of them, either. Therefore, we use a program called PhotoMechanic to edit the images down to a more manageable number. We like PhotoMechanic because it quickly pulls up the embedded JPEG in the RAW files we shoot. This means even if we buy a new camera that wasn't around when the software version of PhotoMechanic we are using was created, the software still can let us see the images because the JPEG is a universal file that doesn't require updated software. With many software programs, you have to update the software, or at least download the information the program needs for the new camera to see the images.

Barbara shoots Nikon and I shoot Canon. Both companies make proprietary software for their camera system. Although we have looked at this software, we don't use the proprietary software that much because of our photo workshop business. It is pointless for Barbara to use and master the Nikon software and me the Canon software when we have workshop clients that don't shoot either system. Perhaps they shoot Sony, Olympus, and others. Using proprietary software is an enormous problem if one must look at images shot with other camera systems, something PhotoMechanic does easily. To be more effective photo instructors, we must use software that works with any system.

By the way, you might be wondering why Barbara shoots Nikon and I shoot mostly Canon, but occasionally use Nikon. We like both systems well, though Barbara really enjoys her Nikon lenses and D4S camera. I like both systems, but mainly shoot Canon. Years ago we realized that we were obliged to be highly knowledgeable photo instructors. We know the vast

Brown bears are abundant and can be approached safely at Alaska's Hallo Bay during early July when we spent a week with Chuck Keim on his bear-viewing boat. We were extremely lucky. A few sow bears had cubs that were born that spring and the weather was excellent. These two cubs played continuously while their mother calmly chewed grass about 50 yards away. Notice how the golden backlight subtly rims the cubs' fur. The Nikon D4S camera is amazing because the shots produce clean images with high ISOs. Barbara used ISO 2000 to keep the shutter speed fast and to stop the lens down more to make sharp images. Nikon D4S, Nikon 200–400mm lens, ISO 2000, f/10, 1/640 second, Sun WB, manual metering, autofocus using AF-C with control on the back-button.

majority (perhaps 85 percent or more) of the workshop market is made up of Nikon and Canon shooters. We felt it was critically important to know everything about the Nikon and Canon systems. While we don't know everything, we know a lot about both systems. Seldom does a Nikon or Canon question stump the two of us, no matter how detailed or esoteric. We know the flash systems, close-up systems, and the internal working of the cameras and lenses to the point that we can nearly always answer our student's question immediately without having to look anything up!

Let us return to PhotoMechanic, which is outstanding at working with a large number of RAW and/or JPEG images. This software is quick at pulling up RAW images. The software is especially good at letting us edit the images rapidly so that we can decide which images we wish to keep. PhotoMechanic allows one to easily label the images and organize them into folders. Before we get into editing the images, you should know that we believe "less is more."

Some photographers believe they should keep everything because they don't know when they might need an image, or portion of an image, at some later date. However, since there is no cost to shooting digital images once you have the equipment, it is easy to bury yourself in images and fill up all of your storage devices. Our goal is to delete as many images as possible to make it easier to find the ones we truly need and to minimize the number of storage devices we must use and back up.

HOW WE EDIT OUR IMAGES

I discovered a large and healthy patch of wildflowers on a calm overcast morning and spent the next hour photographing individual and multiple flowers. Using ambient light alone, or mixing flash with it, I shot ninety-seven total images. I simultaneously shot a large JPEG and a large RAW file to capture the appealing blossoms. Here's my strategy for editing them to reduce the images to only the ones I need.

1. Using PhotoMechanic, I look at each image using as much of the computer monitor as possible, but I allow the histogram to appear on the right side of the screen. Any image that is obviously soft—the breeze suddenly blew—I delete immediately. If my composition fails and something is cut off that shouldn't be, it also is deleted. Any obvious flaw that seriously degrades the image is deleted. I realize many photographers can "fix" a flaw later with software, but I have no interest in doing this, so I delete the image.

 Barbara and I strive to shoot the finest possible image, which includes preventing flaws ahead of time. If the exposure is too dark or too light as shown by the histogram displayed by PhotoMechanic, I delete it. In some images, I use a flash for fill light or main light. Sometimes the

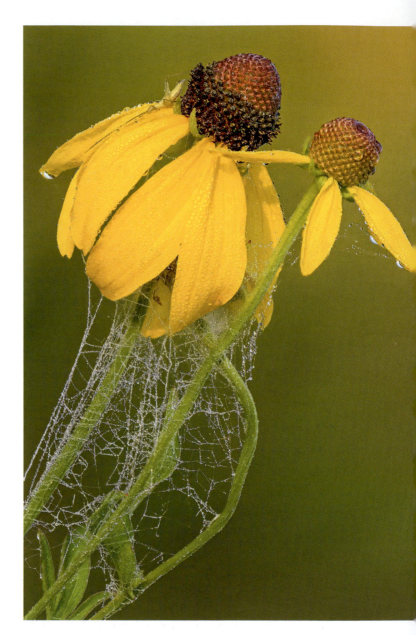

Always look for that little something extra. These good looking gray-headed cone-flower blossoms benefit from the dew drops and the spider web to make a more appealing image. A Plamp was used to stabilize the flower's stem and was carefully attached to avoid shaking off the dew drops. Eighteen images were shot at slightly different focus distances and merged with Helicon Focus to obtain the best possible overall sharpness. Focus stacking works far better than stopping down to f/22 and shooting a single exposure because the depth of field at f/22 still does not cover the subject's depth adequately and the overall loss of sharpness from diffraction is significant. Nikon D4S, Nikon 200mm micro lens, ISO 100, f/8, 1/80 second, Cloudy WB, manual exposure and focus.

flash doesn't do what I had hoped it would, so I delete those images immediately. Many photographers simply check the images they wish to delete.

At the end of the edit, the checked images are selected and then deleted all at once. This way works quite well, but I prefer to delete as I go. It is comforting to see the total number of images that must be edited quickly decrease.

PhotoMechanic's default setting queries you twice before deleting an image so one doesn't accidently delete a "wanted" image. This requires another key, which must be pressed to actually delete the image and send it to the "bit bucket" or recycle bin. This is slow and cumbersome, but indeed allows you a chance to reconsider. I personally don't like this tedious process of deleting that requires pressing *Delete* twice. To make PhotoMechanic send the image to the recycle bin immediately with just one keystroke, I went to *Edit/Preferences/ Files* and checked *Never Warn When Deleting Photos*. Now by pressing *Delete* just one time the image is sent to the recycle bin. Should I make a mistake and delete an image that I wish to keep, it is easy enough to go to the recycle bin and retrieve the image.

2. Once the obvious flawed images are deleted from the set I am editing, I make another pass through the surviving images at 100 percent magnification. I carefully look at the portion of each image I focused on to make certain it is sharp. I immediately delete any unsharp images. Often I move back and forth between similar images to find the one that is the sharpest. It is important here to learn what acceptably sharp looks like. The RAW files I am looking at by viewing the embedded JPEGs within them are sharpened according to the parameters for JPEG processing in the camera. During RAW conversion processing, images can be optimally sharpened. This means the sharpness of the image that is presented on the computer monitor is not as good as the final sharpness will be when the RAW data are processed. It is extremely important to keep this in mind. Therefore, I look at the relative sharpness of the image as I edit and fully realize it can be improved later.

To help me judge the sharpness of the image, I programmed PhotoMechanic Version 5.0 to sharpen the thumbnails of the images I am viewing. Go to *Edit/Preferences/Contact Sheet* and check *Generate High Quality Thumbnails* and *Sharpen Thumbnails*.

3. I edit ruthlessly by looking for reasons to delete images. By the time I make my second pass through a set of images, typically more than 50

percent are deleted and sometimes the percentage is much higher. Of course, the percentage depends on many variables.

Photographing flowers while dealing with a determined breeze causes many more deletes. A mushroom emerging among autumn leaves on a dead calm morning under bright overcast light generates few images that must be deleted. I make a third pass through the images to look for identical or nearly identical photos and delete duplicates.

There is no point in keeping two or more identical photos as they are easy to duplicate when needed.

4. The images that survive my ruthless editing are now reduced to less than 25 percent on average of the number I started with. I plan to keep them permanently, unless I photograph the subject later and get better results. PhotoMechanic makes it a breeze to select the images and label them. I learned long ago to avoid attaching too much detail to an image as it becomes an enormous time waster. For example, although I photograph plenty of plants and animals that could be assigned a scientific name to label the image, I don't bother to look them up and don't use them. I am familiar with scientific names because I was forced to memorize hundreds of them in college botany and wildlife classes. However, adding scientific names to the files takes too much time. Should I ever have a buyer that needs the scientific name—and that hasn't happened in forty years—I can always look it up. Instead, I merely attach the "standard" common name that is published in a current field guide. For example, instead of labeling the images of a butterfly that is abundant around our Idaho home with the Latin name, *Limenitis weidemeyerii*, it is labeled with its common name— Weidemeyer's Admiral.

5. To label all of the images of the Weidemeyer's Admiral, I select all of them and then press *Control-M*. This brings up the *Rename Photos* window, which provides a variety of ways to label all of the images that are selected at one time. Once the common name is on each image, I move all of the images to a separate folder called "Weidemeyer's Admiral." This folder is created in another more all-inclusive folder called "Butterflies."

By organizing all of my images in folders, they are easy to find. All butterfly species that I have photographed (about forty) are found in the "Butterflies" folder. All images of each species are found in their own folder using the common name of the species. For example, I especially like photographing

This Weidemeyer's Admiral quietly perched on the Indian Paintbrush flower one cool morning. The ambient light is underexposed by about one stop and a Canon 580II flash was used as the main light to expose the butterfly and the flower properly. We call this *main flash* because the flash is the main or primary light illuminating the subject and the ambient light serves the role of fill light to prevent the background from appearing too dark. Canon 5D Mark III, Canon 180mm f/3.5 macro lens, ISO 100, f/18, 1/4 second, Cloudy WB, manual exposure and focus.

great spangled fritillaries. To find my images of this species, I merely look in a folder called great spangled fritillary. It is a simple system that works perfectly. For many photographers, it might make sense to also include the place where the subject was photographed. However, I don't do this because I can always remember where I photograph everything, though I can't remember what I did yesterday—and don't ask me to explain it. By the way, this folder system is not unique to PhotoMechanic. Lightroom offers a similar system that is widely used by many photographers.

STORING IMAGES

Image sizes are becoming increasingly large with each new generation of camera models, and it is easy to shoot plenty of images. Fortunately, memory for storing images is inexpensive today. Therefore, we store all of our images on 1.5TB external hard drives that we buy at Costco. We always store the images on two external hard drives to protect us from equipment failure. We have never had a hard drive go bad, but it certainly can happen. Having at least one extra copy of your images is a wise thing to do! Because having a duplicate copy of your images on a separate storage device is desirable, that is another reason to edit the images ruthlessly to reduce the number that must be stored.

SOFTWARE CHOICES

PHOTOMECHANIC VERSION 5.0

We use this program to decide what images we wish to keep, to label the images, and to organize them into folders. Currently we have been using its basic slide program to show the images at our seminars, but we do plan to start using another software program that offers more options for slide presentations.

PHOTOSHOP

Barbara uses Photoshop's powerful program to process RAW images. Thanks to the classes she attends taught by Charles Cramer, she is quite skilled at making Photoshop dance to her commands.

LIGHTROOM

We just started using this program and found it to be terrific for organizing and editing images. It may become my image-processing program because it can do most of the things I want to do with my images without having to go to the considerably more complicated Photoshop program.

WORDPERFECT OFFICE 12

Barbara and I began processing words with WordPerfect decades ago. We think this easy to use program is terrific. Unfortunately, nearly everyone we must send documents to uses Microsoft's Word, so now I have switched to Word.

WORD

Although I am completely comfortable using WordPerfect, *Nature Photographer* magazine, for which I write columns, and our book publisher both use Microsoft Word. I can convert WordPerfect documents to Word, but it never converts the manuscript flawlessly. Therefore, I have reluctantly switched to Word. Fortunately, the problem of errors being created during conversion has been eliminated. I am getting along fine with Word and have written this entire book using Word.

ZERENE STACKER AND HELICON FOCUS

These two programs are extremely useful for processing multiple images to achieve terrific overall image sharpness and tremendous depth of field. The stack of images are shot where each image is focused at slightly different points. We start by manually focusing on the closest object we want in sharp focus, then focus a little deeper and shoot another image, and continue this process until the last image of the set includes the furthest point where sharp focus is desired. The programs sort through each image in the focus stack and select the sharpest parts. These sharp areas are then assembled into one final image where everything is tack sharp.

All photographers should get one of these programs to increase the sharpness of their images. They are especially useful for both landscape and close-up images! Go to the Resources section of this book to find contact information. Both companies offer demos on their website and a free trial download.

CANON DIGITAL PROFESSIONAL

This free software comes with any new Canon camera. I sometimes use it for creating panoramic images and image processing. I would use it more, but because I teach photo workshops, I must use software programs that work with everyone's images and not just Canon shooters' images. For this same reason, Barbara has not availed herself of the Nikon proprietary software.

The crab spider caught the red-tailed bumblebee late in the afternoon. Night arrived while the spider was still eating it, so the spider went to sleep. The bee was still hanging from the spider's jaws the next morning. Barbara spotted the bee and only then noticed the spider holding it. A Plamp was used to stabilize the stem the spider was clinging to just to keep it completely still. Barbara focused on the closest spot she wanted in sharp focus, which was part of the knapweed blossom. Then she changed the focus in tiny increments and shot more images until the furthest spot was sharply focused and shot. It took twenty-seven images to cover the depth of the flower, spider, and bee. Helicon Focus is the dedicated focus stacking software that was used to combine all of these images into a single image with incredible depth of field and extreme sharpness. Nikon D4S, Nikon 200mm micro lens, ISO 100, f/8, 1/50 second, Cloudy WB, manual exposure and focus.

The first rays of amber sunshine illuminate Mt. Woodward while the meadow remains in the shadows. The contrast is too great for a single image capture, so Barbara shot a two-image exposure bracket as fast as possible to keep the horses in sharp focus. The two images were merged with Photomatix Pro 5 and final adjustments were done with Photoshop CS6. Nikon D4S, Nikon 14–24mm f/2.8 lens at 14mm, ISO 200, f/18, 1/5 and 1/20 second, Cloudy WB, Manual exposure mode, AF-C focus using the back-button control.

PHOTOMATIX PRO-HDR

This program is awesome for controlling high contrast. Shoot a series of images and vary the exposure by at least one stop, but not more than two stops. Cover the entire dynamic range of light in the scene. Vary only the shutter speed. Combine these images with this program to capture detail in the darkest shadows and brightest highlights.

CONCLUSION

This is the process we currently use to handle our images. However, this process has and will continue to evolve as new software becomes available or our needs change. What works so well for us may not be the best for you. Everyone needs to find their own procedure that efficiently solves the problem of capturing, sorting, organizing, editing, and storing their images.

Whatever method you adopt, it must be fast and make it easy to locate your images!

Resources

CUSTOM CAMERA EQUIPMENT FOR OUTDOOR PHOTOGRAPHERS

KIRK ENTERPRISES WWW.KIRKPHOTO.COM

We have used the equipment of this innovative company for decades. They offer L-brackets, custom quick release plates for cameras and lenses that have tripod collars, a wonderful focusing rail for high magnification photography, flash brackets, and many other accessories.

WIMBERLEY WWW.TRIPODHEAD.COM

Wimberley is famous for the "Wimberley Gimbal Tripod Head" that revolutionized how big lenses are used today. They also make many accessories that are useful for close-up photographers, including the indispensable plant-clamp (Plamp). In our opinion, all close-up photographers need to have a minimum of two Plamps with them at all times. No other device makes capturing excellent close-up images easier than the Plamp.

REALLY RIGHT STUFF WWW.REALLYRIGHTSTUFF.COM

Although we have no personal experience with their equipment, many of our workshop clients do and they rate RRS quite highly. RRS make their own tripods and heads, along with many other accessories, including a focusing rail that moves forward and backward and side to side for precise framing.

PHOTOFLEX WWW.PHOTOFLEX.COM

This company specializes in making light modifiers for improving the light. We continue to use their popular 32-inch 7-N-1 Multidisc that includes a diffuser and six colored reflecting surfaces.

PHOTOGRAPHY WORKSHOPS

GERLACH NATURE PHOTOGRAPHY WORKSHOPS WWW.GERLACHNATUREPHOTO.COM

Our business website describes our various field workshops and indoor seminars in detail. Many of our most popular instructional photography articles are posted here. We do send out an e-newsletter from time to time. Subscribe to our free newsletter on the website. Hundreds of our images with detailed caption information and an instructional story are found on our popular Facebook page. Go to: www.facebook.com/GerlachNaturePhotographyWorkshops.

CHARLES CRAMER WWW.CHARLESCRAMER.COM

Charles teaches a fantastic workshop using Photoshop to produce exhibition quality prints. Barbara attends his workshop at least once every two years to learn the latest techniques. This is an intensive class that requires the student to be familiar with Photoshop.

PHOTO STACKING SOFTWARE

HELICON FOCUS WWW.HELICONSOFT.COM

The software program that is designed by Danylo Kozub specializes in combining sets of images where the focus has been varied from image to image. Using stacking software is the best way to obtain maximum sharpness in a subject where it is not possible to align the focusing plane with the plane of the subject. Contact Danylo directly at dankozub@gmail.com.

ZERENE STACKER WWW.ZERENESYSTEMS.COM

This outstanding software program by Rik Littlefield is excellent at stacking large sets of images. We use this one and Helicon Focus ourselves and teach their use in our field workshops. Like Helicon Focus, it is highly recommended. Go to both websites to view the tutorials!

BOOKS

The first three books describe the shooting workflow we have developed over forty years of full-time nature photography. Of course, our workshop clients have a lot to do with the shooting system we use because they often ask crucial questions which lead us to a whole new way of taking photographs.

Gerlach, John & Barbara, *Digital Nature Photography – The Art and the Science.* Focal Press, 2007

Gerlach, John & Barbara, *Digital Landscape Photography.* Focal Press, 2010

Gerlach, John & Barbara, *Digital Wildlife Photography.* Focal Press, 2013

Gerlach, John & Barbara, *Close Up Photography in Nature.* Focal Press, 2015

WEBSITES

There are numerous websites that offer outstanding information on photography. Listed below are some of the most popular. These websites are especially first-class for asking specific questions about close-up photography techniques.

Naturescapes: www.naturescapes.net

Nature Photographers Network: www.naturephotographers.net

Luminous Landscape: www.luminous-landscape.com

MAGAZINES

Nature Photographer www.naturephotographermag.com

I have been a regular columnist for this colorful magazine since the beginning. This magazine is especially top-notch at showcasing a wealth of incredible images, and it features many helpful

articles on nature photography. It is published three times a year and is jam-packed with detailed articles and inspiring images.

Outdoor Photographer www.outdoorphotographer.com

This exceptional outdoor photography magazine describes the new equipment and software that becomes available each year and includes many instructional photo articles and images.

PHOTOGRAPHIC EQUIPMENT

CAMERAS

Canon www.canon.com

Nikon www.nikon.com

Olympus www.olympus.com

Sony www.sony.com

Pentax www.pentaximaging.com

LENSES

Tamron www.tamron.com

Tokina www.tokinalens.com

Sigma www.sigmaphoto.com

EXTENSION TUBES

Kenko www.kenkoglobal.com

Kenko offers sets of extension tubes for Canon, Nikon, Olympus, Panasonic, and Sony Alpha. Their tubes preserve autofocus and automatic metering.

TRIPODS

Gitzo Tripods www.gitzo.com

Manfrotto www.manfrotto.com

CAMERA BAGS

We have used photo bags from these companies for years. Both companies offer a large selection of well-designed bags to accommodate anything you might wish to put into them.

Lowepro www.lowepro.com

ThinkTank www.ThinkTankphoto.com

CAMERA AND FLASH RADIO TRIGGERS

PocketWizard www.PocketWizard.com

The PocketWizard Plus III transceiver is terrific for firing your camera remotely by using radio signals. They are also suitable for firing a remote flash. In each case, two units are necessary. One is set to be the transmitter and the other is set to the receiver mode.

Barbara attended a night photography workshop in Acadia National Park to expand her knowledge of capturing the night sky with digital cameras. This image is a combination of two shots. One shot was for the foreground and the other for the starry sky. Nikon D4S, Nikon 14–24mm f/2.8 lens at 14mm, ISO 3200, f/3.2, 25 seconds, 3200K WB, manual exposure and manual focusing.

Index

GERALD ANDRITZ

DELMAR, NY 12054

518 810-8255